PocheCouleur

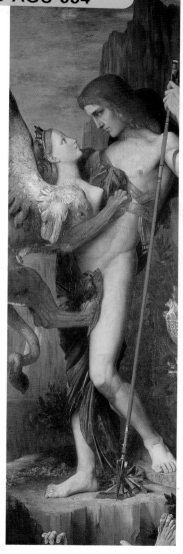

GUSTAVE MOREAU

MONOGRAPHIE ET NOUVEAU CATALOGUE
DE L'ŒUVRE ACHEVÉ

PIERRE-LOUIS MATHIEU

ACR EDITION

Also available:
complete version with catalogue raisonné of the finished
work

468 pages – 265 × 320 mm – 720 reproductions (200 in colour)
hardcover with colour dust jacket
ISBN: 978-2-86770-114-7

Pierre-Louis Mathieu

GUSTAVE MOREAU
The Assembler of Dreams
1826-1898

ACR Edition

PocheCouleur

Contents

Chronicle of the life
of "an assembler of dreams"

*T*he profile of Gustave Moreau's young girl carrying the head of Orpheus ends the cycle of the history of contemporary art, *L'Histoire de l'art francais,* painted on one of the cupolas of the Petit Palais, Paris, in 1925, by the Nabi painter Maurice Denis. As a close friend of George Desvallières, one of the executors of Moreau's will, Denis must have been familiar with the work of Gustave Moreau, and – by referring to Moreau's only painting to be shown in a French museum when he was a young man – respected one of Moreau's dying wishes, that: "there shall be no representation of my person". The profiles of late 19th-century artists such as Puvis de Chavannes, Rodin, Renoir and Van Gogh, and works by Carrière, Gauguin and Redon make up the rest of the cycle.

And that is also what Henri Rupp, Gustave Moreau's sole legatee and organiser of the Musée Gustave Moreau, did when he ensured that the first catalogue of "his museum", published in 1904, contained no portraits of the artist. This wish was also honoured by

Moreau's first historians. As Ary Renan, his first biographer, wrote, "He felt that the artist as individual should not appear in public and that it is right for the man to disappear behind the body of his work."

The big exhibition of Moreau's work at the Louvre in 1961, the only official homage to the artist before the one organised at the Grand Palais for the centenary of his death in 1998, included information about the artist. The reason for this is that knowledge of the artist's life enhances our understanding of what is often considered to be a hermetic body of work.

We should also note that the instructions written down by Moreau in the year before his death, whose imminence he sensed, were somewhat contradictory: he stipulated that his private papers were to be burned then, elsewhere, that they should be put in order but not communicated.

Moreau did destroy some of his papers and no doubt burned his correspondence with his

mistress, Alexandrine Dureux. However, as the creator of his own museum Moreau was wise enough to carefully keep what was undoubtedly the bulk of his letters received and his many handwritten documents. This accumulation was fairly easy to access because Moreau's life – unlike the lives of most artists – was little disrupted by changes of residence, even if, at nearly seventy years of age, he did order the almost complete rebuilding of the town house bought for him by his parents when he was twenty-five. He converted it into a museum to house his studio and the thousands of works of every size and kind that were crammed into it – from the quickest sketches to canvases painted for museums, some begun forty years before and still being worked on only a few months before his death – as if his sources of inspiration and style had hardly changed at all.

Although Moreau enjoyed success after the Salon of 1864when he was about forty years old he deliberately limited the number of works he produced for annual public exhibitions. He stopped making them altogether after 1880, even though, despite all the criticism of his work, he had every chance of appearing in official public shows. He was loath to release any of the four hundred and fifty or more works that constituted his "completed body of work" being the number of those sold. It seems that he applied these words found in his papers: "I love my art so much that I will be happy only when I make it for myself alone."

As early as 1862 Moreau had sought to secure the future of thousands of his sketches and paintings not meant for exhibition and sale. He had gradually come round to the idea of conserving them for posterity in the very place where he had created them. He wrote in his will: "I bequeath the house at 14 Rue de La Rochefoucauld, with all that it contains: paintings, drawings, portfolios, etc., etc., fifty years' worth of work […], on the express condition that they are kept forever – that would be my dearest wish – or for as long as possible. This collection, keeping its character as

an ensemble makes it possible to observe the work and efforts made by the artist in his lifetime."

At the time, this was a surprising and unusual donation, giving the public authorities cause for concern for several years, until they eventually accepted his donation. "Certain artists and museum curators", wrote Gustave Geffroy, a famous avant-garde critic of the day, "when asked how appropriate it was to accept the bequest, objected that Gustave Moreau's townhouse contained few finished works and that it would create a dangerous precedent to accept the bequest by welcoming this collection of sketches and roughs." In the end, the French state decided to accept it, on condition that "Henri Rupp, as sole legatee, pays the sum of 470,000 Francs [approx 1,200,000 Euros] to cover the operating costs of the museum".

Today, we no longer think of the Musée Gustave Moreau merely as a "studio" housing the sketches and proofs of an oeuvre that exists "outside it" – the works that made Moreau famous in his lifetime and were exhibited to the public and sold to art lovers. We also see it as the artist's secret laboratory where no one – except for a few close friends – was allowed to enter It appears as if he was trying to protect himself from the pressure of outside conventions, conventions that indeed he did not dare confront, being perhaps

overly concerned about his image as a "history painter" and too intent on the recognition of his contemporaries as attested by the trappings of fame: Salon medals, the Légion d'Honneur, the Institut, a professorship at the École des Beaux-Arts. Ironically, then, in his quest for artistic success – his "gradus ad Parnassum" (climbing of Parnassus), as his one-time childhood friend Degas chidingly called it – he experienced only a failure to win the Prix de Rome.

However, with only a few exceptions, what is shown by the Musée Gustave Moreau – which has remained as the artist desired it – is more the gestation of an oeuvre, the final creations of which are to be found elsewhere. This is what explains the reticence of the State to accept his donation. It must be admitted that in acting as he did, the painter's reasoning ran counter to the contemporary critic or art historian's conception of the artwork as something that must be as "finished" as possible. Impressionism had sought to break free of this criterion, but Moreau respected it when showing his work at the Salon or offering finished paintings to collectors.

Moreau was a passionate admirer of Michelangelo, and having read Vasari's book about the lives of the great artists, he would have been aware of what the historian wrote about the painter of the Sistine Chapel, where Moreau had spent exciting weeks

copying his works: "Michelangelo had such a distinctive and perfect imagination and the works he envisioned were of such a nature that he found it impossible to express such grandiose and awesome conceptions with his hands, and he often abandoned his works, or rather ruined many of them, as I myself know, because just before his death he burned a large number of his drawings, sketches and cartoons to prevent anyone from seeing the labours he endured or the ways he tested his genius, for fear that he might seem less than perfect."

A hundred years after Moreau's death, posterity seems to have ratified his decision to present the gestation of his work. In contrast, the four hundred and fifty paintings and watercolours that he sold in his lifetime, scattered around major museums or inaccessible private collections, are less well known, and perhaps even less well appreciated. This is, perhaps, because they are too obviously marked by an age when the dominant genre was not history painting but landscape and the representation of everyday life, as passed on by the Impressionists, who were unable to gain admission to the Salon precisely because their paintings were like studies and seemed unfinished.

There are few painters whose work has been so comprehensively preserved, from the first, uncertain sketches, or even ideas still to be given visual expression but dashed down in note form, to the final compositions, and including all the creative phases in between. Until quite recently, previously unshown rough versions were still being discovered in the storerooms of the Musée Gustave Moreau. The complete catalogue – over fourteen thousand items – has still to be drawn up, and is more difficult to put into chronological order.

As for Moreau's life, contrary to what he believed, it is remarkably illuminating with regard to his work, for he put much more of himself than he thought into his art. Indeed, he was one of the initiators and chief proponents of the Symbolist art that was so prominent at the end of the 19th century, defined by the projection of the artist's feelings onto the canvas. More than a century after his death, now that the prohibitions he imposed on his first biographers have fallen away, and the "private" apartments in "his museum", which he had so meticulously set out for posterity, have at last become accessible, we can better understand these feelings thanks to a precise knowledge of his biography. It is now permissible and possible, to say what is known – and in fact we know a lot – about the life of this artist who called himself a "worker and assembler of dreams".

1826–40
A child who loved to draw

*A*s if she somehow knew that sometime in the future a biography would be written about her son, the famous painter, Moreau's mother wrote several pages about his childhood, stressing his precocious taste for drawing: "Gustave was born on 6 April 1826 at 9 o'clock in the morning, in the house of the lawyer Mr Hennequin, in Rue des Saints-Pères, opposite Rue de Lille, which then bore the number 3.

"He was extremely puny, but well formed and very lively. Up to the age of eight months he was the source of great concern to his father and mother; he had to be walked about all night and rocked and sung to, and even then he did not always fall asleep. In spite of his delicate health, he was extremely vivacious and of rare intelligence for his age; he was speaking and walking at ten months. Agile as a monkey, he amazed all and sundry, for he was no taller than a boot.

"His father, Ls Moreau, was made architect of the Department of Haute-Saône in 1827 and moved to Vesoul with his wife and child [children]. The local air proved most beneficial to Gustave and, although still very small, he gained in strength and his health became stronger. He loved horses with a passion and what he most enjoyed was getting up on a big rocking horse and moving endlessly. […]

"In 1830, Monsieur Moreau, although stripped of his functions because of his liberal opinions, was implored to remain in Vesoul for the work on which he was engaged. When revolution broke out, he returned to Paris with his family, and was soon made *architecte-voyer* and architect of the Ministry of Public Works and the Interior. He was a witty, learned man who loved the arts. His wife was a good musician with a very impressionable character. Gustave loved them passionately, especially his mother, from whom he hated to be parted. However, the decision had to be taken to put him in school and, at the age of twelve, he entered the Collège Rollin, where he stayed for two years. For him, this was the most wretched time of his life. Being very shy and small for his age, he suffered from being with other young pupils who were stronger and brought up in a more masculine fashion.

"The death of his younger sister Camille, in 1840 prompted his parents to bring him back home. Shortly afterwards, he travelled to Italy with his mother, his uncle and his aunt. Since he was eight years old, he had always drawn everything he saw and so, on this journey he drew great numbers of sketches – views, figures and horses – bringing a

most interesting album back to his father. His taste for drawing had become a passion, but his father refused to allow him to end his studies, and it was only in the evening, on returning from school, that he went to the atelier of [name left blank] to draw from the model. Finally, after his baccalaureate, his father granted him full freedom, especially after he had submitted to Mr Dedreux d'Orcy an *esquisse peinte* (compositional sketch) of Phryne before her judges.

"It is around about this time (1844) that he entered the atelier of Mr Picot."

These tender maternal recollections were no doubt written for posterity, but also indicate a desire to show that the child was predestined for greatness. "Since he was eight years old, he had always drawn everything he saw." But she is quick to add that his father made it obligatory for him to continue his studies to baccalaureate level. This qualification was rare in Moreau's day, and few artists obtained it. At the same time, Moreau *père* allowed his son to attend a painting atelier "in the evening, on returning from school". We shall see that the paternal influence on Moreau's education lay in the fact that he "did his humanities", as the saying went at the time, and had studied Latin and Greek.

It was at the age of twelve that the young "Tatave" became a border at the Collège Rollin, a municipal school in the Latin Quarter. He won first prize for drawing in 1839 (prize-giving ceremony of 1839–40), when in the first year of secondary school. This, wrote his mother, was the unhappiest time of his life. Fragile and small, the boy was withdrawn from the school after two or three years. His parents were concerned about his health, all the more so since his sister Camille, who was a year younger, had died at the age of thirteen in 1840. Gustave made a pencil sketch of her and still remembered her vividly at the end of his life. In the artist's bedroom there is a bust of Camille, possibly executed after the drawing left by her brother.

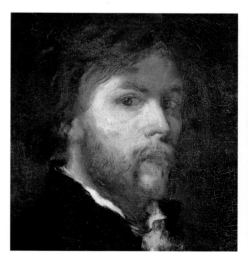

Self-Portrait Aged 24.
Oil on canvas, 41 x 24 cm.
Musée Gustave Moreau, Paris.

1840
The role of Moreau's parents

The influence of the artist's father on his education

*I*n 1840, Louis Moreau took charge of his son's studies. He was careful not to stifle his growing vocation as a painter. Moreau was probably attending a local day school at the time. "You see!" Moreau would later tell Henri Evenepoel, a student at the Beaux-Arts, where he was now a professor, "everyone should have a father like mine: wealthy, first of all, and then very strict, inflexibly strict where work is concerned, an architect who has spent a lot of time with artists, who is aware of the enormous difficulty of a work of art and who has never imposed his ideas on anyone else!"

These lines, which faithfully echo Gustave Moreau's ideas, no doubt also offer a very clear definition of Louis Moreau's attitude towards his son. *Architecte-voyer* to the City of Paris, Louis Moreau (1790–1862) had himself been a student at the École des Beaux-Arts from 1810. There he enrolled in the class of Charles Percier who, with his associate Fontaine, had been the favourite architect of Napoleon I. He had been taught to admire Roman architecture (he executed architectural drawings

of the Pantheon in Rome), and was an admirer of the Encyclopaedists of the 18th century. He was also a highly cultivated man whose library was open to his young son, as well as a collector of objects from Antiquity, with which the young Gustave therefore grew up. During his time in Haute-Saône he was extremely active, covering this very rural department with public constructions such as monumental fountains and village churches. These bore the mark of pronounced Neoclassical tastes, but were also functional.

Louis Moreau was connected to the House of Orléans via his godmother, who was the wife of the Duc d'Orléans, the future Philippe Égalité, and uncle, who was the duke's chief engineer. It would seem that he returned to Paris in 1830, just when the son of the Duc d'Orléans was becoming Louis-Philippe I, King of the French. Shortly after the accession of the new ruler, Louis Moreau published at his own expense a forty-page booklet called *Considerations on the Fine Arts*, in which he expressed regret that the arts were considered

Portrait of Louis Moreau,
the Artist's Father.
Oil on canvas, 45 x 31 cm. Circa 1850.
Musée Gustave Moreau, Paris.

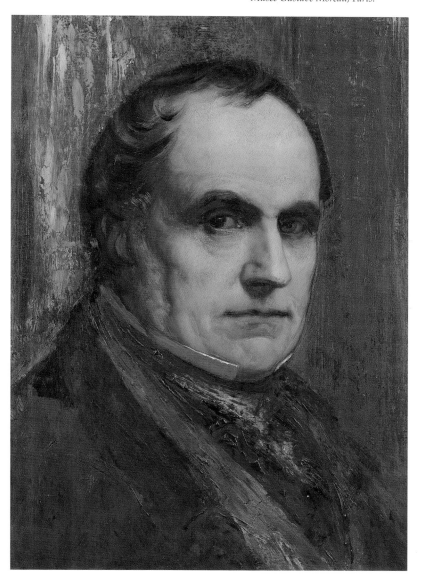

as a pleasure reserved for the elite, and not as a necessity for "the improvement of the most modern classes of society". Whereas in the Renaissance artists were versed in all the disciplines of knowledge, now they were ignorant, despised and doomed to poverty. It was in order to remedy this lack of intellectual training that Louis Moreau proposed to the legislator that an institution be created to provide future artists with a higher education comparable to the one given by the École Polytechnique or the École Normale Supérieure, one that, alongside the teaching of drawing and painting, would offer courses in literature, philosophy, poetry and history, in order to stimulate their imagination with a far-reaching aesthetic training.

Unable to persuade the public authorities to set up such a school, when Louis Moreau observed artistic affinities in his son, he went about providing him with an advanced artistic education himself. For example, he gave him a handsome set of illustrated volumes which included a translation of Ovid's *Metamorphoses*, as well as works by Dante and famous Greek authors, all illustrated by the great English sculptor John Flaxman, which the young boy read avidly.

In addition to his main profession, the fairly modest one of arrondissement architect, Louis Moreau was also in charge of maintenance for several Parisian buildings, in which capacity he had numerous connections in the administration, contacts that he could put to good use in order to obtain commissions for his son, and thus encourage his budding career.

He also helped his son financially, notably with his two-year sojourn in Italy, and was no doubt disappointed that public success did not come more quickly. He later wrote to his son, who at the age of thirty was still passionately absorbed in copying works by the Italian masters: "But in a year, when they are finished, give us one of those works that will all of a sudden raise their author to the front rank. Should not your good father at last enjoy the triumph that he is counting on and expecting? It is a joy that I deserve, for no one will be better capable than I of savouring it." But this "good father" was not a fortunate one; he died in 1862 when his son was labouring on *Oedipus and the Sphinx*, a work that would achieve the success he so longed to witness at the Salon, but only in 1864.

The role of Moreau's mother

If less decisive regarding his education, the role played by Moreau's devoted mother Pauline (1802–1884) was also very important. By taking care of all his domestic concerns and his housekeeping, she enabled him to devote himself fully to his art.

Moreau himself had renounced marriage precisely out of this sense of vocation.

It was long thought that, apart from his loving mother, this inveterate bachelor had no other feminine presence in his life. This was not the case. Nevertheless,

Pauline continued to live with her son right up to her death at the age of 82, in 1884. She became totally deaf some time before 1870, as a result of which Moreau wrote her numerous notes explaining the meaning of his pictures, and fortunately these have been conserved. Her physical handicap did not, however, prevent her from looking after the house for the rest of her life.

Pauline described herself as "a good musician and highly impressionable". It may well be because of her that her young son acquired a solid grounding in music and a real taste for singing; he had a fine, deep tenor voice. She came from a good background. She was born, Pauline Desmoutiers, into the wealthy bourgeoisie of northern France. Her father had been mayor of Douai for a few years during the Revolution, when he had managed to acquire a château that was sold off, having been confiscated by the nation, in Bomy, a village nearby in the area of Pas-de-Calais, where he also served as mayor. That was where Pauline was born and where she married Louis Moreau, at the age of 22 in May 1825. She then moved with her husband to Paris, returning occasionally with her son to Douai. There, in 1872, when he was already well established in Paris, he exhibited with the Society of Friends of the Arts, thus honouring his mother's home region. In fact, Pauline no longer had any property there by this time, and her only material connection took the form of the paintings and photographs of local landscapes that can still be seen today on the walls of Moreau's private apartments, where he kept them as a souvenir of his mother and the places he had known in his youth.

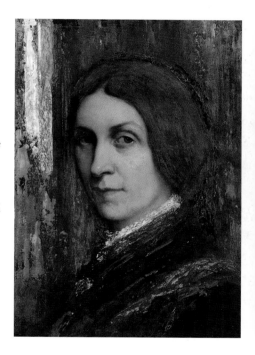

Portrait of Pauline Moreau, the Artist's Mother.
Oil on canvas, 45 x 31 cm. Circa 1850.
Musée Gustave Moreau, Paris.

1841–49
The years of apprenticeship

1841: First travels in Italy

Moreau made his first journey to Italy with his mother, an uncle and an aunt when he was fifteen. Before they left Paris, his father gave him a sketchbook with a green cover in which he had written: "I am entrusting Gustave with an album containing forty-five sheets. Moreover, Gustave must bring back the translation of sixty pages of the *Commentaries* by Caesar. I trust him not to translate the ones he has already translated in the course of the year. He will also have to do arithmetic every day. He shall do one of the four rules.

Paris, 20 July 1841."

We do not know if the young tourist carried out all the assignments set by his father, but he did bring back a sketchbook full of mountain landscapes (Chamonix), views of Venice, Milan, Parma and Genoa, and sketches of peasants and the Swiss Guards in the Vatican States, all skilfully executed between late July and early October 1841.

1843: First studio

In October, at the age of 17, Moreau obtained his first copyist's card for the Louvre. While working towards his baccalaureate, his father also allowed him to take life classes in a studio after school hours.

1844 (or 1845): The baccalaureate

Moreau passed the baccalaureate examination. As to the year, the archives of the Musée Gustave Moreau hold a *Methodological Memento for Candidates for the Literary Baccalaureate*, by Émile Lefrance, bearing the date of 1845.

1844: Picot's studio

Once his son had obtained his baccalaureate, Louis Moreau submitted one of his paintings to be judged by Pierre-Joseph Dedreux-Dorcy, known to the family as his brother was an architect and a painter of modest reputation, whose main historical claim to

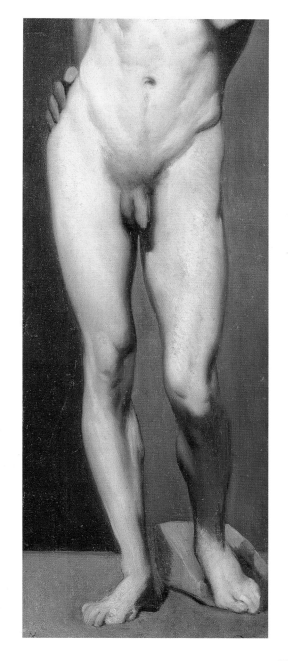

Academy Figure
of a Young Man.
Oil on canvas 80 x 34 cm.
Circa 1845.
Musée Gustave Moreau, Paris.

fame is that he was a friend of Géricault's, and instrumental in the Louvre's acquisition of *The Raft of the Medusa*. The subject of this painting, now lost, was *Phryne before Her Judges*, a pretext for a handsome female nude in an antique setting. If we are to believe Moreau's mother, it was Dedreux-Dorcy's favourable opinion that prompted Louis Moreau to allow his son to prepare himself for a career as a painter by entering the studio of François-Édouard Picot. We know of nothing to suggest that Dedreux-Dorcy shared with the young man, who had a passion for horses, his admiration for Géricault, himself a great lover and painter of horses. At the most, a few reproductions of works by Géricault have been found in the Moreau museum archives, but these were acquired at a later date. However, whenever Moreau featured in an official exhibition he insisted on making it known that he had been a student of Picot. Under the Restoration and July Monarchy, Picot had represented a post-David style of Neoclassicism, and had been involved in the decoration of the Louvre, the Château de Versailles and the church of Notre-Dame-de-Lorette.

A member of the Institut de France and, consequently, involved in the juries for the École des Beaux-Arts, including the Prix de Rome jury, Picot had, at his home close to the house of Moreau's parents, opened one of the three or four private studios in Paris that were frequented by many students preparing for the École des Beaux-Arts. His students included Cabanel, Lenepveu, Bouguereau and Henner, all future

winners of the Prix de Rome. An accomplished technician skilled at adapting to the tastes of the day, he contributed to the Neo-Byzantine revival in religious painting under Louis-Philippe, who particularly admired his work. He was a liberal and greatly appreciated teacher.

In the morning there was a life class with a male or female model. Picot organised competitions between his students preparing for the Beaux-Arts. Moreau won the "composition prize" in the fourth quarter of 1846 and the first quarter of 1847, and piously kept the medals with his name specially engraved on them. In the afternoon, the students made copies in the Louvre. The students, and those already admitted by the Beaux-Arts, went there for drawing classes. That was where Moreau trained and spent two or three years preparing for the "competition for places" at the Beaux-Arts. This school had just built a "Palais des Études", which was richly endowed with casts of antique statuary. These were the main models used in the education of future artists.

1846–49: The École des Beaux-Arts

Presented by Picot, Moreau took the admission examination, or "competition for places" of the École Royale des Beaux-Arts, and was received, sixty-sixth out of 100 artists admitted, for the winter term. His figure drawn from life was examined on 7 October 1846. In keeping with the rules, in spring 1847 he took the examination for the summer term and was ranked seventy-first, then again

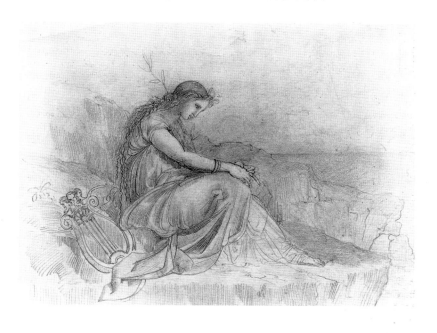

Sappho by the Cliff.
Drawing in graphite on paper.
18.5 x 25.2 cm. 1846.
Private collection, Paris.

in October 1847, for the following winter, where he ranked tenth.

The teaching at this school, which did not prevent students from attending a private atelier, as Moreau did, consisted mainly of having the students draw "la bosse", as they called the casts of antique statues, or nude models (always male) and taking classes in anatomy, perspective and art history. The teachers took monthly stints correcting the work on a rotating basis, while regular competitions allowed students to pit their talents against each other in making painted sketches. Nearly all aspired to win the prestigious prize for history painting, one of the annual Prix de Rome, which was also open to artists from outside the school. Two qualifying examinations whittled down the contestants for the prize itself. Some artists competed no less than ten times before reaching the age limit of 30. Moreau took part twice.

1848–49
Failure in the Prix de Rome

1848: First attempt

*T*he theme for the first history painting competition, known as the *premier essai*, was "The Death of Demosthenes". Candidates were expected to produce a six-metre *esquisse peinte* in a day. On 27 April, Moreau was ranked fifteenth among the fifty-seven candidates by the jury, which included his teacher Picot. He was therefore among the twenty who proceeded to the second examination, along with Baudry, Lévy, Boulanger and Bouguereau, all of whom would go on to win the Prix de Rome during the following years.

Held two weeks later, this second examination selected the ten students who would compete for the Prix de Rome itself. This time, the task was to draw a nude figure in four sessions. Moreau's name was not among those who were selected, but he probably did not regret this too much, for none of these candidates was judged worthy of the prize that year.

1849: Second attempt

This year, Moreau was successful in both the first competition on 26 April (subject: *Tobias and the Angel at Raguel's House*), and the second, on 19 May, and could therefore compete for the prize itself. The subject for this was *Ulysses Recognised by Eurycleia*. The requirement is the representation of the following: "Ulysses has returned to his palace, disguised as a beggar, so as not to be recognised by Penelope's suitors, or by Penelope herself. The Queen of Ithaca orders one of her servants, Eurycleia, Ulysses' former nurse, to wash the feet of the Stranger as a sign of hospitality. The woman brings the brass bowl and fills it with water, then approaches Ulysses, who is in the shadow, and bathes his feet. She at once recognises the scar from a wound he suffered in his youth when hunting boar. The old nurse lets go of Ulysses' foot, and his leg slips back into the bowl, causing the water to splash around the room. She feels a mixture of sorrow and joy."

Ulysses Recognised by Eurycleia.
Oil on canvas, 19 x 24.2 cm. 1849.
Musée Gustave Moreau, Paris.
Sketch for the Prix de Rome.

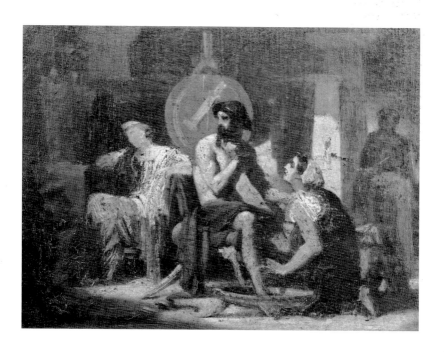

On the first day of this contest, which lasted seventy-two days (from 21 May to 13 August 1849), candidates were required to execute the general sketch for their painting. Excessive deviation from this plan in the final work could mean disqualification. After that, each candidate worked alone in his *loge* for twelve hours a day – excepting Sundays – first on his sketches and then on the final painting. Moreau, whose health was fragile, fell ill and he had to stop for seven days. With the agreement of his nine fellow *logistes*, however, he was given permission to stay on for an extra week.

But this was not enough for him to win the prize, which was awarded on 29 September. During the deliberations of the jury comprising members of the Académie des Beaux-Arts, his name did not come up once, in connection with the slightest distinction. When the works were exhibited to the public, the critic of the influential *Journal des Débats,* Delécluze, wrote: "M. Moreau, author of the ninth painting, has made a work of fair conception and execution. One might even reproach him for having too closely tied his

scene *all'usanza teatrale.* This artist knows how to *make a picture*, but that is not enough: one must also captivate and stir the beholder". Another critic made the following reproach: "M. Moreau understands staging, but he lacks that personal fervour that is manifest in all those who love their art with true faith."

The Prix de Rome that year was awarded to Gustave Boulanger, whose path Moreau would again cross in 1882, when he lost to him in the election for a seat at the Académie des Beaux-Arts, only to succeed him there a few years later.

Moreau's *loge* painting was purchased for 100 Francs by a relative who was a magistrate in Rome. The work has apparently been lost, but the Musée Gustave Moreau did have a sketch, until this disappeared in 1986, during the exhibition *Le Prix de Rome à l'École des Beaux-Arts.* By a strange reversal of values, a simple sketch for a work that had failed to win the Prix de Rome proved more tempting than the winning paintings to the light-fingered visitor, who presumably stole it with its market value in mind.

It was rare indeed to win the Prix de Rome at the first attempt. The very talented Ingres succeeded only

at the second, and for most it took three or four, or even more efforts, to obtain this prestigious honour. Moreau, however, did not persist, and decided instead to compete in the yearly Salon, while turning towards another form of artistic training. A few years later, thanks to his parents' wealth, he was able to undertake the sojourn in Rome that came with the prize of that name. He realised that he lacked the accomplishment that only Rome, and not the French capital, could provide. He wrote: "Paris: exhibitions, the everyday, mental life of external matters, constant movement, familiar art, picturesque art. Rome: the eternal masters, solitary spaces, silence, the life-giving commerce with the dead, the art of imagination and pure poetry."

Moreau became a teacher at the Beaux-Arts (where, since 1863, professors also took ateliers), and he declared that he had "ridden on the back of an ass". However, thirty years later, he still wrote "student of Picot" after his name. He continued to follow the technique he had learnt in Picot's atelier and at the Beaux-Arts, where drawing was seen as essential to the creation of the final work (he left ten thousand of them), which was prepared by increasingly elaborate sketches, from the initial posing of the models for the figures to the preparatory grid, as well as the technique he had learnt from copying the works of the Old Masters. Even in his student years, Moreau was an assiduous copyist at the Louvre. As for his subjects, he more than once chose them from the religious or mythological repertoire provided by the school's competitions. His great project, *The Suitors*, may thus have been inspired by the programme for the 1849 competition. Likewise, we may note that his paintings of "Hercules giving up Diomedes to the horses that the barbarian prince fed with human flesh" and "Angels indiscriminately striking down the inhabitants of Sodom" followed the themes of the 1844 and 1845 competitions, respectively. The École des Beaux-Arts taught only history painting and historical landscape, and Moreau would be a "history painter".

1848–52
The first exhibition

1848–51: The *Pietà* and the first Salon

*A*s early as 1848 the young artist began work on a large canvas to be presented at the Salon, its size making it suitable for a church. A small sketch from these years shows the head of the Virgin, as the preparation for a Pietà, her features those of Moreau's own mother. It is still kept in the artist's bedroom. Other studies for figures in their definitive poses are dated 1849, which suggests that this painting, for which we have only a general study and a single engraving by Moreau himself, was well advanced by 1850.

This first painting which, thanks to his father's connections, Moreau managed to have purchased in 1851 by the state for 600 Francs, the price of a copy, was accepted for the 1852 Salon. It was imposing in size – three by four metres – and was even photographed by Gustave Le Gray in what is the first piece of photojournalism about an art exhibition.

Although hung in the Salon d'Honneur, this painting by a debutant went virtually unnoticed, except by Théophile Gautier, who was amazed that a student of Picot's should present a work attesting the influence of Delacroix. The piece was one of 1,280 works admitted to the Salon that year, and even though it was a public commission, disappeared without trace over a century ago. The few critics who mentioned it emphasised mainly the influence of Titian and the dominance of the colours red and blue but only one, Théophile Gautier, thought to compare it to a large painting that Delacroix had just completed for the church of Saint-Denis du Saint-Sacrement in Paris, which had met with a poor reception from critics – Baudelaire excepted – because it ran counter to the taste of the day. The recent discovery of an etching made by Moreau of this Delacroix painting in the Moreau Museum

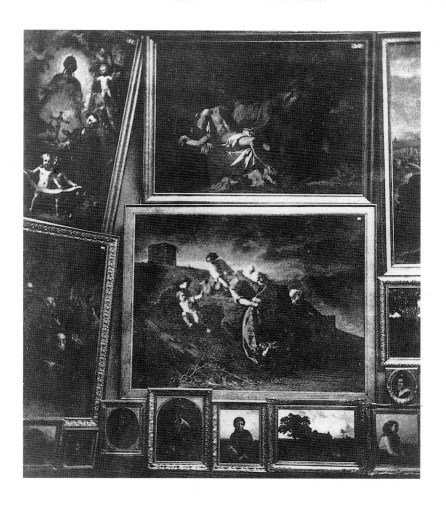

archives proves that the artist had a copy of the work in his possession and was probably inspired by it, although he cannot be accused of plagiarism.

Such, it seems, was the influence of Delacroix, replacing that of Picot and the École des Beaux-Arts, that Moreau paid a visit to the master at his home in Rue Notre-Dame-de-Lorette, very near the home of his parents. "After several years of study, and much hesitation," reports J. Paladilhe, "Moreau decided to seek him out in order to ask his advice because of the confusion he felt, seeing that his training seemed to be stifling his

aspirations.""What do you expect them to teach you?" replied the great Romantic on hearing these grievances, "They know nothing."

Delacroix, who, a few years earlier, had opened an atelier, was not a good teacher, and could not take on Moreau as a student. Our only information about their relationship comes from the few lines Delacroix wrote in his *Journal* on the day of Chassériau's funeral, on 10 October 1856: "Procession for the poor Chassériau. I see Dauzats, Diaz and the young Moreau, the painter. I quite like him." As for Moreau's fervent enthusiasm for the Romantic master, we know all about that from his words to Degas when they met in Rome in 1858.

Delacroix exhibited prolifically at each Salon, which gave Moreau ample opportunity to assimilate his style. From this period date Moreau's small paintings illustrating scenes from Shakespearian tragedies. His *Hamlet* (MGM. Cat. 801) is a pale-faced adolescent holding a skull, dated 1850, his *Hamlet Forcing the King to Drink Poison* (MGM. Cat. 145) is a dramatic, violent scene whose colours and abrupt handling are an exaggeration even of Delacroix's manner. His *Shakespeare Keeping the Horses at the Door of a Theatre* (MGM. Cat. 676), *King Lear* (MGM. Cat. 160), *Lady Macbeth* (MGM. Cat. 163 and 634), *King Canute and His Courtiers* (MGM. Cat.64) are all in the artist's studio; *Macbeth and the Witches* was sold to a private collector; and *Young Venetian Girls Ravished by Cypriot Pirates* is in the Hôtel de Ville, Vichy, and is a scene on an ambitious scale inspired by Sismondi, etc. Some of these scenes

were also made into drawings from which his friend Berchère made small editions of etchings.

Like many other young artists, Moreau strove to imitate the masters he admired. He scrupulously copied Veronese and Titian in the Louvre and applied their colours to canvases such as the *Decameron*, after Boccaccio and *Bacchanale* (MGM. Inv. 15718 and 15717) which, although unfinished, evince real vitality.

1852: The new residence in the Nouvelle Athènes

Moreau's parents paid the Marquis Pazzis of Padua 45,000 Francs for lot no. 1 in a new development, comprising a two-storey house at 14 Rue de La Rochefoucauld, in an area then undergoing extensive urbanisation. Before the Revolution it had been part of an large abbatial estate belonging to the Dames de Montmartre, one of whose last abbesses, Catherine de La Rochefoucauld, gave her name to the street in question. Many prominent actors and actresses began moving into this quarter from 1820, when it was given the name of Nouvelle Athènes (New Athens) as it became covered with rental buildings and townhouses in the Neoclassical style. Among those who lived there were Talma, Mlle Mars, Mlle Duchesnois, and the painters Paul Delaroche, Horace Vernet, François Picot and, somewhat later, Eugène Delacroix, who moved into Rue Notre-Dame-de-Lorette.

In October, Moreau asked his father, as an architect, to enlarge the house, notably at the attic level, by

installing a "painting studio with its ancillary rooms", including a private staircase affording direct access to the studio from the street. Moreau, who had previously rented a studio near the Barrière Pigalle, moved in during July 1853. It was in this house, which he transformed into a museum towards the end of his life, that Moreau spent most of his time.

The Artist's Mother as the Virgin Mary.
Oil on canvas, 30.5 x 28.4 cm, 1848.
Musée Gustave Moreau, Paris.

1853
The second Salon
and the influence of Chassériau

Moreau presented the *Pietà, Darius after the Battle of Arbela, Pursued by the Greeks, Stops, Dropping with Fatigue, and Drinks from Muddied Water* and a *Portrait of a Man, Study of a Head* (unidentified) for the Salon of 1852. The latter two were rejected by the jury. The writer Théophile Gautier had noticed the *Darius* in Moreau's studio, which was close to that of his good friend Chassériau, and spoken glowingly of this "superbly bold piece, in violent colours and with great fire in the brushstrokes; it would have looked very well at what was a rather calm and overly prudent Salon. In art, it is sometimes a good thing to break windows".

The following year *Darius* was again presented, albeit under a slightly different title: *Darius after the Battle of Arbela* (MGM. Cat. 223), and this was accepted, as well as

another canvas entitled *Song of Songs* accompanied by this commentary: "The guards who are patrolling the town met me; they beat and mistreated me; those who were guarding the walls tore away my veil. Chap. V. Verse 8." The painting had already been bought for 2,000 Francs by the minister of state – like the *Pietà* – thanks to an influential recommendation by one of the young artist's relatives, Laisné, a director at the interior ministry, "in compensation for his efforts and for his generosity in executing the work entrusted to him"(this being a reference to the *Pietà* commission).

While the very big *Darius* remained without a buyer and stayed in the studio, where Moreau would later retouch it extensively, the *Song of Songs* was sent to the Musée des Beaux-Arts in Dijon, where it can still be seen today. Its title notwithstanding, this is not a

The Song of Songs.
Oil on canvas, 300 x 319 cm. 1853.
Musée des Beaux-Arts, Dijon.

The Suitors.
Oil on canvas, 385 x 343 cm. 1852–96.
Musée Gustave Moreau, Paris.

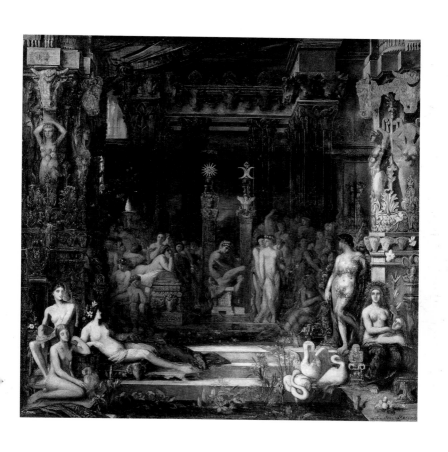

The Daughters of Thespius.
Oil on canvas, 258 x 255 cm. 1853 and 1882–83.
Musée Gustave Moreau, Paris.

religious scene but the prelude to a rape about to be perpetrated on the beautiful Shulamite by the drunken soldiers, who are trying to tear off her clothes. For all the violence and movement of the scene, and despite the audacious interpretation of the sacred poem, this work did not attract much attention from the critics, perhaps because it was not sufficiently different from the works of Delacroix and Chassériau.

Certainly, both these canvases bear the stamp of another major Romantic painter, Théodore Chassériau, a former prodigy who studied under Ingres but had moved away from his teacher and towards Delacroix. In fact, Baudelaire accused him of trying to "rob" him, especially in his scenes inspired by North Africa and Shakespeare. Critics were indeed to observe that Moreau, who called himself a "student of Picot," was imitating Delacroix, who belonged to another school, and likewise Chassériau, who was listed as a student of Ingres.

Moreau apparently met Chassériau after his second attempt at the Prix de Rome. Chassériau was only seven years his senior, but had already received major commissions for churches and public monuments. Between 1844 and 1848 he worked on the decoration for the monumental main staircase of the Cour des Comptes at the Palais d'Orsay, for which he was awarded the Cross of the Légion d'Honneur at the age of only thirty. According to an oral account that J. Paladilhe had from Henri Rupp, Chassériau was painting the frescoes at the Cour des Comptes and Moreau, no doubt through atelier contacts, had a chance to go and see the frescoes. He was greatly struck by the grandeur of the style and the harmonious nobility of the compositions. He came back from this visit in a state of such enthusiasm, and spoke of it to his father with such passion that it was clear that it would be vain to force him to take a path that was contrary to his tastes, and his father gave him the choice to leave the École des Beaux-Arts. "But do you really know what you want to do?" he asked, still worried. "Do you have an idea, a goal?" "I want to produce epic art that does not belong to a school" was the reply.

In about 1850, Moreau's parents rented for their son a studio at 28 Avenue Frochot, not far from their home, which was then in Rue des Trois-Frères. This was in an area much sought after by artists; close to the Barrière Montmartre (today's

Darius Fleeing after the Battle of Arbela.
Oil on canvas, 245 x 165 cm. 1852.
Musée Gustave Moreau, Paris.

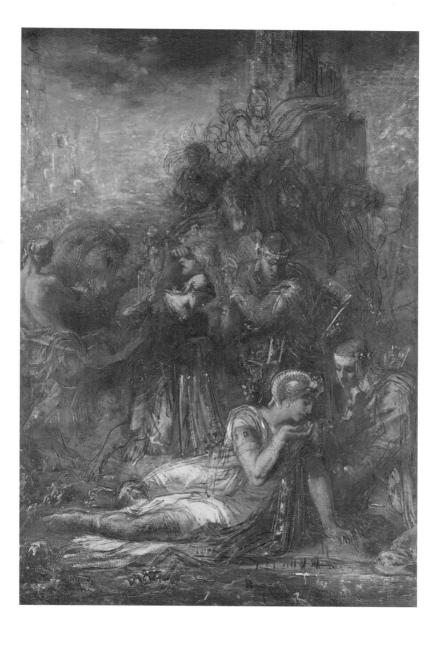

Place Pigalle) and the wall of the Farmer General, which still separated Paris from surrounding villages such as Montmartre, which Napoleon III would annex to Paris in 1859.

This was where Chassériau moved in 1844, when he bought a house full of Oriental magnificence owned by a famous painter of horses – Alfred de Dreux – who himself influenced Moreau for a while. Chassériau, a painter with a gift unrivalled in his day for expressing the sensual grace of the female body, lived a dandy's life, attended by beautiful women from the world of the stage or from the aristocracy, and young artists like Puvis de Chavannes and Moreau, who were fascinated by his success. After meeting in Chassériau's studio, these two painters become lifelong friends.

Moreau never hid his debt to Chassériau, who did indeed have an enduring influence on him. However, he refused to speak precisely about their relations. When Chassériau died suddenly at the age of 37, Moreau paid him homage by starting work immediately on *The Young Man and Death*. Later he decorated the vestibule of his house with photographs of Chassériau's works, and he carefully kept three drawings given to him by the painter, one of which was a graphite portrait of the most famous tragedian of the day, Rachel, below which Moreau carefully noted: "Rachel, sketch made on my wallet by Th. Chassériau, Avenue Frochot 1853". Chassériau's death in 1856 spared him the pain of seeing his masterpiece being burned during the Commune in 1871. In January 1898,

at the end of his life, Moreau was approached to set up a committee that would attempt to save what remained of Chassériau's decorative paintings. Though at death's door, he replied: "I am very ill and can give absolutely nothing to matters in the outside world. That is why it is impossible for me to play an active role in the actions intended to save part of Chassériau's mural paintings. I expressly state that I do not wish my name to appear on any committee list, or be shown in any way. It will, however, be written under its letter in the list of subscriptions, if one is opened, for the sum of 1,000 Francs.

"As for my personal moral commitment, no one can doubt it. Those with any interest in artistic matters are only too familiar with my fidelity to Chassériau's memory, to the memory of that noble and admirable artist whom I so loved."

Under the influence of Chassériau, in the 1850s he began two ambitious compositions that would take several decades of work, albeit discontinuous. He then made these the main exhibits in his museum, having lengthened their four sides and thus doubled their surface area. *The Suitors* (MGM. Cat. 19), after 1852, comprised a "central core" on which the morphologies and postures of some of the figures are clearly inspired by Chassériau. This connection is even more obvious in *Hercules and the Daughters of Thespius* (MGM. Cat. 25), begun in 1853, the model for which is quite obviously Chassériau's *Tepidarium* (Musée d'Orsay), which was presented for the Salon of 1853.

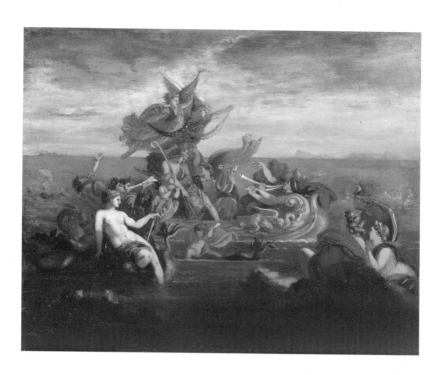

As in the Chassériau painting, the oldest part shows women's bodies close together in languorous poses. Reprised and modified in a very different style, these two paintings were so thoroughly transformed in the course of their "lifetime" that the original work has almost disappeared behind later additions; which is not to say that the differences in handling between the respective periods when Moreau was working on them are not apparent.

The Rape of Helen.
Oil on parquet board, 40.5 x 48 cm. 1854.
Collection Brame and Lorenceau, , Paris.

1854–57
High and dry

Moses in Sight of the Promised Land.
Oil on canvas, 245 x 151 cm. 1854.
Musée Gustave Moreau, Paris.

1854: Eclecticism

Moreau was clearly still finding his way, following tendencies that looked as if they might win him attention from art lovers. Chassériau was the dominant influence, but the young artist was also fascinated by representations of horses, which had been a passion since childhood. It so happened that there was a real vogue for depictions of races and elegant carriages. This genre of painting was dominated by Alfred De Dreux, a dandy and horseman, whose studio in Pigalle was frequented by rich race goers with a passion for English racing and for thoroughbred horses, which they loved to ride and be seen riding. Although, unlike Géricault, he does not seem to have been a real horseman used to riding in the woods, Moreau painted handsome equipages and equestrian scenes in a style close to that of Alfred de Dreux in order to demonstrate his knowledge of horses. Later in his career Moreau would express his continuing love of horses in a more heroic register.

He also proposed the kind of mythological and religious scenes, for which he had more of a penchant. Here he imitated the School of Fontainebleau in his depictions of the loves of Paris and Helen or, more ambitiously, undertook but never finished a big painting entitled *Moses in Sight of the Promised Land, Removes His Sandals*, showing the joint influence of Michelangelo and Leonardo da Vinci. The long commentary that he wrote to accompany this work shows the importance he attached to the representation of the aged prophet who had led to the plain of Canaan "the human family, exhausted by the endless road, but full of hope, enthusiasm and joy". Much later, he would return to this figure as the subject of one of his masterpieces, showing the baby Moses being abandoned on the Nile – a much better-known scene.

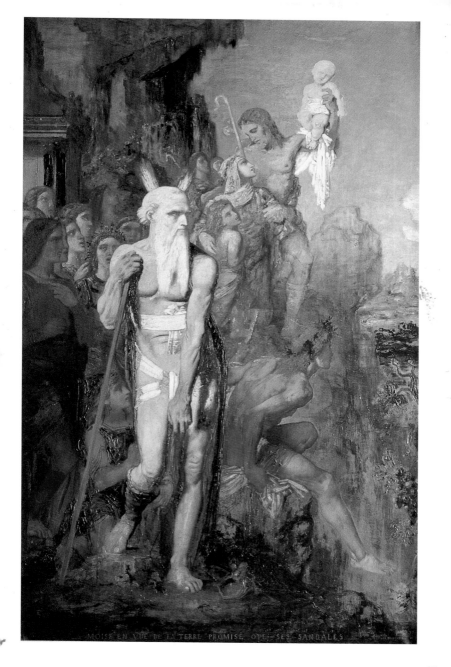

MOISE EN VUE DE LA TERRE PROMISE OTE SES SANDALES

37

1854–55: A painting at the Universal Exhibition

In September 1854, the good offices of a powerful contact won him another state commission on the subject of "The Athenians giving up the annual tribute of young men and young women to the Minotaur". Its price was the considerable amount of 4,000 Francs. The Inspector of Fine Arts responsible for following the execution of the piece judged it "well composed and handsome in colour". Its Neoclassical style brings to mind Poussin and David, and its concern for historical accuracy was very much in vogue at the time. The painting was sent to the museum in Bourg-en-Bresse but first, in what was a great honour for a beginner, exhibited at the Universal Exhibition in Paris. This event, France's response to the inaugural Great Exhibition, held in London in 1852, was intended to show French pre-eminence in the arts. Not unjustly, Moreau's painting was ignored by critics and received none of the 222 citations from the jury when it awarded its 247 medals.

In December, with his new friend Eugène Fromentin, he exhibited in Bordeaux a few small Romantic works which he was pleased to sell. Moreau was no

The Athenians Being Delivered to the Minotaur.
Oil on canvas, 106 x 200 cm. 1855.
Musée de l'Ain, Bourg-en-Bresse.

Apollo and the Nine Muses.
Oil on canvas, 103 x 83 cm. 1856.
Private collection, Paris.

doubt coming to understand that recommendations could no longer guarantee success. Indeed, the Administration was tiring of him. He would give no further public exhibitions until 1864.

1856–57: Years of uncertainty

In 1856, as Moreau reached the age of thirty, there seemed little prospect of youthful success. He had settled in his new studio and was certainly working on *The Suitors* and *The Daughters of Thespius*. He started painting *The Young Man and*

Death immediately after the death of Chassériau on 8 October 1856. Judging by his description of the work to Fromentin (who was trying to establish himself as an Orientalist painter), this painting had progressed well by December of that year, but it was not exhibited until 1865, and had no doubt been considerably reworked in the intervening period.

Thanks to a friend from his teenage years, Alfred de Sourdeval, Moreau gained an introduction to the family of the wealthy banker Benoît Fould, brother of Achille Fould, a minister of Napoleon III. Alfred de Sourdeval had married

Race – Horses and Jockeys.
Watercolour on paper mounted on cardboard, 15.5 x 22.8 cm. Circa 1852–55. Private collection.

Benoît Fould's niece and adoptive daughter, Zélie Oppenheim, to whom Moreau once expressed his conviction that a true painter cannot found a family because "marriage smothers an artist". His opinion was widely shared at the time by fellow painters such as Delacroix, Chassériau, Corot and Degas, although they were not at all averse to a busy love life.

It was Benoît Fould who commissioned Moreau to paint *Hercules and Omphale* (MGM. Inv 13989), a piece that he undertook reluctantly and in fact failed to deliver. "This is the programme," he told Fromentin.

"The main thing is to paint a pretty woman. I am sure you know what is meant by that; no muscle, and nice to look at."

In fact, the young artist was aware that his "artistic education" was incomplete and in 1856 he announced: "My father, my mother and I are making very serious plans to go and spend one or two years in Italy, quite an undertaking! There I shall live on the little I possess in perfect independence, without worry, working like a child to learn all the things I do not know. After that my mind will be at rest and my conscience less troubled."

Postilion and Horses.
Oil on canvas, 62 x 92 cm. Circa 1854.
Musée Gustave Moreau, Paris.

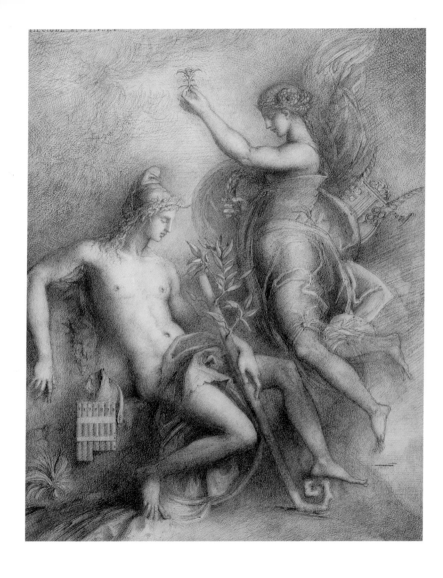

Hesiod and the Muse.
*Graphite, pen, brown ink, with light heightening
in white gouache, 41.9 x 33 cm. 1857.
Collection Mr. and Mrs. Germain Seligman,
New York. On long-term loan to the Fogg Art
Museum, Cambridge. Mass.*

Chaste Suzanne.
*Oil on wood, 52 x 32.5 cm. 1850–55.
Musée des Beaux-Arts, Lyon.*

1857–59
The Italian Sojourn

October 1857-June 1858: Early months in Rome

On 21 October 1857 Moreau got off the boat at Civitavecchia with Frédéric de Courcy, a fellow former attendee of Picot's atelier. The plan was for his parents to join him a little later, in order to spare themselves excessive fatigue and keep down expenditure. A shrewd manager of resources, his father, who had just retired, had calculated that for a year in Italy the family would spend some 12,000 Francs, which was less than their annual income of 16,850 Francs, most of which was property related, and would therefore not eat into their capital.

The Rome visited by Moreau was a provincial city lacking in comfort, one that had hardly changed since Poussin's sojourn there two centuries earlier. The place seemed cut off from the modern world and its ideas, especially when compared to Paris, and yet Moreau succumbed at once to the charm of the Eternal City. During his two-year stay in Italy he devoted himself almost exclusively to studying the Renaissance

masters, with a preference for the colourists – greatly admired by the Romantics – and for the decorative painters. Moreau seemed to be planning to follow in the footsteps of Delacroix and Chassériau. He returned from Italy with over a thousand copies, all of which are kept at the Musée Gustave Moreau, from the quickest sketches to facsimile-like reproductions of certain masterpieces. Moreau sometimes spent weeks looking at some of these works in an attempt to understand their secrets and to absorb their techniques. He threw himself into the work with a passion behind which there also lay a determination to forget an impossible love – one that may have hastened his departure to Italy – that is discreetly alluded to in the letters from his close friends Destouches, Fromentin and Berchère.

"Study, be absorbed, become a Benedictine of painting and, believe me, that poor heart which today is sad will regain its calm," advised Berchère. "The

The Wedding of Alexander and Roxana, *after the work by Sodoma. Watercolour, 70 x 49 cm. Musée Gustave Moreau, Paris.*

Putto, *after a fresco by Raphael at the Accademia di San Luca in Rome.*
Tempera and watercolour on board, 110 x 44 cm.
1858. Musée Gustave Moreau, Paris.

[…] comes to me too often and makes me suffer," Moreau confessed to Destouches. "But I have put good order in all this melancholy and all this weakness of the heart. I am working twelve hours a day, constantly in harness, and I have got used to not fretting." Moreau now dedicated himself to study, even renouncing some of the pleasures he had enjoyed in Paris: "I had a terrible fright this morning," he wrote to his parents in December. "For a moment I thought I was going to be caught once more by that monster that is called the World. But fortunately I got away merely with the fear."

He spent each day passionately absorbed in copying. As soon as he arrived, he began with a fragment of a fresco by Sodoma, a student of Leonardo da Vinci, in the Villa Farnese, *The Wedding of Alexander and Roxana* (MGM. Inv.13614). This took him three weeks of work, as he sought by means of watercolour to capture "the matte tone and soft aspect of fresco", while memorising the respective positions of the figures, which he would later use in *Jason,* a painting executed in 1865.

But his great undertaking was to copy Michelangelo's paintings of Sibyls and Prophets in the ceiling frescoes of the Sistine Chapel. He enjoyed the great privilege of being able to work there for nearly two months, with only a few interruptions due to papal ceremony, and was thus able to recall "the marvellously subtle and colourful colouring of these pendants" in precise drawings of six figures, which he had taken care to trace beforehand.

The Persian Sybil, *after a fresco by Michelangelo in the Sistine Chapel. Watercolour on pen and pencil, 56.6 x 42.9 cm. 1857. Musée Gustave Moreau, Paris.*

In the course of these weeks that were both exultant and diligent, he had plenty of time to meditate on the genius of Michelangelo, one of the artists he admired above all others. In a superb piece of analytical writing, he spoke of his fascination with the "ideal somnambulism" that emanated from the works: "One does not rest, one does not act, one does not walk, one does not meditate, one does not weep in this way on our planet, in our world […] The Artist becomes double and writes for the Earth and for Heaven."

In the evening, after working in museums and *palazzi*, he went to the Villa Medici, where he would meet, at the French Academy, the residents who had won the Grand Prix de Rome. With some of them, notably Henri Chapu, a sculptor with whom he measured the proportions of Antique statues, and the painter Élie Delaunay, he formed lasting friendships. His musical knowledge, and in particular his talent for conveying scores with his voice, was appreciated by Georges Bizet, winner of a Prix de Rome for music, who submitted to him envois such as the one for *Don Procopio*.

The Villa Medici was the only place in Rome where artists could draw nude models, and the French Academy was a welcoming place. There Moreau met other artists also staying in Rome, such as Léon Bonnat, a future official portraitist of public figures in the Third Republic and, above all, Edgar De Gas (he only adopted the form Degas later in his life), who came from the same social background and was likewise staying in Italy at his own expense and copying artworks in order to learn his craft. At the Villa Medici, the two men drew studies of the same models.

At the time, Degas was somewhat lost and was looking for a mentor. For the next few years he became Moreau's disciple. Both men hoped to renew the

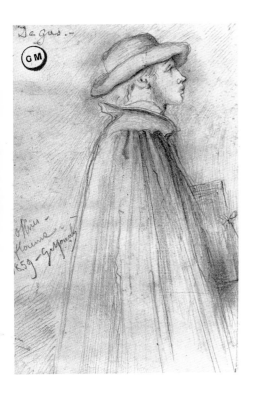

Portrait of Degas at Florence.
Graphite, 15.4 x 9.4 cm. 1859.
Musée Gustave Moreau, Paris.

genre of history painting. Moreau shared with Degas his passion for Delacroix and persuaded him to reject academic painting.

One of the great Roman attractions was the racing of "barbe" or free horses, during the Carnival. Moreau, who knew Géricault's famous painting and shared his passion for horses, attended one of these races one February afternoon but, as he wrote to his parents, found the spectacle disappointing: "It is a show for children: wooden horses, drunken and excited blackguards with lots of gold paper and firecrackers, brought by four or five men who release them when the signal is given. It all lasts only a few moments. I returned soaked and unsatisfied from the artistic point of view." This was clearly no heroic gallop, and Moreau had no taste for the picturesque.

After his stay in the Vatican palace, his enthusiasm was aroused by "the finest piece of painting I have ever seen, for sure". This was a fragment of fresco exhibited at the Accademia di San Luca, a *Putto* attributed to Raphael (MGM. Inv. 13610), which he sought to replicate as faithfully as in his previous copies, and with the satisfaction of having achieved his purpose after four weeks of dogged work.

After a few months, Moreau had managed to refine his technique and, come the spring, he was able to allow himself a little relaxation in the form of excursions outside Rome. These were an opportunity to paint local landscapes previously painted by Poussin.

In fact, it sometimes seems as if he was trying to base the rhythm

of his days on that of the greatest French Classical painter who, as Moreau observed – he had brought the *Letters* with him from Paris – had also come to Rome at the age of thirty-something and studied "the ancients" at great length before starting to do more personal work.

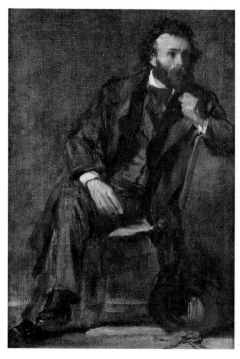

EDGAR DEGAS.
Portrait of Gustave Moreau.
Oil on canvas, 40 x 27 cm. Circa 1860.
Musée Gustave Moreau, Paris.

March-April 1858: "The beautiful skies of March in Roman countryside that we shall not see again"

At the very end of his life, Moreau looked back with emotion on his promenades around Rome some forty years earlier, when the "countryside" still began almost immediately beyond the Aurelian Wall. Taking his portfolio and colours, he executed more than fifty "souvenirs" of these excursions, usually in a brown ink wash, or "sepia" as he called it, but also in pastel and watercolour. He preferred the routes taken before him by Poussin and Claude Lorrain in the 17th century.

View of the French Academy in Rome from the park of the Villa Borghese.
Brown ink wash on graphite, 25.5 x 34 cm. 1858. Musée Gustave Moreau, Paris.

"There is a great deal to study in the open air," he wrote to his parents, "but one must get used to these lines which at first seem rather monotonous." Recalling the manner of Corot, the landscapes made by Moreau on his excursions are exquisite in their freshness, their sensibility to light and their atmosphere. These works, kept at the Musée Gustave Moreau,

are enough to make us regret that he did not spend more time on this genre which he must have considered minor – just when, ironically, it was starting to dominate artistic production. He feared its "commonplace" side and preferred to save his time for visiting "the little towns of Tuscany and the Roman states, for they are precious repositories of the finest

work at the Palazzo Borghese in Rome until his departure for Florence in June 1858.

June–August 1858: First stay in Florence

Shortly after his arrival in Florence, on around 13 June, he obtained authorisation to

mural productions of the beautiful Renaissance and I would have missed too much if I had not been able to make my little journey with my bag on my back through all these charming little towns – Siena, Perugia, Pisa, Orvieto, Assisi". In the end, he was unable to carry out all his plans and never went to Perugia or Assisi, preferring to continue his scrupulous copying

View of Florence.
Watercolour, 21.5 x 28 cm. 1858.
Musée Gustave Moreau, Paris.

Two Episodes from the Legend of Saint Ursula,
after Carpaccio, Venice, Accademia.
Oil on canvas, 44 x 18 cm. 1858.
Musée Gustave Moreau, Paris.

make copies in the Uffizi Gallery
(17 June). This he did "after four
days of visiting churches and
museums in order to get a bit of
an idea about what there is to see".
However, he made no secret of
his preference for Roman frescoes
and, "in the city of Andrea del
Sarto, Michelangelo, Bartolomeo
d'Angelico of Fiesole and so many
other great and pure Florentines",
he began by copying a "sketch" by
the Venetian Titian representing
The Battle of Cadore (now thought
to be a replica): he was, he wrote,
"grabbed by the collar and forced
to get to work. It is splendid in
its skill, its colour and verve". He
then worked on smaller versions
of portraits of *Eleonora di Gonzaga*
and *Francesco-Maria della Rovere*,
both by Titian, and then, at the
Accademia di Belle Arti, on a copy
of the angel in *The Baptism of Christ*
by Verrocchio, which in those
days was attributed to the young
Leonardo da Vinci.

Before and after museum
opening times he visited churches
"to study the primitive paintings,
which are very numerous and very
instructive" and execute "fairly well
finished drawings and sketches".
He decided to take a closer look at
the frescoes by Andrea del Sarto in
the Santissima Annunziata church,
where he may have spent several
days with Degas, who had joined
him in Florence, and with other
artists he had met in Rome, notably
Delaunay.

It seemed now that nothing
could deter him from his vocation,
as he wrote to his Parisian friend
Lacheurié, with whom he so loved
going to the opera: "I am now
going to live alone for a long spell,
in the most complete reclusion.

This apprenticeship will have taken away or at least put to sleep a few last appetites for pleasure or for the world [...] I have decided that nothing now can make me swerve from this path". Unlike Moreau, Lacheurié, who had hoped to take up a musical career, had been forced to give up this ambition when his father died and he had to take over the family's maritime insurance firm.

Venice.
Watercolour, 22.5 x23.5 cm. Circa 1885.
Musée Gustave Moreau, Paris.

August 1858: Meeting his parents in Milan

It had long been agreed that the artist would go to meet his parents in Lugano on 20 or 21 August, before continuing to Milan where, as his father reminded him, "you will find the masterpiece of Leonardo da Vinci, your favourite master". As an architect, Moreau senior was eager to visit the villas built by Palladio, starting no doubt with Vicenza.

They stayed in Milan until mid-September. Under pressure from his father, Moreau took a closer interest in the architecture but he did also frequent the Ambrosiana library to study Titian and Leonardo, and greatly admired, if not the *Last Supper*, which had perhaps been too thoroughly restored to usefully reveal very much about Leonardo's technique, the frescoes by his disciple Bernardino Luini, which he judged "sublime in style".

September-November 1858: Venice and Carpaccio

In Venice, Moreau met up with Delaunay and other painters he knew – but not Degas, who had remained in Florence, and now moped around waiting for his friend's return. He stayed there until the last days of November, fascinated by the work of Vittore Carpaccio, a new discovery, and an artist who in those days was thought of more as an illustrator of Venetian life in the late 15th century. Charmed no doubt by the colours and somewhat medieval sincerity of Carpaccio's "series" of saints' lives, Moreau made numerous copies of his works, particularly the *Legend of Saint Ursula* at the Accademia, and the paintings in the Scuola di S. Giorgio degli Schiavoni, especially the *Saint George and the Dragon*, which he reproduced actual size on a canvas one metre and forty high and three metres and sixty wide (MGM. Cat. 195). These meticulous copies kept him busy longer than expected, prompting Degas to write on 27 November 1858, urging him to return to Florence: "Let's roll up this wonderful St. George and the little pieces after Carpaccio, and come and do a bit of drawing here." The influence of Carpaccio would be perceptible in Moreau's work for years to come. For example, the general composition of an important painting from the 1890s, *Mystic Flower* (MGM. Cat. 37), was inspired by *The Glorification of Saint Ursula,* which he had copied over thirty years earlier, and always had before him in his home on Rue de La Rochefoucauld.

December 1858-March 1859: A second stay in Florence

Pressed by his father to return to Paris, Degas was waiting impatiently for Moreau, and had just started work on a large portrait of his Florentine relations, *The Bellelli Family*, with whom he was staying. Degas was particularly keen to show his friend the works of Botticelli, who at the time was hardly any better known than Carpaccio. Having obtained permission to make copies at the Uffizi on 22 December, Moreau

now went about copying *The Birth of Venus*, but was unable to complete it. In fact, his productivity in general was not as expected because illness kept him from working for three months. The most important event of this second stay, no doubt, was the short trip to Siena and Pisa that he made with Degas, during which he executed several drawings and watercolours based on the frescoes on the Campo Santo in Pisa.

At the end of March, the two friends went their separate ways; Degas to Paris, at the behest of his father, and Moreau to Rome with his parents.

The passport issued to Moreau in Florence on 28 March 1859 describes the bearer thus:

age: 33
height: 1m63
hair: brown
forehead: uncovered
eyebrows: brown
eyes: ditto
nose: average
mouth: average
chin: round
face: oval
complexion: ordinary

April-July 1859: Rome

During this new sojourn, the artist's main concern was his mother's health and the consequences of France's war against Austria waged in order to help the Italians achieve unification. Moreau feared that this might prevent him from travelling to the kingdom of the Two Sicilies, which was allied to Austria. During these few months of uncertainty, he was however able to make a very close study of the

Descent from the Cross by Daniele da Volterra, which was said to have been painted following instructions given by Michelangelo. Poussin had also admired the work, and it was in homage to him, his ancient master, that Moreau ended his Roman sojourn by copying *The Death of Germanicus* (MGM. Cat. 3), with exactly the same dimensions as the original, and with a great concern for accuracy.

July-September 1859: Naples

On 13 July 1859 Moreau obtained a visa for Naples. He spent two months there, working extremely hard at the Museo Borbonico, where the main discoveries made at Pompeii and Herculaneum since the 18th century were on display. He also made a few excursions to these two sites and made an eventful climb to the top of Vesuvius in the company of Chapu and Bonnat.

He made facsimile copies of the most famous antique paintings, such as the *Departure of Briseus*, and *Achilles and the Centaur Chiron*, *Castor and Pollux*, and above all, an actual size copy of *Jupiter Crowned by Victory*, which he would use as a model, thirty years later, for *Jupiter and Semele*. These works are all held at the Musée Gustave Moreau, as are dozens more made during these weeks in the summer of 1859. It is as if, before leaving Italy in mid-September, he had sought to assimilate fresco technique in order to complete his training as a future decorative painter.

1859
The relationship with Alexandrine Dureux, "My best and only friend"

Portrait of Alexandrine Dureux.
Pencil drawing, 16.1 x 12.5 cm.
Circa 1865–79.
Musée Gustave Moreau, Paris.

"**Y**ou must by now be *extremely learned*", wrote Eugène Fromentin, who was renting Moreau's studio in Paris, in June 1859. "I seriously mean it. My dear fellow, it is high time; whatever you may think when far from Paris, where the pleasures of study are concerned, you will never be a *dilettante*; you will be a producer." Fromentin's own situation had changed considerably. He had won renown as a writer with his book *Une Année dans le Sahel,* and was starting work on his novel *Dominique*, which was destined for fame, while his scenes of Algerian life enjoyed huge success at the Salon of 1859 and won him the Légion d'Honneur. Moreau, who was in Naples at the time, was quick to congratulate him.

We know from Moreau's correspondence with Fromentin that he was ill when he arrived in Paris. A much more recent discovery is that shortly after his return he met the woman whom he would describe as his "best and only [woman] friend," and embarked, a few months later, upon a relationship that proved compatible with his resolution not to found a family. It was a very discreet affair, known only to such close friends as Rupp, Berchère and Puvis de Chavannes. In a recently discovered note, dated 10 January 1886, and written not long after his mother's death, Moreau left the following instructions:

"Should I fall slightly or seriously ill, these are my express

57

wishes. I desire and order that Mademoiselle Adelaïde Alexandrine Dureux, my best friend, to whom I have been bound by the deepest affection for twenty-seven years, should be free to come and see me, to enter my room when I am ill at any time of day or night […].

"My close friends all know of my attachment to her, and of the boundless devotion of which she gave me such noble and frequent proof during the terrible days that followed the loss of the person who was dearest to me in this world […].

"In my last hour I want her hand to be in mine, and for us to be left alone. […]."

Moreau met this person who was to be so important in his life in 1859 or 1860. Although it was long thought that the artist had no significant relationship with a woman, that he had lived like a monk with his mother – whose death was indeed devastating for him – the relationship was revealed in 1899 by Henri Rupp, who knew the artist better than anyone else. In an interview with *Le Temps*, he spoke of Moreau's "soulmate, an elite creature to whom he was wedded by twenty-five years of indissoluble intimacy". Later, however, this article was simply forgotten, while psychoanalytical

critics got to work on Moreau's art, interpreting its symbolist vein as the vehicle for outpourings of a deep-seated misogynistic feeling that was therefore taken to indicate the absence of women in his life. "She gave him everything," said Rupp. "And he gave everything in return. She took with her half of him. He cared for her fervently, and suffered at her bedside the most violent pangs of despair. He was there for her last breath. He fell prone to the kind of paralysis that follows irremediable catastrophe. What was best in him collapsed. And yet his moral energy did not desert him. More than ever, he took refuge in his work; it became his consolation. And he poured out the bitterness that welled up from his heart both on his canvases and on the velum of his sketchbooks."

Alexandrine Dureux died at the age of 51, on 28 March 1890. Moreau had always thought that he would be the first to go. The documents found in the archives of the Musée Gustave Moreau bear out every detail of Rupp's testimony.

Alexandrine was ten years younger than Moreau. She earned a modest living as tutor to the children of a family at 48 Rue Notre-Dame-de-Lorette, near the artist's home. Moreau made many

portraits of her, and would seem to have given her drawing lessons as well, albeit to no great effect. Shy and probably devout – the painter's bookshelves contain many a pious volume – and charitable too, hers was a self-effacing life lived alongside the painter and his parents. In her will, Moreau's mother even provided for a substantial allowance to be paid to Alexandrine in the case of her son's death. Small sketches by Moreau evoke their exemplary love. "For twenty-seven years," he wrote, she "never ceased to show the most tender affection and the most admirable devotion". The many works that he gave her, which are among his most delicate, are now displayed in a special room dedicated to Alexandrine at the Musée Gustave Moreau.

It was a bond that must have grown even stronger after the death of Moreau's mother in 1884. Tragically for the painter, Alexandrine herself soon fell ill, and her condition grew worse in 1889. The tomb that he designed for her in Montmartre cemetery, close to and in similar style to the family vault, is marked by their intertwined initials.

In memory of Alexandrine, Moreau painted one of his finest works: *Orpheus at the Tomb of Eurydice* (MGM. Cat. 194), and although he was not a practicing Christian, he also wrote a prayer. Not to tug on the reader's heartstrings, but simply to give an idea of the intensity of the relationship, it is worth quoting a few of these lines addressed by Moreau to God:

"I pray Thee, dear God, that the efforts I am making to improve myself will have a felicitous influence on the beloved being that I have just lost, that this life of renunciation and of striving for the divine will produce for my beloved a great deal of joy, peace and heavenly happiness.

"Take, dear God, this dear creature into Thy bosom and give her, with those who love her and that she has loved tenderly – her good mother, her sisters – a blessed and radiant life in eternity."

Clearly, Alexandrine, was much more than a mistress, and Moreau's intense activity after her death can be seen as a posthumous homage. As Rupp wrote, quoting his master: "God does to men what men do to birds: he plucks out their eyes, the better to make them sing."

1860
The Red Book

Hesiod and the Muse.
*Pen and brown ink with black chalk and
brown wash, heightened with opaque white
and watercolour, on heavy cream wove paper,
37.7 x 29 cm. 1858.
National Gallery of Canada, Ottawa.*

*I*n Italy, Moreau wrote frequently to say that he felt technically ready to produce a work worthy of his ambitions and those of his father, who desired so ardently to see his son produce a masterpiece that would reveal his talent at the annual Salon. But this proved much more difficult and time-consuming than he imagined.

In 1860 his oldest friend gave him a superb orange-red "notebook" with two hundred ninety-six gilt-edged pages of fine paper, in which he wrote: "This book was given me by my best friend Alexandre Destouches on this Wednesday 30 June. G.M."

This book was to prove a very important working tool in the artist's career, for it was here that he put down his ideas for paintings, recorded his readings and visits to museums and libraries and, in 1885, drew up a list of the owners of his works and the "catalogue" of his paintings kept in his studio. Both these lists, sadly, are incomplete.

Quite soon, no doubt, he filled the first pages of what he called his "red notebook" (to distinguish it from the others) with a list of ideas for "Antique and Biblical compositions". Though hard to interpret, this list includes the

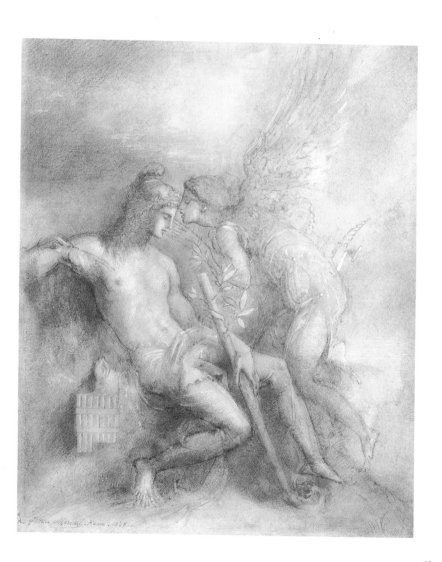

A. Guillon Mérignac. Roma. 1848.

works he left unfinished when he set off for Italy, such as *The Young Man and Death* and *The Suitors* (a big sketch showing one of the suitors in the attire of Attis shows that he worked on this theme again in 1860), but above all the subjects that would keep him busy in the coming years, such as *Diomedes Devoured by His Horses*, *Orpheus and the Women of Thessaly*, *Leda*, *Pasiphae*, *Tyrtaeus*, *Jason*, *Delilah*, *Hesiod*, *The Muses Leaving Apollo to Go and Enlighten the World*, *Hercules Fighting the Hydra*, *The Wise Men Joining Together*, *Oedipus and the Sphinx* (six different ideas), etc.

In 1860 he began work on *Tyrtaeus Singing During the Battle* (MGM. Cat. 18), a painting on which he spent much time but never completed, *Hesiod and the Muses* (MGM. Cat. 28), a piece based on two fine drawings he made when in Italy, and which he almost completed, and *The Wise Men* (MGM. Cat. 32), which he left as a rough version, having planned to make an immense frieze in the manner of his friend Puvis de Chavannes (MGM. Cat. 579). Both the themes and size of these immense paintings intended for the walls of museums more than of private homes, indicate his determination to renew the genre of history painting.

Also at this time he began research for *Oedipus and the Sphinx* – the first studies date from 1860. The gestation of this work that Moreau presented at the Salon of 1864 – his first public exhibition since 1855 – was a slow and laborious process.

"Locked away in your studio," wrote Berchère, "tussling with your many easels, I imagine you barely notice whether there is shadow or sun." Moreau was indeed hard at work, as he had resolved to be. He continued to amass documentation and went regularly to the Louvre. In March 1860 he was particularly interested in the enamels gallery, where he copied mythological motifs and developed his technique. He also became a habitué of the prints room at the Imperial Library, and regularly used the Institut de France, the Arsenal and Sainte-Geneviève libraries, where he studied medieval illuminated manuscripts, the niello work of Maso Finiguerra and Indian miniatures. His numerous copies of their motifs were accompanied by precise notes on their colours. These would be of use in his later work.

Hesiod and the Muses.
Oil on canvas, 263 x 155 cm. Circa 1860.
Musée Gustave Moreau, Paris.

1862
The obsession with death

The Way of the Cross in the church
of Notre-Dame de Decazeville.
Third station: Jesus falling under
the weight of his cross.
Oil on canvas, 100 x 80 cm. 1862.
Church of Notre-Dame, Decazeville.

17 February:
His father dies

Moreau's father died – as
his son would – at the age of
72. At the time, the painter was
exactly half his age, and was still
an unknown in the art world. The
only way of making a name for
oneself in those days was to show a
work at the Salon and, nearly two
years after his return from Italy,
Moreau had yet to produce a piece
that was sufficiently finished for
presentation.

The *Way of the Cross* in
the church at Decazeville

In the summer of 1862,
Fromentin, who was one of
the leading lights of the Salon,
recommended his friend for a
painting of the fourteen stations
of the Way of the Cross. This was
commissioned for the parish church
of Decazeville, a flourishing new
mining town in the Aveyron, by
Élie Cabrol, the son of the town's
founder. In a letter to Moreau
dated 13 October, Fromentin

relegates this potboiler to an aside: "Are you working? Are you happy? I am not talking about the Way of the Cross, which I almost feel guilty for having imposed on you, but real work?" A few days later, Moreau replies that he has almost finished the commission and is about to submit it to his friend for approval. As it happened, this work, which took him only three or four days for each canvas, satisfied both Fromentin and the patron, who paid the artist the agreed 2,800 Francs. His only regret was that Moreau declined to sign the work. This choice of anonymity has been explained by his wish to pay a final homage to his father.

The "real work" mentioned by Fromentin, was to – at last – present a work for the Salon. Fromentin amicably reminded him that, "You have almost promised me to exhibit, anything, but something. Indeterminate goals are too easy. You no longer need to wait; you are ready." A few days later, Moreau thanked him for this reminder and informed him that, "Over the last fortnight I have been working seriously on that Oedipus. I must say that, faced with such a piece of work, I am more inclined to doubt than feel confident in my ability. I hardly dare walk. I have taken a piece of card the size of the work, worked as thoroughly as possible after nature, and for the millionth time in my life I swear (but have no doubt, this will not be the case) not to start until everything – to the last blade of grass – has been finalised once and for all; done well, by the grace of God." On 20 October he purchased the canvas for the painting.

24 December: "I am thinking on my death"

On a drawing of *Delilah at Her Toilet*, Moreau wrote: "Tonight, 24 December 1862/I am thinking on my death and on the fate of my poor modest works, of all these compositions/that I am taking the trouble to bring together/separated, they will die, taken together/they give an idea of what I was/as an artist and of the milieu in which I loved to dream/Gustave Moreau. 1862." (MGM. Des. 3637).

1862–63: The Campana Collection

Sometimes students seek refuge in their research as a way of putting off writing their thesis. Moreau said he had completed his training in Italy, yet now he could not resist applying for a copyist's card for the short-lived Musée Napoléon III, home of the collections of the Marquis Campana. The Marquis's passion for art objects had impelled him to draw upon the funds of the *monte di pietà* of the Papal States, of which he was the administrator.

There the painter studied the Italian Primitives, whose work he had neglected when in Italy, while adding to the copies of artists he had already studied in Italy, notably with a *Holy Conversation* by Carpaccio, which he attributed to Mantegna (MGM. Inv. 13630).

The Way of the Cross in the church
of Notre-Dame de Decazeville.
Eleventh station: Jesus is nailed
to the cross.
Oil on canvas, 100 x 80 cm. 1862.
Church of Notre-Dame, Decazeville.

1864
Oedipus and the Sphinx,
a sensation at the Salon

*A*s he had promised, and despite the self-doubt that he confessed to Fromentin, Moreau worked on his *Oedipus* down "to the last blade of grass". It was finished in March 1864 and exhibited in the Salon that opened on 1 May. It was the most admired of all the works on show and introduced the public to an almost unknown artist of 38 years of age. It not only won him a medal but prompted a purchase by Prince Jérôme Bonaparte, the Emperor's cousin, who was an art lover and collected works by the then uncontested glory of French art, Ingres – Ingres, who at the 1855 Universal Exhibition presented his *Oedipus and the Sphinx* (Metropolitan Museum of Art, New York), one of his most famous paintings. Moreau, though virtually a debutant, was bound to be compared with the master – he was familiar with the Ingres' work as he had made a small sketch of it. In fact, what struck the critics was more the originality of Moreau's work than its resemblance, and so the parallel was not pursued, even though Moreau had chosen a similar presentation and also shown the two protagonists in profile.

In terms of technique, Moreau demonstrated a skill and deftness with the nude that could not fail to attract both critics and the general public, who set great store by finish, alongside a distinctly archaic quality, notably in the use of black line to emphasise the modelling, which set him apart from the Beaux-Arts style. Some wrote of a "new Mantegna" while several commentators mentioned Carpaccio. As we have seen, Moreau had seriously studied both.

At this time "history painting" seemed to be in a rut, stuck with the kind of historical recreations represented, notably, by Meissonier, who at that year's Salon presented *The French Campaign*. Some critics saw Moreau as an artist capable of restoring the genre's lost prestige, by virtue of the nobility of his subjects and the spiritual elevation they inspired in beholders, especially the more cultivated ones.

Oedipus and the Sphinx.
Oil on canvas, 206.4 x 104.7 cm. 1864.
Metropolitan Museum of Art, New York.

By illustrating one of the most famous Greek myths, the artist was not only dealing with the great question of human destiny, but he was also giving it a new significance – its sexual aspect – by representing the sphinx, as Flaubert observed, with its paws gripping Oedipus's chest and engaging him in what seems an exchange of lethal looks. Théophile Gautier spoke of a "Greek Hamlet" and, like others, noted the sensuality with which the artist had infused the famous myth: "Thanks to M. Gustave Moreau's ingenious idea, in this beast the monster is no less coquettish than the woman."

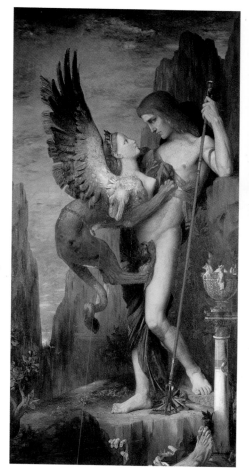

1865
Jason,
The Young Man and Death

Jason.
*Oil on canvas, 204 x 115.5 cm. 1865.
Musée d'Orsay, Paris.*

*E*ncouraged by his success at the previous Salon, in 1865 Moreau exhibited two large-size canvases. Although they again won a medal, their impact was not as spectacular. In fact, this Salon was dominated by the scandal provoked by Manet's nude *Olympia*, which was no history painting.

The Young Man and Death (Fogg Art Museum, Cambridge, Mass.) was dedicated "to the memory of Théodore Chassériau". Moreau began work on it in 1856, only a few weeks after the death of the painter he considered his true master. As he told Fromentin, the preparatory work had made good progress by December 1856, when it occurred to him that he might replace "the figure of death with a figure of a winged girl playing the sistrum; it will be more cheerful and engaging". This indeed was the course he ultimately took, except that he did away with the wings on this young girl whose ethereal body seems to be floating behind the hero, himself an idealised portrait of Chassériau.

The other work, *Jason* (Paris, Musée d'Orsay), had been in gestation since 1863. In December, Moreau's learned friend Destouches communicated to him the verses from Ovid's *Metamorphoses* that would inspire the theme of this work. Moreau inscribed the original Latin on the parchment that is wound around the column supporting the Golden Fleece. It was thanks to the spells of the magician Medea, who was in love with him, that the handsome Jason was able to defeat the dragon that guarded the Fleece. And it is Medea that Moreau portrays here as triumphant, not only over the dragon, but also over its slayer, as indicated by the dominating expression on her face and the gesture of her hand.

Critics detected the influence of Perugino behind this work, whereas in fact Moreau had been inspired by a Sodoma fresco that he had copied at the Farnese in 1857. The painter was also criticised – and not for the last time – for his excessive penchant for esoteric accessories, which put off ordinary viewers and fascinated initiates. "It is difficult," concluded Gautier, "to make a truly balanced judgment of these singular works by an anxious, questing, febrile spirit consumed by all the dilettantisms of art. They charm, they repel. The qualities are so great! The failings so laboriously deliberate! It takes so much talent, emotion, wit and exquisiteness to go astray and succeed in such a fashion! It is a dish for the delicate, for dreamers, for the

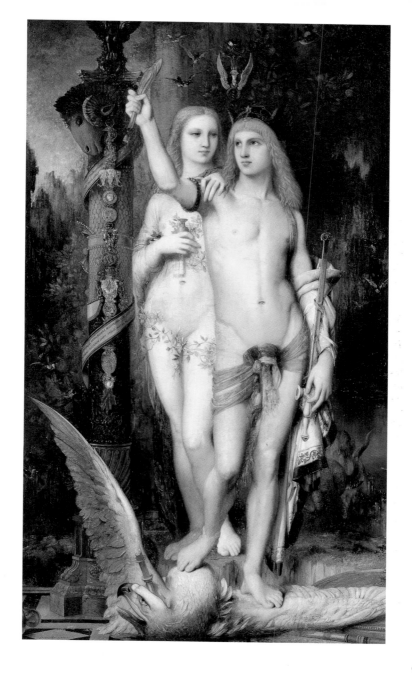

blasé, for those no longer satisfied by nature, but who are looking beyond it for a sensation that is harsher, more bizarre. To such spirits, the truth appears commonplace. They need something strange, supernatural, fantastical; hashish suits them better than life". These lines bring to mind the figures in Huysmans' novel *À rebours*, which was written twenty years later and in which, for the same reasons, Moreau is selected as the artist most in tune with Symbolist tastes.

Leda

Moreau took the trouble to write "Final sketch for the Big Leda" under a watercolour (MGM. Cat. 530), and this provides a very precise model for the Michelangelesque *Leda* (MGM. Cat. 43) on which Moreau continued to work until around 1875 but which, in spite of its very near completion and impressive size, he never sought to exhibit or sell.

November: An invitation from the Emperor

Moreau now found himself invited to the Château de Compiègne, where Napoleon III and the Empress Eugénie invited "series" of prominent public figures, famous people and people in the news. Three or four artists were honoured in this way each year. He wrote to Fromentin, who had been invited to court the year before, asking advice: "This is a real stroke of rotten luck, really rotten luck, although I am as flattered as could be that such an honour should come and seek me out. I am invited to Compiègne and I come to you,

as always, to ask you to be good enough to give me, in detail, and as soon as possible, a short list of what I must take with me on this great journey to the court.

"The invitation protocol and dress: Stay by a gentleman at the Court of Compiègne. This is the wardrobe of the gentleman during his stay:
Chap. I: Attire for gala, ceremony, morning, lunch and evening.
Chap. II: Linen.
Chap. III: Shoes.
Chap. IV: Hats. In Aristotle, I believe, chapter two.
Chap. V: Gloves, cravats, etc.
Chap. VI: Tips.
Tell me if I have overlooked anything and do please believe that, my apparent flippancy notwithstanding, I am very serious and *very worried*".

Equipped with detailed instructions from his friend, the artist spent a week in Compiègne, starting on 14 November. "The Emperor and Empress," he wrote to his mother, "to whom I have been presented, were perfectly gracious. The Emperor said, 'You have painted a very fine picture, Sir,' and I answered, 'Your Majesty is most kind'. He said a few more words along these lines, all kindly and very vague, as these things should be". Moreau found the Emperor likeable, adding, "This face, which people say is cold, has a charming expression when he smiles, and even when at rest".

The Young Man and Death.
Oil on canvas, 213 x 126 cm. 1865.
Fogg Art Museum, Harvard University,
Cambridge (gift of Grenville L. Winthrop).

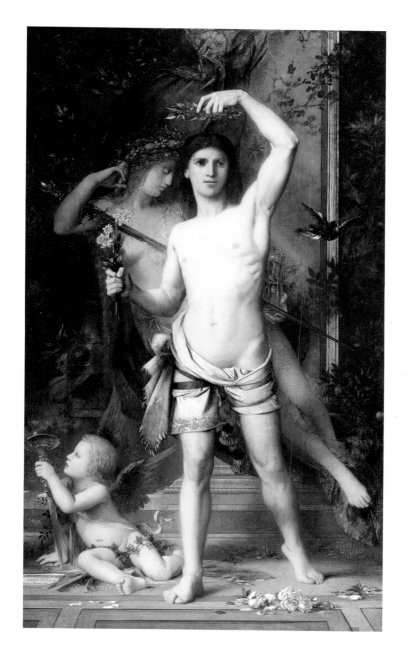

73

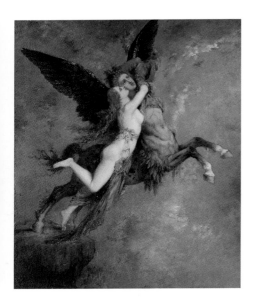

The Chimera.
Oil on wood, 32 x 26 cm. 1867.
Collection Hiroshi Matsuo, Japan.

1866: *Orpheus* and *Diomedes Devoured by His Horses*

*I*n the year of his fortieth birthday, the painter exhibited four paintings at the Salon and had the honour of seeing the state purchase one of them for the Musée du Luxembourg, the modern art museum of the day where works by living artists were exhibited. These works were usually transferred to the Louvre after their death.

"*Orpheus.* A young girl piously holds the head of Orpheus and his lyre, which have been borne along by the waters of the Hebrus to the shore of Thrace." Such is the description given in the brochure of the Salon. This painting on wood was based on Book XI of Ovid's *Metamorphoses*. As we know, Moreau had been given a fine 17th-century translation of the work as a child. "You receive his head, o Hebrus, and his lyre," wrote the Roman poet, describing the death of Orpheus, "torn to pieces by the women of Thrace, whom he had spurned after the death of Eurydice." Also at this Salon, his friend from Picot's atelier, Émile

Diomedes Devoured by His Horses.
*Oil on canvas, 138.5 x 84.5 cm. 1865.
Musée des Beaux-Arts, Rouen.*

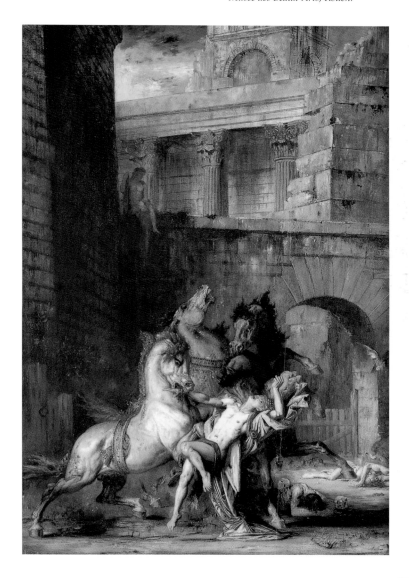

Lévy, exhibited "the previous episode", representing *The Death of Orpheus*, beaten by the frenzied women. Both paintings now belong to the Musée d'Orsay.

Diomedes Devoured by His Horses, a theme derived from the Labours of Hercules, shocked the public with its cruelty, and did not immediately find a buyer. It was exhibited a second time in Rouen in 1869 by the Society of the Friends of the Arts which, as was its custom, offered it to its members as the prize in a lottery. In 1931 it was bequeathed to the fine arts museum of Rouen by the heir of the lucky winner. Moreau also presented two drawings at this Salon of 1866: one of these, *Hesiod Visited by the Muse* (Ottawa, National Gallery of Canada), dated from his Roman sojourn, while the other, *A Peri, design for an enamel* (Art Institute of Chicago) had, according to Chesneau, "the strong flavour of the creations of Hindu art" and prefigured a whole series of works inspired by the themes and arts of Asia.

1867: The Universal Exhibition, Paris

Two of Moreau's previously exhibited works were selected by the jury: *Orpheus*, from the Musée du Luxembourg, and *The Young Man and Death*, which was still in the artist's possession. Unlike his friends Bida, Fromentin, Bonnat, Delaunay, Émile Lévy and Puvis de Chavannes, he did not win a prize.

1868: *The Muses Leaving Apollo to Go and Enlighten the World*

This large canvas, devoted to poetic inspiration, never left Moreau's studio. Underneath the painter wrote: "in the

Prometheus.
Oil on canvas, 205 x 122 cm. 1868.
Musée Gustave Moreau, Paris.

Orpheus.
Oil on wood, 154 x 99.5 cm. 1865.
Musée d'Orsay, Paris.

process of execution, anno 1868" (MGM. Cat. 23). In fact, he started enlarging this work in 1882.

1869: Setbacks at the Salon: *Prometheus, Jupiter and Europa*

Moreau won a third medal at the Salon of 1869, possibly with the help of Fromentin, who was an influential member of the jury. This placed him *hors concours* (out of the competition) for future Salons, and made him eligible for the Légion d'Honneur. The critical response this year, however, was more severe, which mortified him, and neither of his two paintings was sold, remaining instead in his studio (MGM. Cat. 196 and 191). It must be said that there was much to criticise in *Jupiter and Europa,* a theme inspired once again by Ovid's *Metamorphoses*, not least the stolidness of its execution and – Moreau's opinion notwithstanding – the disagreeable appearance of the bull. *Prometheus* was more successful, but also laborious and overly syncretic in the way it depicted the Titan as a precursor of Christ. Moreau produced smaller versions of both of these works which were happily free of these defects.

Moreau's Salon entry also included two small pieces in watercolour, a medium that he would return to with increasing frequency and success. One of these, *The Poet and the Saint*, which was bought by Alexandre Dumas *fils*, demonstrated Moreau's familiarity with medieval miniatures.

Upset by the criticism, Moreau did not enter the Salon again until 1876 – Ingres had responded similarly in his time – but continued to work hard, interrupted only by what, for him, were the deeply disturbing events of 1870–71. He began to build up a devoted clientele whose interest soon meant that he no longer needed the Salon and art dealers in order to generate the income needed for his modest lifestyle.

Jupiter and Europa.
Oil on canvas, 175 x 130 cm. 1868.
Musée Gustave Moreau, Paris

The Poet and the Saint
(The Miracle of the Roses).
Watercolour with gold heightening,
29 x 16.5 cm. 1868.
Collection Hiroshi Matsuo, Japan.

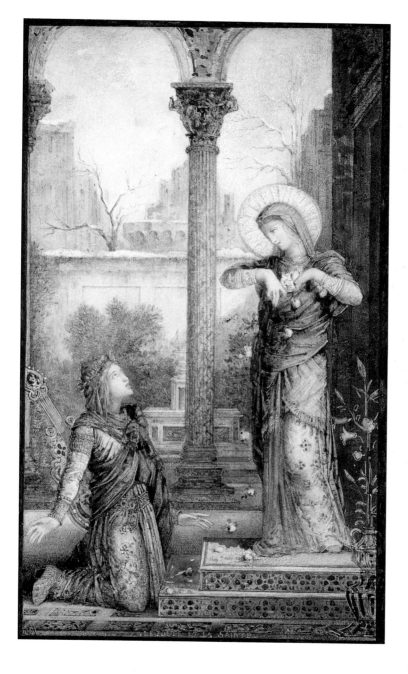

1870–71
The Siege of Paris
and the Commune

The Muses Leaving Apollo
to Go and Enlighten the World.
Oil on canvas, 292 x 152 cm. 1868.
Musée Gustave Moreau, Paris.

*A*ccording to his friends, the
artist hated to talk about politics,
but he had accepted the invitation
to Compiègne from Napoleon III
as an honour. In May 1870, a highly
successful plebiscite confirmed the
increasingly liberal tendency of
the institutions under an imperial
regime that seemed to be at its
apogee. Only months later, after
French defeat at the hands of the
Prussian army, the Second Empire
collapsed in a matter of weeks.

Like many other Parisians,
Moreau joined the National Guard
when the city came under siege by
the Prussian army in September.
He was assigned to the defense
of the walls of the French capital,
which was increasingly isolated
from the rest of the country. On
28 November 1870, Fromentin
wrote from the department of
Charente, where he had been born,

to the painter Protais: "As to those
who are in Paris, I know virtually
nothing. Gustave stayed there,
presumably with his mother. A
note from Cantaloube, a word from
Christophe, which came by balloon,
both in mid-October, told me that
he was serving on the walls and was
well. Since then, the new decree of
mobilisation, which applies to all
men between the ages of 21 and
40, then to 45, and to bachelors first
and foremost, must have affected
him. So he is a soldier. Imagine his
predicament."

The painter conscientiously
performed his military duties in
the 6th company of the National
Guard up until November, when
he developed rheumatism, which
paralysed his shoulder and left
arm. In the archives of the Musée
Gustave Moreau the verses by a
rhymester also serving in the Guard

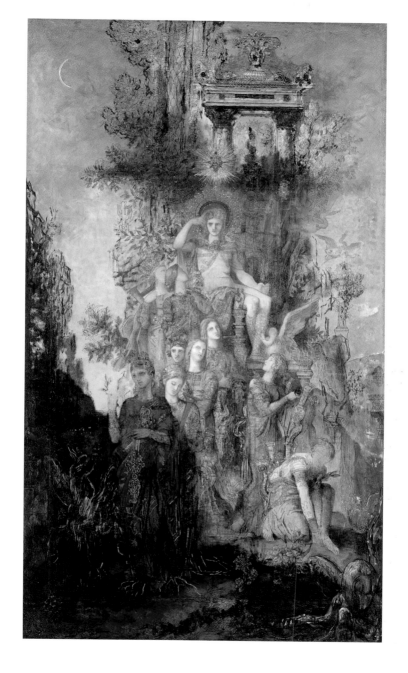

evoke memories of the time under the title "Silhouettes and Profiles of the 6th Company":

> "To Moreau I announce myself,
> dreaming of the pleasure
> of contemplating his art.
> Oh bitter destiny!
> The author of the Sphinx is
> there on his bed of pain,
> his door is closed and, seeing
> that the critics assail him
> to weaken his faith,
> I whisper these words: Take
> heart! Be stoic!
> What do the vipers matter! The
> future is yours."

Unlike most other bourgeois, the artist had decided to stay in the besieged and increasingly starved Paris. As he wrote to a friend, his mother "refuses to abandon to the most unlikely and various acts of fate the products of twenty-five years of my work".

In March 1871 he wrote to Fromentin: "As for ourselves, we are quite well, however, my mother is very tired and I still have a paralysed arm, but they are encouraging me to believe that the waters will restore me […] When will we meet again, my dear friend, surely not so soon, for Paris is not tempting at the moment. There is still, as we all know, a threat of riots and disturbances."

Indeed, on 18 March, not far from Moreau's home, the first clashes took place between the troops from Versailles and the forces that would soon come to be known as the "Communards". The latter had taken power in the French capital, but after the kind of atrocious fighting typical of civil wars, it was wrested back from them in late May.

The bourgeois quarter of Nouvelle Athènes was not spared – it was bombarded – while the mansion of Thiers, leader of the Versaillais government, on nearby Place Saint-Georges, was destroyed. The church of La Trinité was occupied by a club of revolutionary women, barricades were set up and there was sporadic street fighting.

Moreau was obsessed with the thought of his own home being ransacked, and especially the works he had amassed there, by the Communard forces, on the pretext of searching for hidden weapons.

On the night of 23 May, the Communards lit fires in the centre of Paris. No doubt Moreau was deeply shocked by the resulting, almost complete destruction of the mural paintings by Chassériau at the Cour des Comptes (on the site of today's Musée d'Orsay), which had inspired him to leave the École des Beaux-Arts some twenty years earlier.

The painter was among those who were relieved at the victory of the Versaillais forces. "I share your admiration for the army," wrote his old friend Destouches on 30 May. "How it has avenged itself for its misfortunes!" (MGM. Archives).

After this harrowing experience, on 29 June 1871 Moreau obtained permission from the Ministry of the Interior to travel with his mother to Néris-les-Bains (Allier), a thermal centre specialising in the treatment of nervous disorders. The fine drawing entitled *A Muse and Pegasus* that he offered to the doctor who treated him there would seem to indicate a successful cure and the return of inspiration. However, there can be little doubt that the events of this *annus terribilis* left

a permanent mark on Moreau's character. Writing to his niece in 1872, Gustave Flaubert informed her that "I have learned that several people in Paris (including Gustave Moreau, the painter) suffered from the same illness as I did, that is to say, the *unbearability* of the crowd. It has been a common complaint".

The defeat of 1870 was a traumatic experience and left him with a lasting aversion to the Germans, a theme on which he wrote several dozen pages. The artist also made a score of sketches

What he had in mind was a half-sculpted, half-painted composition four metres wide and three metres high, in a style close to that of the great altarpieces that can be seen in Orvieto and Florence. Moreau even went so far as to approach an architect on the question of framing. In the end, however, he abandoned the idea. The only work that can be directly related to the war of 1870 is a small and moving little painting from 1871 called *Death of a Young Crusader* (MGM. Cat. 784).

with detailed annotations with a view to producing a big commemorative diptych on the subject of "One Against Five. To Our Sublime Vanquished and the Heroic Campaign of 1870."

Cupid and the Muses.
Watercolour, 18.7 x 25.7 cm. Circa 1870.
Musée du Louvre, Département des Arts Graphiques

1872–74
The love of the senses

1872: *Dejanira*

*T*he first major painting of the 1870s was a rape of *Dejanira* (Los Angeles, J. Paul Getty Museum), also known as *Autumn*. Inspired by Ovid, this piece differs from his paintings prior to 1870 in that it sets the scene in a grandiose and dominant autumn landscape, of which the figures – usually central – occupy only a small part, placed in the bottom quarter. The starting point for this work was a *Death of Nessus* presented at the Salon of 1870 by Moreau's great friend Élie Delaunay. As Moreau wrote to the work's first owner, this was meant to be the first of four paintings inspired, like the four famous Poussin paintings in the Louvre, by the seasons. "*Dejanira* is one of four compositions representing the four seasons of the year. Setting aside the fable for a moment, this is how I imagine it. I have tried to convey the harmony that may exist between the appearance of nature at certain times of the year and particular phases of human life. The centaur is trying to kiss this white, ethereal form that will escape from him.

This is the last glimmer, the last smile of nature and of life. Winter threatens. Soon it will be night. It is autumn." (MGM. Archives) Unfortunately, Moreau did not pursue his idea and the work remained isolated.

July: An exhibition in Douai

Moreau sent three works for the exhibition held by the Society of Friends of the Arts in Douai, his mother's home town in northern France: *Beauty Appearing to the First Men*, *The Good Samaritan* and *The Descent from the Cross.* These works have not been properly identified but the themes were ones that he illustrated frequently in his paintings and watercolours of the late 1860s.

1873

Despite the urgings of Meissonier, who was president of the jury, Moreau refused to take part in the Universal Exhibition in Vienna because of his "hatred for Germany".

Dejanira (Autumn).
Oil on canvas, 55.1 x 45.5 cm. 1872.
The J. Paul Getty Museum, Los Angeles.

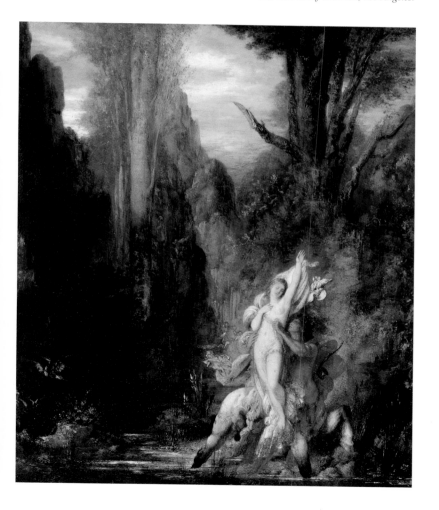

1874: Moreau refuses to work on the decoration of the Panthéon

The new Director of Fine Arts, the Marquis de Chennevières, who had been responsible for organising the annual Salon under Napoleon III, now obtained agreement from the Ministry of Public Education for a major series of mural paintings celebrating the holy figures of French history in the Panthéon, which had now been turned back into a church.

On 15 May 1874 he sent the artist an official commission:

"I have the honour of informing you that Monsieur the Minister has, at my suggestion, agreed to ask you to execute in the church of Sainte-Geneviève in Paris, the paintings necessary for the decoration of the Chapel of the Virgin. A sum of 50,000 Francs, payable over four years, starting in 1875, is to be allocated for this work.

The Director of Fine Arts.
Ph. de Chennevières"
(MGM. Archives)

One would have expected such a major commission to satisfy a painter who so admired Chassériau's great decorative murals, especially since it would have allowed him to work alongside other like-minded artists such as his friends Bonnat, Puvis de Chavannes and Delaunay, and also Cabanel, Baudry, Gérôme, Meissonier, Chenavard and even the realist Millet. Contrary to Chennevières' expectations, given that he had offered him the decorative work on an important chapel and would allow him "the fullest freedom as to the subject and composition", Moreau refused, no longer wishing to paint large surfaces. As the painter explained: "I told him that he had come fifteen years too late for me; that when, on returning from Italy, I realised that, given the prevailing spirit of the Administration at the time, there was no hope for me of obtaining work that I considered at the time as the most precious kind of work, I changed my position and, while continuing to respect the great traditions of art, I understood that I would have to change my approach and limit my surfaces; that in an age as shrunken as our own, for all its great pretensions, and that is acquiring the volume and dimension for grandeur, it was fitting that a few men, taking a small format, should prove the loftiness and nobility of their vision and their tendencies; that this was necessary, in response to the American spirit that is enveloping us, which recognises only *grandes machines*".

"I told him that I was also working for him by doing what I was doing, for I was striving, under his direction, to keep history painting from disappearing, and that there is more to art than frescoes that are not frescoes, and the decoration of monuments."

The truth is that, unlike Puvis de Chavannes, Bonnat and Delaunay, who had already done decorative work, Moreau would probably have found it difficult to complete such a

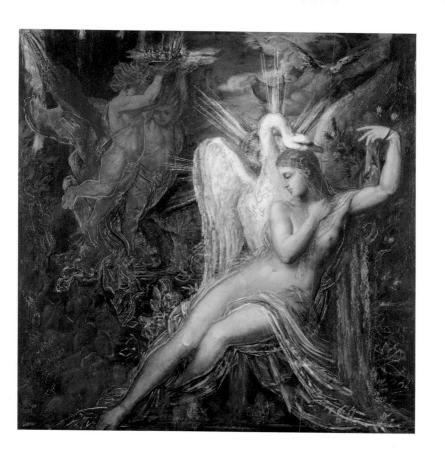

Leda.
Oil on canvas, 220 x 205 cm. 1865–75.
Musée Gustave Moreau, Paris.

Sappho.
Watercolour, 18.4 x 12.4 cm. Circa 1869–72.
Victoria and Albert Museum, London.

Sappho.
Oil on canvas, 81 x 62 cm. Circa 1872.
Private collection.

commission, and that this would anyway have kept him busy for several years precisely when he was absorbed in several major compositions, notably *Salome and Hercules* and the *Lernaean Hydra*, which would occupy him for another two years.

"10 November 1874: there are several projects I am thinking about and that I may never be able to execute:

1. To model in clay or wax compositions with one or two figures that will, once cast in bronze, better than painting, give an idea of my qualities and my skill at the rhythm and arabesques of lines (to be developed)."

These sculptural ambitions – which Moreau shared with other painters such as Gérôme, Meissonier and Degas – are attested by twelve wax figurines kept at the Musée Gustave Moreau, none of which were cast in bronze. Most of them are related to the themes of Moreau's paintings from the 1870s: *Prometheus*, *Salome*, *The Rape of Dejanira*, *The Infant Moses*, *Hercules*, *Jacob and the Angel*, *The Apparition*, etc. It would seem, then, that he was planning to translate some of his works into sculptural form. Even if these wax models, mounted on metal mannequins, were no doubt all modelled at the same time, it would seem that, as a number of drawings show, Moreau often had thoughts of making sculptures. The rough copy of a will from the 1890s show that he had considered "asking Dubois for a young sculptor who can mount my figurines" – the Paul Dubois in question was the director of the École Nationale Supérieure des Beaux-Arts at the time.

Messalina or the "love of the senses"

This painting, which is important for its Symbolist resonance, never left the artist's studio. Moreau dated it 1874 and noted that it was "in the process of execution", when a few weeks of extra work would have sufficed for it to be presented at the Salon in keeping with the standards of the day. The artist wrote notes on the subject at three different moments in his life, clearly showing his interest in this "personal myth" which, if psychoanalytical critics are to be believed, was more autobiographical than it may seem.

In the text written for his mother, the artist noted that, "This composition is a marvel of design. Without it my work would have lacked something. It may be the only note expressing one of the passions of man and woman, which is something terrible: the love of the senses. I have conceived it in a grand and sublime way. It was vital that the style should, by its gravity, elevate the subject. I imagine this daughter of the emperors who personifies the unsatisfied desire of women in general, but also of feminine perversity, constantly seeking out her ideal of sensuality. […] It is by elevating this historical subject to the level of allegory and symbol that I have made this subject into a most noble Satanic poem." The subject, although taken from Suetonius, was scabrous, and was rarely depicted in painting. Moreau's treatment is sufficiently explicit not to need learned commentaries, as other works of his do.

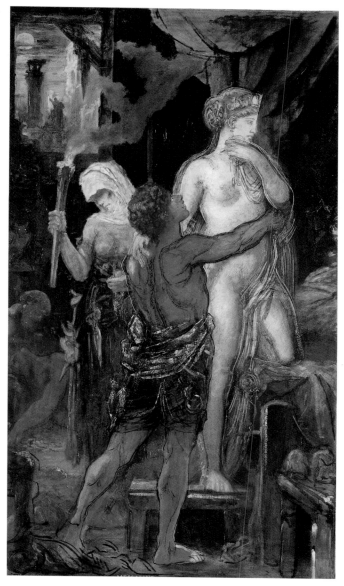

Messalina.
Oil on canvas, 242 x 137 cm. 1874.
Musée Gustave Moreau, Paris.

1876
Back to the Salon

Desdemona.
Oil on wood, 68.4 x 40 cm.
Collection Hiroshi Matsuo, Japan.

1875:
The Légion d'Honneur

After the Salon of 1875, at which he did not exhibit, Moreau was awarded the Légion d'Honneur, for which he was eligible, according to the Salon rules, by virtue of the medals awarded to him up to 1869. One might have expected the Fine Arts administration to have held a grudge after his refusal to decorate the Panthéon the year before, but its director, the Marquis de Chennevières, held Moreau in great esteem as a history painter in the tradition of Ingres and Delacroix, at a time when the genre was increasingly unappreciated.

Moreau wrote immediately to thank Chennevières: "You have made my mother very happy, and it is for this reason above all that I am eternally grateful to you". He also asked him to be his patron.

Moreau was certainly flattered by the honour of this award, especially since he was the only artist to receive it that year, and as it was like an invitation to exhibit once again at the Salon. This was the meaning of the speech by the Minister of Public Education, Religion and the Fine Arts, Henri Wallon, better known today for his famous amendment to the constitution of the Third Republic: "What is he preparing now? That is the secret of the Sphinx, which another Oedipus could question." The work Moreau sent to the Salon the following year was a powerful one, and it made a strong impression.

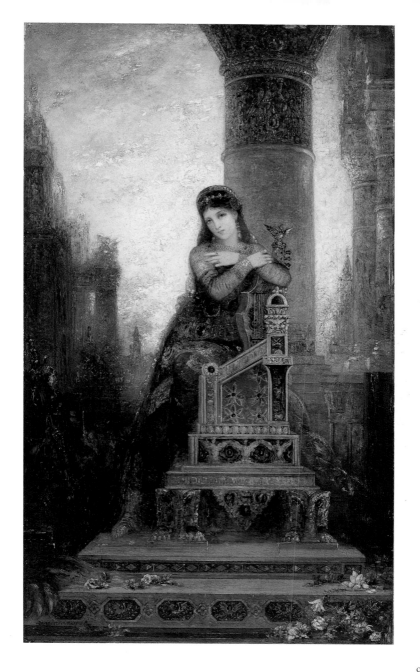

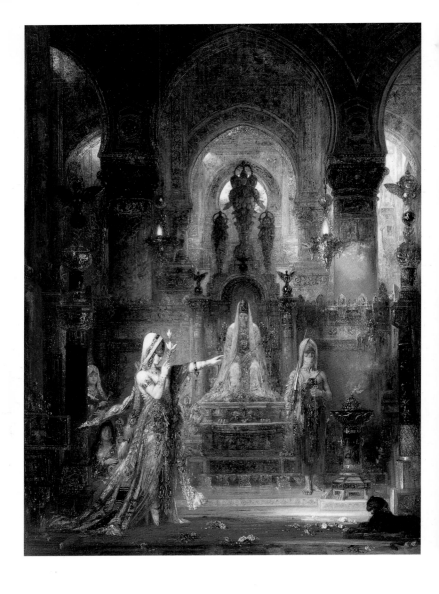

Salome (Dancing before Herod).
Oil on canvas, 144 x 103.5 cm. 1876.
The Armand Hammer Museum of Art
and Cultural Center, Los Angeles.

The Apparition.
Watercolour, 105 x 72 cm. 1876.
Musée du Louvre, Département
des Arts Graphiques, Paris.

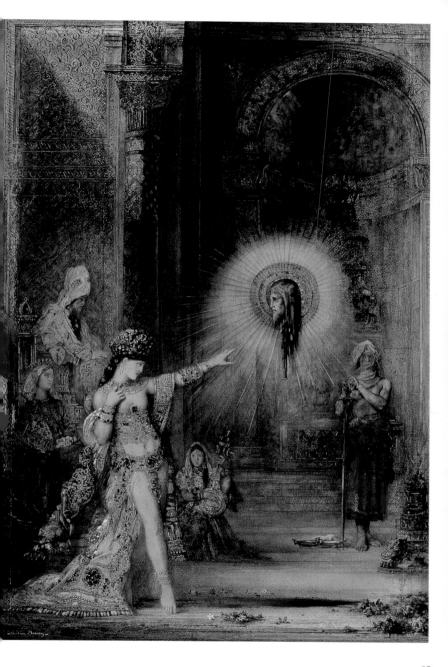

Salome ("Second Empire").
Watercolour, 37 x 25 cm. Circa 1876.
Musée Gustave Moreau, Paris.

Salome Dancing.
Watercolour, 72 x 34 cm. Circa 1875.
Musée Gustave Moreau, Paris.

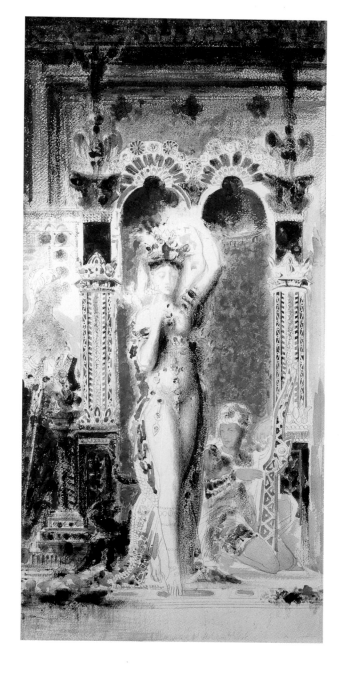

1876: *Hercules and the Lernaean Hydra, Salome, The Apparition, Saint Sebastian*

The rules of the Salon, whose jury – its choices increasingly contested – was made up for the most part (three quarters) of artists chosen by the participants, allowed a maximum of two "paintings" and "two watercolours" per artist. In fact, Moreau exhibited three paintings, for only his *Saint Sebastian*, which was presented as being in "distemper and wax", was admitted into the drawings section, when in fact it was a painting on a panel.

Although Moreau claimed to be a history painter, it was above all the strangeness of his work that was remarked upon, even if his subjects were classics of this noble genre that was increasingly threatened by landscape, portraits and genre painting. Critics spoke of an "opium smoker with the hands of a goldsmith", of "wasted wealth", of work that was "strange" and "indescribable", an "opium dream", "the hallucination of a dream", "the ideas of a madman, the execution of a madman", "a pictorial nightmare that pleads eloquently against an excess of hashish" and so on.

If Moreau's work had a hard core of almost unshakeable admirers, it alienated many more viewers by its hermeticism and its overly learned references. Their reaction is best summed up by Émile Zola, whose naturalist approach was bound to make him reject this kind of painting: "I shall note all the curious nuances of modern painting when I mention Gustave Moreau, whom I have kept for the end, as the most astonishing manifestation of the state that can be attained by a painter in his quest for originality and hatred of realism. It is clear that the naturalism of our age, the tendency, in art, to study nature, was bound to prompt a reaction and bring forth idealist painters. In Moreau's case, this return to the imagination has taken a particularly curious turn. He has not thrown himself back into Romanticism, as one might have expected; he has disdained the Romantic fever, the easy effects of colour, the excesses of a brush seeking inspiration as it covers the canvas with contrasts of shadow and light that make your eyes sting. No! Gustave Moreau practises symbolism. He paints pictures that often remain enigmas, looks for archaic and primitive forms, takes Mantegna as an example and attaches tremendous importance to the smallest accessories in a painting […] His talent lies in taking subjects already covered by other painters and representing them much more adroitly. He paints reveries – but not the kind of simple, harmless reveries that we all have, sinners that we are – but subtle, complicated and enigmatic reveries whose meaning we cannot immediately untangle. What is the meaning of such painting in our age? It is difficult to answer this question. I see it, I repeat, as a simple reaction against the contemporary world. It does not represent a great danger for science. One walks past it and shrugs one's shoulders – that's all".

Two of the works he exhibited, *Salome* (Armand Hammer Collection, Los Angeles) and *The Apparition* (Louvre, Département des Arts Graphiques) did however strike visitors with their evocative power and dreamlike dimension. This was quite irrespective of any notion of historical truth, since the painter combined settings and ornamental details from Egyptian, Persian, Etruscan, Roman, Indian and Hellenistic art, etc. Mallarmé, and above all Huysmans in *À rebours*, took inspiration from him in their writings, and their success encouraged Moreau to produce multiple variants. Less original, *Hercules and the Lernaean Hydra* (The Art Institute of Chicago) and *Saint Sebastian* (Fogg Art Museum, Cambridge, Mass.) presented academy studies of men inspired by the Italian Renaissance and also led to the execution of numerous replicas, made by the painter at the request of collectors who were beginning to build up small museums ranging across the painter's best-known themes.

Publication of Edmond Duranty's brochure, *The New Painting, about the Group of Artists Who Exhibit in the Durand-Ruel Galleries*

Published at the time of the second Impressionist Exhibition, and written before the Salon of 1876, this text written by a close friend of Degas criticised Fromentin and Moreau for opposing *plein air* painting and having a harmful influence on the young generation: "Coming from the Sahel, in Paris he [Fromentin] met another artist [Moreau], a tormented soul, often delicate, nourished with poetry and ancient mythology, the greatest friend of myths, if indeed there are any here below, spending his life questioning the Sphinx, and the two of them managed to inspire new groups of these young people who are weaned on the bottle of official and traditional art, to a strange system of painting, limited to the south by Algeria, to the east by mythology, to the west by ancient history, to the north by archaeology: the genuine murky painting of an age of criticism, of knick-knackery and pastiche […] You hang on to the knees of Prometheus, to the wings of the Sphinx. Well, do you know why you do it? It is in order to ask the Sphinx, although you have no inkling of this, the secret of our times, and Prometheus, the sacred fire of the current age."

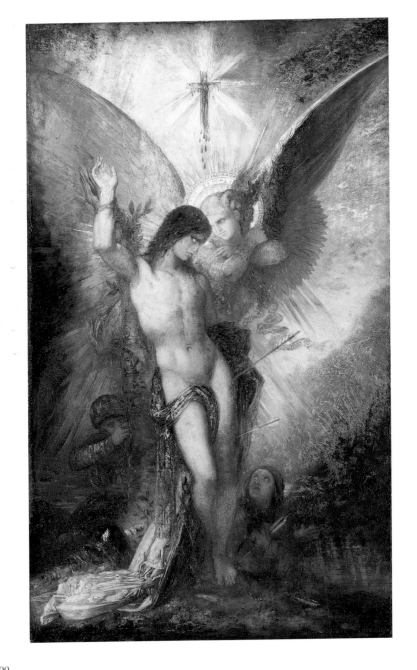

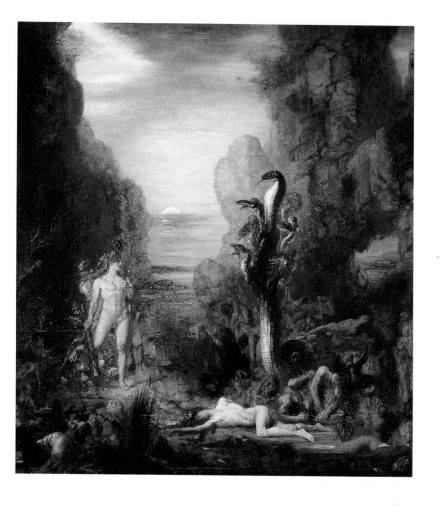

Saint Sebastian and the Angel.
Oil on wood, 67.8 x 38.7 cm. Circa 1876.
Fogg Art Museum, Harvard University,
Cambridge, Mass (gift of Grenville L. Winthrop).

Hercules and the Lernaean Hydra.
Oil on canvas, 175 x 153 cm. 1876.
The Art Institute of Chicago, Chicago
(gift of Mrs Eugene A. Davidson).

1878
The Universal Exhibition, Paris

David.
Oil on canvas, 230 x 138 cm. 1878.
The Armand Hammer Museum of Art
and Cultural Center, Los Angeles.

*T*his new Universal Exhibition, the third one organised in Paris in little more than twenty years, aimed to confirm the rebirth of France after the defeat of 1870 – thanks to the new republican institutions that it was still the only European country to possess.

The curator of the art exhibition, the very learned but somewhat backward-looking Marquis de Chennevières, had deliberately put the emphasis on history painting, even though public taste was moving much more towards landscape and genre painting (Impressionism had yet to be recognised). He therefore chose artists working in the "grand style," with the result that the dominant figures were Bonnat with seventeen works – more than anyone else – Bouguereau, Delaunay, Gérôme, Henner, J.-P. Laurens and Meissonier. The token contingent of landscape painters was made up by Corot, Daubigny and Jules Breton, as well as Courbet, whose single work reflected the discredit still hanging over him for his role in the Commune. Moreau, whom Chennevières particularly admired, had eleven works, for which he thanked the Marquis, including four new pictures, *Jacob and the Angel, The Infant Moses* (both Fogg Art Museum, Cambridge, Mass.), *David* (Armand Hammer Museum, Los Angeles) and *The Sphinx's Riddle Solved* (private collection), plus four watercolours, the most original of which were *Phaeton* (Musée du Louvre, Département des Arts Graphiques) and *Salome in the Garden* (private collection). The jury awarded him a second class medal. Bouguereau won the medal of honour.

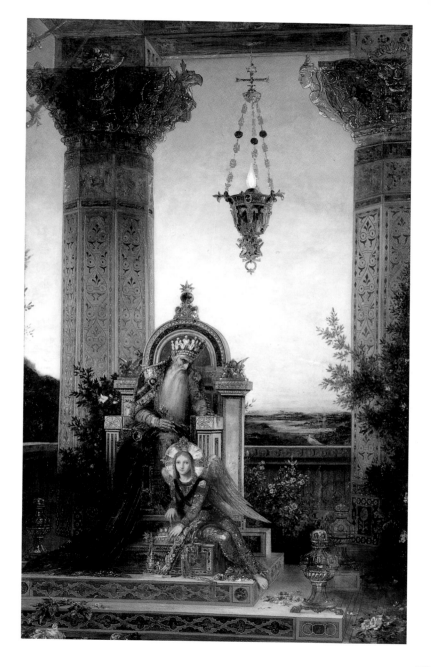

Émile Zola wrote a review of the Universal Exhibition for a Russian journal, and his view is of interest since he represented the most engaged, avant-gardist criticism. The writer regretted the failure to include the young "Impressionists" and dismissed most of the official "glories" such as Cabanel, Bouguereau, Gérôme and Meissonier, while tolerating Bonnat and Henner. He concluded as follows: "I would have left it there if I did not have a gap to fill. Well, not exactly a gap, for in writing this article I thought often of Gustave Moreau whose talent is so disorienting that one does not know where to classify it. He does not fit in any of the categories enumerated here; he cannot be compared to anyone; he cannot be linked to any school; he has had no master and will have no disciples. That is why I must deal with him, on his own and at the end [...] He is a symbolist, archaic talent who not only despises real life, but puts forward the most curious enigmas." After a quick description of the works, Zola admitted that he was both attracted and irritated by some of them, particularly The *Sphinx's Riddle Solved*: "Having looked at Gustave Moreau's paintings to the point of being interested in them, to the point of being almost charmed by them, you leave with the desire to draw the first slattern you see in the street."

6 March: A visit from the Princesse de Caraman-Chimay

On 6 March, Moreau received a visit from the Princesse de Caraman-Chimay, no doubt thanks to the recommendation of Madame de Ratisbonne of the Fould family. As the Count Robert Montesquiou wrote, "I shall see again the little

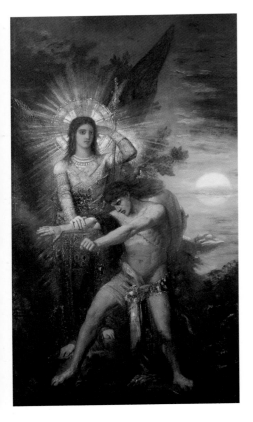

Jacob and the Angel.
Oil on canvas, 255 x 147 cm. 1878.
Fogg Art Museum, Harvard University,
Cambridge, Mass. (gift of Grenville
L. Winthrop).

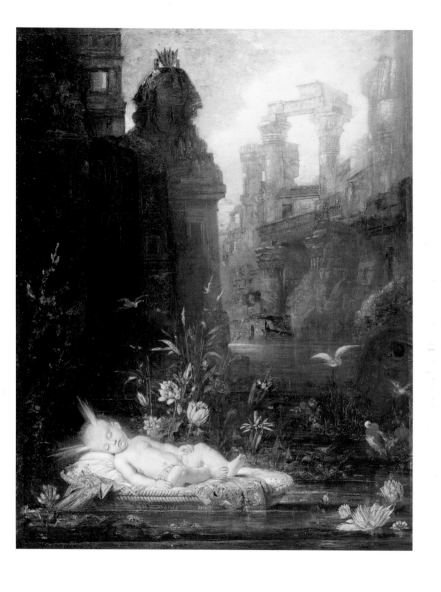

The Infant Moses.
Oil on canvas, 185.4 x 134.6 cm. 1878.
Fogg Art Museum, Harvard University, Cambridge,
Mass. (gift of Grenville L. Winthrop).

house as it appeared to me the first time I entered it as a young man. I was taken there by a cousin, the Princesse de Chimay, accompanied by her daughter Élisabeth, then a very young girl. As an exceptional favour, the painter received us in his studio and showed us, among other works, his fine watercolour of Salome under an arbour. And it was in memory of this visit that, later, I induced the gracious young girl who had now become the Comtesse Greffulhe, to acquire this prestigious painting". As the richest and most prominent aristocrat of *fin-de-siècle* Paris, the Comtesse Greffulhe contributed significantly to making Moreau one of the most sought-after artists in the socialite world described by Proust in *À la recherche du temps perdu*.

Phaeton.
Watercolour with white heightening and varnish on pencil, 99 x 65 cm. Musée du Louvre, Département des Arts Graphiques, Paris.

Salome in the Garden.
Watercolour, 72 x 43 cm. 1878. Private collection, Paris.

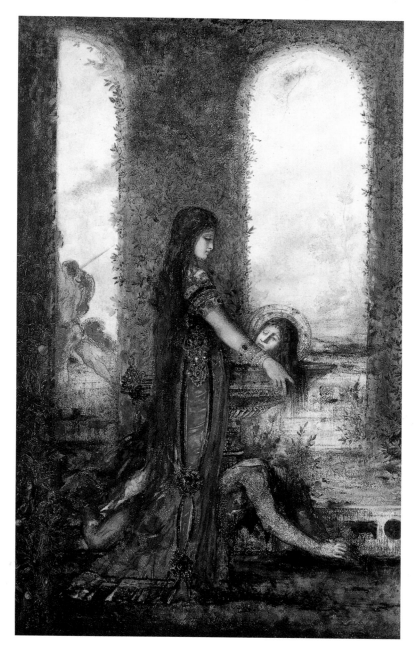

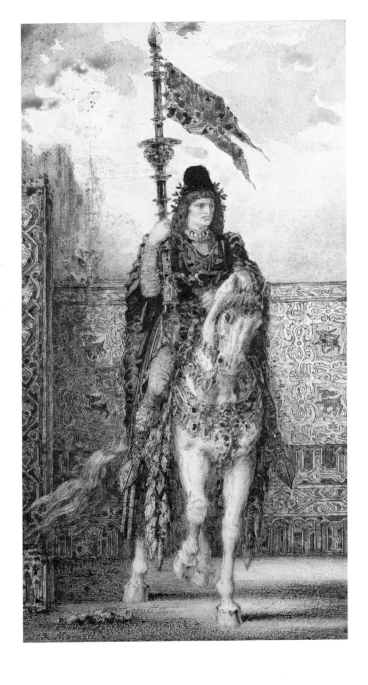

Mounted Standard-Bearer.
Watercolour, 29.2 x 15.5 cm. Circa 1878.
Collection Hiroshi Matsuo, Japan.

Standard-Bearer.
Watercolour on pencil, 19.5 x 23 cm. Circa 1878.
Collection Hiroshi Matsuo, Japan.

1879–84
The Fables of La Fontaine

*I*t is unlikely that Moreau would have thought of illustrating La Fontaine's *Fables*, but he could not resist this commission from one of his main collectors, the rich Antony – or Antoni, as the name was spelt in his native Marseilles – Roux, a shareholder in the mines at Penarroya. Roux, in 1879, decided to have the famous work illustrated by the finest artists of the day and at the same time to take advantage of the revival in watercolour painting, which was too often considered a minor discipline, like drawing, and merely a pursuit for young ladies in good society. Now a certain number of painters, foremost among them Eugène Lami, were trying to promote it through the "Society of French Watercolour Painters", founded in 1878.

Antoni Roux called on illustration specialists such as Jacquemart, Leloir, Lamy and Doré, but also on the history painters Baudry, Delaunay, Français, Gervex, Hébert, Gérôme, Raffaelli, Stevens and Ziem. By 1881 he had nearly hundred fifty watercolours to exhibit at the Circle of Watercolour Painters in the rooms of the Durand-Ruel gallery in Rue Lafitte. No less than twenty-five of these, the biggest selection by a single artist, were by Moreau. Jules Ferry, Minister for Public Education and the Fine Arts, presided over the inauguration on 16 May.

As we have seen, Moreau had already demonstrated his talent as a watercolour painter at official exhibitions, notably the Universal Exhibition of 1878, where he presented large works such as *The Apparition* and *Phaeton*.

According to his first biographer, Ary Renan, Moreau had his doubts about illustrating texts usually reserved for children. He was worried about compromising his freedom. Roux informed him about the illustrated editions already in existence and indicated a number of fables to be translated into watercolour. As for the first twenty-five, exhibited in 1881, it is noteworthy that the artist chose fables involving mythological figures rather than animals, with the exception of creatures that were easy to render, such as lions, rats and mice, monkeys, mules and snakes.

Allegory of the Fable.
Watercolour, 27.5 x 21.5 cm. 1879.
Private collection.

Since he was particularly interested in the arts of India at the time, he was able to introduce Oriental motifs into *Allegory of the Fable* (the first work in the series, delivered in July 1879), *The Dream of the Man from the Mogol Land, The Two Adventurers and the Lucky Charm, The Mouse Metamorphosed into a Girl*, and *The Two Friends*. He rightly recalled that one of La Fontaine's sources had been the Indian Brahmin Bidpay.

It would seem that the initiative for pairing artists with fables lay with Roux, and that he exercised it in a fairly assertive fashion. Thus, in November 1880 Moreau agreed "with great pleasure," to illustrate *The Town Mouse and the Country Mouse*, "for it is one of the nicest ones to work on and, since that is what you desire, I am going to execute the piece at once". Roux had set ideas about the scenery and suggested that Moreau "choose the Louis XIII style, which would allow you to place on the table trinkets in the style of Benvenuto Cellini, stones and gold". In other cases, Moreau was more rebellious and handled the subject in his own way. His approach to *The Cricket and the Ant*, for example, was anthropomorphic, contrasting a very elegant young woman dressed in the fashions of 1880 – she looks a bit like the Comtesse Greffulhe – with a peasant spinning in the doorway of her home, surrounded by her children and a cat – it could almost be a Millet painting. Hence, a degree of tension between the patron and his painter built up, as each felt the need to justify his choice of characters or style, which was often a long way from the more literal

approach of the other artists. "My great concern", explained Moreau to Antoni Roux, "has been to treat each subject in an implicit way, as regards both the idea and the execution. My big preoccupation was not to emphasise or affirm anything […] That is what I wish to meet and talk to you about, better than I could here. I will then explain several of the liberties I have taken, some of the seeming negligence, and you will then be able to defend me better against the criticisms of those who so love photographic rendering and the joys of *trompe-l'oeil*. What long chats we shall have then, but how difficult it is to communicate at a distance."

Certainly, Moreau was always most at home when dealing with subjects that brought him closer to history painting, such as *Phoebus and Boreas* (1879), *Against Those With Too Difficult Tastes, Jupiter and the Thunderbolts* and *The Peasant from the Danube*, whose moralising dimension he abundantly emphasises.

When Roux presented the complete set of illustrated *Fables*, critics all recognised the superiority of the efforts by Moreau, a painter they were hardly expecting to see working in a register of illustration that was close to genre painting. Charles Blanc, the eminent art historian and highly respected critic at *Le Temps*, could not hide

The Lion in Love.
Watercolour heightened with gouache, 37 x 23.8 cm. Circa 1881. Private collection.

his admiration: "One would need to invent a special word if one wanted to describe the talent of Gustave Moreau – the word 'colourist,' for example, which would convey what is excessive, superb and prodigious in his love of colour. The watercolours for the *Fables* of La Fontaine make everything else pale in comparison. It is like being in the presence of a crank who was a jeweller before he was a painter and who, drunk on colour, had ground up rubies, sapphires, emeralds, topazes, pearls and mother-of-pearl to make his palette." (*Le Temps*, 15 May 1881).

In the summer of 1881 the collector decided to entrust the remaining illustrations to Moreau, convinced of the superiority of his talent over that of the other artists. And so, until late 1883 or early 1884, Moreau was busy making 39 more illustrations, with a unit price that had gone from 1,000 to 1,500 Francs. This time, Roux asked him to include more animals. "You told me," answered Moreau, "that you wanted mainly fables in which lions, elephants and other animals play the main role. I have tried to satisfy you, but I have come up against a difficulty that I did not expect to be so great. I am not sufficiently familiar with the appearance of these great beasts, or even of their forms, and what I believe I could muster at the end of my pencil are things that took me a whole month or more of study in the Jardin des Plantes. For it was no longer a matter of animals playing a secondary role that, even if they were seriously studied in the first fables, still belonged in the field of historical art. But for this new series you quite rightly wanted animals that were true and alive, with natural, accurate appearance, and all that needed to be studied once again, and thoroughly, from life."

"Getting up at half-past-five, in the park at seven o'clock, never out of harness, with my lunch in my pocket, the little bottle of reddened water… […] Your twelve compositions are already all drawn and roughed out […] I hope that these new drawings will please you as much as the first; in any case, there will be a new effect, the one you wish for; that is to say, more of a direct impression of nature, both in the form and in the colour of the animals […] But never forget that, as was said by a painter of the 17th century, whom I dare not name, such is his greatness, that I have only one hand with which to serve you." (Letter of 18 September, erroneously dated 1880 instead of 1881.)

Roux, who was sufficiently cultivated to understand the reference to Poussin, and pleased that the painter had adapted to his desires, wrote back amiably from Marseilles: "I can picture you getting up at half-past-five with no more effort or fatigue than a young man full of vim and vigour, with your lunch in your pocket, going quickly to the park, with that conscientiousness that is no less admirable than all your other brilliant qualities, you accept

The Frogs Who Ask for a King.
Watercolour, 31.3 x 20 cm. 1883–84. Private collection.

Gustave Moreau

for a whole month this thorough study of these superb and fearsome animals that nevertheless smell bad, and besides, since these beasts do not like to pose, as soon as you stare at them too much, they love to play all kinds of tricks on you. What patience and what passionate love you have for your art, my dear great master!"

(25 September 1881)

The display cases at the Musée Gustave Moreau are full of drawings made from life in the Jardin des Plantes in August and September 1881: elephants, stags, ibexes, horses, jaguars, leopards, lions, peacocks, rhinoceroses, tigers – all are captured in their natural positions, and with a degree of exactitude worthy of the animal sculptor Barye. These same animals can be seen in the watercolours painted in 1882 and 1883, for example, *The Bear and Garden Lover*, or *The Bear and the Two Companions*. Roux even went so far as to have live frogs delivered to Moreau's house for *The Frogs Who Ask for a King* and *The Frog Who Would Grow as Big as an Ox*.

Roux was impatient to receive each new delivery of three or four or even eight works sent to Marseilles: "The watercolours arrived yesterday in the night," he wrote in January 1882. "My admiration knows no bounds. […] In *The Elephant and the Rat* which, I note in passing, would madden Marilhat [an Orientalist painter who died in 1847] with envy, I believe it would be impossible to feel and render the warm nature of those lands more faithfully."

When the series was finished, Roux had reproductions made on writing paper, and it would seem that he was planning to have a book published by the famous etcher Félix Bracquemond. In the end, Bracquemond made only six etchings for the powerful house of Boussod and Valadon, in 1886; a seventh remained unfinished. Also in that year, The Boussod Valadon & Cie gallery (the successor of Goupil) exhibited the works for a few weeks starting in March at 9 Rue Goupil. The company then presented them in their exhibition rooms at 116 New Bond Street in London that October, along with some larger watercolours.

Moreau had been paid a total of 83,500 Francs for these sixty-four watercolours, and Roux certainly had no wish to sell them. After his death, in 1913, his rich collection was auctioned off at Galerie Georges Petit (19 and 20 May 1914). Sixty-three watercolours after La Fontaine's *Fables* were sold as a single lot prior to the auction. The collector paid 350,000 Francs (about 1,400,000 Euros), and one of them was later given to the Musée Gustave Moreau. "The main thing," wrote Francis Warrain, the collector's nephew, in his preface to the catalogue, "is that such a monument should not be fragmented, that it should be entrusted to the care of a fervent art lover who takes to heart his task of ensuring its completeness for many years, and perhaps for ever. That is why the *Fables* of La Fontaine by Gustave Moreau are not in the place where they should be." At the time of writing, the heirs of that buyer in 1914 have kept their promise. Unfortunately, only a privileged few have been able to see this splendid suite by an artist at the

height of his powers. The sixty-fourth
print, *The Middle-Aged Man*, which
was no doubt too autobiographical,
was removed from the series and
was found in the collection of
André Pastré in Marseilles in 1914.
The sketch for this work can be
seen in the Musée Gustave Moreau
(MGM. at. 426).

The Oak and the Reed.
Watercolour, 28.6 x 23 cm. 1883–84.
Private collection.

1880
The last Salon

Leda and the Swan.
Watercolour and gouache, 34.8 x 22.4 cm.
Circa 1882.
Location unknown.

1880: *Galatea* and *Helen*

*T*he Salon that opened on
1 May 1880 was the 97th such
exhibition of living artists since
1673 and, as it turned out, the
last one to be organised by the
Administration. At the end of the
year, the government asked artists
chosen by their peers to "take
in hand the free and complete,
material and artistic organisation of
the annual exhibitions, instead of
the Administration".

It was also to be Moreau's last
Salon. He presented two new
works: *Galatea* (Musée d'Orsay)
and *Helen* (location unknown).
"His *Helen*," observed one critic,
most judiciously, "is a strange
kind of allegory of the beauty that
brings death, of love that kills,
and no beholder whose soul is to
some degree interested in poetic
speculation can be indifferent to
it."

Galatea was more original. In
this meditation on the impossible
love between beauty and the
beast, Moreau explored new
sources of inspiration, notably
the underwater flora and fauna

Galatea.
Oil on wood, 85 x 67 cm. 1880.
Musée d'Orsay, Paris.

he had discovered in the learned volumes at the Muséum d'Histoire Naturelle, which he would use in several future works. In his review of the Salon, Joris-Karl Huysmans wrote: "Monsieur Gustave Moreau is an extraordinary, unique artist. He is a mystic confined in the heart of Paris, in a cell that is not penetrated even by the noise of contemporary life, even though it is beating furiously at the cloister doors. Deep in ecstasy, he sees the splendour of enchanted visions, the bloody apotheoses of other ages [...] Whether or not one likes these enchantments hatched in the brain of an opium eater, it must be admitted that M. Moreau is a great artist, and that today he stands head and shoulders above the banal horde of history painters." With his novel *À rebours*, the bible of decadent Symbolism published in 1884, Huysmans made Moreau one of the favourite artists of the *fin-de-siècle* generation.

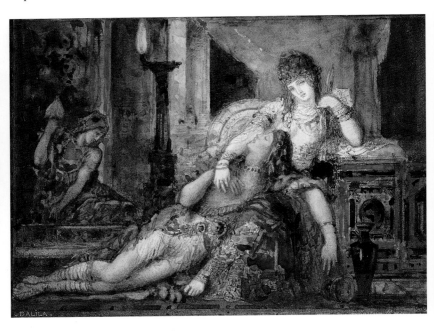

Samson and Delilah.
Watercolour, 15.8 x 21.3 cm. 1882.
Musée du Louvre, Département
des Arts Graphiques.

Dream of the Orient.
Watercolour with gouache heightening,
29 x 17 cm. 1881.
Private collection.

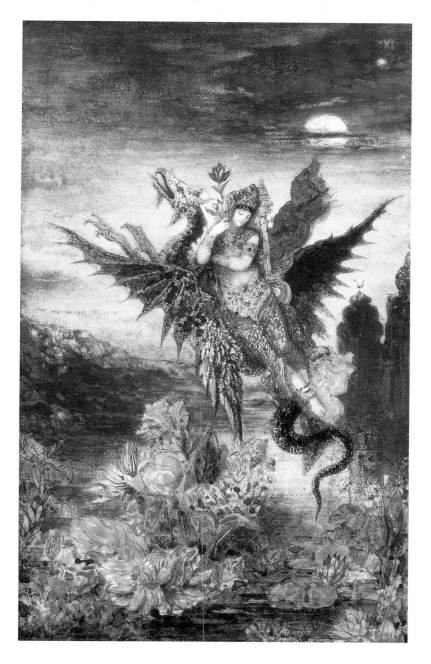

1882

On 26 January Gustave Moreau was made an officer of the Légion d'Honneur, on the recommendation of Antonin Proust, "Minister of Arts" in Gambetta's short-lived "great ministry," which also made Manet a knight of the same order.

On 10 May, Gustave Moreau applied for the chair left vacant at the Académie des Beaux-Arts by the death of Henri Lehman. He was no doubt able to count on the support of the recently elected Baudry, Cabanel and, above all, Delaunay and Bonnat. His competitors were Gustave Boulanger, Jean-Jacques Henner, Émile Lévy, Théodore Maillot, all former winners of the Prix de Rome, to whose names the Painting Section added the name of Jules Breton. At their session of 20 May, the Section elected Boulanger, ahead of Moreau. On 27 May, in the third round of voting, they chose Boulanger, ahead of Henner, Breton and Moreau.

In December, Moreau added strips of canvas to enlarge a number of paintings from the 1850s and 60s: *Tyrtaeus Singing During the Battle* (MGM. Cat. 18), *The Suitors* (MGM. Cat. 19), *Promenade of the Muses* (MGM. Cat. 22), *The Daughters of Thespius* (MGM. Cat. 25), *Hesiod and the Muses* (MGM. Cat. 28), *The Three Kings* (MGM. Cat. 32). He would be busy with these paintings in the years to come, working in a style that was often quite different from his initial manner. Since he no longer took part in the Salon, it would seem that Moreau had, as his friend Puvis de Chavannes recommended back in 1878, thought of putting on a "private exhibition of the works accumulated" in his studio over so many years, but he was not able to bring these works to the status of "finished" pieces like the ones he showed at the Salon.

1883: Costume designs for the Paris Opera

On 3 August, the administrator of the Paris Opera, Régnier, wrote to Moreau: "We are, as no doubt you know, going to revive *Sappho* at the Opera. We would, if it is possible, like to get away from the antique cliché customary in theatre, and no one is better qualified than you to help us do so and thus, emboldened by our mutual friend Delaunay, I would like to ask you, in the name of our director Vaucorbeil, if you would like to give us four or five sketches for the main characters of the work by Gounod and Augier. We will not be performing the piece for a few months, and if you are willing to

The Sirens.
Watercolour, 32.3 x 20.6 cm. 1882.
Fogg Art Museum, Harvard University,
Cambridge, Mass. (gift of Grenville
L. Winthrop).

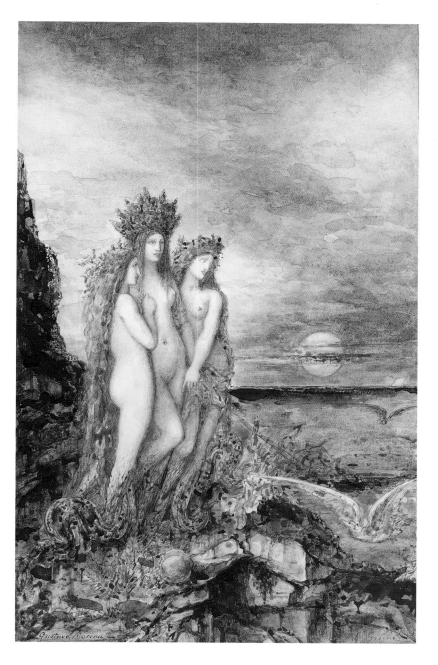

Gustave Moreau

respond favourably to our request, I will at the opportune moment come and ask for the help of your skill and your goodwill." (MGM. Archives) Moreau made some thirty drawings and watercolours for the costumes of the main characters in the opera, complete with precise specifications. For reasons that remain obscure – there was talk of the high cost of his costume designs – the models were entrusted to Eugène Lacroix, the Opera's usual costumier, starting in 1883, and Moreau's name was not even mentioned in this connection. However, he was invited to the premiere on 2 April 1884, when he took the "communication door" that linked the auditorium and backstage, and was used only by *habitués*.

A member of the jury for the National Exhibition

Having left the organisation of the Salon to the artists themselves in 1881, in 1883 the Fine Arts Administration organised an official event with a selection of works from previous years. Half the jury were members of the Académie des Beaux-Arts, others were artists chosen by the minister, among them Moreau, Henner, and Puvis de Chavannes. This national "Salon", which was intended to be a three-yearly event, was poorly attended and not repeated. Moreau did not exhibit there.

31 July 1884: His mother dies

Moreau said that he spent four months composing and drawing his painting *The Chimeras* (MGM. Cat. 39), a "Satanic Decameron" dated 1884. On 12 March he thanked the Perpetual Secretary of the Académie des Beaux-Arts for having chosen him as a "jury member in the painting section helping judge the Prix de Rome competition. It is a great favour for me to have been put on the list drawn up by the Académie des Beaux-Arts, and I would like to thank you and your colleagues at the Institute".

On 31 July, his mother died in her sleep at the age of 82. Jean Lorrain described the traumatic effect on the artist: "A sad, melancholic Gustave Moreau who had stopped working, cutting himself off from the world, at once orphaned and widowed by the death of his mother… will not even hear of painting or his art." Alexandrine Dureux became his consoler. For several years, Moreau was obsessed by the idea of dying in his sleep, like his mother: "Fleeing my family home as much as possible outside the hours devoted to my work, I have come to take refuge with my best and only friend Mademoiselle Adélaïde Alexandrine Dureux", he wrote on 10 January 1886.

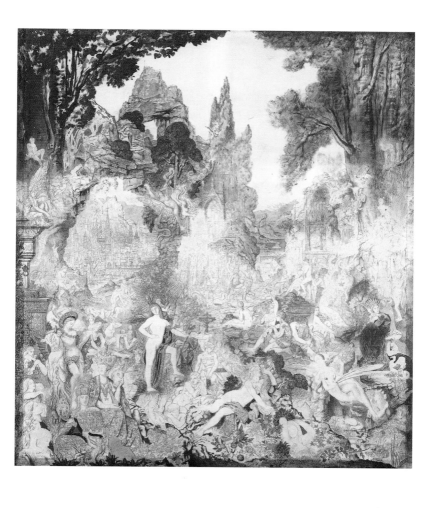

The Chimeras.
Oil on canvas, 236 x 204 cm. 1884.
Musée Gustave Moreau, Paris.

1885
"The Mystic confined in the heart of Paris"

January

Moreau now received a visit from the eccentric Joséphin Péladan, a novelist, art critic and, soon, creator of the Rosicrucian Salon, who was a somewhat embarrassing champion of his work. "I would find it very regrettable if you were to take my natural reserve for unsociability", wrote the artist, when he eventually agreed to a meeting. Péladan recorded the meeting thus: "The man is not like his work. Small, anxious, nervous, meticulously proper, like Hoffmann's magistrate, it seemed to me that his only concern was to politely see me out. All I was able to obtain – and I doubt that one could obtain more – was a look at what was on the wall. He assured me that to him no one seemed as worthy of understanding his art as myself, but that he was more jealous of the two hundred canvases hidden in his townhouse than a caliph of his wives, and that if he allowed them to be seen, he would cease to take pleasure in them himself. I came away from this meeting with only one truly interesting formula, 'I want,' he told me, 'to accumulate evocative ideas in my works so that the owner of a single work may find there new fomentation; and I dream of making iconostases rather than paintings as such. Year after year I add augmenting details, as the ideas come to me, to my two hundred posthumous works, for I want my art to be seen suddenly, in its entirety, a moment after my death'."

June: Studio inventory. A catalogue of works held by collectors

On page 72 of his *Red Book*, Moreau began to draw up a "Little catalogue of the paintings being executed in the studio and a few completed, framed pictures. Studio. 4 June 1885". This comprises forty-eight items, and is followed by the inventory

The Unicorns.
Oil on canvas, 115 x 90 cm. Circa 1885–90.
Musée Gustave Moreau, Paris.

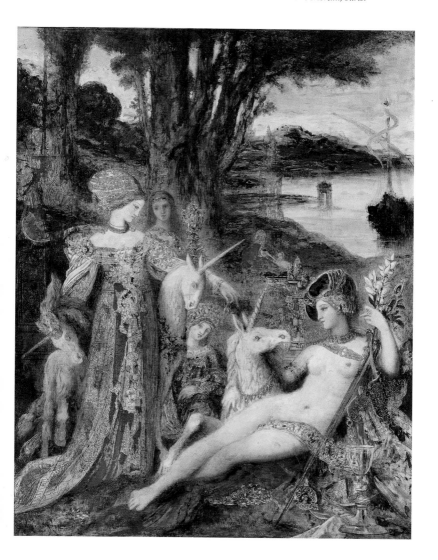

of the "studio Box Room" on the same date, mentioning seventy-two works. This is a precious if incomplete list of works (there are no watercolours or drawings), most of which stayed in the Musée Gustave Moreau. At around the same moment, from memory, he wrote out the list of the works he had sold, with the names and addresses of their owners. Here we find his two main collectors, Antoni Roux in Marseilles and Charles Hayem in Paris, as well as members of the extensive Fould family, who were the first to believe in him, and the names Cahen d'Anvers, Taigny, Ephrussi, Duruflé, Raffalovich and Lepel-Cointet, as well as dealers such as Tesse, Petit, Beugniet and Brame although, at the time, Moreau usually sold directly to collectors.

June: A visit from Jean Lorrain and Joris-Karl Huysmans

In 1882, Jean Lorrain published his first volume of poetry, *Le Sang des Dieux*, with an engraving of *Orpheus* as a frontispiece. Accompanied by the novelist Huysmans, who described the hero of *À rebours*, the Duke of Esseintes, as the prototype of the *fin-de-siècle* decadent, decorating his bedroom with Moreau's masterpieces, he paid a visit to the artist on 16 June. They had no more luck than Péladan when it came to seeing the works, apart from the copies made during his stay in Italy.

Helen on the Walls of Troy.
Watercolour, 40 x 23 cm. Circa 1885–90.
Musée du Louvre, Département des Arts
Graphiques [Musée d'Orsay collection], Paris.

Bathsheba.
Watercolour with gouache heightening, 59.2 x 41.5 cm. 1885–86.
Musée du Louvre, Département des Arts Graphiques, Paris.

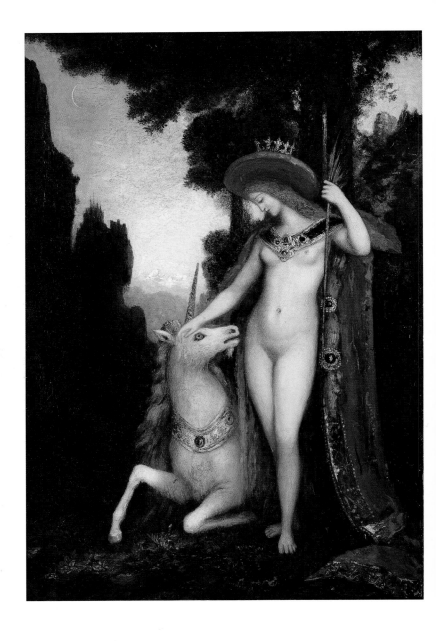

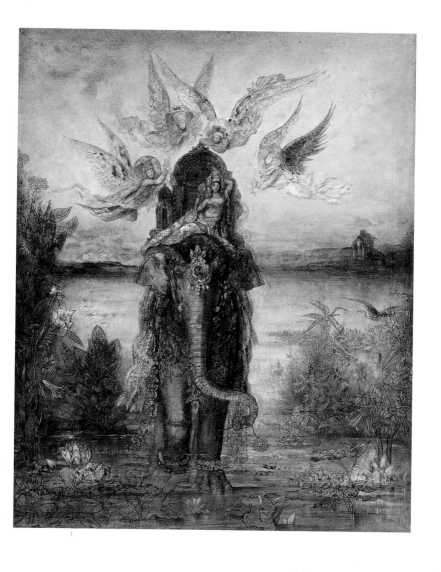

The Unicorn.
Oil on canvas, 50 x 34.5 cm. Before 1885.
Collection Hiroshi Matsuo, Japan.

The Sacred Elephant *or* The Sacred Lake.
Watercolour with gouache heightening,
57.5 x 44 cm. Circa 1885–86.
National Museum of Western Art, Tokyo

1886–87
The Life of Humanity

Moreau now completed his polyptych of *The Life of Humanity,* which he had begun in 1879, painted on wood and surrounded by a heavy gilt frame, in the manner of an altarpiece. In ten panels he retraced the destiny of the human race, following the theme of the three ages (gold, silver, iron). The ages of gold and iron were illustrated by Genesis (Adam, then Cain), the age of silver by the myth of Orpheus, and the ensemble was crowned by the figure of a bleeding Christ borne skywards by angels.

In March-April the *Fables of La Fontaine* and six big watercolours were exhibited by the Goupils "in their galleries in Rue Chaptal". "There was," commented Huysmans, "in the room that contained them, a bonfire of huge blazing skies; crushed globes of bleeding suns, haemorrhages of stars flowing in cataracts of purple on tumbling clumps of nudes […] An identical impression came from these various scenes, an impression of spiritual onanism repeated in chaste flesh; the impression of a virgin, in a body of solemn grace, provided with a soul exhausted by solitary ideas, by secret thoughts, of a woman sitting within herself, rambling on in sacramental formulas of obscure prayers, insidious calls to sacrilege and debauchery, to torture and murders."

In May–July, the first general article about Moreau's work was published in *La Gazette des Beaux-Arts.* It was written by Ary Renan,

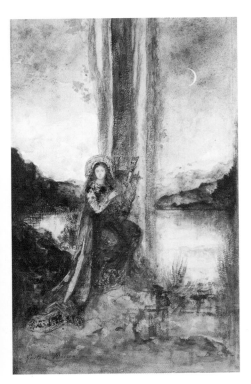

Evening.
Watercolour with gouache heightening,
39 x 24 cm. 1887.
Clemens Sels Museum, Neuss.

Page 136:
Cleopatra.
Watercolour with gouache heightening
and a black border, 40 x 25 cm. Circa 1887.
Musée du Louvre, Département des Arts
Graphiques [Musée d'Orsay collection], Paris.

Page 137:
The Sphinx.
Watercolour, 31.5 x 17.7 cm. 1886.
Clemens Sels Museum, Neuss.

a poet, painter and art critic, the
son of the historian Ernest Renan
(author of *The Life of Jesus*). Ary
Renan was also Moreau's first
biographer. "There will come a
time," he wrote, "when M. Gustave
Moreau will invite us to know his
talent a bit better." But there was
no mention of the works being
prepared in the studio.

1887

On 19 March, the administration
made Moreau a member of the
jury for admission to the fine arts
section of the Universal Exhibition
to be held in Paris in 1889.

In a long letter dated 2 October
to Antoni Roux, who was waiting
impatiently for a new work,
Moreau wrote: "I have spent my
time very fruitfully for the goal
I am pursuing. I have prepared
all my sketches for 8 or 10 of my
big canvases with a view to the
work to be done by the helpers
I have chosen, which work could
not be done without them and, to
conclude, every day during the
long evenings I put down all the
thoughts and all the compositions
that still come to visit my old
mind." We do not know exactly
what "sketches" Moreau was
referring to, but it would seem
that at the time he was working
on paintings like *The Unicorns*,
The Return of the Argonauts and
The Triumph of Alexander the Great,
except that for these he had no
helper, apart, perhaps, from Rupp.

On 14 December he declined
an invitation from Octave Maus
to take part in the "XX Exhibition"
in Brussels, claiming that "at the
moment I have no work ready that
I can make available".

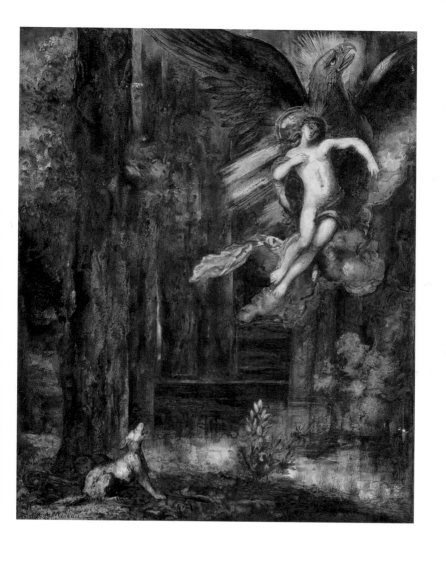

Ganymede.
*Watercolour with gouache heightening,
58.5 x 45.5 cm. 1886.
The Art Collection, New York*

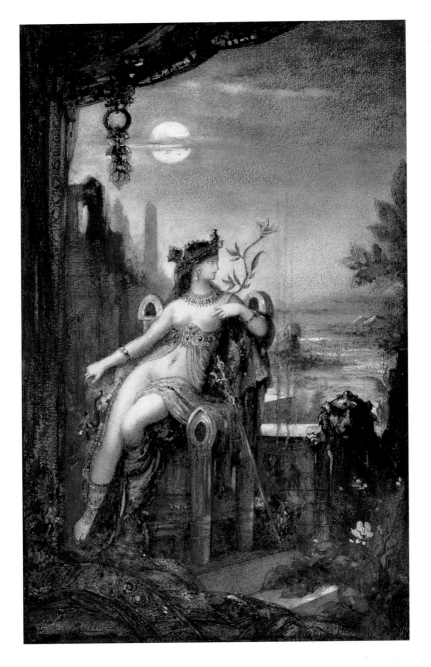

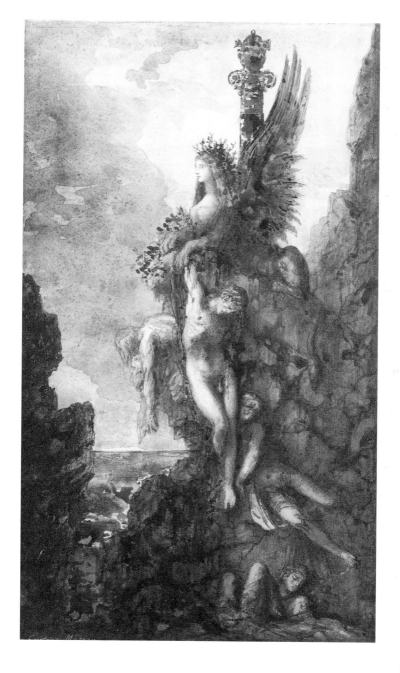

137

1888
A member of the Académie

The Ordeals.
Watercolour with gouache heightening,
29.5 x 19 cm. Circa 1885–86.
Collection Hiroshi Matsuo, Japan.

Summer: A study trip to Belgium and the Netherlands

*A*ccording to Moreau's travel plans, he aimed to visit the museums, churches and convents in Brussels, Mechelen, Antwerp, Ghent, Bruges, The Hague, Haarlem (his presence at the Frans Hals museum in the latter city was noted on 7 September) and Amsterdam. What he saw powerfully encouraged him to continue working towards a "necessary richness", to quote Ary Renan's phrase. "Look at the masters. They all advise us not to make poor art. In every age they put in their paintings all the richest, brightest, rarest and sometimes strangest things they knew; everything that was considered precious and magnificent by those around them. They felt that it was to ennoble the object, to frame it with a profusion of decorative formulae, and their respect, their piety, is like that of the Three Wise Men bringing the tribute of distant lands to the door of the crèche." He concluded his long argument by citing the names of Rembrandt, Van Eyck and Memling.

24 November: Election to the Académie des Beaux-Arts

Applying for the chair of Gustave Boulanger, he was elected in the second round of voting ahead of Jules Lefebvre and Jean-Jacques Henner. The newspapers voiced surprise at the fact that the reputedly reclusive Moreau had stood, and some critics, such as Émile Verhaeren, deplored the fact: "Here he is at the Institut des Beaux-Arts, elected ahead of Lefèvre [*sic*] and Laurens, whose painterly practice, which is clearly academic, one would have thought

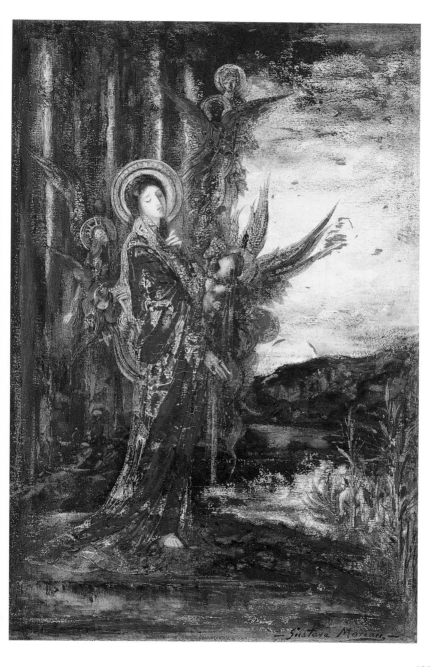

Gustave Moreau

more likely to be distinguished. Far from being a joy, this appointment is a source of regret. […] It was his works alone that mattered to us and their effect was so free of convention or shared ideas, that for me they fell mysteriously from a great paradise of wonders. The fact that the Institut has called upon the master destroys this belief. It is giving him a place in the crowd; it is inscribing him in the catalogue of its members, making him banal, turning him into a *Monsieur*". Gustave Geffroy was worried that Moreau had compromised his reputation by agreeing to "take his place among the so-called ruling class that meets at the Institut".

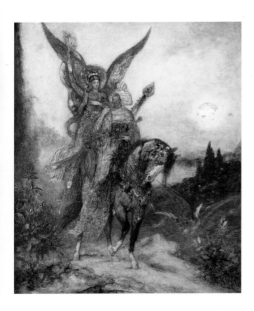

The Arab (Persian) Poet.
Watercolour with gouache heightening, 60 x 48.5 cm. Circa 1886. Private collection, Paris.

December

No sooner had Moreau been elected to the Institut than he received the following proposition from Paul Dubois, director of the École des Beaux-Arts: "Following the appointment of Bonnat to take an atelier at the school, we will need this December to appoint a teacher for the night school. I would be very happy if you were prepared to put yourself forward and I would do all I can to make sure you are chosen. I take it upon myself to present your application to the school's higher council. You do not need to do anything. All I ask is that you should agree to be appointed." This position of teaching drawing, which was shared by four artists, was considered as the last step to a professorship with responsibility for an atelier, to be taken up whenever a vacancy arose, as had just been the case with Bonnat. But Moreau declined, perhaps because he had been informed of certain reservations about him in the administration. It was more the turn of Bouguereau, who had long been a member of the Institut. There was also the fact that the health of Alexandrine Dureux was becoming problematic. On 2 December, Moreau wrote to Dubois: "After much careful thought, I would ask you not to continue with your plans to put me forward for the professorship at the night school. I have very serious reasons for withdrawing." The application of Bouguereau, who was much better known than Moreau, was therefore successful.

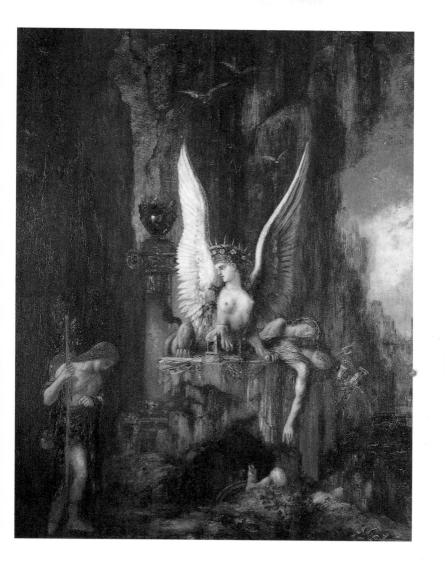

Oedipus the Wayfarer *or* Equality before Death.
Oil on canvas, 125 x 95 cm. Circa 1888.
Musées de Metz.

1889
The Universal Exhibition, Paris

Salome (with Column).
*Watercolour with gouache heightening,
35.5 x 17.5 cm. Circa 1885–90.
Collection Lotar Neumann, Gingins.*

*M*oreau was represented in the centenary exhibition of French art (1789–1889) by *The Young Man and Death* (collection Cahen d'Anvers) and *Galatea* (collection Taigny). This retrospective of one hundred years of French Art included the following living artists: Puvis de Chavannes five works; Bonnat, seven; and Delaunay and Meissonier nine each; as well as works of a few Impressionists, such as Monet and Cézanne. There were nineteen works by Bastien-Lepage, fourteen by Manet and eleven by Baudry, all recently deceased artists.

In the March–May–June issue of *L'Artiste*, Paul Leprieur, a curator at the Louvre, published a thoroughly researched article titled "Gustave Moreau and His Work" in which he described a large number of the painter's works held in private collections. "He is very little known by the current generation, for he carefully avoids all the exhibitions that others seek out with such passion. At most, he exhibits twice every ten years […] Who has had the chance to admire the complete suite of watercolours for *The Fables of La Fontaine* […]? a handful of refined admirers at the very most. As for the paintings that have been piling up in the studio for more than twenty years, nobody but a few close friends is even aware of their existence. […] Why this dogged love of withdrawal? Is it affectation, a need to be different from everyone else? Or might it not show an aristocratic disdain for the judgements of the crowd, and perhaps an underlying bitterness at having been so often misunderstood, or above all the detachment of the true wise man for whom it is enough to create, who cares little for opinion, who slowly savours his own dreams and suffers to be separated from them? Let us not forget, indeed, the scruples of a delicate conscience that is difficult to satisfy and never considers its task as finished. The recent appointment of the artist to the Académie des Beaux-Arts provides us with the opportunity to push open this very carefully closed door. Let us enjoy it. Perhaps one day M. Gustave

Moreau will decide to come out of the shadows and will offer us a private exhibition of a great ensemble of works that will explain him more clearly. In the meantime, there is nothing to keep us from at least trying to guess at his truth. The young literary school, headed by M. Huysmans, has taken to him recently with a sometimes compromising admiration. It admires him tentatively without always understanding him;

it would happily raise up an altar to him between Stéphane Mallarmé and Odilon Redon. It is important to distinguish him from these illustrious eccentrics." Unwittingly no doubt, Paul Leprieur had a remarkable gift for premonition; it is indeed beside Mallarmé and Redon, who both admired him, that Moreau must be positioned where his contemporaries are concerned.

Christ in the Garden of Olives.
Watercolour with gouache heightening, 20.5 x 22 cm. Circa 1885–90. Collection Hiroshi Matsuo, Japan.

Salome Holding the Head of Saint John.
Oil with gouache heightening on paper mounted on cardboard, 35 x 22.5 cm. Circa 1885–90. Private collection, Japan.

Gustave Moreau

1890–91
The death
of Alexandrine Dureux

Dead Poet Carried by a Centaur.
*Watercolour and gouache on paper,
33.5 x 24.5 cm. Circa 1890.
Musée Gustave Moreau, Paris.*

*O*n several occasions, and especially after the death of his mother in 1884, Moreau had imagined his "best and only friend" being there for his last breath, and left instructions for them not to be separated – for this was only an unofficial relationship – at his final hour. After several health problems since 1884, in November 1889 she fell seriously ill. She died at the age of 51 on 18 March 1890 in a clinic run by nuns in the seventh arrondissement. "Ah!" Moreau later recalled, "How well I know them, the streets with refugees, with communities of sisters who care for the sick, with nursing homes. How they make my heart race. How I suffered there. What a long agony. I know every last

stone. There I experienced long days of waiting, of anguish, of hope and more anguish. I had lost all sense of matters of life outside, the matters of life in those streets, of those customs, of that realm of illness, of the dreadful illness that suspends the adored one by a thread over the ever-gaping tomb."

That same year, Moreau turned down a proposition by the director of the Beaux-Arts, Gustave Larroumet, that he provide two cartoons for a hanging to be made by the Manufacture des Gobelins depicting the life of Joan of Arc, for the decoration of her birthplace in Domrémy.

From now on, Henri Rupp, who in 1847 had decided to dedicate his life to his "dear master", was

Moreau's only close friend and helped him to respond to the increasingly pressing demands for commissions from the aristocracy – most brilliantly represented by the Comtesse de Greffulhe – and the world of banking and business (Rothschild, de Beer, Goldschmidt, Mante), who were ready to pay very high prices for works by an artist who, as they knew, was reluctant to part with them. The year in question saw him complete and sell *Saint George* (London, National Gallery), *Jason and Cupid* (Italy, private collection), *Orestes and the Erynes* (Italy, private collection), and start on new works such as *Jupiter and Semele*, the first rough version of which is dated 1889 (MGM. Cat. 94).

On 22 November, in his reception speech at the Académie des Beaux-Arts, Moreau praised his predecessor Gustave Boulanger. This was his one and only public speech.

1891: He again refuses a decorative painting commission

The artist also had his mind on posterity and was working on "museum-format" pieces, although it seems that he had not yet decided where they might be kept. In 1891 he was working on *The Argonauts* (MGM. Cat. 763) – he had made a small painted sketch prior to 1885; *Mystic Flower* (MGM. Cat. 37), a big religious composition with a Byzantine stiffness whose general construction was inspired by Carpaccio's *The Glorification of Saint Ursula*, which he copied in Venice in 1858; and *The Wayfarer Poet* (MGM. Cat. 24). The autobiographical dimension of these canvases is fairly clear: redemptive suffering in *Mystic Flower,* and the suffering of the artist in *The Wayfarer Poet*.

On 5 September 1891, Moreau's friend Élie Delaunay, who

Temptation.
Oil on canvas, 140 x 98 cm. Circa 1890.
Musée Gustave Moreau, Paris.

Saint George.
Oil on canvas, 141 x 80 cm. 1890.
National Gallery, London.

149

directed an atelier at the École des Beaux-Arts, died after several months of serious illness. It was he who, several years earlier, had tried to persuade Moreau to accept a teaching position at the night school (École du Soir). It is commonly thought that later Delaunay appealed again to Moreau, his best friend, to succeed him. On 31 October, Moreau was asked to "direct until further notice the Delaunay atelier" and to "start work on 2 November". On the same day Henri-Paul Nénot, the head architect for building at the Sorbonne, which he had been commissioned to rebuild in 1885 – and for which task he had called on Puvis de Chavannes, another friend of Moreau's – for the decoration of the main lecture room in 1886, now wrote to the artist:

"Dear Master,
"Required to present to the Minister the list of painters for the execution of paintings to decorate the future rooms of the new Sorbonne, I would be honoured if you were kindly prepared to lend your talent to this undertaking by agreeing to be included on the list for a picture or decorative painting of six by three metres, for which our credits would enable us to pay only 9,000 Francs."

A few days later Moreau, who twenty years earlier had refused to help decorate the Panthéon, declined this proposition.

Mystic Flower.
Oil on canvas, 253 x 128 cm. Circa 1890.
Musée Gustave Moreau, Paris.

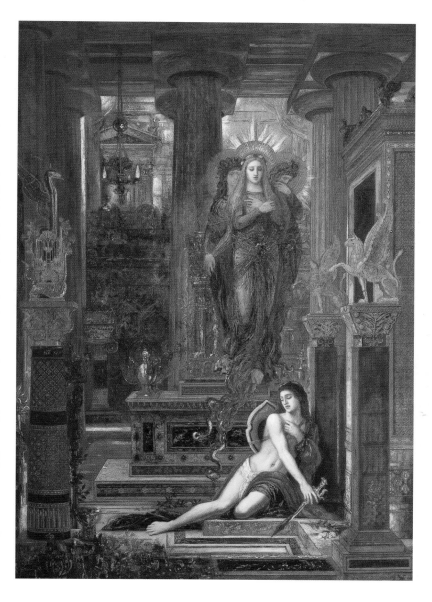

Orestes and the Erynes (*or* and the Furies).
Oil on canvas, 180 x 120 cm. Circa 1891.
Private collection, Turin.

1892
A professor
at the École des Beaux-Arts

21 January

*T*he director for Fine Arts, Henry Roujon, informed the artist that he had been appointed by decree as atelier director at the École Nationale des Beaux-Arts, replacing the deceased Delaunay. On 21 April he succeeded his friend as a member of the Higher Council for Fine Arts, a consultative body that was largely honorific, having little actual power in matters of art.

From now on, almost until his death in 1898, Moreau would direct one of the three painting ateliers at the Beaux-Arts, alongside Gérôme, who had been a teacher there since 1864, and Bonnat, who arrived in 1888. Their role was essentially, but not exclusively, to help students compete for the Prix de Rome, which was the supreme, annual award of the school's teaching system.

Although appointed at the age of 66, he was to prove a very fine teacher. Moreau was adulated by his students, for he did not try to impose a style (especially his own) but sought to inspire their vocation. Encouraging them to paint at an early stage of the course, he urged them to follow the example of the "masters of the Louvre" and would take them to the museum to perfect their technique by copying. When he took over Delaunay's atelier, his eighty or more students – in fact, teachers were free to admit more at their own initiative, usually on the recommendation of a colleague, which was the case with George Desvallières and Jean-Cornélius – included Georges Rouault, who would become his favourite student, Léon Bonhomme, Simon Bussy, Raoul du Gardier, Jacques Gruber, the future master glassmaker of the School of Nancy, Antoine Bourbon, Charles Milcendeau, Edgard Maxence and Eugène Martel. Over the coming years, those who left were replaced by such as René Piot, Marcel Béronneau, Arthur Guéniot (a future sculptor), Léon Lehmann, Henri Evenepoel, Fernand Sabatté, Edmond Malassis, Raoul de Mathan, Jules Flandrin,

The Triumph of Alexander the Great.
Oil on canvas, 155 x 155 cm. 1885–90.
Musée Gustave Moreau, Paris.

Henri Manguin, Henri Matisse, Albert Marquet, Théodore Pallady and, among the latest enrolees, with whom Moreau barely had time to get acquainted, Charles Camoin and Chaurand-Naurac. The most recent historian of the atelier, Philip Hotchkiss Walsh, has calculated that more than two hundred and thirty students were enrolled there. Those listed above are the ones who made some small or great mark on the history of art.

Moreau was very close to his students. He would receive them at home – in his room or living room, but never his studio – with a simplicity and human warmth that made a deep impression on them. He expected them to work hard and be genuinely dedicated, but did not impose any styles or genres, even if the official teaching at the school was still based on history painting, which led to the Prix de Rome and although he encouraged them to create a kind of art that "elevates, ennobles and moralises".

With the exception of Georges Rouault, who appeared to be the most talented in the atelier – and who came within a hair's breadth of winning the Prix de Rome – the best-known names there were those of future Fauves: Henri Matisse and Albert Marquet. If the art they practised was a long way from the kind of thing Moreau believed in, they never forgot the liberal and kindly teaching of a master who, in both their cases, took the trouble to advise their parents not to attempt to discourage them from what was a very real vocation simply because their deep artistic personalities were not in conformity with the official aesthetic of the Beaux-Arts.

This great teacher, whose influence was as great as that of Ingres – but who, unlike his predecessor, did not create a school – also found among his students his own historian, in the person of one of his most promising students, the Belgian Henri Evenepoel, who was cut down by typhus at the age of twenty-seven, just when he was beginning to make a name for himself in the art world. His *Lettres à mon père*, recently published in a complete edition, constitute an invaluable chronicle of life in the atelier and a very perceptive analysis of Moreau's role as an educator; conveyed in a set of letters of remarkable intelligence and great documentary interest.

March: Refusal to take part in the Rosicrucian Salon

In spite of the insistence of Sâr Péladan, who hoped to place the Rosicrucian Salon under his patronage, Moreau refused to take part: "I saw Moreau again when I created the Rosicrucian Salon," wrote Péladan. "I thought that this rich, independent man would support, with one of his works, an art movement that was likely

Soothsayer with Blue Bird (*or* Study). *Watercolour, 24.2 x 12.2 cm. 1892. Private collection.*

Gustave Moreau

to create new admirers for him. He replied to me in courteous words that he was a member of the Institut and a teacher at the École des Beaux-Arts, that what he most valued was peace, and that what I was really asking him was to expose himself to the harassment of his colleagues." Since, on another occasion, Moreau had told him that he was preparing a posthumous exhibition, the Sâr concluded this article thus: "If you are the unbalanced and Hoffmanesque character that I saw, then die immediately, for the greater good of art, and for your own glory." However, some ten students from Moreau's atelier, including Rouault, did take part – with his sanction – in certain Salons, notably in 1897, and Péladan could even write a word of thanks to Moreau, in spite of his resentment: "Master, I am grateful to you for having sent me your student Bourbon, and I beg you to consider the Rosicrucian Salon as in some way your own, since at this moment you are certainly the leader of idealism in France." (MGM. Archives, no doubt 1897)

October

Moreau underwent an operation for "the stone" (gallstones) and, over the next three years – 1893, 1894 and 1895 – he went to Évian every August for a cure and to take treatment for his digestive and urinary tracts. On returning from his convalescence, he received a letter dated 18 November from Antoni Roux, who had just moved to Monte-Carlo. Roux asked Moreau to retouch *Orestes*, and to finish *The Triumph of Alexander*

the Great, which he must have seen before, so that he could buy it, and therefore delay somewhat the *Jupiter and Semele* being made for Léopold Goldschmidt: "I am sure that you have already gone up to your studio, and that in a few days you will be able once again to pick up your brushes with a delicious, adorable peace of mind, as you confidently behold the rough works that remain for you to do [...] You will soon be on to the Goldschmidt, but what if you took *The Triumph of Alexander* before him, for you know that he is in Bohemia, hunting grouse." In the end, Moreau kept *The Triumph of Alexander* and instead sold him *The Infant Moses,* which he had presented at the Universal Exhibition of 1878.

20 December

Moreau wrote to Francis Warrain, Roux's nephew like Baillehache, asking him to come and see the painting he was executing for him, *The Poet and the Siren* (Japan, private collection), before its completion.

Towards Evening.
Watercolour with gouache heightening,
31.5 x 18.5 cm. 1893.
Private collection.

Gustave Moreau Vers le Soir

1893–94
Jupiter and Semele

Jupiter and Semele.
Oil on canvas, 213 x 118 cm. 1894–95.
Musée Gustave Moreau, Paris.

12 March 1893

*M*oreau was elected for a period of three years to the painting jury of the Society of French Artists, of which Bonnat was president, and which followed the Salon. In a letter to his father dated 24 June, Evenepoel wrote: "I have not seen Moreau all week. He has been busy with his judgements at the Salon and the Institut.". The following year, Moreau resigned from the Salon jury.

The administration of the Manufacture des Gobelins now asked him to find a composition that would serve as a cartoon for a tapestry. On 7 May 1894 the artist prepared the full-size cartoon for *The Poet and the Siren*, which was very similar to the canvas painted for Warrain. He was commissioned for the sum of 10,000 Francs. For the Baron Edmond de Rothschild he finished work on *The Persian Poet* (Paris, private collection).

16 May 1893

Charles Hayem wrote: "Help us, I beg you, to find our fiftieth Moreau. We would like a mythological subject."

June 1893

Moreau was a member of the jury for the French section of the art exhibition of the World Fair in Chicago, but exhibited nothing himself.

29 May 1894

Moreau now wrote to Goldschmidt to implore him to "kindly ask Madame Goldsmidt [*sic*] to do me the favour of coming to see the painting of *Semele* in my studio, for I am eager to show it to her now that it is nearly finished". The artist enlarged the canvas and in the end did not deliver the work until May 1895, for the sum of 40,000 Francs (approximately 150,000 Euros in 2009). Failing

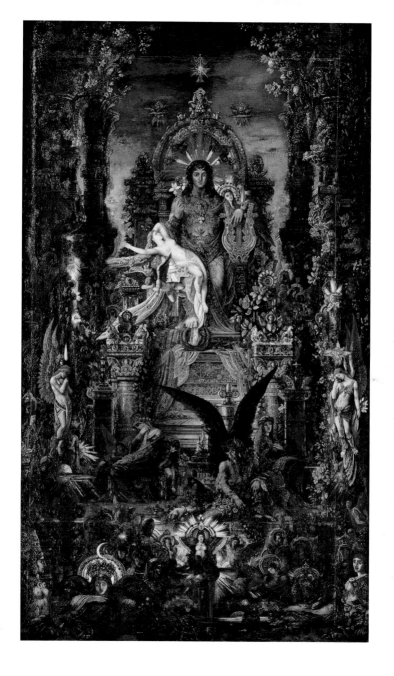

to grasp its meaning, his patron repeatedly requested that he provide an explanation.

12 August 1894

Taking a cure in Évian, Moreau wrote to Henri Rupp, telling him that he had received a letter from Georges Rouault announcing that "on my recommendation he has just been granted a subsidy of 1,200 Francs by the City of Paris. It is a superb year for him and I am very happy indeed". As a teacher, Moreau often had occasion to recommend his students – and especially Rouault, whom he considered as his spiritual son – when the government wanted to buy copies of Old Masters.

Late 1894

The Italian painter Giovanni Boldini, who was famous for his paintings of Parisian high society, now called on Moreau and other artists to act as patrons of the "First International Exhibition of Art of the City of Venice", now known as the Venice Biennale. Moreau agreed to have his name appear alongside those of Dubois, Carolus-Duran, Henner and Puvis de Chavannes (to mention only the French artists). The exhibition opened in Venice on 22 April 1895. Moreau did not exhibit.

The Poet and the Siren.
Oil on canvas, 97 x 62 cm. 1893.
Collection Hiroshi Matsuo, Japan.

Woman with Pink Ibis.
Watercolour with gouache heightening,
37 x 24 cm. 1894.
Private collection.

1895
Building the museum

*I*n 1895 Moreau approached his Parisian architect friend, Dainville, to transform his small townhouse into a big space containing two large exhibition rooms (he did however insist on keeping a few of the existing rooms as well). As he wrote on 5 April, "The work I had accumulated over forty years was cluttering me up to such an extent that I no longer knew where to put myself to work. It was all deteriorating and although I am not so foolish as to attach too much importance to all these works, I do like them well enough, because of the effort they cost me, to wish to leave them intact when I am gone, and in the best possible state. […] I therefore wish, with what reserves of money I have, to extend my spaces as much as I can, but it is important that these gentlemen – Lafon and Duclos – whom you so warmly recommend to me, bear in mind that my means are modest and that, beyond what is strictly

necessary, that is to say, more room for my works, all striving for luxury, or even comfort, must be forgotten. Today, since the death of my mother, I have become like a student, having reduced everything concerning my person to the bare essentials."

15 May

The painter informed the Comtesse Greffulhe of the start of work on his house, "which we are going to rebuild almost entirely. My exile is going to last for months". He had to move to a flat nearby at 5 Rue Pigalle, where he stayed for a year, to May 1896, before taking possession of his "new" house, where he would live for only two years. Built to a very short deadline, the building that constitutes today's Musée Gustave Moreau cost the artist 140,000 Francs (about 500,000 Euros, 2009 value).

Daedalus and Pasiphae.
Enamel plaque by Grandhomme. Circa 1895.
Collection Hiroshi Matsuo, Japan.

24 June

In 1887 Moreau was invited by the director of the Uffizi museum in Florence to produce a self-portrait to be hung in the long series of such works exhibited in the Vasari corridor. In 1895 the Uffizi reminded him of his promise, to which he responded by declining the honour, even though he did already have several such works painted at different moments in his life: "The truth is," he replied, "although I was genuinely uncertain and extremely wary of myself, I did not dare turn down this very flattering offer of having my portrait by my own hand in your handsome Uffizi Gallery, but once calm returned, and giving the matter serious thought, I felt that it would have been ridiculously presumptuous on my part to have dared place myself in the company of those admirable artists of the past, of those venerated and adored teachers whose names are enough to make me tremble [...] I would ask you, therefore, to allow me not to abide by an undertaking too frivolously made."

26 August

While at his cure in Évian, he planned to go and "stop in Basel to see this famous Holbein whom I am so eager to know".

Woman Rising.
Oil on canvas, 24.5 x 16.5 cm. 1885–90.
Collection Hiroshi Matsuo, Japan.

Galatea.
Oil and tempera on board, 45 x 34 cm. Circa 1896.
Museo Thyssen-Bornemisza, Madrid.

1896
A commission
for Les Gobelins

The Poet and the Siren.
*Tapestry. Wool, silk and gold,
351 x 241 cm. 1895.
Mobilier National. Transferred to the
Musée National d'Art Moderne, Paris.*

10 February

Moreau now delivered his painted model for a Gobelins tapestry. The resulting hanging (Mobilier National), woven in wool, silk and gold, was finished on 29 April 1899 and presented at the Universal Exhibition the following year.

12 March: A visit to Henri Matisse

"Yesterday, at half past one, I was walking along the riverside when I met Gustave Moreau," wrote Henri Evenepoel to his father, "who, like me, was going to visit one of my good friends, Henri Matisse, a subtle painter who is highly skilled in the art of *greys*. He is suffering from violent neuralgia in the arm and can hardly walk!

We struggled along to the Quai Saint-Michel, where Matisse was walking up and down as he waited for us. We toiled up the stairs of his old house at no. 19. At last we were in the little studio filled with bits of tapestries and knickknacks grey with dust. Moreau said to me: 'We are the jury'." He sat in a chair, with me beside him, and we spent a most delightful hour. He told us all about his loves and his aversions. Matisse showed us his *envoi* for the Champ de Mars, some ten canvases in delicious colours, nearly all of them still lifes, and thus began all kinds of discussions about matters of art, including music. He has remained astonishingly young. He is not a professor; he shows not a hint of pedantry. He is a friend."

167

30 May

On a proposition made by the ministerial commission on 30 April 1896, the administrator of Les Gobelins, Jules Guiffrey approached Moreau for a second hanging: "The model that you kindly painted for Les Gobelins has made a fine impression on those who have seen and admired it, and the director for Fine Arts has officially asked me to make haste to contact you with a view to obtaining a second panel.

"When we began talking together, you were good enough to show me a *Triumph of Leda*, which appeared to lend itself admirably to execution as a tapestry."

Because of Moreau's illness, and then his death, this project had to be abandoned.

31 August

Moreau was beginning to feel acute pain. From his cure in Évian, he wrote to Rouault: "Although I am very tired and my stomach is very sick, making me little inclined to bend down in order to write, I very much want to thank you for your kind and affectionate letter […]" On returning to Paris, in September, he began wasting away physically.

While continuing to perform his teaching duties at the Beaux-Arts – apparently until January 1898 – Moreau, who continued to produce the occasional work for collectors such as Baillehache and Mante, or the dealer Allard and Noël, was increasingly occupied – with the help of Henri Rupp, to whom he wrote numerous instructions to be followed after his death – with the organisation of his future museum.

Susanna and the Elders
(with Brown Drapery).
Oil on canvas, 96.5 x 64.5 cm. Circa 1896.
Private collection, Basel.

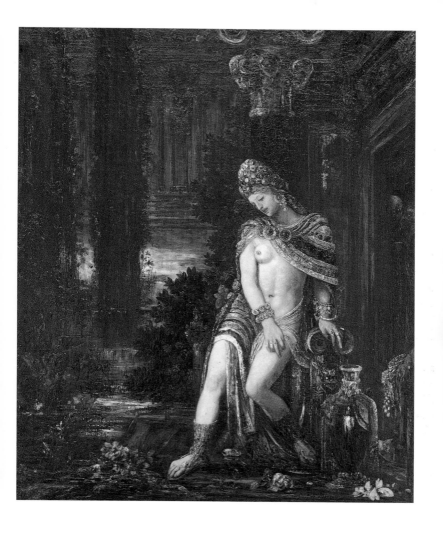

Susanna and the Elders
(with Green Drapery).
Oil on canvas, 81 x 65 cm. 1895.
L'Estaque Gallery, Tokyo.

1897–98
Final Visions

*I*n the preceding years Moreau had executed large painted sketches on canvas for his future museum, notably *Moses Saved from the Waters* (MGM. Cat. 36), *Galatea* (MGM. Cat. 100), *Helen Glorified* (MGM. Cat. 217), which were variations on works he had sold in the past. Towards the end of 1896 he moved his studio to the two big rooms that had been created, and set up dozens of easels – Desvallières speaks of over a hundred – although the inventory suggests that there were fewer. On them he placed canvases he had been working on for some time already, some as old as *The Suitors* and *Tyrtaeus*.

Moreau enlarged his painting of *The Argonauts* by adding the prow of a boat at the bottom, then gave it a title and date, *Anno 1897*. Two of his students, Rouault and Delobre, helped him. According to the traditional account, Rouault painted the mandorla, the rays of light, surrounding the goddess Athena in *The Suitors*. But did Moreau have the strength to sketch *The Dead Lyres*, or did he execute this big – more than two metres high – colourful canvas (MGM. Cat. 106) the year before? In any case, on 24 and 25 December 1897 he executed small, highly precise drawings of the main figures that appear

in this drawing, leaving it to Delobre to prepare the board to the exact dimensions of the big rough version (MGM. Cat. 804). His last vision was a *Great Pan Contemplating the Terrestrial Spheres* (MGM. Cat. 44), which he signed and dated 1897. This large canvas, one and a half metres high and two metres wide, was executed in charcoal and paint.

Leaving it to Rupp to set out the rooms of the future museum after his death, he concerned himself mainly with creating a personal "place of memory" in a few rooms on the first floor of the family apartment, which were kept in their original state: the dining room with its original furniture and photographs of his main works; the bedroom, formerly his mother's salon, where he gathered most of his family mementoes, portraits and photographs of his entourage and the places he had known. His own bedroom became a boudoir where he assembled the furniture and works of his that had belonged to Alexandrine Dureux.

During the second half of 1897, he also drew up notes regarding the painting in the future museum. Their inspired style shows that illness had not impaired his intellectual faculties.

On 10 September 1897 he wrote his will: "I leave my house

Helen Glorified.
*Watercolour with gouache heightening,
30 x 23 cm. 1896–97.
Collection Lecien Corp., Kyoto.*

at 14 Rue de La Rochefoucauld with everything that it contains – paintings, drawings, cartoons, etc.: fifty years of work – along with everything in this same house contained in the apartments once occupied by my father and my mother, to the State, or failing that, to the City of Paris, or failing that, to the École des Beaux-Arts, or failing that to the Institut de France, on the express condition that they keep for all time – and this is my dearest wish – this collection, maintaining its character as an ensemble which gives an idea of the artist's work and efforts throughout his lifetime."

The sole legatee was Henri Rupp. With total selflessness, he installed the museum after the artist's death, made the planned bequests – notably to four former students, including Rouault – and spent several years struggling with an administration that was reluctant to accept a donation consisting mainly of unfinished works.

Many other recommendations were made to Rupp who, during Moreau's final days, helped the master to go back over his sketchbooks, and often to sign them. "Lying on his bed of agony," remembered Rupp, "sapped by an atrocious pain, he had his last sketch brought to him; in accordance with his instructions, I altered a detail, I changed a shade, I attenuated a white that was too bright."

Galatea.
Oil on paper, 37.8 x 23.5 cm.
Fogg Art Museum, Harvard University,
Cambridge, Mass. (gift of Grenville
L. Winthrop).

The Return of the Argonauts.
Oil on canvas, 434 x 215 cm. 1891–97.
Musée Gustave Moreau, Paris.

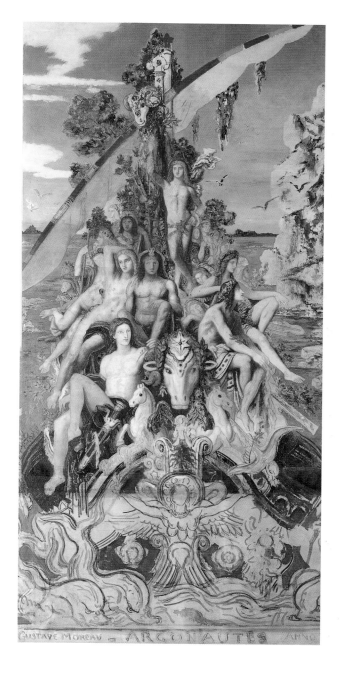

GUSTAVE MOREAU = ARGONAUTES ANNO

1898
The death of Gustave Moreau

18 April

*G*ustave Moreau died in his home at six in the evening on 18 April. Evenepoel wrote to his father on 22 June 1898: "He died, not from his illness of the bladder, but of a cancer of the stomach which, in the space of six months, gnawed away at him, hollowed him out and wrinkled him to such an extent that on his deathbed he was barely recognisable. He died as this indefatigable worker was destined to die, and two days before his last day, he had his collection of a thousand drawings brought to him on his deathbed and signed and corrected them all with delicate accents! In his will he bequeathed five thousand Francs each to Rouault, Delobre, Gilles and Eaubonne! He was thus rewarding the first two for having worked on his last canvases, and the other two he was helping, knowing that they were in urgent need of money."

22 April. 10 o'clock

The funeral was held at the church of la Sainte-Trinité.

The register contains the signatures of many students, of old friends such as Lacheurié, Frédéric de Courcy, Sourdeval, of collectors such as Ignace and Charles Ephrussi, Duruflé, Taigny, Warrain, of his colleagues Frémiet, Gérôme, Merson, Henner, E. Lévy, A. Morot, O. Redon, Bouguereau, Cormont, Detaille, Puvis de Chavannes, etc., of writers and art critics: Judith Gautier, Marius Vachon, Jean Lorrain, Roger Marx, Léonce Bénédite, and Robert de Montesquiou, who wrote thus of Edgar Degas' presence at the funeral: "Such a feeling [of misunderstanding] no doubt inspired M. Degas during the long journey we made side by side at Moreau's funeral; he [Degas] summed it up with this witty observation that bore the hallmark of his deep sense of humour:

Self-Portrait at the Age of 50.
Indian ink on canvas, 41 x 33 cm. Circa 1876.
Musée Gustave Moreau, Paris.

'Moreau was one of those men who always begin by drawing back their feet, so that no one can step on their toes.' The observation was accurate, and was borne out in the funeral itself, which he wanted to be simple and strict, and which he deprived of flowers, honours and even invitations, for fear of imposing, even when dead, and wanting to answer to nothing except spontaneous regret and esteem, which abounded."

Moreau was buried in the family tomb at the North Montmartre cemetery, 22nd division, Samson Avenue. It is numbered 2 in the seventh lane. On 29 May the cemetery conservator authorised that a box containing his hair, is placed in the tomb where M. Moreau rests.

5 May–28 November

During this period, an inventory was made of the estate.

7 May

In May, Charles Hayem made a donation of four works by Gustave Moreau, including *The Apparition*, to the Musée du Luxembourg, as he had promised. A second donation, including *Phaeton*, followed in January 1899.

Late December

Rupp had made progress laying out the museum, which now received its first visits from students.

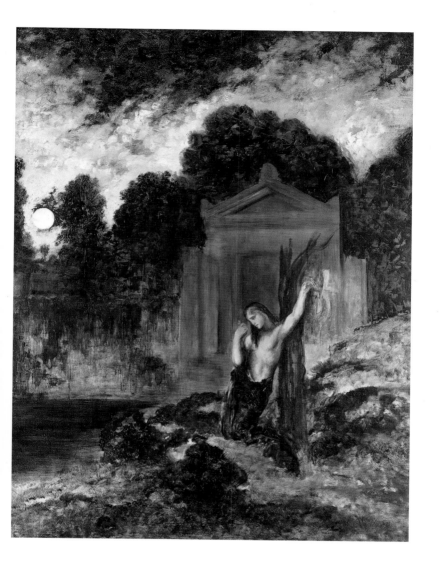

Orpheus on the Tomb of Eurydice.
Oil on canvas, 173 x 128 cm. 1891–97
Musée Gustave Moreau, Paris.

1900–03
The opening of the Musée Gustave Moreau

1900: Universal Exhibition in Paris

*F*ive paintings and two watercolours by Gustave Moreau, all from private collections, were exhibited in the Exposition Centennale.

1899–1902: The state eventually accepts the bequest

Although it had been completely ready by 1899, the opening of the museum, which had been announced for 13 July 1900, had to be postponed, for the public authorities considered that it contained too many rough and incomplete works and not enough finished ones. This view was indeed shared by many visitors: "This, gentlemen, is the source of what is contestable and, above all, incomplete in the work of our colleague" said Gustave Larroumet in the tribute that he made to the painter in front of the Académie des Beaux-Arts in 1901. "His brain was bursting with ideas, and his hand was able to translate only a small part of them. He undertook a great deal, and finished relatively

little. Hence, too, the different impressions that he made on artists and men of letters. Artists admired this productivity and regretted that it was so rarely brought to completion. Men of letters were more pleased with this unfinished quality, which enabled them to continue the dream for themselves that he had begun, and to assert the only superiority they can claim compared to a work of art, which is the ability to develop its ideas."

Proceeding cautiously – but then this was also the first time in France that an artist had made such a bequest – the state demanded that Rupp and the Académie des Beaux-Arts renounce their own share. Having obtained this, they could publish the decree of 26 May 1902:

"In light of the decree of 28 February 1920 authorising acceptance of the bequest made to the state by the painter Gustave Moreau, the said acceptance being subject to the payment by M. Henri Rupp, sole legatee, of the sum of 470,000 Francs [about 2,000,000 Euros, 2009] to cover the operating costs of the Museum.

"In light of article 73 of the Finance Law of 30 March thus conceived: a national museum is hereby created under the

name Gustave Moreau, as an independent legal entity.

The donation of 470,000 Francs (1,700,000 euros 2009) will be invested as a bond with the Grandes Compagnies de Chemin de Fer Français at 2.5%."

14 January 1903: The Musée Gustave Moreau

The Minister of Public Instruction and the Fine Arts inaugurated the museum on 14 January 1903 in the presence of its delegated administrator, Henri Rupp. Its first curator was Georges Rouault. An illustrated catalogue was published, containing 1,132 items as well as descriptions of the panels of drawings, with articles by the artist himself and by Édouard Schuré, author of Les Grands Initiés: *Esquisse de l'histoire secrète des religions*, a study of the work of Gustave Moreau, and poems by Jean Lorrain inspired by Moreau's art.

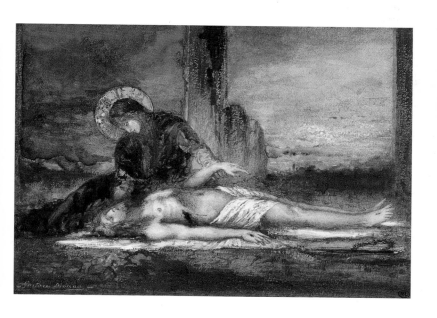

Virgin of Pity.
*Watercolour with white gouache heightening and a black border, 20 x 26.5 cm. 1882.
Musée du Louvre, Département des Arts Graphiques, Paris.*

Chronology

1824

The brother of Louis XVI, Charles X, becomes King of France. One victim of his reactionary politics is Moreau's father, who is dismissed in 1830 for his liberal ideas. Birth in Paris of Puvis de Chavannes, who will be one of Moreau's closest friends (they meet in Chassériau's studio).

1825
Death of David.

6 April 1826
Birth of Gustave Moreau at 3 Rue des Saints-Pères, Paris. His father, Louis, is a highly cultivated architect who exerts a great influence on his son, giving him a strong grounding in Classical culture and never attempting to prevent him from becoming a painter. Moreau's mother, née Pauline Desmoutiers, is extremely attentive to her fragile young boy. She spends the rest of her life alongside her son, who never marries.

1830
The revolution in Paris overthrows Charles X. Louis-Philippe I is crowned "King of the French". Moreau's father, a supporter of the Orleanist *cause, is reinstated as an architect.*

1834
Birth of Degas.

1836–40
Gustave Moreau attends the Collège Rollin, near the Panthéon, where he wins the class drawing prize in 1839 (his passion for drawing began at the age of eight). When his sister dies at the age of 13, Moreau's parents withdraw him from the school on account of his delicate health. His father prepares him for the baccalaureate.

1840
Births of Monet, Redon and Zola.

1841
Moreau travels to northern Italy and brings back an album of drawings of places visited (Chamonix, Milan, Venice, Parma, Pisa, Genoa).

1843 (October)
Aged 17, Moreau obtains his first "student's card" for working in the Louvre.

1844–46
Moreau attends the private atelier of the painter François-Édouard Picot, a member of the Académie des Beaux-Arts and maker of decorative paintings for public monuments and churches in Paris. He prepares for the entrance exam for the École des Beaux-Arts.

1844–48
Théodore Chassériau decorates the Cour des Comptes, Paris.

1845
Baudelaire enters his first Salon.

1846
Moreau is admitted to the École Royale des Beaux-Arts. He is 56th out of 100.

1847
Couture: Les Romains de la Décadence *(Musée d'Orsay).*

1848
Revolution of February: Louis-Philippe I is overthrown after eighteen years of increasingly authoritarian rule. Prince Louis-Napoleon Bonaparte is elected president of the new republic.

1848
Moreau is 15th out of 20 successful candidates in the first exam for the Grand Prix de Rome, but fails in the second.

1849
He passes the two preliminary tests and enters the "*loges*" for the final competition of the Prix de Rome, held from May to August. Other entrants include Baudry, Bouguereau and Gustave Boulanger, who wins. After his failure, Moreau leaves the Beaux-Arts.

1849
Courbet: The Burial at Ornans *(Musée d'Orsay).*

1849–50

Moreau makes copies at the Louvre, especially of Mantegna. He paints small Romantic compositions on Shakespearian themes in the style of Delacroix. Thanks to his father's connections, he receives a few commissions from the administration.

1850
Death of Balzac.

1851

Moreau befriends Théodore Chassériau, a former student of Ingres, now working in the Romantic style. Only seven years Moreau's senior, he is already an established painter who has decorated numerous churches and public monuments. Moreau greatly admires the paintings that Chassériau has just completed at the Cour des Comptes. He rents a studio near Chassériau's on Place Pigalle.

1851
Death of Turner.

1852

Moreau is admitted to the Salon for the first time, but his big *Pietà* goes unnoticed. He is living the dandy's life, frequenting the theatre and opera and singing at Parisian salons in his fine, deep tenor voice.

1852
Second Empire: Napoleon III is made emperor.

1853

Moreau presents the *Song of Songs* (Musée de Dijon) and *Darius Fleeing after the Battle of Arbela* (Musée Gustave Moreau) at the Salon. Both canvases are very close in style to Chassériau. Starts work on several large-scale compositions, most of which will stay in the studio (*The Suitors*, *The Daughters of Thespius*). His parents buy a house in his name at 14 Rue de La Rochefoucauld and create an artist's studio under the roof: this will be Moreau's home for the rest of his life.

1854

Moreau receives a commission for *The Athenians Being Delivered to the Minotaur* (Musée de Bourg-en-Bresse). The canvas is shown at the Paris Universal Exposition in 1855 but goes unnoticed. Start of Moreau's friendship with Eugène Fromentin.

1855
Confrontation between Delacroix and Ingres at the Universal Exhibition.

1856

Death of Chassériau at the age of 37. Delacroix meets Moreau at the funeral and notes in his *Journal*: "Procession for the poor Chassériau. I see Dauzats, Diaz and the young Moreau, the painter. I quite like him."

1857
Baudelaire: Les Fleurs du mal.

1857

Moreau stays in Honfleur, where Baudelaire's mother has a house. Moreau paints a watercolour of the garden (Musée Gustave Moreau).

1857–58

Dissatisfied with his painting and eager to complete an education that his failure at the Prix de Rome has kept him from acquiring, he decides to go and spend two years in Italy. In Rome (October 1857–June 1858) he makes meticulous copies of Michelangelo, Veronese, Raphael, Correggio, etc. and executes delicate watercolour and pastel works during his strolls in and around Rome. He frequents the Villa Medici where he takes life classes and meets the young Edgar Degas, on whom he has a powerful influence. After Rome, Moreau stays in Florence, Milan and, above all, Venice, where he copies works by Carpaccio, then a little-known figure.

1859

Stays in Florence, Rome and Naples, where Moreau is fascinated by the art at Pompeii and Herculaneum. He returns to Paris in September.

1860

Starts work on *Oedipus and the Sphinx* (New York, Metropolitan Museum of Art), *The Wise Men, Tyrtaeus* (Musée Gustave Moreau). Around this time he meets Adelaïde-Alexandrine Dureux (born 1839), for whom he furnishes a flat near his own. He teaches her about art. Only a few close friends will know about this intense relationship which lasts until her death in 1890.

1859–61
Italian unification.

1862

Death of Moreau's father in February. Commission to paint fourteen canvases of the Way of the Cross for the church at Decazeville in the Aveyron.

1862
Gustave Flaubert publishes Salammbô.

1863
Death of Delacroix. Napoleon III authorises artists whose work has been eliminated by the Salon jury to exhibit in a Salon des Refusés. This is where Manet presents Le Déjeuner sur l'herbe *(Musée d'Orsay).*

1864

Moreau presents *Oedipus and the Sphinx* (New York, Metropolitan Museum) at the Salon. The painting causes a big stir and Moreau wins a medal, which establishes his position in the art world. The work is purchased by Jérôme Bonaparte.

1865

Moreau presents *Jason* at the Salon (Musée du Louvre) and *The Young Man and Death* (Cambridge, Mass. Fogg Art Museum), in homage to Chassériau. In November he is invited to Compiègne by Emperor Napoleon III.

1865

Manet exhibits Olympia *at the Salon.*

1866

Moreau sends *Orpheus* (Musée d'Orsay) to the Salon. It is bought by the administration for the Musée du Luxembourg, the modern art museum of the day. His other *envoi* is *Diomedes Devoured by His Horses* (Rouen, Musée des Beaux-Arts).

1866

Birth of Kandinsky.

1867

Two paintings by Moreau are presented at the Universal Exhibition in Paris but win no prizes. He starts working on paintings of poetic inspiration (*The Muses Leaving Apollo to Go and Enlighten the World*, Musée Gustave Moreau).

1867

Deaths of Ingres and Baudelaire.

1869

Exhibits two paintings at the Salon: *Prometheus, Jupiter and Europa* (Musée Gustave Moreau) and two watercolours. He wins a medal, but the hostile critical reception will keep him away from the Salon until 1876. Begins to acquire a select circle of passionate collectors.
Baudelaire's mother dedicates her son's collected works to Moreau.

1869

Birth of Matisse.

1870–71

Moreau joins the National Guard at the start of the Franco-Prussian War in 1870 but is declared unfit after contracting articular rheumatism when guarding the walls. He stays in Paris during the Commune and the nervous strain that results necessitates a stay at the spa of Néris-les-Bains in the summer of 1871.

1870
Franco-Prussian War. Fall of Napoleon III and proclamation of the Republic. Siege of Paris by the Prussians.

1871
The Paris Commune.
Births of Rouault and Marcel Proust.

1872.
Death of poet and art critic Théophile Gautier, an admirer of Moreau.

1873
Marshal MacMahon is made President of the Republic.

1874
Moreau refuses the proposal of the administration to decorate the Chapel of the Virgin at the Pantheon.

1874
First Impressionist exhibition.

1875
Moreau is made a Knight of the Légion d'Honneur.

1875
Birth of Marquet. Death of Millet.

1876
Gustave Moreau returns to the Salon with several carefully prepared works: *Salome Dancing* (Los Angeles, Armand Hammer Museum), *Hercules and the Lernaean Hydra* (Chicago, The Art Institute), *Saint Sebastian and the Angel* (Cambridge, Mass. Fogg Art Museum) and a watercolour, *The Apparition* (Musée du Louvre).

1876
Fromentin: Les Maîtres d'autrefois.
Death of Fromentin. In an opuscule titled La Nouvelle Peinture *and published on the occasion of the Second Impressionist exhibition, Duranty reproaches Fromentin and Moreau, "perhaps the greatest friend of myths", for limitting the development of Impressionism.*

1877
Death of Courbet.

1878
Presents six paintings and five watercolours at the Universal Exhibition in Paris, including *The Apparition*, *Phaeton* (Musée du Louvre), *Salome in the Garden* (Paris, private collection), a *Mace Bearer* (Japan, private collection) and a *Dead Man* (Musée du Louvre).

1879

Starts work on a series of sixty-four watercolours for a wealthy collector illustrating La Fontaine's *Fables* (private collection, sketches at the Musée Gustave Moreau). This commission will keep him busy until 1883.

1879

First lithographs by Odilon Redon, who takes inspiration from the work of Gustave Moreau.

1880

Last Salon. He presents two canvases: *Helen* (now lost) and *Galatea* (Musée d'Orsay).

1880

Death of Flaubert. Rodin is working on The Gate of Hell.

1881

The first twenty-five watercolours of the *Fables* are exhibited in Paris, along with illustrations by other artists, at the Cercle des Aquarellistes.

1881

Renoir: Le Déjeuner des canotiers.

1882

Officer of the Légion d'Honneur (January). Stands for the Académie des Beaux-Arts but is not elected.

1882

Wagner: Parsifal *in Bayreuth.*

1883

Deaths of Manet, Wagner.

1884

In July the death of Moreau's mother, his lifelong companion and daily confidante, plunges him into deep despair. Alexandrine Dureux is a great comfort to him in his distress.

1884

The symbolist writer Huysmans publishes À rebours, *a novel that gives great prominence to Moreau's work. Mallarmé, Albert Samain, Jules Laforgue, José-Maria de Hérédia and Lorrain also take inspiration from Moreau's painting.*

1885

Death of Victor Hugo.

1886

Completes his polyptych *The Life of Humanity* (Musée Gustave Moreau).
Exhibits his watercolours of La Fontaine's *Fables* at Galerie Goupil, Paris,
and then in London, along with six big watercolours. This is Moreau's only
personal exhibition during his lifetime.

1886

Émile Zola publishes L'Œuvre, *a novel in which he describes the failure of an
Impressionist painter who, in spite of himself, paints a woman in the style of Moreau,
and finally commits suicide. Eighth and last Impressionist exhibition.*

1887

Cézanne: La Montagne Sainte-Victoire.

1888

Travels to Belgium and the Netherlands in September to study the Flemish
and Dutch masters who will be an important influence on his final works.
November: election to the Académie des Beaux-Arts. December: refuses a
teaching position at the École des Beaux-Arts.

1889

Member of the jury for admissions to the Fine Arts section of the Universal
Exhibition in Paris, where he presents *The Young Man and Death* and *Galatea*.

1890

Death of his friend Alexandrine Dureux after a long illness. Moreau is grief-
stricken. In memory of her he paints *Orpheus at the Tomb of Eurydice* (Musée
Gustave Moreau).

1890

Death of Van Gogh.

1891

Although his pieces are much in demand, Moreau continues to amass works
in his studio. He refuses to contribute to the decoration of the Sorbonne but in
November, after the death of his friend Élie Delaunay, he does – as a duty to
the deceased, and on a provisional basis – agree to take over his atelier at the
École des Beaux-Arts.

1891

Gauguin in Tahiti. Death of Seurat.

1892

First Rosicrucian Salon organised by the Sâr Péladan, which Moreau refuses to support.

1892

Operated for "the stone" in October.

1893

Oscar Wilde: Salome.

1892–98

Is officially appointed professor and atelier director at the École Nationale des Beaux-Arts, where his students include Rouault, Matisse, Marquet, Camoin, Manguin, René Piot, Marcel Béronneau, Edgard Maxence, Léon Lehmann, Bonhomme, Sabatté, Evenepoel, Émile Brunet and the future master glassmaker of Art Nouveau, Jacques Gruber. On Sundays, he is at home to students, ready to converse and offer advice. Other guests include young artists such as Ary Renan, his first biographer, George Desvallières, Jean-Georges Cornélius and the future filmmaker Georges Méliès, to whom he offers advice. In addition to his students, Moreau also has considerable influence on artists such as Odilon Redon and the Belgian Symbolists Fernand Khnopff and Jean Delville.

1894

Commissioned to produce a cartoon for the Manufacture des Gobelins tapestry works, *The Poet and the Siren* (Paris, Mobilier National).

1895

Completes the masterpiece of his old age, *Jupiter and Semele* (Musée Gustave Moreau). Extends and transforms his home so that it can serve as a museum after his death. He creates two big exhibition rooms and installs his studio there in 1896. When taking a cure in Évian, writes of his eagerness to make a "stop in Basel to see this famous Holbein whom I am so eager to know".

1895

First film projection by the Lumière brothers.

1895

Moreau is a member of the patronage committee of the "First International Exhibition of Art of the City of Venice," now known as the Venice Biennale.

1896

First films by Méliès. Birth of André Breton, who will admire Moreau as a precursor of Surrealism.

1897

Gustave Moreau suffers the first symptoms of stomach cancer.

1897

Gauguin: Where Do We Come from? What Are We? Where Are We Going?

1898

18 April: death of Moreau. Funeral at the church of la Trinité, Paris, on 22 April. He is buried in the family vault with his parents in Montmartre cemetery, near the tomb of Alexandrine Dureux, which he had designed in the same style as his own.

1898

Deaths of Puvis de Chavannes, Burne-Jones, Mallarmé, Garnier (architect of the Paris Opera).

1899

The legatee of Moreau's will, Henri Rupp, organises, at his own expense, the rooms of the Musée Gustave Moreau. The public authorities hesitate to commit to the venture because of the unfinished nature of most of the works.

1900

Seven works by Moreau feature in the Universal Exhibition, Paris.
Marcel Proust writes Notes sur le monde mystérieux de Gustave Moreau.

1901

Deaths of Böcklin, Toulouse Lautrec.

1902

The legacy is accepted under the law of finances of 30 March under the name of Musée Gustave Moreau, an autonomous national museum. Henri Rupp must pay the French state 470,000 Francs to cover its operating costs.

1902

Death of Zola.

1903

The first curator of the Musée Gustave Moreau is Georges Rouault, the painter's favourite student. He takes up his functions on 15 January.

1903

Death of Gauguin.

1904

Birth of Salvador Dalí. In 1970 the Spanish painter will use the Musée Gustave Moreau as the setting to announce the creation of his own museum at Figueras.

1905

The Fauves at the Salon d'Automne, Paris: Matisse, Rouault, Marquet.

1906

Retrospective of Gustave Moreau at Galerie Georges Petit, Paris, organised by the Comtesse Greffulhe and Robert de Montesquiou.

Index of the works

Artistic and technical Director:
Ahmed-Chaouki Rafif
Assistant:
Marie-Pierre Kerbrat

Translation from the French:
Charles Penwarden
Revision:
Jo Collett

Photographic credits

Armand Hammer Collection, UCLA at the Armand Hammer Museum of Art and
Cultural Center, Los Angeles, pp. 94, 103. Artothek-G. Westermann, Peissenberg,
p. 69. Fogg Art Museum, Harvard University Art Museums, Cambridge (Mass.),
pp. 42, 73, 100, 104, 105, 123, 172. J. Paul Getty Museum (The), Los Angeles, p. 85.
National Gallery (The), Londres, p. 149. RMN-A. Malaval, Paris, pp. 65, 67.
RMN-Gaspari, Paris, p. 97. RMN-Gérard Blot, Paris, pp. 106, 147. RMN-Hervé
Lewandowski, Paris, pp. 71, 77. RMN-Jean Schormans, Paris, p. 150. RMN-Jean, Paris,
pp. 41, 46, 81, 133. RMN-Jean-Gilles Berizzi, Paris, pp. 83, 95, 120, 128, 129, 136, 179.
RMN-René-Gabriel Ojéda, Paris, pp. 11, 17, 27, 30, 33, 47, 50, 51, 52, 53, 76, 78, 87, 91,
96, 125, 127, 148, 153, 159, 173, 175. RMN, Paris, pp. 13, 15, 31, 37, 49, 63, 177. And R.D.

A History of South Africa

A History of South Africa

Gideon S. Were, B.A., Ph.D.
Associate Professor in History, University of Nairobi

**AFRICANA
PUBLISHING
COMPANY**
A division of Holmes & Meier Publishers, Inc.
30 Irving Place, New York, N.Y. 10003

Published by Evans Brothers Limited
Montague House, Russell Square
London WC1B 5BX

Evans Brothers (Nigeria Publishers) Limited
PMB 5164, Jericho Road
Ibadan

First published 1974
Seventh impression 1978

Illustrations by Ray Martin

Printed in Great Britain by
BAS Printers Limited, Over Wallop, Hampshire

ISBN 0 237 28802 8 PRA 6042

Contents

Preface

A History of South Africa was written in order to provide the reader with a simple but comprehensive history of South Africa from its earliest origins. At present this need is not adequately met by the bulk of existing textbooks, which tend to be either too detailed and complex or too specialized and uncomprehensive.

Many books have been published on the history of South Africa and our knowledge of South Africa is relatively greater than that of many other parts of the African continent, but most existing surveys suffer from two fundamental weaknesses. Firstly, they are mainly written through the eyes of the white man and, due to the official policy of discrimination based on the fiction of the superiority of the white race, the vast majority of these books are biased against Africans and other non-whites. Secondly, while most books on the subject tell us a great deal about events in South Africa since the white settlement, they tell us little about African societies and states both before and since the coming of the whites. Indeed, for the most part Africans are simply mentioned in connection with friction with the whites. To the authors of such books the African was merely a passive character who was incapable of initiating change or influencing policy, thus making history. Accordingly they were preoccupied with the history of Europeans in South Africa, as seen by Europeans, and ignored the contribution of Africans to the total history of the country.

It is these serious weaknesses which *A History of South Africa* attempts to overcome by portraying developments among African and other non-white societies and by emphasizing their role, as well as that of the whites, in the development of South Africa. Though objectivity is an elusive phenomenon in history, I hope this book has gone some way towards redressing the old imbalance.

<div align="right">Gideon S. Were</div>

Acknowledgments

The publishers are grateful to the following for permission to reproduce the illustrations in this book:

Anti-Apartheid Movement: pages 170, 184, 185 and 186. Associated Press: page 190. Trustees of the British Museum: pages 3 (margin) and 16. Camera Press: pages 73, 155, 167, 169, 175, 176, 178, 183, 186 (top) and 188 (bottom). J. Allan Cash Ltd: pages 137 and 153. Congregational Council for World Mission: pages 4, 8 (bottom), 29, 46, 47 and 59. De Beers Consolidated Mines Ltd: pages 50 (top), 63, 112, 142, 143 (margin), 145 and 147. Heinemann Educational Books Ltd: pages 12 and 101, reproduced from *Moshweshwe of Lesotho* by Peter Sanders. *The Illustrated London News*: pages 1, 2, 35, 60 (top), 77, 90, 92, 93, 96, 99, 106 (top), 107, 113, 123 (bottom), 126 (bottom margin), 134, 135, 139, 143 (top), 144 and 152 (bottom). Imperial War Museum: pages 37, 124 and 125. Keystone Press Agency: page 62. Mansell Collection: pages 5 and 19 (bottom). National Archives of Rhodesia: pages 85 and 86. National Army Museum: page 127 (margin). National Portrait Gallery: page 123 (top). *Pictorial Education*: page 121. Radio Times Hulton Picture Library: pages 3 (top), 7, 14, 18, 30, 31, 44 (bottom), 48, 53, 55, 56, 61, 89, 104, 106 (bottom), 108, 110 (top), 111, 114 (bottom), 116, 117, 126 (top), 127 (top), 128, 130 (top and bottom), 131, 132, 152 (top), 154, 159 and 163. Royal Commonwealth Society: 8 (top), 32 and 69. South African Library: pages 15, 50 (margin), 60 (margin), 70, 87, 88, 103, 110 (bottom), 114 (top), 126 (top margin), 138, 160, 162 and 188 (top). United Press International: pages 164, 182, 187, 189 and 191.

The illustrations on pages 6, 19 (top), 21, 22, 25, 26, 27, 36 (top and bottom), 40, 41, 43, 44 (top), 83, 91, 100 and 102 are reproduced from *Pictorial History of South Africa*, published by Odhams Press Ltd and kindly lent by the Mansell Collection. The illustration on page 72 is from *The Life and Times of the Right Honourable the Marquis of Salisbury, K.G.* by S. H. Jeyes, published by J. S. Virtue. The illustration on page 179 is from the Evans picture library.

The publishers are grateful to the Trustees of the British Museum for references for the artwork on pages 9, 68 and 71, and to the South African Museum, Cape Town, for assistance with research.

Time Chart

1497	Vasco da Gama sails round the Cape.
1593	**The Bantu reach the Umtata River.**
1600	Foundation of English East India Company.
1602	Foundation of Dutch East India Company.
1652	**Jan van Riebeeck arrives in Table Bay.**
1657	**First colonists allotted plots of land. First slaves brought from Java and Madagascar.**
1679	Simon van der Stel becomes Commander.
1688	**First Huguenots arrive in the Cape.**
1699	Willem van der Stel becomes Commander (to be recalled in 1707).
1713	Treaty of Utrecht, and temporary end of European wars.
1737	Mission station built at Baviaan's Kloof by Moravian Brethren.
1780	**Eastern boundary of Cape Colony extended to Fish River.**
1783	Birth of Shaka.
1794	Bankruptcy of Dutch East India Company.
1795	**First British occupation.**
1802	**Peace of Amiens: Cape Colony transferred to rule of Batavian Republic.** L.M.S. mission station founded at Bethelsdorp.
1806	**Second British occupation.**
1812	**Colony's frontiers extended to include the Zuurveld.**
1815 (approx.)	Moshesh becomes ruler of Basuto.
1816	**Shaka becomes ruler of Zulu.**
1818	**Ndandwe under Zwide defeated by Shaka. Beginning of the Mfecane.**
1819	Dr Philip arrives in the Cape.
1820	**First British settlers (1820 settlers) arrive in the Cape.**
1821	**Mzilikazi rebels against Shaka.**
1824	**Parts of Natal ceded to British by Shaka.**
1825 (onwards)	Nedebele under Mzilikazi attack across the Vaal.

1826	Cape Colony's frontier extended to Orange River.
1828	**English made the official language. 50th Ordinance restores civil rights to Hottentots and Bushmen.** Death of Shaka in Zululand: Dingane succeeds.
1833	**Emancipation of slaves.** Foundation of Morija and Beersheba mission stations.
1834	**Sixth of a series of Kaffir Wars.** New constitution launched by Governor Sir Benjamin d'Urban.
1835	Further extension of boundaries proposed by Sir Benjamin d'Urban, but vetoed by British Government. Commencement of Great Trek. Piet Retief asks Dingane for land.
1836	Second and third parties of Trekkers leave the Cape. **Ndandwe under Zwangendaba reach (present-day) Malawi.**
1837	**Ndebele defeated by Boers under Potgieter and move northwards into (present-day) Rhodesia.**
1838	**Piet Retief again asks Dingane for land and is murdered by the Zulu. Dingane defeated by Boers at Battle of Blood River.**
1840	**Ndandwe under Zwangendabe reach (present-day) Tanzania.** In Zululand, Dingane deposed by Mpande. Death of Sobhuza in Swaziland: Mswati succeeds him.
1842	**Republic of Natal founded.**
1845	**Natal incorporated into Cape Colony.** Much Swazi territory granted to Boers by Mswati.
1846	**Moshesh enters into agreement with Britain in order to ease conflict with Boers.**
1848	**Territory between Orange and Vaal Rivers and the Drakenberg annexed by Cape Colony.**
1850	Basuto victory over Boers.
1852	**Boers granted self-government north of the Vaal River by the Sand River Convention (South African Republic).** Copper mining begins in Springbokfontein. British invade Basutoland.
1853	Moshesh defeats Mantatees.
1854	**Bloemfontein Convention grants self-government to colonists of Orange River Sovereignty.**
1856	Death of Shangane in Swaziland.
1857	Three more Boer republics founded (Lydenburg, Utrecht and Zoutpansberg).
1858	Moves towards federation under Governor Sir George Grey. Basutos attacked by Boers and lose much land.

1858–60	**Unification of the Transvaal.**
1866	Basutos again attacked by Boers and lose more land.
1867	Discovery of diamonds in Griqualand West.
1868	Death of Mzilikazi, rule of the Ndebele: Lobengula succeeds him. **Basutoland becomes a British Protectorate.**
1869	**Diamonds discovered at Kimberley.**
1870	Cecil John Rhodes arrives in the Cape.
1871	**Griqualand West declared British territory.**
1872	Rhodes goes to Kimberley.
1873	Cetewayo installed by British as ruler of the Zulu.
1875	Death of Mswati in Swaziland.
1876	**Transvaalers defeated by the Pedi under Sekukuni.**
1877	**Zululand and the South African Republic annexed by Britain.**
1878	Peace Preservation Act (for disarming Africans).
1879	**British defeated by Zulu at Isandhlwana, but win battle of Ulundi:** Cetewayo captured. **Basutoland comes under control of Cape Colony. Formation of Afrikaner Bond.**
1880	**War of the Guns in Basutoland. Transvaal War of Independence. Griqualand West incorporated into Cape Colony.**
1881	**Britain defeated by Boers at Battle of Majuba Hills. Pretoria Convention.** Formation of De Beers Consolidated Mines Ltd.
1883	Cetewayo exiled: Dinizulu succeeds him. **Foundation of Angra-Pequena in South West Africa by Germans. Kruger elected President of Transvaal.**
1884	**Gold discovered on the Witwatersrand.**
1885	**Bechuanaland annexed by Britain.**
1887	Opening of railway, Transvaal to Delagoa Bay.
1890	Death of Mbandzeni in Swaziland: Bunu succeeds him. **Rhodes becomes Prime Minister of Cape. Rhodesia declared British territory.**
1891/2	Railways opened: Natal/Transvaal, Delagoa Bay/Pretoria, Cape/Rand.
1893	**Ndebeles defeated by British South Africa Company.** Witbooi's Hottentots rebel against German rule in South West Africa.
1894	**Zulu state annexed by Natal. Swaziland comes under rule of Transvaal.**

1895	Jameson Raid. Rhodes resigns. Railway opened, Natal/Rand.
1896	Telegram of congratulations (re Jameson Raid) from Kaiser in Germany to President Kruger.
1897	Milner becomes British High Commissioner at the Cape.
1899	British troops reinforced.
1899–1902	**Anglo–Boer War.**
1899	(December) British defeats at Colenso, Stormberg and Magersfontein.
1900	(February) Relief of Ladysmith and Kimberley, and Bloemfontein occupied. (May) Relief of Mafeking. (June) Capture of Pretoria.
1902	**Peace of Vereeniging.**
1904	**Herero arising in German South West Africa.**
1905	**Formation of Het Volk Party in the Transvaal.** Cape School Board Act passed.
1906	**Transvaal granted self-government.** Bambata rebellion in Zululand.
1907	**Orange River Colony granted self-government.** Dinizulu arrested.
1908	Unification of four colonies discussed at Conference in Pretoria.
1908–9	**National Convention.**
1910	**Act of Union passed**; the four colonies become the Union of South Africa.
1911	Mines and Works Act passed.
1912	Land Bank Act. **Foundation of South African National Congress.**
1913	Immigration Act. Land Act. **Nationalist Party formed.**
1914	**Commencement of World War I.**
1915	**South West Africa won from the Germans.**
1918	**End of World War I.**
1919	**Treaty of Versailles: South West Africa declared a mandated territory under South African administration;** African uprising crushed.
1922	Co-operatives Act. Native Urban Areas Act. Apprenticeship Act.
1925	Fruit Export Board formed. Colour Bar Act.
1933	**Formation of United Party.**
1935	**South African National Congress re-forms itself as African National Congress.**

1936 Native Trust & Land Act. Representation of Natives Act, and **Africans placed on separate voters' roll.**

1937 Marketing Act. Industrial Conciliation Act.

1939 **Start of World War II. General Smuts leader of a coalition government. All sections of the community involved in the War effort.**

1945 **End of World War II.**

1948 **Nationalist Party win at General Elections.** Dr Malan replaces General Smuts as Prime Minister.

1949 Prohibition of Mixed Marriages Act. **A.N.C. adopts the Programme of Action of the Youth League and a more militant policy.**

1950 Immorality (Amendment) Act. Suppression of Communism Act. Group Areas Act. Population Registration Act. **Communist Party banned.**

1951 Native Building Workers Act. Bantu Authorities Act. **Cape Coloureds placed on separate voters' roll.**

1952 **Civil disobedience Campaign launched by A.N.C.** 'Pass Laws' Act. Chief Luthuli banned.

1953 **Liberal Party founded.** Bantu Education Act. Native Labour (Settlement of Disputes) Act. Public Safety Act. Criminal Law (Amendment) Act. **Nationalist Party increases its majority in General Elections.**

1954 Walter Sisulu banned, together with many other leaders.

1955 **A.N.C. adopts Freedom Charter.**

1956 Riotous Assemblies Act.

1958 **Nationalist Party again increases its majority.**

1959 **Progressive Party founded.** Extension of University Education Act. Promotion of Bantu Self-Government Act (re creation of Bantustans).

1960 **Referendum re establishment of a Republic. Disturbances in Pondoland and Transkei. Demonstration against pass laws organized by A.N.C. The Sharpeville massacre.**

1961 **South Africa becomes a Republic. Territorial Authority of the Transkei asks for self-government.**

1963 **New Constitution in the Transkei.**

1965 Nelson Mandela imprisoned and his wife detained.

1966 **Assassination of the Prime Minister, Dr Verwoerd;** Mr Vorster becomes Prime Minister. Department of Bantu Education set up. **S.W.A.P.O. launches armed struggle against white rule in South West Africa. International Court of Justice rules against South Africa regarding South West Africa.**

1970 President Kaunda of Zambia leads delegation of Organization of African Unity to appeal against arms sales to South Africa.

1971 **International Court of Justice again rules that South Africa has no mandate in South West Africa.** President Banda of Malawi pays State visit to South Africa.

Chapter 1 Early inhabitants

Early man

Australopithecine man

The Bushmen

Archaeological evidence suggests that southern Africa was inhabited by man many thousands of years ago. At any rate, between half a million and two million years ago the country was already peopled by early man. These early men are called australopithecines (i.e. 'Southern apes') by archaeologists, on whom we depend for our information. Physically the australopithecines were not exactly like modern man as they were still evolving from the animal stage. They were not as upright as modern man, though they were the first creatures to acquire an erect posture and to walk on two legs. They were vastly different from and superior to animals and are known to have been the first creatures to use real tools. But, unlike modern man, they used bone implements rather than metal, which was still unknown. They are also said to have made and used stone tools. The australopithecines are thought to have had a small brain, a huge lower jaw with large molars and no forehead.

As man became more advanced, so also his culture and implements for cutting, defence, hunting and even for digging up roots for food became more refined. His tools became more and more efficient. During the late Stone Age, that is the age when stone tools were widely in use, this complex and long process of change, adaptation and advancement led to the emergence of a group of people similar to the present Bushmen of the Kalahari Desert. These people, who were not quite like the modern Bushmen, lived by hunting, fishing and gathering. All this information is assembled and interpreted by archaeologists from the remains of animals and people of the period and the tools used by these early men and their descendants.

The Bushmen are thought to have been the earliest modern inhabitants of southern Africa. In South Africa they are known by various names: Europeans call them Bushmen, the Xhosa call them Twa, they are known as Roa among the Sotho, and as San or Saan among the Hottentots. However, they are most widely known as the Bushmen, a name first given to them by the Boers who referred to them as Bosjesmannes, i.e. 'men of the bush'.

A rock painting showing Bushmen stealing cattle from the Bantu

The Bushmen's early occupation of the country is partly proved by numerous relics of their stone implements, rock paintings and sculptures. These remains closely resemble similar features in the present culture of the Bushmen. They are found all over South Africa, for example, in Damaraland, Batlapin, the hills of Griqualand West, the Orange Free State, the Transvaal and the Transkei. It is also worth noting that as late as the middle of the nineteenth century the Bushmen still occupied many parts of the country, including the Somerset and Cradock divisions. Today they still live in the dry areas of Botswana, South West Africa and even Angola; they number about 10,000 people.

The Bushmen are short and yellow- or brown-skinned. Their language is characterized by the use of 'clicks', i.e. it has click sounds. They are generally hospitable and peaceful although they hate any intrusion by strangers into their privacy and their hunting grounds, for they are great hunters. Any intruders are attacked with poisoned arrows,

A Stone Age flint, used as a cutting tool or weapon

3

and sometimes they launch sudden raids on cattle belonging to their enemies. The Bushmen are therefore only peaceful and friendly as long as they are left alone. This, of course, applies to practically every society in the world; no society likes to have hostile strangers, who may be potential enemies, in its midst.

Although they had only simple tools, the early Bushmen had no major difficulty in getting food, as long as they were the masters of their rich hunting grounds and the surrounding territory. They lived on wild animals, wild roots and fruits, and also on locusts, wild honey, white ants and caterpillars. They supplemented their rich diet with fish which they caught in the numerous rivers, such as the Kei, Vaal, Tsomo, Mzimvubu and the Tugela. Their way of life explains why the Bushmen are called hunters and gatherers. They did not grow food crops, and they kept no domestic animals except the dog, which they used for hunting. For hunting, as well as for fighting, they used bows and poisoned arrows. Such was, and still is, the life of the Bushmen.

A nineteenth-century print of Bushmen armed for hunting

It was not the kind of life which could encourage a high degree of social and political organization. As there was plenty of land and people lived by hunting and gathering, the Bushmen led a predominantly nomadic life. Then, as now, the Bushmen lived in numerous small isolated settlements, each settlement practically an independent unit. Normally, each settlement or village had a small population of between 25 and 70. The largest villages consisted of between 200 and 500 members each, but such villages were not common. Whether they lived in small or large villages, they all slept in caves or temporary shelters. Their homes were always decorated with beautiful wall paintings, for the Bushmen loved art and their painting was based on their daily experiences as human beings and, in particular, as hunters.

The Hottentots

To the Bushmanoid family also belong the Hottentots. They are taller than the Bushmen but, like the Bushmen, they are yellow-skinned and their language is full of click sounds. Originally they called themselves Khoikhoin, i.e. 'men of men'. Some writers refer to them as the Khoikhoi, omitting the suffix. Europeans called them Hottentots and their language Hottentot, and this is the name by which they are most widely known.

When the Portuguese came to southern Africa in 1487, they found the Hottentots living at Saldanha Bay, Table Bay

Bushmen today still hunt with bows and poisoned arrows

The Hottentot settlement at Table Bay

and Mossel Bay. By the middle of the seventeenth century they were living around the Cape, along the banks of the Orange River and on the coast, in Natal and over much of modern South West Africa. Today they are found in South and South West Africa. Like the Bushmen, who resemble them in some respects, the Hottentots evolved in Africa, probably in southern and eastern Africa. It is reliably reported that by the tenth century A.D. Bushmen were living on the coast of mainland Tanzania and, since they appear to have common origins, the Hottentots may also be presumed to have been in existence by that time.

The Hottentots kept large herds of cattle and flocks of sheep, which formed the basis of their economy. One section of the Hottentots, called the Nama, also kept goats. Since they were cattle-keepers, the Hottentots had to move from place to place with their herds of cattle and flocks of sheep in search of fresh pasture and water. This was particularly necessary since the number of cattle was always far greater than that of the people themselves. Fresh pastures were always in demand as the old ones were exhausted. Although they kept numerous cattle, the Hottentots rarely

A Hottentot family with their cattle at Table Bay

killed them for food, except when there was an important
function such as a ceremony or feast. Milk was a basic food;
the men drank cows' milk and women and children drank
ewes' milk. Like the Bushmen, the Hottentots also fed on
honey, wild fruits and roots, and fish. Wild game, which they
killed with their poisoned arrows, enriched their diet with
meat. Thus, like the Bushmen, the Hottentots were hunters
and gatherers. They did not grow any food crops like their
future opponents, the Bantu, but, unlike the Bushmen, they
domesticated cattle, sheep and, to a small degree, goats.

The Hottentots had a larger and more efficient social
and political organization than the Bushmen. They lived in
large groups or camps, each of which consisted of several
related clans. Each camp was therefore a large village.
Apart from members of related clans, the camp also en-
closed all the herds of its inhabitants. Intermarriage between
members of one clan was forbidden. Each camp was an
independent political unit: it could make alliances with its
neighbours for purposes of peace, war, raids and trade, and
it was free to choose its friends and enemies in the same way
as modern states. Each camp had a chief who ruled with the

Bushmen and Hottentot features, showing how the two peoples were originally related

The Bantu

help of the heads of the clans comprising his territory, i.e. the camp or village. Disputes were settled in two major ways. If it involved members of one clan, the dispute was usually settled by the leading elder of the clan. Other members of the camp were free to attend the proceedings, which always took place in public. Differences between members of different clans were settled by the chief of the camp, who even had power to sentence a man to death. He did not have complete power, however, and in all his work he was assisted by the heads of the camp's clans. The relatives of a murdered man had a right to take vengeance on his assassin, and neither the chief nor the elders could compel them to accept compensation or any other form of settlement. Such was the limitation on the powers of the chief. Nevertheless, the Hottentots had a higher level of political organization than the Bushmen. Their chiefs had clearer and heavier responsibilities than Bushmen chiefs.

As we have seen, the Hottentots and the Bushmen seem to have originally been related. The Bushmen were the first to settle in South Africa, followed by the Hottentots. Exactly why they later developed along different lines has yet to be explained. Perhaps this was simply the result of the influence of environment; perhaps they were separated from each other for a considerable period during which the Hottentots developed their own independent culture. It is also possible that the Hottentots turned into pastoralists after acquiring cattle from the advance party of early Bantu immigrants. Be that as it may, the old theory that the Bushmen are a different race from the Negro and that the Hottentots are the offspring of a marriage between the Bushmen and some stray Cushitic-speaking people is no longer valid.

Unfortunately for the Bushmen and Hottentots, time was not on their side. Their form and degree of organization, the nature of their settlements and the simple nature of their implements could only sustain them in the absence of better-organized, better-armed and better-built enemies. They could not hope to maintain their sway over the country in the face of superior invaders.

But a strongly built and taller race did arrive on the scene. These were the Bantu. Like the Hottentots they kept cattle; unlike them and the Bushmen they grew food crops on a large scale and were renowned for it. Their economy was more advanced, combining agriculture with pastoralism, and their standard of living was a great deal higher than that of

their predecessors. How did the Bantu manage to do all this? They had one important asset which their predecessors lacked: they knew and introduced the art of iron-working. As a result they were able to make and use iron implements, which were vastly superior to the stone and bone implements used by their predecessors and neighbours. With their efficient tools they could clear the forest and bush and cultivate the soil on a large scale, and their metal weapons (e.g. iron spears) were far superior to anything their weaker opponents had. Their growing population could be sustained by food from the soil and cattle products.

Another reason for the success of the Bantu newcomers was the kind of economy they practised. They kept many herds of cattle and cattle were highly valued as a source and form of wealth. People who possessed numerous herds of cattle were greatly respected in the community; they were wealthy and therefore prominent. Cattle were used for important functions, e.g. the payment of bride-wealth, and they were valued for their milk, meat and skins. Because the Bantu kept cattle and also grew food crops their population increased, and population increase led to territorial expansion. The mixed economy of cattle-keeping and agriculture supported a fairly high population, by contemporary standards. People had enough to eat; more important, they had a rich and balanced diet.

The actual date of the arrival of the Bantu from the north and north-east is still uncertain, but it is generally agreed that this must have happened over a thousand years ago. At any rate, by the tenth century A.D. the Bantu were already living in some parts of the country. Instead of coming together in one group, the immigrants came in several groups at different times and settled in different places. Later they gradually spread out. During the sixteenth century and certainly by the middle of the seventeenth century they had already settled in Natal and parts of the Cape Province, as a result of many centuries of migration, settlement and expansion.

The coming of the Bantu and, later, of Europeans had a disruptive effect on the Bushmen and the Hottentots. The Bushmen in particular suffered disastrous consequences. They were conquered and dispossessed of their favourite hunting grounds by the strongly-armed newcomers. As a result they were pushed into remote and unfavourable parts of the country where game and food were scarce and life difficult, and many of them even had to flee into the hostile Kalahari Desert for refuge. Some of them were absorbed by the Bantu newcomers, living among them as people without their own independent identity and intermarrying with

Examples of Bantu ironwork: an iron spearhead

an iron hoe head

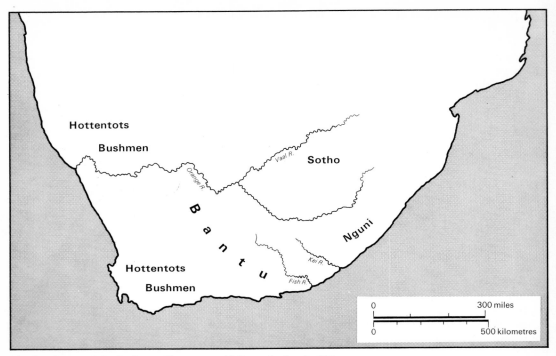

The distribution of the Bushmen, Hottentots and Bantu in South Africa

them. A few others had a worse fate. They were either killed in clashes with the Bantu or died as a result of the social and economic hardship following their defeat and dispossession.

1. The Nguni

With the passing of time, there emerged three major distinct divisions among the Bantu of South Africa. These are language groups and should not be mistaken for political divisions. First, there are the Nguni-speaking people. Formerly they lived in the eastern coastal area from Zululand and Natal to the border of the Cape Colony. Today they occupy parts of the Transvaal, Natal, Cape Province and Zululand. Among others the group consists of the Zulu, Ndebele, Swazi and the Xhosa, all of whom speak dialects of the same language. It is still not certain when they arrived in the country. What seems clear is that their advance party, the Xhosa, had reached the upper part of the Umzimvubu River by about A.D. 1300. By 1593 they had spread south as far as the Umtata River. In the next 200 years they expanded as far as the Fish River.

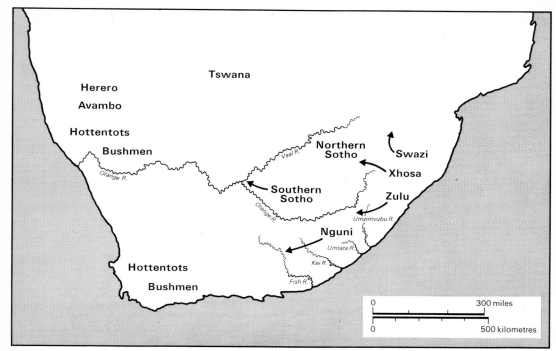

The origins and spread of the Bantu

The second group of the Bantu of South Africa consists of three main subdivisions. These are the Tswana, or Bechwana, who mostly live in Botswana (formerly Bechuanaland); the Southern Sotho who live in Lesotho (formerly Basutoland) and the immediate neighbourhood; and the Northern Sotho of central and northern Transvaal. Their country was formerly occupied by the Venda and Lemba who are small branches of the Kalanga of Rhodesia. Today the northern part of their country is also settled by the Nguni, particularly in northern Zululand and Swaziland.

The group arrived in the country many centuries ago. Certainly by the thirteenth century, or early fourteenth century they had arrived in Bechuanaland. They seem to have come in three main independent migrational groups. By the beginning of the seventeenth century, for instance, the ancestors of the Tswana were living close to their present settlements. Later the Sotho expanded to the east, to the south as far as the Orange River and to the west. The westward expansion was hampered by the Kalahari Desert. One small group called the Tawana were strong and brave enough to move on and settle on the coast of Lake Ngami.

2. The Tswana and the Sotho

3. The South-Western Bantu

The third major group of the Bantu of South Africa is represented by the Herero and Avambo. They live in South West Africa and are generally called the 'South-Western Bantu'. Practically all these Bantu groups have been influenced by the Bushmen and Hottentots with whom they came into contact. This is why the Nguni languages have clicks, just like the languages of the Bushmen and the Hottentots.

Political organization

The biggest single reason for the success of the Bantu against their predecessors was their political and military organization, which was highly advanced and efficient compared to that of the Bushmen and the Hottentots. To understand the nature and functions of this organization let us look at the Nguni and Sotho divisions of the Bantu.

A Sotho warrior

Before the revolutionary changes of the early nineteenth century in political and military organization, the tribe was the biggest political unit among the Sotho and Nguni. Consisting of several thousand people, it was much larger than similar political units among the Bushmen and the Hottentots. Each tribe had its own territory, a central clan, a central family and a chief. The chief always came from the central family and clan. Each tribe was made up of new members, who were partially absorbed in due course, and original members, who formed part of the central clan. The non-royal or commoner families took pride in associating themselves with the traditions and practices of the ruling clan, and this had the effect of strengthening tribal unity. Among the Nguni the name of the tribe was usually taken from that of a prominent ruler, while among the Sotho it was taken from the ruling clan.

In both groups the chief was very powerful, but an autocratic and unpopular chief could not last long; his subjects could desert him and join a friendly and just ruler. The chief also had to rule according to local custom and accepted practices, and with the advice of his leading elders. He was assisted by two councils, an inner council and a larger council or assembly. The inner council consisted of the chief's confidential advisers who advised him on day-to-day matters and problems. The wider assembly was called the *pitso* among the Sotho. It comprised all important junior chiefs and met to transact important policy decisions or whenever there was an important national issue. During the meeting any adult male was free to speak his mind, and the chief could be criticized. Among the Nguni the *pitso* met only at the annual first-fruit ceremonies. The chief usually appointed his close relatives to important positions and to his council.

The chief was highly esteemed as the symbol of tribal unity and as the focus of loyalty in the tribe. In addition he was the head of the tribe in all matters relating to religion, the administration of justice, government and warfare. Appeals could be made from small courts to his court. In this way his court served as the country's Supreme Court and was the only court competent to try murder cases. In cases of natural death, the relatives of the deceased had to give a cow to the chief, demonstrating the power of the chief and the high esteem in which he was held.

To enable him to do his work properly, the whole dominion was divided into several subdivisions. The most important of these were the provinces and below them the districts. Each was directly ruled by a sub-chief. The system of administration was further strengthened through

Zulu chiefs

the appointment of *indunas*. These were state officials in various fields, both military and civil. They were permanent and assisted the chief in his duties. Of particular significance was the chief *induna*, who could deputize for the chief in his absence and could also give instructions in the chief's name. He had the responsibility of keeping the chief well-informed about public opinion and about any dangerous developments such as conspiracies and rebellion. No wonder the chief *induna* came to be regarded as the 'eyes and ears' of the chief. To avert any danger of such a powerful personality rebelling and seizing power, the chief *induna* was always chosen from the common families who were not supposed to rule.

Initiates of today emerge after their period of seclusion. Their faces are hidden so that they cannot be seen by married women.

Among the Sotho and the Nguni this form of political organization was reinforced by initiation ceremonies. Initiation entailed circumcision followed by a period of ritual seclusion. During this period the initiates were given instructions in the responsibilities and obligations of manhood. These ceremonies marked the end of one era and the beginning of another as the initiates moved from childhood to maturity. Among the Sotho, however, initiation ceremonies also had a political significance. They were performed under the authority of the chief and it was he who decided when initiation should take place. Of greater significance was the fact that all members of the same initiation group formed an age-regiment, which was associated with a royal prince belonging to that age-group. In wartime the age-regiment fought as a group under their royal group-mate, and the regiments sometimes helped with construction and similar work in the royal homestead. For most of the time, however, they were scattered in different parts of the state where they lived and worked among the people. Women regiments also existed among certain sections of the Sotho and were led by the chief's daughters, belonging to their respective age-regiments. Through the existence of these regiments political and military organizations were closely connected and, although there was no professional or permanent army among the Sotho and Nguni, they were better able to attack the enemy or defend themselves than their weaker neighbours, the Bushmen and the Hottentots.

Chapter 2 Colonization under the Dutch

When the Dutch first went to South Africa during the seventeenth century, they had no intention of establishing a white colony on similar lines to the British North American colonies. That the Dutch community at the Cape later developed into a settled colonial society was largely due to unforeseen circumstances.

Portugal and the route to the East

Vasco da Gama

The Dutch were late-comers in the sea-trade with the East Indies; as is well-known, Portugal was the first European nation to discover the route to the East. In 1485 Diego Cam had reached the mouth of the River Congo and in 1488 Bartholomew Diaz, another Portuguese, rounded the southern-most point of the African continent as far as Algoa Bay. The climax of these tiresome and dangerous sea voyages came in 1497 when the famous Portuguese, Vasco da Gama, sailed right round the Cape as far as present-day Natal (where he arrived on Christmas Day) and thence to India. The Portuguese, however, did not settle at the Cape. They wanted gold, ivory and slaves which were not available there. Until the end of the sixteenth century Portugal was unchallenged as master of the rich trade with the East. Being in sole control of the sea-route, Portugal grew rich from the sale of Eastern spices, carpets, perfumes and precious stones. Her merchants brought these highly valued commodities to Lisbon where traders from other European countries purchased them. In 1595, however, Cornelis Houtman, a Dutchman, sailed round the Cape to Java, in modern Indonesia. The long period of Portuguese monopoly of the profitable trade with the East was clearly coming to an end. The new challenge to the Portuguese came from the Netherlands* (which, led by William of Orange, had rebelled against Spain in 1579) and England.

The East India Companies

Both the Dutch and the English conducted their commercial activities through chartered companies. In 1600 the English

* The Netherlands comprises the United Provinces of which Holland is a member. The Dutch people come from Holland.

The Dutch East India Company trading route from the Netherlands to the East Indies, via the Cape

East India Company was founded, and two years later, in 1602, various Dutch companies united to form the Dutch East India Company. The Dutch Company had a powerful central committee and more funds than its English rival. While the English Company had a capital of only £30,000, the Dutch started with a capital of more than £50,000. Both Companies were mainly interested in trade with the East Indian islands, unlike the Portuguese whose commercial activities extended also to eastern Africa and southern India.

But all seamen, whatever their nationality, were faced with one big problem. In those days the Suez Canal had not yet been constructed and, as there was no short cut, the route

Establishment of a calling station at the Cape

17

to the East was extremely long and arduous. The route passed along the West African coast, touching Sierra Leone, and thence across the Atlantic Ocean to Brazil. From the southern coast of Brazil it ran eastwards across the Atlantic to the coast of South Africa, and it was from there that the traders travelled to the East Indian islands. By the end of the long journey, they were extremely tired and quite frequently they ran out of fresh water, fresh vegetables and fruit and other supplies. Many died on the way and others suffered from scurvy. Quite clearly, there was an urgent need for a calling station where the long journey could be broken, and fresh supplies of food and water procured.

As early as 1619, representatives of the English and Dutch Companies met to consider how best to solve the need for a calling station. They failed to reach any agreement, although the suitability of Table Valley for a permanent calling station was vaguely recognized. An attempt in 1620 by two members

The Dutch East India Company's fleet at anchor off Table Bay, 1670
Inset: the small wooden fort built by Jan van Riebeeck

of the English Company to annex the land adjacent to Table Bay in the name of King James I was also unsuccessful because of lack of support from the English Government. The first opportunity for a positive attempt to be made to establish a calling station in the Table Valley was virtually accidental. In 1647 the *Haarlem*, a vessel belonging to the Dutch East India Company, was wrecked in Table Bay. Its crew moved into Table Valley where they stayed for six months. To sustain themselves, they grew vegetables and bartered with the local people for meat. The district had a favourable climate and fertile land and was thus suitable for settlement. The crew of the *Haarlem* were so impressed that on their return home, in 1649, they gave a glowing report about it. It was just the right place for a station and a European settlement. The reaction of the Company was favourable and it was decided to establish 'a rendezvous and a stronghold' in Table Bay. An expedition consisting of three ships and 130 men and women, led by Jan van Riebeeck, was consequently launched. On 4 June 1652, it reached Table Bay.

Jan van Riebeeck, leader of the expedition to Table Bay

The need for a calling station

Here it is important to consider some of the original functions which the proposed station was supposed to serve. As already seen, the route from Europe to the East Indian islands was extremely long and the journey was tiresome and full of danger. Mention has been made of the shortage of fresh food and fresh water and of the poor health this caused. In fact it has been estimated that about one-third of the crew normally died on the way, while by the time the seamen reached Batavia in the East Indies another one-third were suffering from scurvy, owing to lack of fresh vegetables and fruit. As time went by, the need for a refreshment station at the Cape became increasingly urgent, partly due to the exhaustion of the supply of goats, wild pigs and apples on St Helena, the main port on the return journey to Europe. By the middle of the seventeenth century St Helena had very little fresh fruit and meat, but the sailors needed a place where they could rest and replenish their food supplies. By that time too, the Cape was regularly visited by ships sailing to and from the East. It was the ideal place for a refreshment post.

The words 'refreshment post' must be emphasized to remove any possible confusion between this kind of settlement and an orthodox colony. At no time did the Dutch East India Company contemplate founding a colony in South Africa during these early years. The Netherlands had a small population and the acquisition of new colonial territories would have required more men. In any event, at least

Vessels of the Dutch East India Company

in the initial stages, there was no need for a settled colony for the Company's post could, if properly managed, meet the basic needs of the seamen. Furthermore, the work was undertaken not by the Netherlands as a nation, but by a trading company which was only interested in making money through trade. The instructions given to Jan van Riebeeck clearly support this view. According to these instructions the station was intended to serve three main functions. First, a fort called Good Hope was to be built to protect the supply of fresh water and also to accommodate a garrison for defensive purposes. Second, the station was to supply sailors with fresh vegetables, fruit and meat and to act as a place of refreshment. To that end vegetable gardens and orchards had to be developed. Meat was to be procured by exchanging European goods for cattle and sheep from the local Hottentots. Finally, a hospital was to be built to treat the sick, and here sailors could stay for treatment and rest. The Company further instructed Jan van Riebeeck to avoid all possible extravagance, thus showing that their intentions were strictly limited to the basic necessities of founding a calling station.

Main economic and social problems

It was one thing for the Company to issue instructions on what should be done and what should be avoided, but it was a different matter when it came to the practical problems of actually establishing and running a 'refreshment station' in a distant and unfamiliar land. For neither the officials of the Company nor van Riebeeck and his men had any dependable knowledge of the geographical conditions and economic potential of the territory. They were to learn the hard way.

The first ten years were full of a mixture of distress, disillusionment and half-hearted attempts at adaptation. In spite of the difficulties, however, a limited measure of development was attained during this period, during which van Riebeeck was in charge of the new station. From the very beginning the Company's servants at the Cape suffered from malnutrition, scurvy and generally poor health, caused by unexpected and prolonged drought. Many of the men were disappointed with the living conditions and life at the Cape promised to be tough and rigorous, which was not what they had expected. Even the coming of the winter rains turned out to be a mixed blessing. Although plenty of vegetables were planted and grass and reeds (for thatching houses) and edible plants became available, the rains also brought much discomfort. The Company's men lived in old tents and poorly constructed wooden huts. Leaking roofs, wet floors and cold huts consequently became an additional hardship. Even more disastrous was the dysentery which came with the

rains. The settlers were already starving, weak and unhealthy, and many of them could not withstand an attack of dysentery. By the end of June 1652, only 116 men and five women were still alive, and of this number only about half were capable of doing any useful work.

The expected acquisition of cattle and sheep by barter from the local people also turned out to be a disappointment, in immediate terms. For the local inhabitants of the Cape had neither cattle nor adequate food for themselves when the settlers arrived. The prolonged drought had forced many of them to move their surviving herds away to better grazing areas. After about six months' stay, however, the situation improved. With the return of good weather and good pasture some Hottentots also returned with herds of cattle and many sheep. By the time the wandering pastoralists departed after three months' stay at the Cape, van Riebeeck's men had acquired more than 200 horned cattle and 600 sheep; in exchange the Hottentots were given tobacco, brass wire and copper bars. Fresh meat now became available. But, despite the slowly improving social and economic conditions, basic

A group of European sailors bartering with Hottentots in Table Bay. The buildings of early Cape Town can be seen in the background

problems still persisted. In the first place, cattle and sheep for barter were not always available at the right time. Much depended on when the wandering pastoralists would next come to the Cape and how many head of cattle they were willing to part with, at any one time. Secondly, though the settlers were expected to grow some food, they were too few for the task, and they were not experienced farmers. Yet they were required to grow barley and wheat which needed much care and money, particularly during the first few years of experimentation. It is not surprising, therefore, that farming proved to be a costly and unrewarding occupation during the early years at the Cape. As farming was unsuccessful, food had to be purchased to sustain the settlement. For purely financial reasons, the Company could not indefinitely encourage this practice.

Attempts to solve the problems

If the refreshment station at the Cape was to serve the purpose for which it was built, a new policy was urgently needed. This was imperative if some of the important problems already outlined were to be overcome. Van Riebeeck attempted to improve the situation in a number of ways. First, it was decided to expand the settlement to bring more land under use, thus increasing agricultural production. But this could only be successful if there were more people to develop the land. Hence the second important decision—to increase the number of workers. More men were also needed for defence.

The first land grant issued at the Cape, for lands in the Liesbeeck Valley

Perhaps the most important single recommendation made by van Riebeeck to the Company was that the workers should be free men and not employees of the Company. The men would, in addition, be given plots of land free of charge. The recommendation was accepted and provided an opportunity for the first white farmers to settle at the Cape. Previously only employees of the Company had worked there but now farmers and their families could settle permanently. The first group of settlers consisted of nine men who were specifically discharged from the Company's services for that purpose. In February 1657, they were allotted small plots in the Liesbeeck Valley, land which was free from taxation. With the establishment of this settlement the process of the European colonization of South Africa began. Progress was so slow, however, that by 1672 there were only 64 colonists.

One reason for the slow development of the settlement is to be found in the Company's regulations, which rigidly controlled the activities of the colonists. While they were clearly designed to benefit the Company, these regulations made it virtually impossible for individual colonists to

prosper economically. It is true that the colonists did not pay for their plots, but the Company had acquired the land free of charge and lost nothing financially in making the land available for settlement. The regulations required the colonists to remain in the country for 20 years. They had to participate in the defence of the country, apart from their normal farming functions. The worst restriction, however, was the fact that prices of foodstuffs were kept very low, while at the same time facilities for marketing such commodities were severely limited. For example, all cattle had to be sold to the Company at a fixed price. Added to this, the colonists were not allowed to pay more money to Hottentots for their cattle than the price paid by the Company. Another restriction was that, to protect the Company's monopoly of trade in tobacco, the colonists had to abstain from growing it, and they had to grow sufficient vegetables for their needs only. Finally, in return for the rights of pasturage, they had to pay 10% of their cattle to the Company.

Not unnaturally, the colonists complained about the severity of these restrictions. In 1658, in particular, they voiced their grievances in a manner which amounted to a virtual threat to strike. The price paid for grain, they pointed out, was far below the cost of production, and the farmer was running at what amounted to a permanent loss. Hence the colonists' demand to the Commander of the Company to 'let a price be fixed, for till that is done, we will not cultivate any more ground, for we will not be slaves of the Company'. The demand won the colonists two minor concessions. The price of grain was slightly increased and, they were allowed to sell grain and other locally produced commodities to the crews of visiting ships.

By the end of the period under van Riebeeck, therefore, the Cape settlement was still small and temporary in nature. It consisted of a small number of fruit growers, gardeners and keepers of poultry, and there were a few cattle. In other respects, however, the settlement developed: a temporary hospital was built and slave labour introduced. The first 12 slaves arrived in 1657 from Java and Madagascar, and the following year 185 more slaves were imported from West Africa. Many of them later ran away. The important point here, however, is that a new factor was introduced in the complex history of South Africa with the implementation of the policy of slave labour.

The policy of racial superiority and racial distinction can also be said to have gained ground in the colony by the end of the seventeenth century. For the settlers (known as Boers) hated menial tasks and hard work. This work was considered

to be the domain of non-Europeans who were regarded as 'hewers of wood and drawers of water'. For ten years after their arrival at the Cape, the authorities tried to attract Chinese, who were known to be industrious, to South Africa in order to supply the much-needed labour. They failed and an alternative source had to be tried. Thus, although the climate was suitable for white labour, the colony's development was based, from the beginning, on African labour. Van Riebeeck imported slaves as one way of making labour not only abundant but also cheap. Instead of raising the price of food, which the farmers complained was far below the production cost, slave labour was introduced to lower the cost of food production. The number of slaves steadily increased from 12 in 1657 to 1,258 (adults and children) in 1708. Slave labour, however, was wasteful and inefficient. It also encouraged the settlers to be lazy and was an important social problem in subsequent years.

The Cape Coloured Community

Another important consequence of the use of slaves in South Africa was the birth of an entirely new community, the Cape Coloured people. They were of mixed race, being the result of the union between the Boers and the slaves, Xhosa, Hottentots and Bushmen. While a few white men were legally married to non-white women, the great majority of these unions were illegal. As Boer farmers and traders continued to have illicit union with Xhosa and Coloured women, the population of the Cape Coloured community gradually increased. By 1820 the Cape Coloured people had gradually abandoned their original languages and adopted Afrikaans,* the language spoken by the Boers.

The Cape between 1679–1707

As has already been seen, the first few years of the Cape settlement were full of economic and social difficulties. Despite the measures taken by van Riebeeck to improve the situation, many of the problems remained unsolved by the end of his term of office as Commander. The supply of cattle continued to be inadequate and uncertain, while farming remained equally unsatisfactory. In short, the colony could not pay its way. A more vigorous and systematic policy was necessary to make the colony self-sufficient in matters of food supply and effective defence. The question of defence

* Afrikaans is the language spoken by the Boers. Though it has close connections with Dutch, which was originally spoken by the Boers, it is different from it. The Boers prefer to be known as Afrikaners and refer to the Africans of South Africa as the Bantu.

became especially important during the seventeenth century wars in Europe as there was some fear that the French, under Louis XIV, might attack the colony.

Between 1679 and 1699 Simon van der Stel was Commander of the settlement. During this period brave attempts were made to overcome the colony's economic and social problems. Van der Stel's aim was to increase the number of settlers by making it easier for intending Dutch immigrants to come to South Africa. He was the first person to encourage the Dutch to come to the Cape as colonists, and under his leadership prospective colonists were given free passage. He provided free land for settlers, thus encouraging the Company's employees to resign and become settlers and, therefore, farmers. Van der Stel also realized that one way of enabling the colony to grow steadily and to increase its population was by providing the settlers with an opportunity to get married and beget children. This was achieved by

Simon van der Stel being presented with copper by Hottentots

Willem van der Stel's estate at Vergelegen

sending out orphan girls as wives for the settlers, at the Company's expense.

Thus, during this period the population of the colony steadily increased and the frontiers of the settlement were extended. A new village was founded in the valley of the Eerste River at a place called Stellenbosch. Between 1688 and 1700 about 200 French Huguenots came to the Cape and enriched the colony with their valuable commercial experience and knowledge. They were Protestants who had fled from France in 1685 when the Edict of Nantes, which had guaranteed them freedom of worship, was revoked by Louis XIV of France. By 1708 the colonists' population had steadily increased from 64 in 1672 to 1,441. Because of the growing farming population, there was a general improvement in food production. The free burghers (as the farming colonists were called to distinguish them from the employees of the Company) increased their agricultural output. However, this achievement was made ineffective by the fact that local consumers were few, and the food supply soon exceeded the effective demand. The price of food consequently dropped, to the great disadvantage of farmers. Economic development was further hampered by the severe restrictions of the Company, which rigidly controlled the commercial and agricultural activities of the colonists. For example, the Company was responsible for the granting of contracts for the retailing of such goods as spirits, wine, beer, tobacco, meat and bread.

A son of van der Stel, Willem Adriaan van der Stel, was Governor of the Cape Colony from 1699 to 1707, when he was recalled home. Although he was enterprising and generally enlightened, his main weakness was that he was bent on getting rich quickly, regardless of how he acquired his wealth. This was a common attitude among the Company's servants, who were generally paid very little, but Adriaan's record is hard to defend. He acquired large farms despite the Company's regulations forbidding this practice and used the Company's employees to develop his farms, while at the same time people gave him slaves, sheep and other presents to obtain his favour. Furthermore, he gave preferential treatment to his friends at the expense of other colonists, giving them such benefits as wine and meat contracts. Within a period of eight years Willem grew so powerful and wealthy that, together with his relatives and friends, he owned about one-third of the total farming area in the colony. He also controlled one-third of the wine stocks, as well as participating in the supply of meat, corn and wine to the Company. All this was, needless to say, against the Company's laws.

The best produce of the colony being brought to Willem van der Stel

While Willem was busy concentrating all economic power and privileges in his own hands, the colonists were faced with a critical situation. First, because the Governor and the Company monopolized most of the profitable commercial activities and goods, the colonists had very little chance of improving their lot. And secondly, when Willem became Governor, the country had just gone through a period of great hardship due to the locust invasion of 1695 and the severe drought which followed it. Clearly, the Governor was not sensitive to the interests of the colony. He was only interested in his personal welfare, and his desire for wealth was insatiable. It is not surprising, therefore, that when the colonists voiced their grievances in 1705 and demanded the Governor's recall, the Company's response was favourable. In 1707 Willem was accused of corrupt and oppressive practices and dismissed. Several other corrupt officers were also dismissed with him and all Willem's land and property in the colony were confiscated by the Company.

In spite of Willem van der Stel's mismanagement of the colony, by the time he was recalled in 1707 the Cape Colony had made notable progress. A large hospital had been built and the country's defences strengthened by the completion of a castle. By this time, too, a large water reservoir had been built, the Church expanded and elementary schools built. Education was neglected for a long time, however, because there were no teachers. Even elementary schools were able to function only because of their ties with the local churches. The parish clerks were in charge of the local elementary schools, and most parents either taught their children themselves or hired teachers for them. By 1707 the colony had again grown and expanded far beyond its original frontiers. This expansion suffered a setback, however, when the Company decided to abandon the policy of assisted immigration after 1707. It was felt that the growing friction between the Governor and the settlers was partly due to the continuing influx of immigrants and the consequent expansion of the colony.

Territorial expansion

By the end of the eighteenth century, the Cape Colony had greatly extended its territory and the number of Europeans in the country stood at about 15,000. Yet this territorial expansion was achieved not by official encouragement and support, but through the determined efforts of individual white farmers. Neither the Company nor the local administration was in favour of the expansionist policy and practices of the white farmers. For the bigger the settlement became, the greater the number of problems the administration would have to cope with, and the authorities did not have enough men for both administrative and defensive functions. Besides, territorial expansion involved clashes with the local African peoples, and such territorial expansion had to be accompanied by a further extension of administrative control. All this required men and money and neither the Company nor the local administration had enough personnel or funds.

Reasons for early territorial expansion

Let us now look at the particular factors which enabled the Cape Colony to expand. From time to time, the administration was forced to extend its control over the newly settled areas, and the settlers who had moved to the outlying districts were reluctantly brought under such control.

The expansion of the Cape Colony was extremely haphazard because it was neither planned nor properly co-ordinated. It was caused by a combination of factors, geographical, economic, social and administrative. In the early years there was plenty of unoccupied land, encouraging

the settlers to move from one area to another. It also enabled them to acquire large tracts of land, most of which remained undeveloped for a long time. Where the land was already occupied by the Bushmen and Hottentots the settlers used their superior weapons, i.e. firearms, to crush any local resistance. The Hottentots had been greatly weakened by the smallpox epidemic of 1713, and many of the Bushmen and Hottentots voluntarily moved to new districts in order to avoid any close contacts with the settlers. However, as the colony progressively expanded, the settlers encountered more powerful resistance from the relatively well-armed and properly organized Bantu. More will be said about this in chapters 5, 6 and 7. The important point to remember is that, because of the vastness of the country, the settlers found it convenient to extend the area of settlement with or without official approval and encouragement.

But the vastness of the country was not the only incentive for expansion. Much of the land was semi-arid with scanty and uncertain rainfall. This encouraged farmers to migrate

A typically gabled Dutch South African house

Dr John Philip, of the London Missionary Society

from one district to another in search of good land with adequate rainfall and water supply. It also meant that pastoral farming was the only possible agricultural occupation in the drier parts of the country. Such farming required plenty of land if the farmers were to prosper, for they had to move their cattle from one area to another as grass and water became scanty, and they gradually developed the habit of owning extensive farms. This was the pattern of farming over a great part of the country, particularly to the east and north of Cape Town. As against this, arable farming was the chief agricultural occupation in the Western Province which enjoyed favourable climatic conditions. Commenting on the farming habits of the Boer farmers in 1830, Dr Philip, a persistent missionary critic of discriminatory practices, said:

> Accustomed to large grants of land when land was abundant and colonists few, they still think that they cannot subsist unless a farm includes the same range of country which it did in the days of their ancestors. Their habits are pastoral, they seldom cultivate more ground than is necessary for their own use, and their wealth is in their cattle. Having extensive herds they not only require much pasture, but are not satisfied if they have not different places to resort to at different seasons of the year. . . . Besides what they require for their herds, to save them, they must have game also, and each farmer living in this manner, instead of on a moderate-sized farm, must have a district for himself. . . . All they can see they consider their own, and when needed, the natives are obliged to remove [to make room for] their cattle or their children. By this means they first take possession and afterwards get the Government to sanction the deed. . . .

It would, however, be wrong to suppose that the expansionist tendencies of the colonists were caused by the above factors alone. As we have just seen, the Company's laws considerably restricted the economic activities of the colonists. Prices of local products were kept too low for the farmers to make any significant profit. There were laws restricting the growth and sale of certain products, such as tobacco, and contracts for the sale of profitable goods such as meat, wine and tobacco were usually given to friends or relatives of those in authority. This encouraged people to move away from Cape Town and to establish new homes in outlying areas where they would be free from such restrictions and official control. In other words, it indirectly led to the expansion of the colony.

Another factor in the colony's expansion was the insecurity of land tenure, which had the undesirable effect of discouraging improvements. For example, on the death of the owner of a farm, the buildings and any other valuable improvements, particularly permanent ones, were sold by auction. The proceeds from the sale were then divided equally among the heirs of the deceased. Whoever bought the buildings and permanent improvements (known as the *opstal*) could, according to law and practice, lease the deceased's farm. Farmers consequently tended to neglect the improvement of their estates; there was no lasting interest in the farm and no incentive for improvement. Instead, they concentrated on the acquisition of extensive farms for their sons, and land was cheap and easy to acquire. One direct consequence of this was the growth of isolated farms and homesteads. Another was the development of nomadic characteristics; the farmers and their sons were on an endless and unsystematic move.

Thus by the end of the eighteenth century the Cape Colony had considerably expanded. It had started as a temporary calling station consisting of a few houses on the shores of Table Bay. In due course, it developed into a beautiful small town with the necessary defence system and basic social amenities.

The process of expansion

The settlement at Table Bay at the end of the eighteenth century

The colony's continuing expansion over the years was made possible by the military superiority of the colonists, who were armed with guns. The Bantu were their only effective opponents, and there were numerous clashes between the Bantu and the colonists as the colony gradually expanded. On both sides many people lost their lives and many others were injured. In 1780 the Fish River was made the eastern boundary of the colony after several clashes in the 1770s between the Boers and the Bantu. Of particular significance was the war of 1779 against the Xhosa, during which the Xhosa lost about 5,000 head of cattle.

The establishment of Graaff-Reinet as a magistracy (*landdrostdy*) in 1786 was made necessary by the need to serve the newly acquired territory. Indeed the process of expansion was so fast (despite lack of official support) that in 1826, for example, the Orange River was given official recognition as the new northern boundary. In other words, the Government usually extended its authority and territorial boundaries after the colonists had extended the frontier by moving away into neighbouring or outlying areas. Much of the expansion, however, took place during the Great Trek (see chapter 4).

The Griqua

A Griqua huntsman

The northward expansion led to an encounter with the Griqua of Griqualand. Though little is known about their past, the Griqua were clearly of mixed blood. Intermixture between the Hottentots, Namaquas, Bushmen, Koranas and Europeans seems to have given rise to the community. Some of them are said to have fled from the Cape Colony to escape from European control. By 1820 the total Griqua population stood at 3,000, and there were three Griqua villages, Griquatown at Klaarwater, Campbell and Philippolis, led respectively by Andries Waterboer, Cornelius Kok and Adam Kok. All three leaders were appointed by the missionaries, who had reached the territory by the beginning of the nineteenth century.

With the continuing expansion of the Boers into the area, the Griqua were soon outnumbered. They lost their land and became a subject people. The missionaries, however, defended their rights, though not always with success. To the missionaries the Griqua were the rightful owners of the land, for they were the first occupants of the district in the neighbourhood of the Orange River. But even at that early date it was evident that, in spite of the sympathy of some liberal Europeans and missionaries, the future of the indigenous people was bleak. More will be said about this in chapter 12.

South Africa under the British Chapter 3

In 1795 British troops invaded the Cape Colony and, after some minor resistance, captured it. Their occupation after this first invasion was brief, however, for in 1802 the Peace of Amiens ended British rule by transferring the colony to the Batavian Republic,* which had been established in the Netherlands in 1795. The Batavian Republic assumed control of the territories previously governed by the Dutch East India Company, which had gone bankrupt in 1794. In the case of the Cape Colony, however, the Batavian Republic's responsibility lasted for only three years; it came to an end in 1806 when British forces invaded the colony for the second time, again with success.

The first British occupation, 1795

A number of factors combined to weaken the Dutch, the Dutch East India Company and the Cape Colony, thus causing the Dutch to finally lose the Cape Colony to the British. In the first place the Dutch were subjected to increasing commercial rivalry from the French and the English, undermining their commercial and economic position. This rivalry also extended to their colony at the Cape, owned and administered by the Dutch East India Company which had close ties with the Dutch Government. The situation was further worsened by the numerous and prolonged European wars, which were temporarily ended by the Treaty of Utrecht in 1713, and in which the Dutch were involved. Trade and commerce could hardly prosper in a period of war, and the war cost a lot of money and diverted men and attention from profitable commercial undertakings. Add to these the general state of administrative inefficiency, corruption, commercial restrictions and discontent on the part of the colonists at the Cape and the reasons for the Company's and colony's weakness become

Decline and bankruptcy of the Dutch East India Company

* The Batavian Republic was the new name which the Netherlands assumed after a change of government. While the old Government had supported England against France, the Batavian Republic was an ally of France and, therefore, Britain's enemy.

at once abundantly clear. It was, therefore, no surprise when the Dutch East India Company declared itself bankrupt in 1794. Earlier, in 1782, it had paid the last dividend to the shareholders and its total debts in 1794 stood at the alarming figure of £10,000,000.

By this time too there was widespread discontent in the colony. We have already referred to some of the basic grievances of the colonists in the previous chapter. In addition to these there was general dissatisfaction with the country's defence arrangements. The colonists felt they were not adequately protected against the local Africans, some of whom were skilled fighters. They complained that they, rather than the administration, shouldered the main burden of defence in their conflicts with the Africans. It is enough to note here that these grievances (and many others, genuine or otherwise) culminated in the rebellion of 1795. The rebellion was partly influenced by contemporary events, notably the American War of Independence and the French Revolution, both struggles for the principle of 'Liberty'.

When the British first occupied the Cape Colony in 1795, their stated aim was to prevent it from falling into the hands of France, with whom Britain was at war during the famous Napoleonic Wars. Such a possibility was more likely now that the Dutch East India Company had been disbanded. Britain therefore occupied the Cape because of its strategic value: it lay about half-way on the long route to the East, where she had her valuable Indian empire. The new British administration was neither liberal nor progressive. It was only popular among the supporters of the Dutch ruler, the Prince of Orange. No serious attempt was made to remove the old abuses or to improve the country's administration; although the English occupied the higher posts, the colonists generally filled the rest of the posts in the civil service. Such was the position when in 1802 the Peace of Amiens ended British rule at the Cape. In February 1803 the Batavian Republic replaced Britain as the administering authority, in accordance with the terms of the Peace of Amiens. This treaty concluded the first stage of the Napoleonic Wars in which Emperor Napoleon of France played a prominent role in a bid to conquer all Europe.

The Cape under the Batavian Republic, 1803–5

Although the Batavian Republic was in charge of the Cape Colony for only three years, it succeeded in introducing a number of important reforms in many spheres of life, with the effect of making the administration less conservative and more effective. The new administration was headed by

Jan Willem Janssens, Governor of Cape Colony, 1803

Lieutenant-General Jan Willem Janssens as Governor and Jacob Abraham de Mist as Commissioner-General. Senior posts were given to Batavians (who were Dutch) while the English were retained in the civil service as subordinate staff.

Among other things, the new administration reformed the judicial system by making the High Court independent of the executive, removed restrictions on trade so that the colony now traded with all Batavian territories, gave land to the Hottentots and encouraged a policy of humane treatment for non-white workers. It also favoured white labour instead of slave labour, which the colonists preferred and even insisted on. Freedom of worship was extended to all religious organizations while in the economic field new agricultural projects were started, for example, the importation of *merino* sheep from Spain. Finally, the Batavians reformed local government by re-arranging and subdividing the districts each under an administrative officer. In each district the Government's representative was known as the *landdrost*. He performed the functions of a magistrate, settling minor criminal cases and punishing slaves. He was assisted by six elders when dealing with civil cases. As distinct from this, each subdivision of the district (i.e. the ward) was headed by a government officer known as the 'field cornet' (*veldkornet*). He kept the peace, settled minor quarrels in his area and generally acted as a link between the Government and the public.

The second British occupation, 1806

Jacob Abraham de Mist, Commissioner-General at the Cape, 1803

In May 1803 England resumed fighting with France and this was followed by unprecedented French victories over the greater part of Europe. War lasted till 1815 when peace was made. To prevent France and her Dutch allies from interfering with her valuable sea trade with India, via the Cape, in 1806 Britain sent 61 warships under General Baird which captured the Cape without much resistance. Although British troops occupied the Cape Colony in 1806, Britain did not formally acquire it until 1814. This was part of the much wider settlement of the Congress of Vienna which followed the defeat of Napoleon and the collapse of his empire. The Congress met in Vienna, the capital of Austria, from October 1814 to February 1815, when agreement was reached, and was attended by prominent men from all over Europe.

The 1806 British administration, like that of 1795, was conservative and less progressive than the Batavian administration, at least for the first 20 years. For example, up till 1825 the Governor exercised wide powers. He legislated for the

colony, made appointments and dismissed government officers, and heard both criminal and civil appeals. Apart from major judicial changes, such as the introduction of circuit courts in 1811, the judicial system remained what it had been in the days of Dutch rule, and was still based on Roman-Dutch law. Again, apart from the establishment of additional magistrates' courts in the countryside, everything else remained as before. As for local government, the old Burgher Senate in Cape Town continued to function as the town council. All in all, there was very little improvement, if any. The economy continued to be weak in spite of new agricultural experiments in cattle and horse-rearing and in wool production.

The only notable progress before 1825 appears to have been made in the field of the general welfare of the people. There were minor improvements in the postal system and health facilities and although education was generally poor (consisting as it did of the teaching of English, reading and writing) existing schools were given official encouragement. An attempt was also made to provide free education, although the schools taught Latin and religious knowledge in the Dutch language, with consequently poor results.

A Dutch Reformed Church

British reforms to 1834

The economy

From about 1824, the British administration improved and several important reforms were introduced. To improve the chaotic financial and economic situation, in 1825 Britain introduced new paper money based on English denominations to replace the old notes which had greatly fallen in value. This was coupled with a reduction in official salaries, including that of the Governor which had stood at £10,000 per annum. At the same time the Government reduced the number of public schemes and the amount of money spent on them. Even the policy of giving financial assistance to prospective immigrants to the colony was stopped. Nevertheless, there was no immediate improvement and the economy remained weak.

The Church

From 1824 onwards the Dutch Reformed Church was given a certain degree of liberty, which was considerably extended between 1826 and 1828 when government representatives ceased to attend meetings of its council, the Synod. As for Roman Catholics, who had been given the right of worship and other civil rights in 1820, their lot greatly improved when the Government decided to pay their priests, a privilege already enjoyed by other denominations. In general, the Church's position improved and freedom of worship was extended to all denominations.

Language	In 1822 a proclamation had been issued concerning the gradual replacement of Dutch by English as the official language. The transitional period lasted until 1828 when English became the official language, although notices in the official *Gazette* continued to be issued in both languages. As we shall see in chapter 4, the language issue was one of the basic factors which contributed to the outbreak of the Great Trek. In particular, Boer farmers in the countryside, where the knowledge of English was extremely limited, were most unhappy about the change-over to English.
The Press	During this period, the Government demonstrated its increasingly liberal tendencies by removing some of the old restrictions on the Press. From 30 April 1828, the laws governing the printing of newspapers were reformed to enable the printers to do their work without undue difficulty, subject to the usual laws of libel. All intending printers were required to deposit £300 and a similar sum of money had also to be guaranteed by their friends. In addition, there was a duty of a penny on all printing paper. The significant point to note, however, is that, in general terms, the Press was given more freedom than in the past. As a result a number of papers were printed in Dutch and English. Among others, there were the *Grahamston Journal, Zuid Afrikaan* and the *Commercial Advertiser.*
The judiciary	During this period, the judiciary also underwent some positive change. This was introduced by the Charter of Justice of 1828 and completed by the Charter of 1834. A Supreme Court was set up, and judges were to be appointed by the British Crown. Judges were supposed to be independent; in other words, they could hold office for as long as their conduct was proper and the Governor could not dismiss them. This had the effect of making the judiciary more reliable and just. Finally, the English criminal law (which was less harsh) replaced the old Roman-Dutch criminal law, although civil cases were still based on Roman-Dutch law.
Administration	Similar changes also took place in the administrative field. From the very beginning of the British administration, the colonists were not allowed any important say in the running of the country. They were a conquered people and had to be governed firmly. In due course, however, it became necessary to relax the control and liberalize the administration. Even then the change was not radical; it was gradual. The colonists themselves were vociferously agitating for

the establishment of a government in which they would be represented. This agitation was effectively expressed in the columns of the *Commercial Advertiser.* Thus, when administrative reforms were introduced, the British were partly responding to local demands by the colonists. In 1826, for example, two members of the Burgher Senate (which served as a town council) in Cape Town had resigned in protest against the Government's policy on slaves. This had been followed by a local petition for their replacement by elected members, a request which had been rejected by the authorities. A similar petition to the British Parliament for a representative assembly had also been rejected. Although the British Government at this stage thought the Colony was not yet ready for representative government, some minor changes were introduced. As early as 1825, for instance, an Advisory Council was set up in Cape Town. Among others, its members comprised the Governor, the Chief Justice and the Colonial Secretary. Its functions were mainly advisory, that is, to advise the Governor, although the Governor could reject the advice. In 1827 the colonists were given another concession, in the form of two seats on the same Advisory Council. However, as the two members had to be nominated by the Government, the colonists were dissatisfied with the concession. Hence their reiteration of the famous slogan of the English North American colonists: 'No taxation without consent' (the original American slogan was 'No taxation without representation').

Despite the growing clamour for a representative assembly, for some time the British Government did not make any major concession. It was not until 1834 that an important constitutional change occurred. In that year a Legislative Council was introduced in the Cape Colony, consisting of an Executive Council and a Legislative Council. The Executive Council, which now replaced the old Advisory Council, was composed of the Governor and four leading administrative officers. The Legislative Council comprised members of the Executive Council, the Attorney-General, and between five and seven nominated members. It was empowered to debate bills and pass laws.

While these developments were taking place, clashes between the colonists and the Bantu had increased. To a considerable extent, the Mfecane wars paved the way for the Great Trek by decimating, weakening and dispersing the Africans in southern Africa (see chapter 5). But long before that event the Boers who lived on the frontier of the Cape Colony, who were incessantly acquiring more territory in the outlying

British acquisition of Albany, Queen Adelaide Province and Southern Natal

districts, had on a number of occasions clashed with Africans and driven them from part of their land. Unlike other African societies, however, the Xhosa strongly resisted Boer encroachments into their land. As early as 1803 they had defeated the Boers. As a result the district between the Fish and Sunday Rivers became theirs not only by right of occupation but also of conquest.

The Zuurveld In 1812, however, the Cape Government extended the colony's frontiers. The aim was to create a land corridor between the colony and the warlike Xhosa. This, it was hoped, would strengthèn the colony's defence system. The new district which was thus acquired became known as the Zuurveld. Its old occupants, including some 20,000 Ndhlambi and Gunukwebe, were forcefully removed.

The clearing and garrisoning of the Zuurveld was only the beginning of a more ambitious scheme. After the end

Below: The Chapman, *first British ship to reach Algoa Bay in 1820*
Opposite: The Chapman's *passenger list*

of the Napoleonic Wars in 1815 the British Government decided to settle some people in the Zuurveld. There was much unemployment and misery in Britain after the war and many people wanted the chance to start afresh overseas. In 1819 a total of £50,000 was set aside to assist intending migrants. To qualify for assistance prospective migrants had to be adults and in parties of not less than ten people. Apart from free passages, the migrants were also given 100 acres of land each. The first such settlers arrived at Algoa Bay in 1820 and gradually spread over the Zuurveld. By May 1821 the total population of settlers (men, women and children) in the Zuurveld stood at 5,000.

The Zuurveld now became known as Albany, and Port Elizabeth replaced the old name of Port Frederick in Algoa Bay. For the first time, there were British farmers in South Africa; previously the British had simply administered the

The Zuurveld renamed Albany

CAPE TOWN.

Saturday, 25th March, 1820.

ARRIVALS and DEPARTURES.

Arrivals in Table Bay.

17 March, Chapman, Transport Ship, John Milbank, Master, from Gravesend 3d Dec. and St. Jago 16th Jan with 100 Men, 51 Women, and 92 Children, Settlers for the Cape of Good Hope. *Under Quarantine.*

Lieut. Cole, R.N. Agent for Transports.

Ditto, ditto, Nautilus, ditto Ship, Wm. Walton, Master, from ditto, ditto, with 57 Men, 44 Women, and 92 Children, Settlers for ditto. *Under Quarantine.*

Ditto, ditto, Eclipse, Eng. Ship, Jas. Stewart, Master, from Columbo and Point de Galle, 1st and 3d Feb. bound to London, cargo Sundries.

Passengers.—General Sir ROBERT BROWNRIGG, Bart. and G.C.B., Lady BROWNRIGG, Lieut. Col. Hardy, 19th Regt. Deputy Qr. Mr. Gen. Dr. Davy, Physician to the Forces, Revd. G. Bissett, Captain King, Aide de Camp, Captain Page, 1st Ceylon Regt. Masters Sewell and Bayley, 2 Servants, 51 Invalids, 3 Women, and 3 Children.

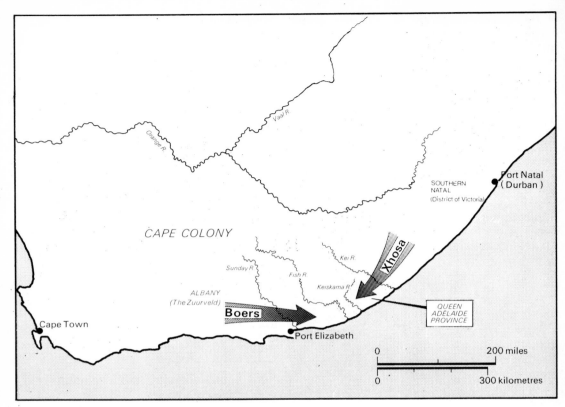

The Kaffir War, 1834

territory. The arrival of British farmers in the colony was important because, in passing legislation, Britain now had to consider the interests and wishes of the new settlers as well as those of the Boers. In other words, the Cape was now a colony of Boers and Britons (not merely of Boers) ruled by Britain. This factor was bound to influence and, indeed, modify the colony's legislation. We shall return to this in chapter 4.

Unfortunately, the settlement of British colonists in Albany did not remove the border friction with the Xhosa and the original intention for extending the frontier was not accomplished. Clashes were still prevalent; they were mostly caused by the land problem, cattle-lifting and consequent reprisals by both the colonists and the Xhosa.

The Kaffir War of 1834

By far the most memorable of these conflicts between the Boers and the Xhosa was the Kaffir War of 1834. The war

A Xhosa warrior

was caused by cattle thefts. The Xhosa who had moved into the territory between the Keiskama and the Fish Rivers proved to be expert cattle rustlers, but so were the Boers who were bent on taking the land and cattle of the Africans. Raids and counter-raids followed, but in the end the Xhosa were defeated and driven out of the district. This war was extremely destructive: many people were killed and much property was destroyed or seized. On 21 December 1834, for instance, the Xhosa retaliated to the colonists' seizure of some cattle belonging to Tyali, a son of the late chief Gaika, with disastrous consequences. The colonists' seizure of Xhosa cattle had been intended as a punitive measure for earlier cattle thefts. Between 12,000 and 20,000 Xhosa warriors fell upon the colonists, killing them, burning their houses and seizing and destroying their property. In addition they captured practically all the cattle to the east of the Sunday River. All told, property worth about £300,000 was destroyed.

The annexation of Queen Adelaide Province

Benjamin D'Urban, Governor of Cape Colony, 1833–8

Throughout this critical period the colonists greatly assisted Governor Benjamin D'Urban in his fight against the Xhosa. His aim was to push all the Bantu beyond the Kei River to ensure the settlers' security. The settlers' help was not in vain. When the Kaffir War ended D'Urban annexed the district between the Keiskama and the Kei Rivers as the new Province of Queen Adelaide. All the Xhosa and other local people were driven out of the new province which was then set aside for European settlement. However, according to the agreement of September 1835 which concluded the war, Xhosa chiefs and their people could reside in the new province on condition that they promised to be peaceful, to obey the colony's laws, to surrender their arms, to desist from and discourage cattle thefts and to become British subjects. This minor concession to the Xhosa was made possible partly by the fact that the missionaries were critical of D'Urban's policy of driving the Africans from their land, and partly because the Zulu and other peoples who inhabited the lands into which the Xhosa were to move would not allow them in. Nevertheless, the Xhosa were forbidden to settle in the land to the south of the Kei which was set aside for Europeans only.

The acquisition of Southern Natal

Captain Allen Gardiner, missionary

The 1835 agreement was followed by the signing of treaties of friendship with a number of chiefs, the most important of whom were Moshesh of the Basuto and Dingane of the Zulu. According to the treaty made between Dingane and Captain Allen Gardiner, the Zulu ruler gave the southern part of Natal to Gardiner. This was in return for Gardiner's promise to return all Zulu refugees to Dingane's dominion.

After this transaction, Gardiner renamed Southern Natal the District of Victoria and the small settlement at the local port became the township of Durban. Finally, Gardiner (who had gone to Zululand to establish a missionary station) handed the new territory to Governor D'Urban. As we shall see in the next chapter, the British Government refused to sanction the annexation of Queen Adelaide Province and the District of Natal, which had been proposed by Governor D'Urban. This was one of the important immediate causes of the Great Trek.

D'Urban and the colonists

The British Government's rejection of D'Urban's policy of annexation endeared the Governor to the colonists. They felt that he stood for their interests. His good image among the settlers was further reinforced by the fact that it was he who launched the new constitution of 1834 which marked

the beginning of solid constitutional development, as already seen above. D'Urban had also attempted to curtail public expenditure by reducing public servants' salaries, amalgamating government offices, and reducing the Government's expenditure on roads, bridges and public schemes. In this way, it was hoped, the colony would emerge from dependence on Britain to virtual self-sufficiency.

Although he had been instructed by the British Government to emancipate slaves and to work out a satisfactory 'native system' (something the colonists disliked), D'Urban's further instruction to introduce municipal or local governmental institutions was bound to make him popular with the colonists. Right from the outset, circumstances were on D'Urban's side as far as his relations with the colonists were concerned. In contrast, the British Government, because it had reversed D'Urban's annexation of the two territories, was regarded with mistrust, anger and dismay by the colonists.

At about the same time that the above developments were taking place, there was increasing friction between the missionaries and the colonists. The source of this friction was simple. The colonists were vocal about the principles of 'Equality', 'Fraternity' and 'Liberty', but they limited the application of these principles to themselves (i.e. the Boers) in particular and to other European residents of the colony in general. In their view there could be no question of extending these noble principles to Africans or non-whites.

Missionaries, Africans and the colonists

Practically all the known slaves were Africans and to the Boers it was unthinkable for Europeans to share the same rights and privileges with a race that supplied slaves. It did not matter in the least that they might live under the same roof and within the same territorial boundaries. Right from their earliest contacts with Africans, the Boers had despised them as backward and inferior. Africans were not the equals of Europeans but an inferior race and, regarding themselves as God's own chosen race, the Boers saw the Africans as the servants of the chosen race. As it was beneath the chosen race to do menial tasks and to perform hard labour, God had wisely provided the white man with the non-white for that specific purpose. Hence the famous phrase that Africans were only valuable as hewers of wood and drawers of water. It is this mentality, this twist of mind, which is at the very centre of the crucial race problem in the life and history of South Africa. Its full impact will be discussed in chapter 12.

The colonists' attitude to Africans

Reverend J. J. Kichener with Bushmen converts to Christianity

Missionary protection of Africans

On their part, the missionaries of the London Missionary Society, the Roman Catholic Church and the Moravian Brethren also valued the principles of 'Equality', 'Fraternity' and 'Liberty'. But, unlike the Boers, they wanted these principles to be applied to all mankind, white and non-white. To the missionaries all men were equal; all men required humane treatment and were entitled to the fundamental rights of man. Thus, while the Boers were bent on oppressing non-whites, many missionaries fought for their rights, thereby creating friction between themselves and the Boers.

All missionaries, however, did not champion the rights of non-whites. A notable exception was the Dutch Reformed Church which was the official church of the Cape Colony. The Boers belonged to it and were, therefore, united by it in religious and social matters. It believed in and preached the Old Testament, emphasizing the role of God's chosen people among the masses of unbelievers amongst whom they (the Boers) found themselves. The Dutch Reformed Church believed in predestination* and its Dutch adherents con-

* Predestination is the religious theory that God has decreed from eternity that part of mankind shall have eternal life and part eternal punishment, i.e. that mankind is divided into the 'saved' and the 'damned', and nothing the individual does in his life will alter this decree.

Bethelsdorp

sidered themselves a superior race by birth and the non-
white people a servant race by the same token. They believed
their mission was to preserve white civilization. Though
there were some missionaries of the Dutch Reformed Church
who tried to convert non-whites and to defend their rights,
they formed an insignificant minority and the Dutch Re-
formed Church still cherishes the same views on the question
of race relations.

In 1737 a missionary station was built at Baviaan's
Kloof by George Schmidt of the German Moravian
Brethren. The year 1802 saw the building of another
important station at Bethelsdorp, close to present-day
Port Elizabeth. This was the work of Dr Van der Kemp, a
Dutchman who was a member of the London Missionary
Society. Together with his three colleagues, he lived and
worked among the Hottentots spreading the gospel. He even
married a Coloured woman whose mother had been a slave.
He regarded Hottentots as human beings with full civil
rights and not as mere property, as the Boers believed.

Dr John Philip was another missionary of the London
Missionary Society who did his best to defend the civil
rights of non-whites. He arrived in South Africa in 1819
and worked among the Griqua, Hottentots and Bantu.
He demonstrated his courage and religious conviction by
making endless attacks on the treatment of non-whites,

Dr Philip (right) heading a delegation giving evidence before the Committee of the House of Commons, London, on the position of blacks in South Africa

which earned him many enemies in Boer circles. He argued that the whites and the blacks should live in separate districts so that the former should not exploit the blacks and thwart their progress. He visited London in 1828 and won the support of other evangelists, notably the Nonconformists. The same year he published his famous book, *Researches in South Africa*, in which he reinforced his attack on the whites' attitude to the blacks. Dr Philip was thoroughly hated by the Boers for his outspoken manner and for his defence of the blacks, and was held responsible for the enactment of the 50th Ordinance which restored civil liberties to non-whites.

There were other reasons for continuing conflicts between the Boers and the missionaries. For example, non-Dutch Reformed Church missionaries gave protection to any African who fled from the difficult and unrewarding service of the colonists. In addition, they listened to the complaints of runaway servants against their white masters. Because of the sympathetic treatment which mission stations accorded the refugees, these places became popular as homes for any non-whites who were dissatisfied with their masters' treatment. Another important source of hostility between the colonists and the missionaries was that the latter gave some kind of education to the refugees. It was believed by

the colonists that such education could have only one result: it would spoil the Africans by making them believe that they were the white man's equals. Moreover, the kind of instruction they received from the missionaries would discourage them from serving the whites as it did not prepare them for such service. It would also have the effect of encouraging them to reject the low wages for which they laboured.

The colonists were critical of the manner in which the missionaries persistently pressed for a redress of Africans' grievances. In particular they viewed with dismay and disappointment the establishment of a roving or mobile court (known as the Circuit Court) in 1811 to hear the complaints of Africans, particularly the Hottentots in the colonists' service. Not only was the system expensive, for the accused had to travel to the court at their own expense; it was felt that it was an unprecedented act of insubordination for the non-white servants to initiate court proceedings against their white masters. In addition, it was not always convenient for the farmers to attend court, and even when they attended some of the evidence against them was found to be flimsy or even non-existent.

The Circuit Court

Finally, as we shall see in the next chapter, the passing of the 50th Ordinance of 1828, which restored civil rights to Hottentots, Bushmen and other free non-white people, was highly disapproved of by the colonists. Earlier, in 1809, a Hottentot proclamation law had been passed restricting the movement of Hottentots. They could only leave their home districts if they had written permission, i.e. a pass. Later another law was passed requiring all Hottentot children who had been born and had lived on the farms of their parents' employers for eight years to serve such employers as apprentices for ten years. It goes without saying that these restrictions were highly resented by the Hottentots, and their repeal under the 50th Ordinance was warmly received by them. Because the missionaries were always defending the rights of non-whites, it was believed that they had influenced the authorities to pass the Ordinance. Dr John Philip, in particular, was regarded by the Boers as the main influence behind it. Hence the aggravation of the already bad relations between the two white groups representing conflicting interests.

The 50th Ordinance

As we have seen, the events of the whole period to 1834 effectively paved the way for the Great Trek, whose course and impact were accelerated, strengthened and influenced by the intricate events leading up to it.

Chapter 4 The Great Trek

A party of trekkers with their waggons and livestock

Piet Retief

As we shall be primarily concerned with the causes and results of the Great Trek in this chapter, it may be fitting to quote at the outset the remarks of Piet Retief, one of the leaders of the Trek, on the eve of that famous episode:

> As we desire to stand high in the estimation of our brethren, be it known *inter alia* that we are resolved, wherever we go, that we will uphold the just principle of liberty, but whilst we will take care that no one shall be in a state of slavery, it is our determination to maintain such regulations as may suppress crime and preserve proper relations between master and servant We will not molest any people, nor deprive them of the smallest property; but, if attacked, we shall consider ourselves fully justified in defending our persons and effects to the utmost of our ability We propose ... to make known to the native tribes our intentions, and our desire to live in peace and friendly intercourse with them We quit this Colony under the full assurance that the English Government has nothing more to require of us, and will allow us to govern ourselves without interference in future.*

* Quoted in E. A. Walker, *The Great Trek*, Adam & Charles Black, London, 1948, p. 105.

As these few remarks by one of the chief leaders of the Trek imply, the Great Trek was caused by many different factors. As such its course and impact were highly complex. Among the major causes of the Trek may be distinguished those factors which had been at work ever since the Europeans settled in the Cape Colony, along with more immediate grievances. Trekking itself was not a new feature in the history of South Africa. Indeed much of the history of South Africa from the late seventeenth century to the early nineteenth century is one of gradual territorial expansion, so that the frontier was never constant at any one time.

First, then, the long-term causes. Here we are primarily concerned with those factors which over the years made it possible, and sometimes even necessary, for the colonists to extend the original area of settlement by migrating to new territories. Sometimes the colonists, particularly those on the frontier, simply extended the area under their occupation. This may be rightly regarded as a process of territorial expansion as it involved a steady and gradual extension of the frontier of the colony, as distinct from migration from one district to another, perhaps several miles away.

Long-term causes

In chapter 3 we discussed some of the factors which made it possible and necessary for the Cape Colony to expand. We saw how the availability of large tracts of land encouraged the colonists to acquire enormous estates. It also encouraged them to move about more extensively than would have been the case had the supply of land been limited. Thus, by 1836 when the Great Trek occurred, the colonists were long used to trekking. They had acquired the spirit of adventure and were used to migrating—sometimes from the colony to neighbouring areas and back again to the colony! In other words, the vastness of the country and the small number of the colonists had the effect of making the Boers migratory in character.

Expansion and the availability of land

This particular tendency was further accelerated by the fact that most of the colonists were pastoralists and, consequently, more nomadic than sedentary. They moved about frequently. As old pastures became poorer, new ones in other areas had to be acquired. The interaction of these three factors —the mode of livelihood, i.e. pastoral farming, the vastness of the country and the resulting migratory character of the colonists—had the result of paving the way for a much more significant episode when the right time came. This was the Great Trek.

Pastoralism

The character of the Great Trek

Significant though the long-term factors may have been in bringing about the Great Trek, it was subsequent events which immediately led up to it. But before we can distinguish some of the more immediate causes of the Great Trek, it should be pointed out that this particular trek was unique and certainly different from the earlier migrations already discussed. It was also different in character and size from the expansion of the preceding two centuries. For, unlike the earlier movements, the Great Trek was a large-scale migration; it was well-organized and had disciplined leadership. Secondly, unlike the earlier migrants, the trekkers of 1835 had neither the intention nor the wish to return to the Cape Colony. They hoped to establish a new home where they could lead their own way of life under their own government, free from the control of British administration both in South Africa and in Britain.

Immediate causes

While the leaders and many of the trekkers must have had more precise motives for joining in the Trek, there were some who simply migrated for a change or because it was fashionable to do so. When they saw their neighbours, relatives and friends migrating they also decided to pack up and go. Others migrated because of the fascination they would derive from the journey into the unknown. Such people loved adventure and they would have migrated under any circumstances, grievances or no grievances.

Racial prejudice

The very nature and attitudes of the Boers made the Trek almost inevitable. They believed that they were 'the chosen race', God's own people. As such they had a clear duty to God and mankind to preserve their traditions and culture. They had an obligation to preserve their race by avoiding mixing with other races, above all with non-whites. The Great Trek was therefore regarded by them as something which would provide them with an opportunity to preserve the purity of their race and culture by founding a new home in a new country under their own control. In joining the Trek, they believed they were fulfilling a divine mission: to keep God's chosen race free from contamination through intermixing with the 'inferior' races, the 'Gentiles'.

Because of these beliefs, it is not surprising that the Boers resented any attempt by the Government to introduce measures to improve the lot of the non-whites. They were strongly opposed to government attempts to extend more liberty and human rights to the Hottentots and half-breeds. They were even more angry with the Government over the issue of the emancipation of slaves. To the Boers these measures smacked of an attempt by the Government to

Boer settlers camping for the night

equate them with non-whites and with slaves or ex-slaves. Nothing could be more intolerable. Had the Almighty God not made them his chosen race? Had he not given them Africans and other non-whites as their eternal servants?

The process of Anglicization which started in about 1822 after the arrival of the first English colonists was also viewed by the Boers with horror, fear and strong resentment. From 1820 the Cape Colony had ceased to be simply a colony of Boers ruled by the British, for now there were British settlers as well, whose interests had to be protected. In other words, official policy was increasingly influenced by the British.

Anglicization

This influence found expression in various forms. For example, the English currency (English silver) was adopted; it replaced the old rix-dollar. Even more important were the legal changes which, among other things, introduced the English system of magistrates and abolished the old Dutch system of *landrosts*. These changes were embodied in the Charter of Justice of 1828 which was subsequently modified in 1834 (see page 38). Apart from the unfamiliarity of the new system and, therefore, the inconvenience involved in its application, the introduction of the English judicial system was hated because it was foreign and because what it replaced was part of the Dutch cultural heritage, which the Boers were fully committed to preserving. But, if the Boers resented the process of Anglicization on these grounds, they were even more indignant over the language issue. From 1822 the Government encourage the use of English as the

official language of the colony. The change-over from Dutch to English as the official language occurred in 1828. There was nothing unique about this: practically every colonial power used its own language for official purposes in its colony. But, as we have already noted, the Boers were opposed to all forms of alien culture and influence and, instead, preferred to preserve their own customs and civilization. No wonder they regarded the introduction of the English language as deliberate provocation by British authorities. This was one of the most important grievances which contributed to the outbreak of the Great Trek. Not only was the question of national pride involved; it was no easy matter for the old people and the rural population to carry out their official transactions in English. They needed more time in which to learn the new official language, yet they hated the very idea of communicating in that language, because it was foreign. There is no doubt, therefore, that the replacement of the familiar and native Boer system with unfamiliar alien English practices was an important source of dissatisfaction among the Dutch settlers.

Conflict with missionaries over non-whites

Apart from the above grievances, the Boers resented the fact that official government policy and the policy of the missionaries was directly opposed to their own views on the treatment of non-whites. Whereas the missionaries preached the gospel of brotherly love, the equality of all men and the need to protect the rights of all men, the Boers believed and practised the very opposite of this. I have already discussed the full details of this issue in chapter 3. Here we are mainly concerned with its implications.

The Boers felt that any attempt to remove restrictions from slaves and Hottentots would create a dangerous situation for them. Their fears were virtually confirmed with the passing of the 50th Ordinance which restored civil rights to Hottentots, Bushmen and other non-whites (see page 49). They argued that such legislation could only destroy the master-servant relationship between the whites and the non-whites. The non-whites would become insubordinate and regard themselves as the equals of the whites—an unpardonable crime. Moreover, the supply of labour would be affected by such legislation: as the non-whites became free, they would also be able to move about and to desert their employers. Lawlessness, vagrancy, scarcity of labour and the weakening of the authority and prestige of the master-race, the whites, would be the result. Nobody among the Boers wanted to see such a situation; rather than

live under such conditions, many of them chose to move elsewhere, so that they could be free to perpetuate the enslavement of the non-whites and the doctrine of the superiority of the white race.

The theory and practice of the superiority of the white race could never co-exist with the policy of removing restrictions on the Africans and other non-whites. Above all such a philosophy could never accommodate the new official policy on slaves. The emancipation of slaves by Britain in 1833 was applied to all parts of the British Empire, South Africa included.* This became one of the most important sources of friction between the Boers and the British administration. The Boers did not see why the slaves should be freed from what was, in their view, their natural and lawful station in life. It was further argued that the emancipation of slaves would lead to anarchy, vagrancy and, even more important, shortage of labour. Farmers would, as a result, pay higher wages where in the past they had paid none in many cases.

The emancipation of slaves was thus viewed by the Boers with considerable dismay and indignation. It implied an official recognition of the principle of equality of all races, and the acceptance of such a principle would undermine the very foundation of the kind of society the Boers wanted to create and preserve. At the centre of that society was the policy of racial inequality and segregation. Apart from that, there must have been many people who feared that, as a result of the emancipation and the removal of other restrictions, the whites would have to compete for jobs with ex-slaves and other non-whites. Others were against the emancipation of slaves and the restoration of civil rights to Africans and half-breeds because this might encourage the mixing of races and, in particular, inter-marriage. At the same time, slaves were regarded as the property of their masters. Their emancipation was therefore an enormous financial loss. It is true that slave owners were compensated, but the compensation was only £1¼ million while the total value of the slaves in the colony stood at £3 million. Moreover, the farmers or slave-owners had to make their claims in London, a system which proved to be so inconvenient and expensive that some farmers never bothered to claim their compensation. By the end of 1845, for example, when the time for the payment of compensation expired, some £5,900 had still not been claimed.

Emancipation of slaves

A slave rejoicing at his emancipation

* The Act of 1833 abolished slavery but it was not until August 1834 that all slaves in the British Empire were actually set free.

Important though the foregoing grievances may have been in influencing the Boers' decision to migrate from about 1835, the most immediate single cause of the Great Trek was the Government's decision to cancel Governor D'Urban's annexation of the Province of Queen Adelaide and Natal (see page 44). In the famous Kaffir War of 1834, the Boers had given considerable support to the Government under D'Urban. In addition, as we have already noted in chapter 3, the Boers lost much valuable property and many of them were killed in the fighting, which lasted until September 1835, when the two warring sides made peace. The Boers consequently regarded the new territory of Queen Adelaide as theirs by right of conquest. Having given substantial support to the Government's war effort, they now expected some compensation from the authorities. D'Urban's annexation of the Province of Queen Adelaide was accordingly warmly received by them. They hoped to settle in the newly acquired district and the destruction of hostile communities seemed to provide the colony with more security. Security had been a burning issue ever since the Boers settled in South Africa, for the colonists always complained (often with justice) of lack of adequate protection by the administration. Now D'Urban's administration appeared to be determined to defeat and displace the hostile local people; now at last the Government was listening to the colonists' complaints; more land would be made available and security could now be enjoyed.

But Britain's Secretary of State, Lord Glenelg, had other thoughts on the subject. Supported by his fellow philanthropists, he was critical of D'Urban's policy and nullified all his proposed territorial adjustments. He regarded D'Urban's expansionist policy as an attempt to wipe out the non-whites by taking their land and, by extending the British frontier by about 100 miles, D'Urban's policy was bound to increase the number of Britain's African subjects by thousands. The British Government was reluctant to sanction such a measure on security and financial grounds, as conflicts between whites and blacks would inevitably assume new proportions with such an increase in the African population.

When, therefore, on top of all the other grievances, it was learnt that the British Government had reversed the Governor's action, many dissatisfied farmers decided to emigrate. They felt the Government had deliberately let them down. They believed the administration did not consider them and that neither their interests, their lives nor their property mattered to the Government. It is debatable, however, whether the Great Trek would have occurred but

Lord Glenelg, Britain's Secretary of State

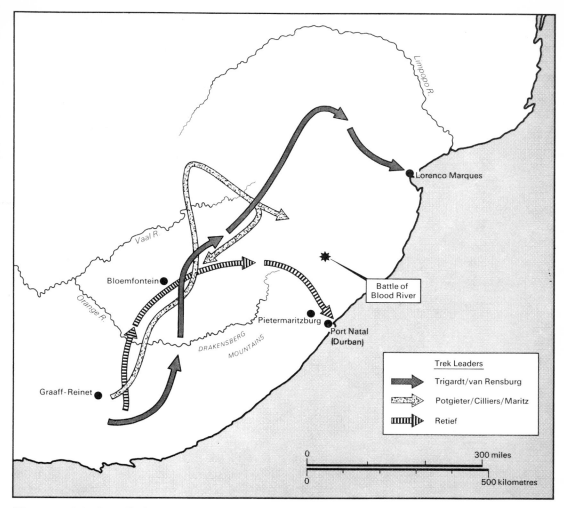

Trek Leaders

→ Trigardt/van Rensburg

⇨ Potgieter/Cilliers/Maritz

⫸ Retief

Battle of
Blood River

Lorenco Marques

Limpopo R.

Vaal R.

Orange R.

Bloemfontein

Pietermaritzburg

Port Natal
(Durban)

DRAKENSBERG
MOUNTAINS

Graaff-Reinet

| 0 | | | 300 miles |
| 0 | | | 500 kilometres |

The routes of the Great Trek

for the decision to nullify D'Urban's land annexation. Indeed it may be justifiable to regard this incident as the occasion for, as well as the prime cause, of the historic trek.

Rumours

Added to the Boers' grievances were the many rumours prevalent at this time—that all the land would be given to the Hottentots; that a policy of mixed (inter-racial) marriages was imminent; that compulsory military service would soon be introduced; and that the Boers would be forced to abandon their Dutch Reformed Church and become Roman Catholics. Such rumours, however ridiculous and groundless, had the effect of raising the political and social temperature; they increased the degree of misunderstanding and contributed to the final rupture.

It is thus apparent that, in deciding to emigrate, the trekkers were not protesting against any one particular grievance. The Great Trek was the culmination of numerous and long-standing grievances and misunderstandings, some of them real but others imaginary. As Macmillan has rightly stated in connection with Piet Retief's determination to emigrate, nothing could have held back the trekkers in 1835:

> [The Lieutenant-Governor might have] 'soothed' Retief with a definite promise that the slaves should not be free, that the 50th Ordinance be repealed, that Kaffraria be divided up as farms, that the missionaries be hanged, and the blacks extirpated; even so . . . Retief was irreconcilable, and the Trek would not have been stopped.*

Preparations for the Trek commenced as early as 1834. In that year three groups were sent out to investigate prospects for settlement in three different areas: Damaraland in modern South West Africa, Zoutpansberg in present-day Northern Transvaal, and Natal. Early the following year the three investigating teams brought back favourable reports. The land they had visited was fertile and scantily peopled.

The progress and results of the Great Trek

The first trekkers who left just before November of 1835 are collectively known as the *trekboers*. They were few in number and ill-prepared for the hazards that lay ahead. They were virtually wiped out by the inhabitants of the Limpopo Valley; many others died of fever. Their leaders, Louis Trigardt and Jan van Rensburg, must have cursed the day when they led their respective parties out of the colony into

* W. M. Macmillan, *Bantu, Boer and Briton*, Oxford University Press, London, 1963, pp. 198–9.

The trekkers had to cross the mountains by dangerous routes

the dangers of unknown lands. But the Boer farmers were not dissuaded by the terrible fate of their colleagues. Early in 1836, soon after learning that the annexation of the Province of Queen Adelaide had been cancelled, a large party of trekkers left the colony. Led by Andries Hendrik Potgieter and Sarel Cilliers, this, the largest single contingent of trekkers, was subsequently joined by another large group in August of 1836. This group was led by Gerrit Maritz and consisted of farmers from Graaff-Reinet. The trekkers transported their belongings in ox wagons and moved with their livestock. By 1836, therefore, it could be confidently said that the Great Trek was in full swing.

Boer settlers repelling a Zulu attack

Encounters with the Ndebele and the Zulu

Andries Pretorius, Commander of the Boers at the Battle of Blood River, 1838

During their journey, the trekkers encountered fierce resistance from the local people. In 1836 they clashed with the Ndebele under Mzilikazi. The Ndebele were defeated and forced back across the Limpopo River, and as a result the trekkers settled to the north of the Vaal and Orange Rivers.

By far the fiercest resistance came from the Zulu of Natal under the leadership of Dingane. On one occasion, their negotiations for land having failed, Retief and his party were killed by the Zulu. The Zulu were prepared to fight to protect their land and sovereignty, and the trekkers would not go back to the colony they had left. Continuing warfare was the inevitable result.

In the last phase of the fighting the trekkers were led by Andries Pretorius. They were determined to win and mounted a joint attack against the Zulu. Finally their rifles and superior military techniques were fully rewarded: on 16 December 1838* Dingane and his Zulu warriors were

* 16 December was celebrated in South Africa as Dingane's Day until 1952, when it was renamed the Day of the Covenant.

An early picture of Pietermaritzburg

completely defeated at the Battle of Blood River. Six months later Dingane ceded a large part of the district of Natal to the trekkers as part of the terms of surrender. Dingane's days as a leader were clearly numbered if not actually over, and in fact after this humiliation he was expelled and murdered by his own people. His successor, Mpande, enjoyed the support of the trekkers under Pretorius.

After this victory over the Zulu, the trekkers established a new state of their own, the Republic of Natal. A Volksraad (People's Council) was established in the newly created town of Pietermaritzburg. The Council exercised full executive, legislative and judicial powers. It thus combined the powers and functions carried out separately today by the judiciary, Parliament and the Cabinet or Ministers. It served as a court of appeal and had 24 members, electing a president at each session. The Republic of Natal was, however, short-lived, because of the determination of the British to bring the district under their control as part of the Cape Colony. The British offensive of 1842 met with weak resistance and the following year the Boer Republic and the Volksraad

The Republic of Natal

61

surrendered. Two years later, in 1845, Natal was incorporated in the Cape Colony as one of its provinces.

Meanwhile, many farmers who were unhappy about the prospects of British rule were busy fleeing from Natal. They joined other trekkers in the country between the Orange and the Vaal Rivers. At first Britain tried to bring them under control. In 1848, for example, Governor Harry Smith annexed the territory between the Orange, the Vaal and the Drakensberg Mountains to the Cape Colony. The event was received with considerable dissatisfaction and even resistance among the farmers. Continuing friction between the farmers, on the one hand, and the neighbouring Basuto and Ndebele, on the other, required a more positive and active policy if peace was to be restored. In particular, the Basuto victory over the colonists in 1850 greatly worried British authorities in the Cape Colony. They feared the possible effects of such insecurity and instability in the Cape Colony in particular

The territory occupied by the Boers: (1) the Drakensberg Mountains

and among the African people in general. But at the same time Britain was reluctant to shoulder the financial burden of extending its administration beyond the recognized boundaries of the colony. To succeed, such a task would require money, a strong military force, the sympathy of the colonists and the co-operation of the Africans.

Realizing, therefore, that to maintain control in the area would require much money, the British decided to abandon the migrant Boers. Accordingly, by the Sand River Convention of 1852, the British Government granted to the Boers to the north of the Vaal River the right of self-government, with an end to British interference and encroachment in the new Boer country. This gave rise to the legal existence of the South African Republic (Transvaal), although it did not last long. Marthinus Wessels Pretorius (the son of Andries Pretorius), its first President, took office in 1858.

The Sand River Convention, 1852, and the Convention of Bloemfontein, 1854

(2) the Vaal River

Two years after the proclamation of the Sand River Convention, the British extended the same concession to the Orange River Sovereignty. By the Convention of Bloemfontein of 1854, full independence was granted to the colonists of the Orange River Sovereignty which now became the Orange Free State (see chapter 7).

Disruptive forces So far the trekkers had succeeded in keeping together, wherever they settled, as groups of people with a common enemy (the British) and destiny (independence and the freedom to preserve their values and traditions in purity), though they were not actually united. By 1857, however, divisive forces were actively at work within the new republics. As a result three small splinter republics were established at Lydenburg, Zoutpansberg and Utrecht, bringing the total number of Boer republics to five. Apart from these there were the three British colonies of the Cape Colony, Natal and British Kaffraria (the former Queen Adelaide Province which was formally annexed by Britain in 1847).

The racial issue Territorial expansion (e.g. the occupation of Transvaal, Natal and the Orange Free State) brought the colonists into increased contact with Africans and half-breeds. By extending their administration into the new settlements, therefore, British authorities assumed the task of governing the non-whites of those areas as well. This was no easy matter, especially when it is recalled that the attitude of the Boers to non-whites conflicted with the official British policy. Hence the increasing complexity of what is popularly known as the South African native problem.

There is no doubt that the position of the African deteriorated in the years following the Great Trek.* Not only did friction between the Government and the colonists over the issue of the treatment of Africans become more intense, but Africans were also subjected to severe treatment in the Boer republics. The official British policy was modified to please the colonists, because it was felt that the Government's liberal policy on the racial issue had partly contributed to the Trek. Even apart from all this, the effect of the Trek on Africans was considerable. As well as losing their land, property and independence, many of them were killed while trying to resist the advancing colonists. The full implications of the conquest of the Africans by the Boers will be related in chapter 12.

* For details of the effects of the Great Trek on Africans and their relations with whites, see chapters 6 and 7.

The rise of the Zulu kingdom Chapter 5

As will already be evident from the preceding chapters, one of the most important themes in the history of South Africa from the earliest times was, and still is, the powerful clash of interests. This took various forms at different times and in different circumstances. Before the coming of the Europeans there had been some conflicts among the various local communities, especially the more powerful ones. For example, the coming of the Bantu had led to the conquest and decimation of the weaker Bushmen and Hottentots. The clash of interests became more intensified during the eighteenth and nineteenth centuries. There was conflict between the various African peoples, between Africans and European colonists, between some of the colonists and the Government, between the English and the Boers, amongst the Boers themselves, and between the settlers and some missionaries over the issue of the treatment of Africans and slaves.

One major development which led to and resulted from conflicts amongst the Africans was the rise of the Zulu state under Shaka, one of the most important events in the history of the nineteenth century in South Africa. It is important, therefore, to understand the role played by Shaka in the creation of the most important state of its kind in Bantu South Africa. How did Shaka manage to build such a powerful and autocratic state and how did he maintain it? How were Shaka's subjects, neighbours, friends and enemies alike, affected by the new state? How was the state governed?

Before the time of Shaka the people of present-day Zululand and Natal were organized into numerous small communities. Some of these political units were as small as an average clan, in terms of population and territory, and many of them were not capable of defending themselves against their stronger and bigger neighbours. Altogether there were more than 100 such political and social units and, in spite of their military weakness, practically all of them were independent. Each was ruled by a chief, who was in turn assisted and advised by junior chiefs, councillors and important state officials called *indunas*.

The social and political situation before the Mfecane

There were good reasons why these people lived as they did, in numerous, small, independent settlements. The population was still small and there was, therefore, plenty of unoccupied land for new settlements. At the same time, due to internal friction and instability, the disgruntled members of the community often decided either to break away and establish their own independent societies or to migrate to other districts where they would be free to live as they wished. Because the states were generally small they were governed in a simple way and, although clashes were not uncommon, large-scale fighting was rare and the effects of warfare were generally less severe than in later years. There was thus no necessity for large-scale political and military organization. This had the effect of encouraging the continued existence of numerous small states with simple systems of government and small-scale military organization.

Such a situation, however, could not last indefinitely. By the end of the eighteenth century the population was rapidly increasing and, as this happened, new land became necessary for further expansion. As pressure on the land gradually increased, fresh land could only be acquired by force of arms and in due course only the bravest and strongest could acquire land at the expense of their weaker neighbours or enemies. This does not mean to say that by the beginning of the nineteenth century Zululand and Natal were over-populated by our standards. All it means is that these areas had more people than the land could support, using the contemporary methods of pastoralism, agriculture and settlement. People could only live in their settlements as long as their lives and property were safe and distance from the enemy was, therefore, an important factor.

About the beginning of the nineteenth century, the population increase in Zululand and Natal resulted in significant political and military changes. The rapid population increase led to frequent clashes over land needed for further expansion. Warfare became common and increasingly wasteful of life and property. Social instability and general insecurity necessitated better and larger social and political organization. It also became necessary to improve and strengthen the military organization and methods of fighting to cope with the prevailing conditions. By the time Shaka became an important figure in the history of South Africa, there were already positive developments towards the creation of larger and more powerful political units. Chief among them were the Mthethwa or Abatetwa, led by Dingiswayo, the Ndwandwe, under Zwide, and the Ngwane, led by Sobhuza. All three rose to pre-eminence by military means, by strengthening their armies and conquering their

The Zulu chiefdoms

neighbours. And it was by military means that Shaka was later to reorganize all the Zulu chiefdoms into a united and powerful empire.

But, before we proceed, it is necessary to understand how people were organized and equipped for purposes of warfare in the pre-Shaka period. Let us look at events during the time of Dingiswayo, Chief of the Mthethwa. As the greatest of the three rulers of the new age before the time of Shaka, he was more powerful than either Sobhuza or Zwide. Dingiswayo's period is also important because it was under him that Shaka got his early military training and experience.

Dingiswayo's achievements

Born a son of the chief of the Mthethwa, Dingiswayo conspired to assassinate his father and, when the plot was discovered, fled from home. In about 1740 he returned and, after his father's death, ousted his brother from the throne. Under his rule the traditional ceremonies of initiation were abolished, and instead young men of initiation age were recruited into military regiments. These regiments, which were formed on an age basis and were known as age-regiments, constituted the tribal army.

Although the introduction of the age-regiment system is usually attributed to Dingiswayo, this may not be entirely just for his chief rivals, Sobhuza and Zwide, are known to have also used it. The system certainly had many advantages over the old one. First, it encouraged tribal coherence and unity since the regiments fought together and shared common experiences as members of one nation. Second, it resulted in military efficiency. Third, it strengthened tribal loyalty to the centre, i.e. the ruler. Previously local chiefs had commanded their own military units. Now, however, the regiments were commanded by men who were all appointed by one central ruler. Although Dingiswayo used the system to extend his dominion, he was not sufficiently ruthless to destroy his enemies. He defeated his neighbours and made them subordinate to his rule, but allowed them to retain their own chiefs, thus weakening loyalty to the centre. He was lenient to his enemies to the extent of giving them back their captured cows, only retaining the oxen which he gave to his warriors.

During this period there was no permanent army in Zululand, although there were many trained warriors attached to the different age-regiments. Warriors were summoned only when the need arose, otherwise staying in their homes attending to their ordinary day-to-day work. There were, therefore, no professional soldiers who lived by fighting alone. Despite the improvements made by Dingiswayo, the warriors still used the same weapons as before, the large shield and the long-handled spear. The shield was cumbersome and inconvenient due to its immense size. The long-handled spear had one major weakness as a fighting weapon: because it was usually thrown at the enemy, the warriors were left defenceless and helpless but for their large shields. And, though each warrior carri several spears, these could be collected by the enemy and returned, thus turning the Zulu warriors' weapons against themselves. Efficiency and discipline could not, therefore, be fully maintained on the battlefield; for this to be accomplished a thorough military reorganization was necessary. This was the task and achievement of Shaka.

The long-handled spear used by the Zulu

Zulu warriors with shields and long-handled spears

Shaka, founder of the Zulu

Shaka and the origins of the Zulu kingdom

The man who was destined to transform the history of his country and age was born about 1783. His father, Senzangakona, was the chief of the Zulu who at that time formed the small Zulu chiefdom, which was of little or no significance compared with the Ngwane, Ndwandwe and Mthethwa chiefdoms. His mother was called Nandi and came from the Langeni tribe. Shaka was particularly fond of his mother, under whose care he grew up after her disagreement with his father. Brought up away from his father's home, he had an unhappy and difficult early life. He was taunted and harassed by his playmates, to whom he always boasted of his chiefly descent, for even then he was conscious of his important social status. As he grew up he demonstrated a high degree of intelligence and courage, qualities accompanied by arrogance and indifference to human suffering. In addition he was energetic, adventurous and merciless. By

all accounts Shaka had the qualities of a man who could shape society, for better or worse, by force of arms. He was destined to be great by sheer willpower, determination and ability.

He gained his early military experience as the commander of one of Dingiswayo's regiments. The latter soon recognized in him the qualities of a brave and persistent warrior. However, it was not until about 1816 that Shaka had an opportunity to use his good qualities to his own advantage. About that time his father died and was succeeded by Sigujana, one of his sons. Shaka decided to fight for the throne. Realizing that he could not succeed in deposing Sigujana on his own, he appealed to Dingiswayo, his over-lord, for military assistance. Sigujana was defeated and Shaka became ruler of the Zulu.

Shaka's training under Dingiswayo taught him new fighting tactics which he put into practice immediately he came to power. Although he later improved many of these fighting techniques, this early military experience paved the way for the distinguished military and political role he was destined to play among the Zulu and neighbouring peoples.

Shaka's military reforms

In many respects, the military reforms initiated by Shaka were revolutionary. He created a standing or permanent force of warriors, reorganizing the old age-regiments and making them more efficient and effective for large-scale warfare. Regiments were established throughout the country. Each had its own colour which was the colour of its shields and head-gear. The warriors lived in special military settlements or towns. Each settlement was under a military commander, called an *induna,* who was appointed by Shaka himself. The *induna* had a number of junior officers under him, who were in charge of smaller units. The army commanders were usually appointed from the commoner families or clans and, because they owed their position to Shaka they were completely dependable. Each military town contained a royal household, cattle enclosures and dwelling huts for the warriors. In these towns the warriors were armed with shields and spears, drilled, attired and fed at the king's, or rather the public, expense. While there, they constantly sang the praises of Shaka, their lord and master. They were full-time warriors who earned their living solely by fighting. Warfare under Shaka had become a real career.

In order to overcome the traditional weakness of the long-handled throwing spear, Shaka introduced a new weapon. This was the stabbing spear which had a much shorter handle, enabling the soldiers to engage in hand-to-

The Zulu stabbing spear

hand combat with the enemy. It made warfare more ruthless and fighting more efficient. The warriors could protect themselves with their shields and concentrate on destroying the enemy with their knife-like spears. No more would they be left defenceless and at the mercy of the enemy.

The warriors were subjected to thorough regimentation and discipline. They were not even allowed to marry before the right time, and that time was determined by Shaka himself. However, when the appropriate time came, the whole regiment was freed from service. A female regiment of the same or equivalent age-group was also dissolved and its members given to the freed warriors as wives. The women were organized in age-groups, partly for this purpose,

A Zulu arms store-house

partly for ceremonial purposes and partly for the supply of labour. Under Shaka's leadership the young men of the conquered people were absorbed into the central army and accorded the same treatment as Zulu warriors. They joined appropriate age-regiments and mixed with young men from all over the country. If they were still too young to join the regiments, they looked after cattle and acted as weapon-bearers for warriors, like the young Zulu boys. The old and infirm among the defeated people had a worse fate. They were deemed worthless and cumbersome, with no place in the military-orientated and regimented society, and therefore were put to death. The girls and young women of the defeated groups were spared to work in the fields.

A ceremonial Zulu marriage dance

Diagram of the 'cow's horns' fighting formation

Shaka is also credited with the introduction of the famous fighting technique known as the 'cow's horns' formation. It is not clear whether he was actually responsible for its introduction, as his contemporaries are also known to have used it. Nevertheless, the 'cow's horns' formation was widely used by him and with great success. By this means of fighting, the bulk of the regiments formed a thick and therefore strong centre or base. On each side of this a regiment would curve towards the enemy, rather like the horns of a cow. As the 'horns' tried to surround enemy warriors, the thick centre would press forward and thereby annihilate them.

Administrative changes It goes without saying that the Zulu nation was a military state ruled by a despotic king. The army was the source of all power and army commanders became the king's advisers. They were consulted by him, though he could and often did ignore their advice. The old traditional councils of chiefs and leading elders fell into abeyance as the machinery of government became increasingly totalitarian and militaristic. Even the military *indunas* who could advise the king were not allowed to hold unauthorized meetings lest they plot against him. Absolute loyalty to the ruler became the order of the day.

This also applied to the conquered and incorporated peoples. Their chiefs lost their powers and their authority was restricted to routine issues such as the administration of justice. Normally, however, they were replaced by Shaka's own nominees who were more reliable. In both cases power resided in the army and the king. Such was the kind of state created by Shaka: the Zulu nation was born in war and organized for war.

The results of all these innovations were far-reaching. The years 1820–34 are known as the period of the Mfecane, i.e. 'the crushing', for they were characterized by devastating warfare. Practically every community within the vicinity of the Zulu was affected by the events of that period. The Zulu became powerful, aggressive, ambitious and expansionist. The Zulu kingdom was a state of warriors maintained by warriors and sustained by warfare and it could only survive in its entirety as long as there was enough fighting to keep the king, the *indunas* and the warriors busy. No wonder the Mfecane left a permanent mark on the history of southern Africa.

The wars of this period were numerous and intricate and the situation is, therefore, not easy to understand. Nevertheless, a few of the major ones are worth noting. After the Ndwandwe had defeated the Mthethwa and killed Dingiswayo in 1817 or early 1818, the Zulu emerged as the main source of opposition to the Ndwandwe. The Zulu first defeated and incorporated their weaker neighbours, including the Mthethwa, their former overlords. Shaka even killed their new chief, Mondisa, replacing him with his own nominee.

Zwide of the Ndwandwe, who was now the most powerful and feared ruler in all Zululand, became alarmed at the growing might of the Zulu under Shaka. He feared what might happen to his state if the Zulu became more powerful. The danger of being attacked and perhaps defeated by the upstart Zulu ruler greatly worried him, and he decided to attack first while the Zulu were still weak. Fierce fighting took place at Gqokoli Hill. The well-drilled and disciplined Zulu warriors proved to be a match for the numerically superior Ndwandwe fighters, and in the end the Zulu threw back the Ndwandwe attack. Shaka's modernization and determination were beginning to pay off.

This was further demonstrated towards the end of 1818, when Zwide sent his whole army against the Zulu. Fierce fighting followed, with Shaka's warriors employing elusive tactics, such as night raids and temporary withdrawal. The Zulu warriors adopted these elusive and cunning tactics in order to harass and weaken the invaders, while at the same time avoiding any serious harm to themselves. The Ndwandwe fighters soon became tired, weak and demoralized, and starvation set in as they could not find food in the settlements deserted by the Zulu. It was exactly at this well-chosen moment that Shaka gathered his forces and attacked the exhausted Ndwandwe warriors on the banks of the Mhlatuze River. The Ndwandwe forces were literally annihilated, and the rest of the state was mercilessly crushed.

Shaka's wars—the Mfecane

The collapse of the Ndwandwe

Zwide and a few Ndwandwe managed to escape and fled to the upper Nkomati River. Two other groups of warriors, led by Soshangane and Zwangendaba, fled northwards into southern Mozambique. Zwangendaba's group finally settled in mainland Tanzania under the new name of Ngoni, while Soshangane founded the empire of Gaza in Mozambique. We shall return to them later (see page 81).

The collapse of more nations

After the collapse of the Ndwandwe, Shaka became the most powerful and feared ruler in Zululand. Many tribes were defeated and brought under his control; a few others fled to remote areas where they built new homes. Endless warfare was waged over a large area. Natal, for example, was attacked five times, in 1817, 1818, 1819, 1820 and 1824, before being completely destroyed. Even Kings Sobhuza, of the Ngwane, and Moshesh, of the Basuto, acknowledged Shaka's overlordship by paying regular tributes. The Tsonga and the remnants of the original inhabitants of Natal also recognized him, though they were practically independent. This was Shaka's finest hour.

Shaka's ambition was to exterminate his neighbours and enemies and to extend his dominion. To that end the Pondo, Xhosa and Thembu also suffered ruthless attack and conquest. Practically the whole of Zululand, Natal and the coast were directly affected by these wars. By 1823, however, although fighting still continued, the climax of the Mfecane was over.

Contacts with the English

The year 1824 saw a new development in Shaka's policy. He realized the benefit which could result from good relations with the small English trading community at Port Natal, the future Durban. Trade with the English would enable him to acquire firearms which were highly valued. Shaka decided to win the support of the English community and in 1824 he gave much of present-day Natal to an English trader called Farewell, who had helped him by giving him medical treatment.

The white traders in the ceded area became Shaka's subjects and fought for him, although for the most part they were left alone. Their military assistance proved valuable, however, when the Zulu again fought the Ndwandwe in 1826 and the Beje in 1827. In both cases they inflicted heavy losses on the enemy. The Ndwandwe lost about 60,000 head of cattle while the Beje similarly lost huge herds. As a result, the Ndwandwe disintegrated as a united community. Their ruler, Zwide, had died the year before, in 1825.

Shaka offering land to Lieutenant Farewell in return for his support

But by this time Shaka's days were also numbered. His death was preceded by that of his mother in 1827. Nandi's death greatly distressed Shaka and he proclaimed national mourning for a whole year. During the period of mourning women were not allowed to cohabit with their husbands, and for about three months people were forbidden to drink milk. Thousands of people were put to death for not mourning or for not mourning adequately. Others were accused of wishing Nandi's death and were also put to death, as were women who became pregnant.

Early the following year Shaka was stabbed to death by his brothers, Mhlangana and Dingane, in collaboration with his chief *induna*, Mbhopa. As he fell to the ground in agony, his last words were: 'Oh children of my father, what have I done to you?' The great conqueror of kings and nations, the terror of his age and the ruthless and efficient modernizer was dead. His murderers claimed that they had killed him to rid the nation of hardship and tyranny, but it is also clear that they killed him out of their own greed and thirst for power.

Negative consequences of the Mfecane

Depopulation and devastation

The Mfecane had a permanent impact on the history of southern Africa. Many of its effects were negative and destructive, others were positive and constructive. First, the destructive results. Thousands of people were killed, much property destroyed and whole communities either destroyed or disrupted. Endless wars turned whole districts from centres of population and prosperity to utter desolation and bleakness. The land was littered with human corpses and skeletons. It was a land full of death, misery and acute hardship. For, as the Zulu fought their neighbours, they in turn attacked those in their way in an attempt to escape from Shaka's forces. Thus Shaka's wars indirectly led to other wars in distant places where his own warriors never actually fought. Whole districts became practically empty, for example, present Natal, the north-eastern area of modern Orange Free State, and present-day Transvaal. Where a few people still survived their condition was pathetic. Subjected to acute starvation and extreme poverty, many of them resorted to cannibalism in order to survive. Others wandered from place to place harassing and raiding their neighbours.

The Fingo, Kololo and Mantatees

The Fingo are a good example of these impoverished refugees who were uprooted from orderly society. Having lost all their property, cattle, land and food, they wandered from place to place begging for food and sometimes taking it by force. Their name Mfengu, i.e. 'Fingo', originated from

The Mfecane Wars

this practice of begging for food. They included refugees from the Ngwane and Hlubi as well as those from the coast of Mozambique. Eventually some of them settled among the Xhosa, the Pondo and the Thembu where they looked after their hosts' herds. The establishment of the Kololo people across the Zambesi is another direct result of the Mfecane. Originally known as the Fokeng, they were led by Sebetwane out of the war-stricken area and finally settled in their present homes. They belonged to the Sotho group of people.

The Mantatees are another good example of a people which was affected by the wars of the early nineteenth century. Originally they formed the Tlokwa chiefdom. During the wars of Dingiswayo, the Ngwane fled their country and on their way attacked the Hlubi and defeated them. One section of the Hlubi in turn attacked the Tlokwa and drove them out of their homes, seizing their property, cattle and food. At that time the Tlokwa were ruled by Mantatisi, the widow of their late chief. Hence their new name, the Mantatees.

About 1824 the whole neighbourhood was devastated and terrorized by hordes of Ngwane, Hlubi and Mantatees. The Mantatees harassed and ravaged all before them. They attacked the people living around the sources of the Caledon River, who in turn fell upon their neighbours and all those in their way. They lived by fighting and murdering those around them, stealing the cattle and grain of their victims, and were joined by some of the people they defeated. Under their new leader, Sikonyela, the son of Mantatisi, they repeatedly raided the Basuto until Moshesh defeated them in 1853. Sikonyela escaped to the Cape Colony with a few followers, but the majority of the Mantatees were incorporated into the Basuto nation.

Side-effects The wars of this period had the further effect of worsening local feuds and causing social and political unrest. For the first time, also, Africans came into direct prolonged contact with Europeans in the Cape Colony. By 1828 at least a few of the refugees had found their way into the Cape Colony, where they became farm labourers. The displacement of population over much of South Africa, which resulted from these wars, greatly facilitated the Great Trek when it started from about 1835. The Boer trekkers were able to settle in the temporarily unoccupied land, thus extending still further the frontiers of the original colony at the Cape.

Positive consequences of the Mfecane
In spite of the misery and destruction it caused, it would be wrong to conclude that the effects of the Mfecane were wholly or even largely negative. Its constructive effects were profound and long-lasting and it is for these that it should be remembered. For the sake of clarity I shall consider them one by one although they are all closely connected.

Political reorganization and birth of new states
In the first place, many communities responded to the critical conditions into which they were forced by reorganizing themselves politically. They incorporated their less important neighbours and many of the people they had conquered. During this period some outstanding leaders of

remarkable ability and wisdom went even further and organized their own peoples and the numerous refugees into new, powerful and united states. The kingdoms of Basutoland, Swaziland and Bechuanaland are the best examples of these (see chapters 6 and 7).

The Mfecane also led to the emergence of entirely new societies both in South and East Africa. They were founded by refugees who trekked away from their original homes into distant regions. During their long journey, they conquered those in their way and incorporated many of them, and their settlement in their new homes was always preceded by fighting. After the collapse of Zwide's army at the hands of Shaka, the Ndwandwe split into several sections. Two of these groups of warriors were separately led into southern Mozambique by Soshangane and Zwangendaba. In 1831 they fought each other and Soshangane's group won. The victorious leader then proceeded to build a new state which he called Gaza, after his grandfather. Zwangendaba led his followers away from Mozambique and by 1835 the bulk of them had crossed the Zambesi River, having absorbed many people on the way. Still moving steadily, they arrived in Malawi in 1836 and within four years they had settled in Ufipa in mainland Tanzania. This was followed by a number of splits and further migrations to Songea, Safwe, Pangwa and even across the Rovuma River. In Tanzania the Gwangara Ngoni settled at Songea, the Tuta in Unyamwezi to the north of Tabora and the Maseko Ngoni at Songea. Their arrival encouraged the local people to organize themselves into larger and stronger units, of which the Nyamwezi under Mirambo and the Hehe are the best examples.

The Mfecane led to fundamental changes in political and military organization. Many states were established along the lines of the Zulu kingdom. They borrowed the Zulu military and political organization and modified it to suit their particular needs and circumstances. Such states were often formed from diverse cultural and linguistic groups, but from these diverse groups emerged powerful united states with a common language, culture, ruler and government. The languages of the dominant groups became the languages of the new, enlarged trans-tribal and expansionist states. Examples of these are the Zulu, Swazi, Basuto, Ndebele, Ngoni and Botswana. The new states adopted Zulu military techniques and political organization with great success. More will be said about this in chapters 6 and 7.

Growth of national cohesion and unity

New type of leadership Finally the Mfecane resulted in the emergence of a new type of leadership in eastern and southern Africa. The harsh conditions of that time required brave, intelligent, adventurous and steady leaders if their nations were to survive. Such leaders realized the value of a well-organized and properly equipped and efficient army, and of an efficient administration. Only the fittest could survive, and they did so by attacking and destroying their enemies, incorporating their neighbours and extending their domains. The new leaders like Moshesh, Shaka, Sobhuza and Mirambo in Tanzania were not content with the old traditional frontiers of their states. Hence the emergence of bigger, stronger and better-organized nations, in which law and order were effectively maintained and severe discipline enforced. The army rather than the old kinship ties was the basis of power in the new states and the new leaders and their governments depended on it for their survival and success.

The growth of new nations I: the Ndebele and the Zulu

Chapter 6

In the last chapter we saw how, as a result of the political and social unrest caused by the wars of the early nineteenth century, many old societies disintegrated while, at the same time, other larger and stronger states sprang into existence. As already mentioned, such states owed their origin and survival to the new type of leaders of that difficult time. In this chapter I shall describe developments among the Ndebele and the Zulu.

THE NDEBELE

Just as the Zulu had Shaka as their leader, so also the Ndebele had their great founder, called Mzilikazi. Born the son of Mashobane, chief of a Nguni-speaking group called the Khumalo, Mzilikazi was an intelligent and courageous leader who rarely let his people down. He fought many wars and won important battles for his country. Though he is known to have killed many people in war, he was of a mild disposition and did not enjoy cruelty for its own sake.

The Ndebele have linguistic and cultural connections with the Zulu and Xhosa. Their name is of Sotho origin and was once applied to the Nguni. While the majority of them live in Rhodesia, others still live in the Transvaal. By far the most distinguished group among them were the Khumalo who founded the Ndebele state in Rhodesia under Mzilikazi's leadership. The Khumalo were originally under the rule of Zwide during the pre-Shaka wars between the Mthethwa, led by Dingiswayo, the Ndwandwe, led by Zwide, and the Ngwane, led by Sobhuza. During the war between the Mthethwa and the Ndwandwe, in which Dingiswayo was murdered, Mashobane, the father of Mzilikazi, was killed on the orders of Zwide because he was suspected of having assisted the Mthethwa. After his death Mzilikazi became the new ruler of the Khumalo, though still under the overlordship of Zwide. Later Mzilikazi transferred his loyalty to Shaka, who was impressed by his qualities as a brilliant and able leader. Shaka made him a commander of one of his regiments, a regiment largely formed by his own people,

Mzilikazi, founder of the Ndebele

83

the Khumalo. In 1821, however, Mzilikazi defied Shaka and declared his independence and that of his people, with the result that Shaka's warriors attacked the Khumalo and scattered them. Mzilikazi led his people away from Shaka's reach and in 1824 halted at the upper Oliphant's River. From there he made raids throughout the neighbourhood, capturing women, children and herds of cattle. Among those attacked were the Pedi of northern Transvaal, the Tswana and the Kololo.

Mzilikazi's wars

Between 1825 and 1834 Ndebele warriors ravaged the central and northern areas of the Transvaal. Previously these districts had been full of peaceful inhabitants who flourished economically and socially. Now, however, they were literally destroyed by the endless wars and raids of the Ndebele. The country soon became a graveyard, many settlements, crops in the fields and foodstuffs were destroyed, and herds of cattle were seized by the invaders. Women and children were taken captive and absorbed into the Ndebele community. Those who survived were so impoverished and demoralized that life became unbearable and worthless to them. They were full of despair in a land full of lions. The Kwena are an example of the communities which were almost entirely destroyed during these wars.

The year 1829 saw a reversal of Ndebele military success. In that year they were attacked by the Korana, in conjunction with the Taung and the Rolong, and large herds of cattle were captured. Following this defeat, the Ndebele were attacked by, among others, the combined forces of the Korana, Griqua, Taung and Rolong and again lost many cattle. The Ndebele warriors were away fighting the Ngwato when the attack was made. On their return, however, they made a successful surprise attack on their opponents and recovered their cattle, also capturing several guns and ammunition and killing the bulk of the invading warriors. In the following years the Ndebele made several attacks on the Basuto, the Ngwaketsi (the dominant Tswana group), whom they pushed to the Kalahari Desert, and the Kwena of Botswana.

Early in 1836 a party of Boer trekkers was attacked by the Ndebele who mistook them for Griqua warriors. The Boers had guns and defeated their opponents, whose simple weapons and tactics proved ineffective. The following year a combined attack by the Boers, Tlokwa, Griqua and Korana forced the Ndebele to flee northwards. It was not until October 1837, however, that their settlements were finally destroyed by a Boer attack led by Potgieter. Henceforth the Boers settled in areas previously occupied by the Ndebele.

Mzilikazi's son, Lobengula, outside his residence at Bulawayo, the Ndebele capital built by his father

As a result of the Boer victory, the Ndebele decided to move northwards to present-day Rhodesia. One group comprising women, children and what was left of their cattle was led by the chief *induna*, Gundwana Ndiwene, and built their first settlement near the Matoppo Hills. They called it Gibixhegu, in memory of Shaka's town of the same name. Meanwhile the second party, led by another *induna*, Magqekini Sithole, and containing Mzilikazi in its number, lost contact with the first one. It was discovered by messengers from the first group which had already settled in Rhodesia. After rejoining the first group, Mzilikazi built his capital near Bulawayo. He executed Gundwane and other *indunas* and Kuluman, the heir apparent, for having conspired to make Kuluman ruler during the time when the two parties had lost contact with each other. The execution took place on a hill which later became known as 'the hill of the *indunas*'. A new royal capital, Inyati, was later built close to the place of the executions.

Soldiers of the British South Africa Company in action against the Ndebele, 1893. They are using a Maxim gun

The Ndebele had little difficulty in defeating and ruling the local people. Thanks to the earlier invasion of the area by the Ngoni, the Rozwi empire had fallen and its last ruler killed, so that the Ndebele met only ineffective resistance by small, weak and isolated groups of the Rozwi and Kalanga. They are better known collectively as the Shona. In their new country the Ndebele grew rich and strong and increased in numbers. The population increase was helped by the arrival of some Nguni who had split from Zwangendaba's army. The prosperity which the Ndebele enjoyed during this formative period is fully illustrated by the high number of settlements and towns which sprang up all over the country. Chief among these were Inyati, Mahlokohlokho and em Hlahlandhlela.

In many respects the Ndebele state had much in common with the Zulu kingdom, and the Zulu considerably influenced the Ndebele system of administration and military settlement. As in the Zulu kingdom, each settlement was headed by an *induna*, who was appointed by the ruler from the commoner clans and not from the royal ones. It was the *indunas* who enforced the king's orders, instructions and policy and who, therefore, governed. The regiments of warriors were given weapons and fed by the ruler. Like their Zulu counterparts, they remained in active service till they were released, when they also became free to marry. The Ndebele also assimilated most of the people they defeated, such as the Shona, Tswana and several Sotho-speaking people, into their community. Like the original Nguni immigrants and their descendants, all absorbed elements still speak Sindebele and have adopted the Nguni culture.

However, the Ndebele organization differed from the Zulu one in two important respects. First, practically the entire Ndebele population was an army of warriors. Because the Ndebele lived among hostile peoples and had to fight most of the time, their society was specifically organized to meet that challenge. There were two categories of warriors. The first category consisted of a regular force of young unmarried men called *machaka*. The second group comprised the older married warriors who were only called upon to fight either when there was an emergency or when large expeditions were necessary. In normal times they grew food crops and looked after cattle. The second difference was that the Ndebele did not have two types of chiefs or *indunas*, i.e. the military ones and those in charge of administrative areas, as did the Zulu. Since the entire nation formed one large army, the military *indunas* performed all the functions of district chiefs among the Zulu. The army was the centre of power, although it was headed and controlled by the king.

Mzilikazi lived until 1868 when he died at a very old age. He was succeeded by his son, Lobengula. But times were soon to change and the future of the Ndebele state was in the balance. In 1893 the British South Africa Company fought and defeated the renowned nation of warriors. Traditional methods of warfare which had sufficed in earlier days under different circumstances proved ineffective against the new Maxim guns from Europe. The Ndebele rebellion of 1890 was mercilessly crushed and the entire nation destroyed. The Ndebele lost their best land to the whites. They had also the painful experience of seeing their age-old regimental settlements and institutions ruthlessly destroyed by their new white rulers.

Military organization

Lobengula, son of Mzilikazi, Chief of the Ndebele

Lobengula and the collapse of the Ndebele

The rule of Dingane

Dingane, Chief of the Zulu, 1828–40

For a short time after the assassination of Shaka, Dingane and Mhalangana shared power with the support of Mbhopa. Then jealousy, greed and hatred set in and the three of them became bitter enemies. Mhalangana was the first to be murdered, on Dingane's orders. His death was followed by the murder of many potential rivals, including Mbhopa. Dingane was left as sole ruler. He tried to please the people by relaxing the severe discipline imposed on the regiments by Shaka. Warriors were freed from the regiments and allowed to marry earlier than under the previous regulations. At the same time Dingane put an end to military expeditions. However, this could not last long. Soon there were attempts at secession and severe discipline was enforced once again to keep the army busy. Zulu warriors launched attacks against the Pondo, the Ndebele, under Mzilikazi, and the Ngwane, led by Sobhuza, capturing many cattle.

Under Dingane's rule the Zulu first came into decisive contact with the whites. On the whole Dingane was friendly to the English in Natal, but he was concerned about the security of his state as more and more Europeans settled in Natal. He was also unhappy about the fact that many of his subjects fled to Natal where they were well received as refugees. Such people could endanger the stability of the state by attacking it. Dingane therefore decided to enter into an agreement with an Englishman called Captain Allen Gardiner, who had some authority over the whites in Natal. We have already come across this agreement in chapter 3 (page 44). It required Natal authorities to send back all Zulu refugees to Zululand. It also made it possible for missionaries to do their evangelical work, and in 1836 one English and three American missionaries started to teach the gospel. Later in 1838, however, the missionaries left Natal as a result of the war between the Zulu and the Boers.

Relations with the Boers were difficult because of their insatiable greed for land. In November 1835, Piet Retief arrived at Dingane's home in Natal and asked that Natal's fertile land be given to the Boers (who were then on the Great Trek). The Boers were determined to occupy Natal, with or without Dingane's permission. On 3 February 1838, Retief came to Dingane again to repeat his request. However, that same day the Boers moved into Natal and occupied it before Dingane had decided what to do. Seeing that he was in a difficult position, the king signed a charter giving Natal to the Boers. It was the only way he could prevent a disastrous war, but he was not happy with the agreement forced on him and he ordered the murder of the Boer party, which was suddenly attacked on Matiwane Hill. The Zulu hoped

British troops at bay during the Battle of Isandhlwana

of the Boers and there were no wars between them. During this period of prolonged peace the Zulu population steadily increased, due to the return of refugees and also because of natural growth. But now there was no room for expansion. The long period of peace had the negative effect of undermining the discipline of the regiments which existed specifically for purposes of fighting. Warriors grew weary of the new, monotonous life which offered them neither adventure nor challenge. The situation was made worse by a dispute which developed between Mpande's sons over the succession issue. The king's sons became increasingly impatient as their aged father lingered on from year to year, further weakening the power of the state.

The rule of Cetewayo

In 1873, however, Dingané's son, Cetewayo, was officially installed ruler by Sir Theophilus Shepstone, Natal's Secretary for Native Affairs. The Usutu (the faction led by Cetewayo) thus won the battle for the throne against their Usibebu rivals. Under Cetewayo the army became strong once again.

Mpande, Chief of the Zulu, 1840–73, on his throne

to remove the Boer menace in this way but, although Retief and many Boers were killed, the Zulu were later defeated and driven away with heavy losses. Reinforcements of soldiers were sent from the Cape, and Pretorius led a big attack against the Zulu, defeating them at the famous Battle of Blood River on 16 December 1838.

The collapse of Zulu resistance was completed by the agreement which ended the war. According to that agreement, the Zulu had to vacate the entire district of Natal, which would then be occupied by the Boers. Two years later, in February 1840, Dingane was deposed by his brother, Mpande, with the help of the Boers, in return for which he gave them several herds of cattle.

Under Mpande's leadership the country enjoyed relative prosperity and stability, largely because he had the support

The rule of Mpande

By this time, however, the independence of Zululand was in the balance. The decisive day came in April, 1877, when Zululand was annexed to Britain. The official reason given was that the Zulu state was a threat to the Transvaal, and the Transvaal had just suffered a humiliating defeat at the hand of Chief Sekukuni of the Pedi. However, this was not the real reason. The Zulu were crushed in order to create the necessary climate for the formation of a federation of white South African states. It was hoped that the annexation of Zululand would remove the Cape Colony's fear of belonging to a federation (with Natal) which would be subject to Zulu attacks. The Boers had no doubt about Britain's ability to deal with Africans, and the Zulu's land would become available for Boer settlement.

Once a decision was made to crush and subjugate the Zulu, there was no turning back. Earlier the Zulu had been ordered by Sir Bartle Frere, Governor of Cape Colony, to destroy their entire state organization. This they could not accept. In January 1879, British troops invaded the country, only to meet with a humiliating defeat at the Battle of Isandhlwana.

Annexation of Zululand

Sir Bartle Frere, Governor of Cape Colony, 1876–80

The Zulu War 1879

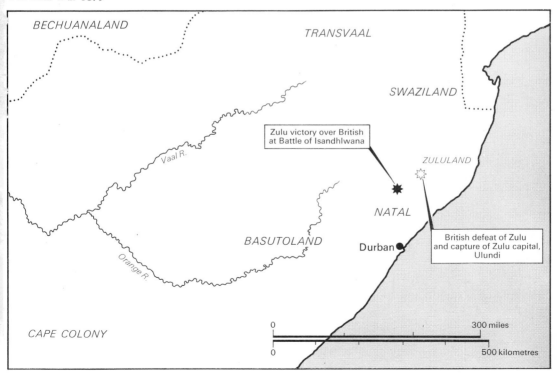

Cetewayo escorted by British troops after his capture at Ulundi

The Zulu victory scared the British and encouraged the Boers of Transvaal to rebel. It also resulted in the abandonment of attempts at federation. Six months after the Battle of Isandhlwana the British sent a larger and greatly improved expedition against the Zulu. They defeated the Zulu and captured Ulundi, the Zulu capital. Cetewayo was captured and taken to Cape Town. The age-old Zulu military tactics and weapons had been overpowered by the enemy's firearms. The Battle of Ulundi marked the end of the independent Zulu kingdom.

Though the kingdom was not directly annexed by Britain, it was divided into 13 states under different chiefs appointed by the British. One of them was even placed under a Scotsman called John Dunn. The system was a failure and resulted in chaos and anarchy among the various divisions and between them and their neighbours. The old Usibebu and Usutu factions resumed their rivalries. A temporary restoration of Cetewayo to the throne in 1883 proved fruitless and he had to leave the country again almost immediately. The following year he died in exile.

The rule of Dinizulu and the collapse of Zululand

After a confused period marked by succession disputes, friction and scheming, Cetewayo's eldest son, Dinizulu, emerged as the new ruler. Though he was only 15 years old at the time of his father's flight into exile, he received the support of some of the former councillors of his father who regarded him as the legitimate heir to the Zulu throne. His

position was strengthened when the councillors successfully appealed for support to the Afrikaner farmers in northern Zululand. The Afrikaners helped him against his opponents, the Usibebu, and recognized him as the paramount chief of the Zulu. They declared a large district in north-western Zululand a 'New Republic' for their exclusive use, and claimed overall control of the rest of Zululand, except for the Zulu Reserve next to Natal. In 1886, Britain recognized the 'New Republic', which was much smaller than its original size. At the same time the Republic renounced its claim to overlordship over Dinizulu. The following year the 'New Republic' ceased to exist when it was incorporated in the Transvaal.

Dinizulu and his councillors were never reconciled to their new status as a subject people. Their hostility to the new régime was intensified by the growing power of the British-appointed district magistrates at the expense of the chiefs' authority. Dinizulu and his councillors finally tried to resist this erosion of their power but Dinizulu was arrested, convicted of treason and exiled to St Helena, returning in 1897 as a mere headman in the Usutu district.

Earlier, in 1894, what was left of the original Zulu state had been annexed to Natal. This resulted in the loss of more Zulu land to the Afrikaners in 1902–4, when about two-thirds of the country was thrown open to white settlement. Relations with Natal were poor, mainly because of the introduction of a poll tax of £1 per head. Though the tax was intended as a measure to overcome economic problems it was not popular among the Zulu. Early in 1906, for instance, magistrates in the districts of the Umgeni and Greytown were obstructed in their work of tax collection. A former chief called Bambata, who had been dismissed by the Government, reappeared and aroused the support of thousands of rebels across the Tugela River. The rebels clashed with government forces which soon regained control of the situation. This was the Bambata Rebellion in which 32 whites and 3,000 Africans were killed.

The Government of Natal arrested Dinizulu in 1907 on the allegation that he had been behind the Bambata Rebellion and that he was involved in a new conspiracy against the Government. The trial lasted from 1908 to March 1909 when he was acquitted. By that time, however, the Zulu nation had been ruthlessly and systematically subjugated. That the Zulu identity and the sense of unity created by Shaka have survived in the face of such odds is one of the most remarkable features in history. It is a great tribute to the founder of the Zulu kingdom, his successors and their subjects.

The Bambata Rebellion, 1906

Dinizulu, Chief of the Zulu from 1883, at the time of his arrest in 1907

Chapter 7

The growth of new nations II: the Swazi and the Basuto

As we saw in the last chapter, as a result of the greatly changed social, economic and military conditions from about the end of the eighteenth century onwards, larger and stronger states came into existence. Here I shall consider the Swazi and the Basuto.

The rule of Sobhuza

THE SWAZI

The origins and growth of the Swazi state date back to the time of kings Sobhuza and Mswati. After the Ngwane had been defeated by the Ndwandwe, they were led by Sobhuza to the central part of modern Swaziland (see chapter 6). In their new homes they fought and defeated the small Nguni and Sotho-speaking communities and organized them into a new and larger state. The Ngwane were able to defeat their opponents due to two main reasons. They vastly outnumbered the local people and they were better organized. While their opponents were organized into small, and therefore weak, independent groups, the Ngwane were organized in age-regiments, in the same way as the Mthethwa under Dingiswayo (see chapter 5).

Due to the policy followed by Sobhuza, the new enlarged nation achieved unity and cohesion, particularly necessary for the success of a multi-tribal state. Under Sobhuza's leadership the opponents of the Ngwane were treated sympathetically after their defeat. They were conquered and lost their independence, and their young men were recruited into the age-regiments of the Nguni-speaking Ngwane, but Sobhuza was lenient to them and even allowed them to retain their old chiefs. In addition, capable non-Ngwane warriors were given the same status as their Ngwane colleagues. Because of this lenient treatment the non-Ngwane people soon developed loyalty to the new state. For example, they adopted the Nguni language and culture, although they retained much of their original identity at the local level.

In his relations with the neighbouring states Sobhuza followed an equally cautious and sound policy. Since his main aim was to strengthen his own position and that of the new state, he had to avoid unnecessary wars with his neighbours. For example, friendly relations were restored with the

Ndwandwe, and Sobhuza married one of Zwide's daughters. Sobhuza's people were also on good terms with Shaka who, therefore, never attacked them. Even when Dingane (who succeeded Shaka) sent Zulu troops against the Swazi, Sobhuza advised his people to withdraw into safe areas in order to avoid the disaster which would have resulted from resistance. In the end the Swazi drove the invaders away when they had grown tired and weak. Unfortunately for the Swazi, this period of peace and stability could not last for ever. In 1840 their conciliatory ruler died and was succeeded by his son, Mswati.

Mswati was the son of Sobhuza and Zwide's daughter. He ruled for a long time and became the greatest of the Swazi kings, giving his name to the nation over which he ruled. It was under his rule that the Swazi people became strong and adventurous, improving and strengthening their political and military organization to cope with contemporary demands. Mswati's rule is also important because of the contacts he established with the Boers.

The rule of Mswati, 1840–75

The Swazi system of government was partly influenced by that of the Zulu. They had territorial chiefs, most of whom were descended from the original ruling families before the Ngwane invasion. At the same time there were chiefs who owed their appointment to Kings Sobhuza and Mswati. All the chiefs were directly under the central administration and were associated with the royal homesteads in their respective areas. They were not free to behave and act as independent rulers. Swazi chiefs, however, unlike their Zulu counterparts, exercised considerable power. Together with other leading commoners, they formed an important council which considered major state issues. The chiefs could also use the young warriors who were under their authority in local conflicts. This tended to strengthen their local position but was in no way a threat to the central government. The Swazi system also differed from the Zulu one in another important respect: all adult males were free to attend the regular meetings of the leading men in the state. This was a much larger assembly than the chiefs' council and was a valuable forum for open discussion and criticism. It met periodically. The king could be criticized and even fined if, for example, he failed to attend a meeting after calling one. In addition, the assembly could amend or reject the decisions of the smaller council of chiefs and chief commoners. This amounted to government by consent, based on freedom of speech. It was vastly different from the autocratic system of the Zulu and the Ndebele.

Administrative system

Unlike the Zulu, the Swazi attached great importance to the Queen Mother. Though she did not have any real power, she was highly respected and was superior to the king. Her homestead was also the official capital of the kingdom. She acted as regent if a king died while his heir was still young, and was expected to restrain her son whenever he tended to be wild and irresponsible. By all accounts, therefore, the Queen Mother was held in very high esteem and, together with the king, was the centre of national loyalty.

As in many similar societies, such as the Zulu and the Ndebele, loyalty to the nation was a genuine binding force, and not merely a matter of sentiment. Indeed the very nature of these people's political and military organization would have made a mere symbolic expression of loyalty to the state

The Swazi Queen Mother, Usibati (centre), in conference with Theophilus Shepstone (sitting left of the Queen Mother)

impossible and unnecessary. To be meaningful and effective, loyalty to the state had to be part of, and result from, the accepted pattern of life. Among the Swazi this pattern of life was based on one's personal ties with the wider society from the lowest level, the clan. Because all men had intimate ties with and obligations to their respective clans, age-regiments, territorial chiefs, the chief military commander, public councils and, therefore, the nation at large, they developed a strong sense of loyalty to the state. These loyalties worked together to strengthen the unity of the multi-clan and multi-tribal state.

To a large extent the rapid and effective centralization of the Swazi state was made possible by the nature of its military organization. This was greatly influenced by the Zulu system of age-regiments, particularly the use of the stabbing spear and the assimilation of conquered peoples (see chapter 5). The Swazi built military settlements and formed age-regiments to which men from all over the country belonged, depending on their age. Under normal circumstances the majority of young men remained under the authority of their chiefs, but in wartime they all marched to the king's capital and fought in their age-regiments. In peacetime some of the young men also went to the king's capital where they looked after his herds and acted as weapon-carriers. In the capital they mixed with many young men from other parts of the nation, and in due course joined appropriate regiments and remained there until their disbandment. All the regiments were commanded by officers appointed by the king from commoner families. This efficient organization welded men from all corners of the state into one nation of people with common interests and experiences. Conquered peoples were assimilated and became part of the larger state, and the system had the further effect of strengthening the position of the king.

Military organization

Mswati's military might was tested when he intervened in the Shangane kingdom of southern Mozambique (see chapter 6). After Shangane's death in 1856, his two sons, Mawewe and Mzila, fought for the throne. Mawewe, the rightful heir, was deposed and appealed to Mswati for help. Swazi forces intervened but were defeated by Mzila, who was assisted by the Portuguese from Delagoa Bay. Inconclusive fighting continued until 1862, by which time the Swazi had destroyed much property, including their opponents' villages.

After Mswati's death in 1875, his successor, Mbandzeni, became increasingly adventurous and used the army he inherited from his father to raid his enemies. He sent Swazi

warriors against the people of the Zoutpansberg and Lydenburg Republics in the Transvaal and caused much destruction. In 1880 his warriors fought alongside the British against the Pedi, led by Sekukuni, and defeated them. He died in 1890 and was succeeded by Bunu.

Contact with Europeans

So far the Swazi had succeeded in assimilating aliens into their society. The coming of white men altered that situation for they could not easily be assimilated into the Swazi society and, in any case, they were not willing to become the subjects of Swazi kings. Yet they wanted the fertile Swazi land. At first the Boers arrived in peace and were given a friendly welcome. In 1845 Mswati gave them an extensive territory for their own use, and later they were allowed to graze their cattle in the country. During this period the Boers increased their influence in the country by assisting it against the Poko in 1864. They also helped Mbandzeni into power.

As the Boer population and influence increased, the Swazi became increasingly anxious about their security. Because the Boers envied their fertile land, the Swazi were worried about the possibility of a Boer attack. To overcome this threat Mbandzeni reorganized his administration and gave the whites in his country their own chief who would be answerable to him. The man chosen was Theophilus, 'Offy', Shepstone, the son of Sir Theophilus Shepstone, who was a British officer in Natal. He was in charge of all matters affecting the Europeans in Swaziland, but he was subordinate to the king and had to respect his opinion. To help him in his work a white committee was set up, consisting of elected members and nominees of the king. The situation, however, was far from simple. The whites could not be easily controlled, not even by Shepstone. The Boers were farmers who wanted more land, and they sought to annex the whole country to the Transvaal, their centre. At the same time, the British in Swaziland wanted their mining and business interests and rights to be protected. Mbandzeni had given them the right to import tobacco and prospect for minerals. These rights would be endangered if the country was annexed to the Transvaal and came under Boer control.

Annexation of Swaziland

The failure of the white committee to work properly led to its dissolution. It was replaced by a provisional government in which Swazi, Boer and British interests were represented, but the experiment failed owing to corruption and white domination and arrogance. In the end persistent Boer demands for annexation received British support and in 1894 Swaziland came under Transvaal's rule.

Theophilus Shepstone, British Resident Adviser to the Swazi nation

The change was unpopular among the Swazi, who never approved of it. The Boer rule was resented because it undermined the authority of the Swazi Government. The Boers even went to the extent of trying to arrest the new king, Bunu, who had succeeded to the throne after Mbandzeni's death in 1890. They also introduced taxes which were for their own benefit but to the disadvantage of the Swazi. However, thanks to the outbreak of the Anglo-Boer war of 1899–1902 (see chapter 9), Boer rule came to an end and Swaziland became a British protectorate, although by that time it had lost most of its fertile land to the whites. Though now independent since 1966, Swaziland's economy is still weak and many of its people have to work on South African farms and in South Africa's rich gold and diamond mines. Swaziland also depends on South Africa for its main communications with the outside world.

Motlomi and early foundations

The country now called Lesotho was previously known as Basutoland. Originally it was the home of the Bushmen and of the Kwena and the Fokeng branches of the Sotho and the Nguni-speaking people. All these people lived in small isolated settlements; the Bushmen lived in caves in the hilly areas. By the early nineteenth century, however, Chief Motlomi of the Kwena was busy trying to bring the various groups together into a larger community. Unlike many of his contemporaries who liked war and terror, Motlomi preferred peaceful and just methods in dealing with other people. In this way and also because of his marriage ties with different ethnic groups, he exercised great influence over a wide area. Before his death in 1815 he succeeded in influencing Moshesh, the son of Mokachane, one of the minor chiefs of the Kwena. He taught him that good rulers were those who were just to their subjects and peaceful in their relations with their neighbours. Moshesh grew up to become a great and wise leader.

Moshesh's greatness

Moshesh, founder of the Basuto

To understand the nature of the greatness of Moshesh we need to know what he achieved for Basutoland. Just as Shaka and Mzilikazi were the respective founders of the Zulu and Ndebele states, so also was Moshesh responsible for the creation and growth of the Basuto nation. He incorporated many diverse groups, which had been driven from their homes by the wars of the early nineteenth century, into a united and stable state. Through his peaceful policy, patience and understanding he restored law, order and stability among those people who had been reduced by continuous wars to cannibalism, savagery and recklessness. They were given cattle and land on which to settle and so became law-abiding.

Some of the refugees came from Natal, while others belonged to the Rolong (half-caste Hottentots), Koranas and Thembu. The Hlubi and Mehlomakhulu of Pondoland were also allowed to settle in the country for a short time during the long period of instability. With the return of peace many Sotho-speaking people returned to the country from the Cape Colony, where they had gone for protection. They brought back their herds and swelled the local population.

Warfare and diplomacy

Though Moshesh disliked war, he had many enemies whose aim was to destroy his country. For, example, the Griqua and Korana (whose warriors had guns and fought on horseback) made several devastating attacks on the Basuto. They took Basuto cattle and destroyed their villages and crops.

The stronghold at Thaba Bosiu, showing the plains below it

The Tlokwa and the Ngwane were also attracted by the Basuto cattle and attacked them. The Tlokwa (then known as Mantatees) were defeated in 1853 and incorporated. Sikonyela, their leader, fled with a few followers to the north-eastern part of the Cape Colony. To save his people from catastrophe, Moshesh combined war with diplomacy: he paid tribute to Shaka and gave some cattle to the Ndebele warriors after their retreat. As a result the Basuto were left alone.

One reason for Moshesh's success was that he understood the value of good defensive positions. He built his capitals in places that could be easily defended against the enemy. In those days of insecurity and constant warfare this was a paramount consideration. His first capital was on Butha-Buthe in the north-east of the country. When this proved inadequate during the Tlokwa attacks, the capital was moved to Thaba Bosiu ('the hill of night'), so called because the weary migrants arrived there at night. It was big enough to accommodate the people together with their food and cattle during a prolonged siege by the enemy, and its steep hills could be easily defended. In peacetime the people could live on its flat top and work on the plains.

The state over which Moshesh ruled was bound together by one main factor: external threat. Common interests and problems imposed a sense of togetherness on the people. Moshesh's system of administration alone could not have achieved such effective unity. It is true that all the territorial chiefs recognized his authority, but they also enjoyed considerable local autonomy in matters of administration and culture. The age-regiment system was not applied as rigorously as among the Zulu and the Ndebele, and the chiefs of conquered people retained much local authority. They were not replaced by the king and, unlike the Zulu, had their own initiation ceremonies.

Contacts with missionaries

In his new state Moshesh received missionaries and gave them land on which to build stations. In 1833 the representatives of the Paris Evangelical Missionary Society arrived in the country and built missions at Morija and Beersheba. The same year Wesleyan missionaries came and settled near Thaba Nchu. They all recognized the authority of Moshesh.

Relations with Europeans

The Agreement of 1846

By far Moshesh's greatest achievement was his ability to preserve the autonomy of his state in the face of mounting hostility from the Boers. Though the Boers had come there to graze their cattle since the 1820s, it was not until the Great Trek that they came in large numbers and became a threat to the safety and integrity of the state. The Basuto received them well and gave them land for temporary grazing and settlement, but the Boers refused to recognize Moshesh's authority and considered the land given to them as permanently theirs. They had come to stay and were prepared to fight the local people. Alarmed at this strange and dangerous behaviour, Moshesh asked for British protection as a means of safeguarding his sovereignty. The British twice rejected his request, but in 1846 Moshesh entered into an arrangement with Britain, aimed at removing conflict between his people and the Boers. It was not a satisfactory arrangement but, in the circumstances, it was better than none at all. According to the agreement, Moshesh was to set aside some land on which only European farmers could settle. The Basuto had to vacate that area and move elsewhere. The arrangement provided that the white men should pay for their right to use the land. At the same time they were forbidden to live or farm outside the areas allocated to them in Basutoland, and those living in Basuto areas had to move out. Furthermore, Europeans living in areas set aside for white settlement were supposed to be under the general authority of the Basuto, although they

Sir Harry Smith, Governor of Cape Colony, 1847–51

were under immediate British control through a British Resident at Bloemfontein.

The Agreement of 1846 failed to solve the Basuto-white problem. The whites were unwilling to abandon the farms they already occupied outside the area set aside for them, and the British Resident at Bloemfontein found it difficult to control them. In 1848 Governor Harry Smith annexed the whole district as the Orange River Sovereignty, but conflicts between the Basuto and Boers could not be removed so easily. There was still no clear and acceptable boundary between the two peoples living in Basutoland. Although their population was growing rapidly, the Basuto were unable to expand, due to Boer settlements. The Basuto soon found themselves in an awkward position as Major H. D. Warden, the British Resident in charge of the new Orange River Sovereignty, gave more and more of their land to the whites and others without their consent. Warden drew an arbitrary boundary dividing Boer farms from Basuto settlements. The Basuto lost much land and many of them were included in the white area. This was followed by more boundaries, this time between the Basuto and the Rolong and Tlokwa with whom they had land conflicts. Here again the Basuto lost some land. Moshesh was forced to accept the unfavourable boundary arrangements, and still stuck to his policy of peace and reconciliation. Not so his subjects. The Basuto became restless and impatient as more and more of their land was lost and their authority undermined. Soon fighting broke out in many parts of the country. The British supported the Rolong against the Taung, who were in turn supported by the Basuto. The Basuto and their allies won. This battle was followed by a combined British, Griqua and Rolong invasion, on Warden's orders; the Basuto had to be crushed in the interests of British honour. But to everybody's amazement, the invaders were again badly defeated and had to withdraw. And later the Tlokwa also suffered defeat at the hands of the Basuto.

The situation became more critical and confused when Sir George Cathcart replaced Sir Harry Smith as Governor. He was determined to crush the Basuto in order to restore British prestige. A pretext for aggression was soon found. The Basuto were given three days to pay a fine of 10,000 head of cattle for their recent acts. Moshesh managed to pay 3,500 by the third day and asked for more time to pay the rest. The appeal was rejected out of hand and on 19 December 1852 the British invaded Basutoland and captured large herds of cattle. They were intercepted by Basuto warriors

Warden's boundaries and Basuto victories

Major H. D. Warden, British Resident in charge of the Orange River Sovereignty

British aggression

Sir George Cathcart, Governor of Cape Colony from 1851

who drove them away before they could do any further damage. The immediate danger had been averted, but Moshesh knew that the future of his nation was in the balance. The British were determined to conquer and destroy Basutoland. Accordingly, Moshesh decided to write a letter to Governor George Cathcart before the British could make a massive all-out attack. The tone and timing of the letter again show Moshesh's wisdom and diplomacy. It read:

Your Excellency,

This day you have fought against my people and taken much cattle. As the object for which you have come is to have a compensation for the Boers, I beg you will be satisfied with what you have taken. I entreat peace from you—you have shown your power, you have chastised— but let it be enough, I pray you, and let me no longer be considered an enemy of the Queen. I will try all I can to keep my people in order in the future.*

Moshesh's diplomacy won the day and his people were not attacked again by the British. But the Basuto had been badly shaken and their morale and authority considerably weakened.

The Bloemfontein Convention, 1854

One important result of these conflicts was that Britain decided to end her part in the endless conflicts by granting independence to the Boers of the Orange River Sovereignty. The Boers were not prepared for such a step, although a few of them favoured it. Not unnaturally, they too were afraid of the Basuto, who had just proved their military strength against the British, and were reluctant to lose British support. Nevertheless, by the Bloemfontein Convention of 1854, they became independent and their country became known as the Orange Free State. The British agreed to sell them guns and ammunition and also undertook not to sell ammunition to the Basuto. In this way, it was hoped, the Boers would become strong and the Basuto defenceless. The Basuto were in for a hard struggle.

In 1858 and again in 1866 the Basuto were attacked by the Boers. In the first war the Boers suffered heavy losses and failed to capture Thaba Bosiu, the Basuto mountain strong-hold. The second war was disastrous for the Basuto. Though their capital was saved, they lost much property, including cattle and crops. Their homes were destroyed and many lives were lost as the Boers tried to exterminate the whole population in a bid to seize their land. At the same time

* Quoted in J. D. Omer-Cooper, *The Zulu Aftermath*, Longman, London, 1966, p. 111.

Basutoland was experiencing internal instability and weakness. Moshesh was growing old and weak and his sons were struggling between themselves for the throne. Once again the old king was forced to sign away most of his country's fertile land to the insatiable Boers.

There was a real danger of the Basuto being left landless. Already they had lost all their agricultural land at a time when there was no room for outward expansion. In a last desperate attempt to save ` his country, Moshesh made another request for British protection. This was granted by Governor Philip Wodehouse of the Cape Colony and in 1868 Basutoland became a British protectorate. Had Basutoland disintegrated any further, conflict and instability would have occurred throughout southern Africa as Basuto refugees sought land and protection in areas already crowded.

The collapse of Basutoland, and British protectorate, 1868

Swaziland and Basutoland

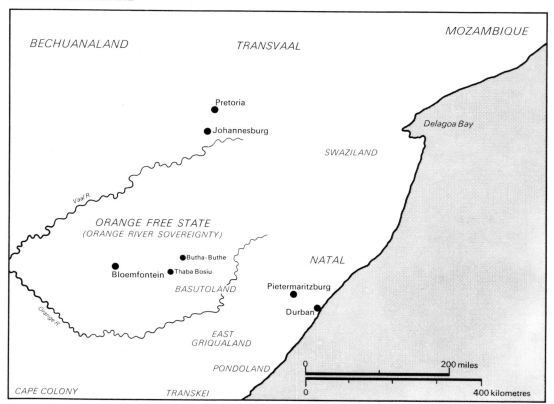

A Basuto warrior

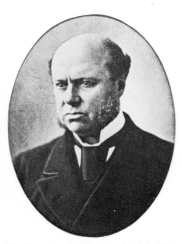

Sir Hercules Robinson, British High Commissioner

By annexing Basutoland the British hoped to establish a strong and effective government in the area. In this way peace and stability would return to the country and skirmishes between Europeans and Africans would be eliminated. But the very annexation of the country caused a great deal of ill-feeling among the colonists of the Orange Free State. Anti-British sentiment was aroused and many people expressed a wish for a republican status on the lines of the South African Republic. By alienating public opinion in the Orange Free State the annexation of Basutoland therefore reduced still further the chances of closer union. But it ought to be added that, as more and more of South Africa came under British control and administration, it became easier to apply a uniform policy.

It was a long time before Basutoland was to enjoy a period of peace and prosperity. In 1879 it came under the direct control of the Cape Colony. The following year the Basuto were again at war, this time against the Cape administration. This was the famous 'War of the Guns' which was caused by the Basuto's refusal to give up their valuable guns, as required under a new law, the Peace Preservation Bill of 1878, passed by the Cape Colony to disarm Africans. The Basuto refused to be left without their only means of self-defence in a hostile world and fought for two whole years. The Cape Government also decided to increase the 'hut tax' paid by the Sotho and to open part of southern Basutoland to white settlement, according to the proclamation of April 1880. Moorosi, the ruler of southern Basutoland, had led the defiant southern Basuto against the Government before he was defeated and killed in November 1879. Then, as a result of the 1880 proclamation, more Basuto joined the war, led by Lerotholi whose troops at one time numbered 23,000 armed warriors, some of them on horseback. Gradually fighting spread to the Transkei and East Griqualand where some Thembu, Griqua and people of Sotho origin rose against the authorities. The Basuto adopted guerilla tactics by avoiding government forces and making surprise attacks. The Cape forces were demoralized and exhausted and failed to contain the situation, although in the Transkei and East Griqualand the rebels were crushed by April 1881. Later the same year the British High Commissioner, Sir Hercules Robinson, mediated between the two sides and the war was ended. Though the peace terms required the Basuto to register and license their guns and pay a compensation to the Cape Government, this was of little practical value since the Cape had withdrawn its forces and could not enforce these terms. Despite their apparent victory, however, the Basuto were greatly weakened by the

war which had also aroused old hostilities in Moshesh's family and created fresh hatred between those who had fought against the Government and those who had supported it. But the Basuto nation survived the crisis and prepared itself for a challenging future. In 1966 it attained independence under the name of Lesotho. Like Swaziland, it is dependent on the Republic of South Africa for its economy and communications and many of its people live and work there.

Government troops attacking Moorosi's mountain stronghold in southern Basutoland, 1879

Chapter 8 Background to political unification

By 1857 there were eight European-ruled political units in South Africa. Of these, five (the Orange Free State, the South African Republic, Lydenburg, Zoutpansberg and Utrecht) were Boer republics while the remainder (the Cape Colony, Natal and British Kaffraria, i.e. the former Province of Queen Adelaide) were British colonies. In May 1910 South Africa became one country under one central government with one parliament and one flag. The actual process of unification will be narrated in the next chapter. Here we shall confine ourselves to the events of the period from about 1858 to 1899, the date of the outbreak of the Anglo-Boer War.

The opening of the first Cape Parliament in the State Room, Cape Town, in 1854

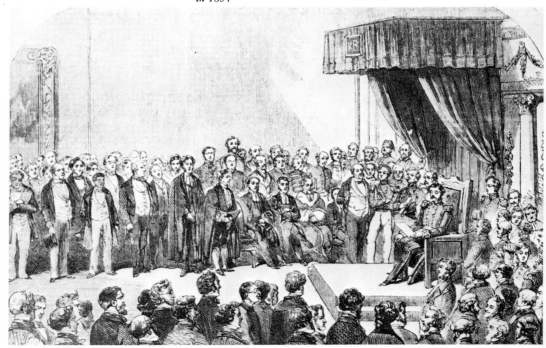

The chief characteristics of this period were trends towards greater union, mainly created through Britain's adoption of a much more aggressive and expansionist colonial policy, and the inevitable consequences of this policy—friction between the British administration and the Boers. This culminated in the Transvaal War of Independence of 1880 and the Jameson Raid of 1895.

The year 1858 saw the unification of the two republics of Lydenburg and Utrecht and Zoutpansberg's acceptance of the Constitution of the South African Republic (Transvaal). This was followed by the union of the small republics with the South African Republic in 1860.

Trends towards greater union

Political map of South Africa at the end of the nineteenth century

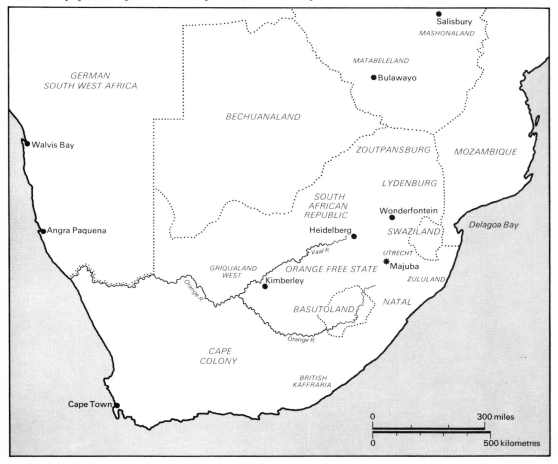

Sir George Grey, Governor of Cape Colony, 1854–8

Meanwhile, the British were also busy devising a suitable scheme for a closer union between their colonies. Accordingly, in 1858 the British Government enpowered Governor George Grey of the Cape Colony to make recommendations on the possibility of creating a federation of the three British colonies in South Africa. The report which Grey submitted was in favour of the idea of a federation. Equally significant was his recommendation that the Orange Free State, which was very sympathetic to the idea of a federation, also be allowed to become a member of the proposed federation. Even in the case of the South African Republic (which was hostile to the federation issue), Grey recommended that the door be left open in case she should decide to join at a later date. Grey, however, was rather over-enthusiastic and impatient. Without waiting for the reaction of the British Government to his report, he asked the Parliament of the Cape Colony to give favourable consideration to the Orange Free State's request for federation. By his precipitate action, Grey ruined the chances of the acceptance and implementation of his valuable report. He was recalled home and rebuked for his conduct.

Apart from the unification of the Cape Colony and British Kaffraria in 1866, therefore, it would be safe to say that the British move toward closer union had suffered a setback. But the events of 1868 and 1871 in Basutoland and Griqualand West indirectly provided Britain with a second chance of creating a federation, extending her sphere of influence and control in South Africa. More of South Africa came under British control and administration and it became easier to apply a uniform policy. As will become evident in chapter 11, this was one of the factors responsible for the creation of a united South Africa.

Annexation of Griqualand West

Waterboer, Chief of the Griqua

As with the British occupation of Basutoland, so also with their annexation of Griqualand West. In immediate terms it poisoned relations between the British and the Boers and weakened the possiblity of closer union but, by extending the area under British control, the annexation helped to make it possible for a uniform policy to be applied over a wider area of South Africa. This, without doubt, helped pave the way for closer union.

Following the discovery of diamonds in Griqualand West in 1867, the value of land there suddenly shot up and it became the centre of attraction. Though the actual area where the discoveries were made (roughly where the Kimberley mines are at present) was legally an integral part of the Orange Free State, this fact was disputed by Waterboer, a Griqua chief. Waterboer was encouraged by an Englishman,

David Arnot, to stick to his claim that the land where the diamonds were discovered was under his jurisdiction and, under Arnot's advice, Waterboer asked for British support. Britain accordingly entered the conflict, and in 1871 Griqualand West was declared a British territory. This was followed by the incorporation of the territory into the Cape Colony nine years later in 1880. Both events provoked much anger and hostility in the Orange Free State, and relations between the two white communities in South Africa suffered yet another severe setback.

The Boers felt that the British were deliberately making life intolerable for them instead of leaving them alone. Britain's opposition to the South African Republic's expansion in the area around Delagoa Bay only served to strengthen this feeling. The Republic had to withdraw from the Bay in 1868 and seven years later the Portuguese acquired it by arbitration. Opposition to these events took various forms. In the South African Republic public indignation was so strong and the local parliament (the Volksraad) so critical of the Republic's weakness that President Pretorius had to resign. And, despite the payment of compensation of £90,000 to the Orange Free State in 1876, harmonious relations with Britain were not restored until much later.

Marthinus Wessels Pretorius, first President of the South African Republic

The already deteriorating relations between the British and the Boers were pushed even further by the events of 1877. In that year the Boers suffered their greatest single humiliation ever when the British disregarded their pride as a nation and degraded their status by annexing the South African Republic, the seat of Boer nationalism.

After the fall of President Pretorius, the financial state of the Republic had become very bad. In spite of the devotion of the new President Burgers to the service of the nation, little progress was made in restoring efficiency and stability. It soon became evident that the Government was not only incompetent but also militarily weak, shown by the authorities' failure to suppress a rising of local Africans. The public grew increasingly critical: how could such a Government offer the necessary protection to its subjects if it could not keep the Africans under effective control?

The British, who were interested in the security of their colonies in the neighbourhood, watched developments in the Boer Republic with considerable anxiety. The internal instability in the South African Republic could easily affect the progress and security of neighbouring Natal. The British had solved this problem in the case of Basutoland by its annexation to the Cape Colony. A useful precedent had thus been established. The British Colonial Secretary, Carnarvon,

Annexation of the South African Republic

III

seemed, in any case, to be in favour of annexing the Boer Republic. The domestic problems of the Republic may, therefore, have served as a mere pretext for annexation. Thus when the Colonial Secretary appointed Sir Theophilus Shepstone to investigate the circumstances surrounding the trouble in Transvaal, he went further and secretly instructed him to annex the Republic. This was duly accomplished in April 1877.

The annexation of the South African Republic had the undesired effect of arousing and strengthening Boer nationalism. For the time being, at least, co-operation between the two white communities was practically impossible. In the long run, however, the British policy of expansionism during this period brought a large part of South Africa under British control. In other words, the British policy at this time indirectly paved the way for the eventual unification of South Africa.

The political views of some leaders

While these developments were taking place, there were attempts by some influential people in South Africa to create harmonious relations between the two European sides. This group of people was represented by an Englishman called Cecil Rhodes and Jan Hofmeyr, a Boer. Working in direct opposition was a group of South African leaders who were preoccupied with parochial issues and whose brand of nationalism was opposed to closer union. The strongest member of this group was Paul Kruger, the former President of the South African Republic. The political philosophies of the two groups could never be reconciled.

Cecil Rhodes

Cecil Rhodes was an Englishman who in 1870, at the age of 17, went to Natal to grow cotton. In 1872 he decided to go to Kimberley to work in the diamond industry, which was then in its early stages. He formed the De Beers Company which controlled South Africa's diamond trade. Through hard work and helped by good luck, he grew rich and even managed to finance his own education at Oxford University. In 1881 he became a Member of Parliament in the Cape Colony and nine years later became Prime Minister.

Rhodes was an ardent empire-builder and wanted the British Empire to extend from the Cape to Cairo. He wanted to stop the Germans and Portuguese from expanding into the interior from the west and east respectively, as this would hamper Britain's northward expansion. He believed this could be done by acquiring land in the north, and he planned to run his famous 'Cape to Cairo Railway' through the acquired territory, to connect the British Empire in eastern

The first engine of the Cape to Cairo Railway to reach Salisbury

Africa from south to north. To that end he formed the British South Africa Chartered Company which received a royal charter in 1890. Between 1888 and 1893 Rhodes' men, by a mixture of war and diplomacy, occupied Mashonaland and Matabeleland. They built the town of Salisbury in Mashonaland and took over the Ndebele town of Bulawayo. Thus the foundations of the British colony of Rhodesia were firmly laid and the British flag was hoisted at Salisbury, the future capital of Rhodesia, in 1890.

As a staunch supporter of the British Empire and British rule in the world, including South Africa, Rhodes believed in the value of British traditions and institutions; they were among the best in the world and ought, therefore, to be preserved and propagated. Later, however, his views were modified and he became a defender of local autonomy for South Africans. He saw that imperialism would have to give way to self-government in South Africa. For the time being, however, the colony was still weak and imperial ties should be retained for defence. By abandoning his earlier political beliefs, Rhodes became a supporter of co-operation between the two white communities in the country. Such co-operation was necessary if the country was going to progress peacefully towards the creation of one nation, one South Africa and one government.

Jan Hofmeyr

Jan Hofmeyr's attitude is of great significance here, for he emphasized much the same points. In 1878 he founded the Farmers' Protection Association which at first fought for the interests of brandy producers but later became politically orientated and demanded the use of Dutch as an official language in the Cape Colony. As a moderate, he was opposed to du Toit's* narrow Afrikaner nationalism and, instead, advocated the creation of one South African nation in which all whites would have equal rights. He favoured the idea of self-government for South Africans with the maintenance of British connections, provided the destiny of South Africa was in the hands of its white citizens. Mutual respect and equality were, in his view, the foundations upon which such a nation could be built. He was opposed to the republicanism supported by Kruger and du Toit. In May 1881 he became a Minister in the Cape Colony's Government but resigned six months later.

Although he joined the Afrikaner Bond in 1882 and merged his Farmers' Protection Association with it the following year, Hofmeyr still remained a moderate. The ultimate aim of the new Bond of which he was a member and leader was the creation of a united South Africa. Though the Bond's main achievement was in the literary and linguistic (Afrikaans) fields, it flourished as a political party in the Cape Colony, under Hofmeyr's leadership. It remained the only organized political party there until 1898, and between 1884 and 1898 it always had at least 40% of the seats in both Houses of Parliament in the Cape Colony. Elsewhere in the Orange Free State and Transvaal the Bond was less successful in the political field.

Paul Kruger

Born in the north-east of the Cape Colony in 1825, Kruger participated in the Great Trek as a child. His family joined the party led by Potgieter and eventually settled in Transvaal. While there Kruger took part in the conflicts between the Boers and Africans, and this experience was later to influence his whole attitude to the issue of Afrikaner nationalism. Indeed Kruger became a source of inspiration in his people's resistance movement against the British. His success as a leader was due to his formidable personality, the tenacity of

* Du Toit was a staunch Afrikaner nationalist who aimed at the creation of a united and Afrikaner-led South African nation. He was the editor of the *Patriot* which championed Afrikaner nationalism, culture and language. In 1879 he founded the Afrikaner Bond, a political party, in the Cape Colony. By May 1883 the Bond had 23 branches in the Cape Colony and ten in the Orange Free State and Transvaal.

his character and his absolute conviction in the rightness of his cause. This was combined with a ruthless and persistent pursuit of his policies and the powerful hold he had over the Boers, for whom he stood as a symbol of Afrikaner nationalism.

South Africa has always been a land of conflicts and contrasts and Kruger's political ideas were the very antithesis to those of Rhodes and Hofmeyr. To Kruger the solution to the South African problem lay in the division of the country into Afrikaans-speaking South Africa and English-speaking South Africa. The country, he argued, should sever all colonial ties with Britain and become a republic. But here Kruger was mainly concerned with the Boer area of the country. As long as the Boers were left alone he did not care what happened to the rest of the country. Left to themselves the Boers could unite under one government and flag and, if need be, they could live in complete isolation from the rest of the country.

Kruger's philosophy was reinforced by the Cape Government's rejection of his request, in 1885, for co-operation in matters relating to tariffs and the railways. Economic problems had forced him to make the abortive request for co-operation and henceforth he decided to develop the South African Republic, as it were, in isolation. A railway was constructed to Delagoa Bay and the Transvaal (formerly South African Republic) Government declined to join the South African Customs Union, which was formed in 1889 by the Orange Free State and the Cape Colony. Earlier, in 1886, Kruger's hand had been strengthened by the discovery of the all-precious mineral, gold, in the Witwatersrand district of Transvaal. He saw no further need for assistance from his neighbours.

So much for South African politics before the actual process of unification. We must now focus our attention on internal developments in the country since the annexation of the South African Republic (Transvaal) in 1877. In general terms the period is characterized by warfare of one kind or another.

Internal developments after 1877

The annexation of the Transvaal left the Boers disgruntled, bitter and more critical than ever of British policy in South Africa. The Transvaal even went to the extent of sending a delegation to London to persuade the British Government to restore its independence. The delegation comprised Kruger and Jorissen, a state attorney, but their request was rejected and they returned home empty-handed. The only concession made by the British Government affected the position of the Afrikaans language: henceforth Afrikaans was to be one of

Boer soldiers fighting in the Transvaal War of Independence

the official languages in the Transvaal. In the circumstances, dissatisfaction among the Boers was bound to increase; they could not see why their country had been annexed and reduced to the humble status of a colony.

The Boers were encouraged to rebellion by the removal of the Zulu threat after their defeat at Ulundi, and by the enthusiastic offer of support by the Orange Free State. But no steps were taken towards rebellion until December 1879 when the Transvaal adopted a much more active policy and prepared for war. In that month more than 6,000 Boers met at Wonderfontein and launched the new policy, which entailed a boycott of anybody who co-operated with British authorities, the hoisting of the old flag of the Republic before annexation, and, even more important, the decision that the old Volksraad should meet in April of the following year, 1880.

The Transvaal War of Independence

There is no need to go into the intricate details of the Transvaal War of Independence which broke out in 1880. The war was popular among the Boers, who felt that they were fighting for the restoration and preservation of their sover-

eignty, and they came out in their thousands to help defeat the British. The Boers decided to restore the Republic in the Transvaal and apointed a committee of three men, Kruger, Pretorius and Joubert, to administer the country. As if to demonstrate their intention to be on good terms with their neighbours, they intimated their willingness to form an alliance with other states in South Africa. On 16 December 1880, the historic Dingane's Day, the old Republican flag was hoisted at Heidelberg and the independence of the Transvaal appeared to have been accomplished. When on 27 February 1881, the Boers defeated the British at the celebrated Battle of Majuba Hills, few people in Transvaal could have regretted the decision to go to war.

After the Boer victory at Majuba, however, fighting did not suddenly come to an end. Indeed it lasted till August 1881, when it was terminated by the Pretoria Convention. According to the terms of this agreement, the Transvaal accepted British overrule, and in return the country was granted complete self-government in all internal matters. Foreign affairs remained under British control. The Convention also defined the boundaries of the Transvaal, thus removing any further cause of friction with neighbouring territories. Finally, equal civil rights were extended to all people and slavery was prohibited. The main reason why Britain gave back Transvaal's independence was because Gladstone's Liberal Government had replaced Disraeli's Conservative Party rule in April 1880. The new Government was opposed to continuing British involvement in the intricate and expensive politics of South Africa. They decided to leave Transvaal alone in internal matters.

If the Transvaal War of Independence had worsened relations between the British and the Boers, the Pretoria Convention which concluded the war had the effect of lessening hostilities by granting self-government to the Transvaal. That is not to say that harmonious relations were restored after the war. On the contrary, the Boers were dissatisfied with their new colonial status and later they would again take up arms and fight the British. But, as the saying goes, 'half a loaf is better than none'.

About this time important developments were taking place in another part of southern Africa which were later to affect the course of its history. In South West Africa the Germans were busy establishing themselves. After the unification of Germany under Bismarck's leadership in 1871, Germany became increasingly nationalistic and aggressive. As a new and great nation she wanted to be respected and to make her

The Pretoria Convention, 1881

P. J. Joubert

German involvement in South West Africa

117

The German settlement of South West Africa

presence known and felt. German culture was widely praised as superior to all others and the German mission to civilize the world was freely proclaimed. And since it was fashionable for great powers to own overseas colonies there was no reason why Germany should not do the same. Such was the unofficial view of German merchants and adventurers. The colonies would be valuable as sources of raw materials and as markets for German manufacturers. They could also be settled by the so-called 'surplus' German population.

It was this enthusiasm and sense of mission, real or imaginary, coupled with strong economic motives, which drove German missionaries, traders and adventurers into South West Africa. Their argument was that, if the Germans did not act quickly, their British and French rivals would. German missionaries and traders settled around Walvis Bay, despite British claims to it. The pace of colonization was intensified with the foundation of the German Africa Society in 1878 and the German Colonial Society in 1882. By means of war and dubious treaties, colonies were acquired in East Africa (present mainland Tanzania), Cameroon and South West Africa.

In 1883 the German Government allowed a German trader, Franz A. E. Lüderitz, to build a trading station in Angra Pequena, in South West Africa, where he had acquired land from the local ruler. The following year Germany annexed the land between the Orange River and Angola (leaving out only Walvis Bay). South West Africa became a German protectorate the same year. At that time the country was inhabited by three major African communities: the Ovambo, Herero and Hottentots (such as the Nama).

The scramble for territories by the British, Germans and Boers in Southern Africa was extended eastwards to Bechuanaland. The Germans threatened to expand into the area which the British in the Cape Colony considered as within their space for northward expansion. To add to the confusion two Boer republics, Stellaland and Goshen, had already been established there. As a result of Rhodes's insistence the British acted and in 1885 annexed the southern part of Bechuanaland to the Cape Colony and made the northern part a protectorate. In 1966 the protectorate of Bechuanaland became independent and is now known as Botswana.

British annexation of Bechuanaland

While the political situation was still fluid and tension high, a new crisis was suddenly sparked off in December 1895 through the criminal act of one Dr Leander Starr Jameson, a Briton and a friend of Rhodes. The famous Jameson Raid is not important because of any success or achievement, for it had none to talk of. It achieved nothing positive. Rather its significance lies in the fact that it brought all the Boers together in support of Kruger's Transvaal.

The Jameson Raid

As the name suggests, the raid, or invasion of the Transvaal, was led by Dr Jameson. For some time there had been concern, on the British side, for the rights of the so-called Uitlanders—foreigners or outlanders. These were Englishmen who had assembled in the mining Witwatersrand district of the Transvaal and who owned the bulk of the wealth. Kruger's Government was reluctant to grant them the voting rights for which they vehemently clamoured.

The situation was a difficult one as wealth, politics, age-old differences and other basic considerations were all involved. Kruger and his Government were reluctant to grant voting rights to people who already outnumbered the local rural Boer population in the mining district. They could easily control the Government if they were allowed to vote for Members of Parliament. In addition, the interest of the Uitlanders was seen as temporary and financial. They

had only come into the country to grow rich from the newly discovered mineral wealth and then return to their British part of South Africa. The Boers felt they should not be enfranchised (i.e. allowed to vote) and, in any case, they were members of the hated British nationality against whom the Boers had fought for so many years. There could be no question of leniency with people who threatened the Boer way of life.

Previous to 1882 anyone could be enfranchised after only one year's residence in the Transvaal. In 1882 this residential requirement was raised to five years. A further restriction was enforced at the local level in mining districts, where a special council was set up by the Government. According to this, Uitlanders had to stay in the country for a minimum of two years before they could qualify to vote for the local councillors. The strongest restriction, however, related to the election of Members of Parliament. Only those people who had lived in the country for 14 years or more were eligible to vote for Members of Parliament. It was this which precipitated conflicts between the Boers and the Uitlanders.

Prime Minister Cecil Rhodes of the Cape Colony was the central figure in the arrangements for the raid which followed. By this time Rhodes was determined to bring the Transvaal under British control by force, since Kruger was equally determined to retain and safeguard his country's independence. Having late in life apparently abandoned his policy of moderation, patience and harmony between the two white groups in South Africa, Rhodes now advocated British supremacy. The Transvaal was too rich in minerals to be left out of the British sphere of control and, since his health was weakening, the inclusion of Transvaal in the Empire had to be accomplished soon if he was to live to see it.

With the full knowledge of Britain's Colonial Secretary, Joseph Chamberlain, Rhodes arranged for arms to be smuggled into the Transvaal and instructed certain British mining industrialists in the area to plan for a rebellion in December 1895. The plan was that the outbreak of a revolt by the Uitlanders would lead to and legitimize British intervention in the interests of the security of British women and children. In this way British invasion would assume an air of legality and Kruger would be overthrown and his country subjugated. Acting on Rhodes's instructions, Jameson led 500 men from Bechuanaland (where he headed Rhodes's private army) into the Transvaal, where they were easily defeated and Jameson himself arrested. The invasion was poorly planned and organized and, contrary to Rhodes's expectations, the Uitlanders did not rebel against the Transvaal Government. After the raid Jameson

Dr Jameson taken prisoner by the Boers

was tried and imprisoned in London for four months. Many of the leaders and sympathizers of the raid in the Transvaal were imprisoned or fined.

Coming so soon after the Transvaal War of Independence, the Jameson Raid was an unnecessary catastrophe of which the inevitable result was the inflammation of the already bad relations between the two white communities. Rhodes had to resign as Prime Minister of the Cape Colony and as head of his British South Africa Chartered Company. At the same time, Kruger's prestige was boosted and, with it, Boer nationalism, with independence as its aim.

The raid had the further effect of drawing the Orange Free State closer to the Transvaal, for both had been subjected to British aggression. Kruger thus received unexpected moral support in his struggle against the British, which substantially strengthened his hand and hardened his attitude towards the Uitlanders. Of equal significance was the raid's effect on Britain's international relations. On 2 January 1896 the Emperor of Germany sent a congratulatory telegram to Kruger for his efficiency and success in crushing the raid. Though the telegram did not promise any assistance for the Transvaal against the enemy, its implications were, nevertheless, important. It encouraged the Boers to believe, rightly or wrongly, that Germany would go to their assistance should Britain attack them. This worried the British, who suspected Germany's motives. Britain was critical of Germany's behaviour and became more resolute in its declared policy of maintaining and safeguarding its interests in South Africa. The raid had the effect of isolating Britain internationally, for it was regarded as an unwarranted attack on a small weak state. By intensifying existing misunderstandings, suspicion, jealousy and hatred between the Boers and the British, the Jameson Raid prepared the way for the Anglo-Boer War of 1899–1902.

The process of political unification, 1899–1910

THE ANGLO–BOER WAR, 1899–1902

The Anglo-Boer War of 1899–1902 was the culmination of many generations of misunderstanding, suspicion and rivalry between the Boers and the British. In more immediate terms, the War was preceded by increasing friction and hostility of which the Jameson Raid was an excellent example. After the dismal failure of the raid, hostilities intensified. Britain's Colonial Secretary, Joseph Chamberlain, who had been implicated in the raid, believed that the Boers wanted to bring the whole of South Africa under their control. This could only be achieved at Britain's expense. He believed that the way to avert the danger was by being firm and ruthless with Kruger's Government in the Transvaal. In this he was supported by Sir Alfred Milner who in 1897, on Chamberlain's advice, was appointed Governor of the Cape Colony and High Commissioner for South Africa. Milner was a firm believer in the desirability of extending British imperialism over alien peoples, the Boers included. Indeed, he saw the British as a people endowed with the right to rule over other peoples. As a result, Milner exaggerated anti-British feeling and activities among the Afrikaners, or Boers, to the detriment of the cultivation of harmonious relations in South Africa.

Joseph Chamberlain, British Colonial Secretary

While the British authorities adopted this negative attitude, the Boers in the Transvaal were no less convinced of the rightness of their cause: the defence of their land and sovereignty. They were determined to defend their independence, come what may, and they despised the British whose local military record was not, after all, remarkable. For example, in 1881 the Boers had defeated the British at Majuba and won self-government from them. Earlier, in January 1879, the Zulu had defeated the British at Isandhlwana. Thus the Transvaal became increasingly defiant, an attitude which was strengthened by the hope of getting aid from their kinsmen in Natal and the Cape Colony and, more specifically, from the Orange Free State. It was further hoped that aid against Britain would come from her European enemies, such as Germany.

Sir Alfred Milner, British High Commissioner for South Africa, 1897–1905

The Anglo-Boer War, 1899–1902

Key (legend):
- ✴ British victories
- ☆ Boer victories
- ➤ Boer guerilla attacks

Colt machine gun and crew

The Uitlanders assumed increasing importance as the central people in the conflict, though, as we have seen, their lack of political rights was merely exploited by the British as a pretext for aggression against the Transvaal. After Kruger's re-election as his country's President in 1898 (he had been elected President in 1883 and again in 1893), Milner intensified the conflict by encouraging and supporting anti-Afrikaner and pro-British groups in the Transvaal in their fight against the Government. The aim was to create a confused situation, almost amounting to disorder, in order to justify British intervention on behalf of the underdogs—the Uitlanders. Chamberlain went further and declared that Britain had a legal right to intervene in the area in accordance with the Pretoria Convention of 1881. It was evident that neither Milner nor Chamberlain wanted the conflict to be resolved by peaceful means. In vain the Government of the Cape Colony tried to mediate, for Milner was bent on

intervention and conquest. This was made abundantly clear during his talks with Kruger in Bloemfontein in the Orange Free State. During the discussions, which were held from 31 May to 6 June 1899, Milner obstinately restricted the agenda to the problem of the Uitlanders. He demanded the vote to be extended to all the Uitlanders who had lived in the country for five, instead of 14, years. Reluctantly and after much hesitation Kruger agreed to reduce the residential qualification to seven years to which Milner objected and broke off the talks, when agreement was so imminent. He refused to listen to the Cape Colony's mediation and in August rejected the Transvaal's acceptance of the five-year residential qualification, provided Britain undertook to cease all interference in the country's internal affairs and to respect its sovereignty.

By that time it was clear that Britain wanted war and the issue of the vote for the Uitlanders was only a pretext. In a letter to the British Cabinet, Chamberlain observed: 'What is at stake is the position of Britain in South Africa— and with it the estimate formed of our power and influence in our colonies and throughout the world.'* Britain began to reinforce her troops in South Africa, in readiness for war. As British troops moved nearer the Transvaal's border with Natal, Kruger realized that war was imminent. Accordingly, the old President decided to strike first. On 9 October 1899 he issued an ultimatum to Britain to remove her troops from the border within 48 hours and to refer the dispute to arbitration; failure to comply with the ultimatum would automatically result in a declaration of war. Since Britain wanted war the ultimatum was not answered and fighting broke out two days later.

A British soldier in the Lothian and Border House yeomanry

It is unnecessary to narrate all the details of the Anglo-Boer War, but a few facts are worth noting. Despite its troop reinforcements, the War found Britain unprepared compared to the Boer republics, the Transvaal and the Orange Free State. The republics had long foreseen war, had prepared for it and had the advantage of fighting in a country they knew well, on home ground. They mobilized their forces with considerable speed and were successful at Ladysmith in Natal, and Kimberley and Mafeking in the Cape Colony. However, the Boers had attempted too much too soon and they quickly became weak and ineffective. This tactical error gave the small British force of 2,500 a chance to rally. They received more soldiers from England

* Quoted in Wilson, M. and Thompson, L., *Oxford History of South Africa*, Vol. II, Oxford University Press, London, 1971, p. 324.

A Boer laager near Ladysmith

De la Rey, Commander of the Boer forces in the Transvaal

Sir Alfred, later Lord, Kitchener British Chief of Staff, 1900–4

and India. Boer resistance did not easily give way for the enlarged British forces again suffered heavy defeats at Magersfontein, Stormberg and Colenso. The week of these defeats is known as the 'Black Week'. Then, early in 1900, the Boers suffered decisive defeats as the British occupied Bloemfontein (the capital of the Orange Free State), Mafeking and Kimberley (in the Cape Colony), Ladysmith (in Natal), Pretoria (the capital of the Transvaal), and annexed the Transvaal. Disappointed, desperate, old and weak, Kruger was forced to emigrate to Europe in August 1900, where he died on 14 July 1904. Though skirmishes continued for the next eighteen months, by September 1900 the main fighting was over.

From 1900 Boer resistance took the form of guerrilla warfare. Led by de Wet in the Orange Free State, de la Rey in the Transvaal, and Louis Botha as the Commandant-General of the Transvaal forces, Boer warriors went to the extent of invading the Cape Colony. This greatly worried Lord Kitchener, who had replaced Lord Roberts in 1900 as the Chief of Staff in the last days of the war. He feared a renewed Boer effort might be disastrous. Accordingly, he adopted a ruthless and thorough policy aimed at weakening and wiping out Boer resistance once and for all. He systematically destroyed the enemy's farmhouses and crops and captured their livestock. Concentration camps were built to accommodate Boer civilians and to facilitate mopping-up operations by making it difficult for enemy troops to hide

Boer prisoners in a prisoner-of-war camp at Pretoria

among the civilian population. Soon the Boer resistance collapsed in the face of persistent British attack, accompanied by extreme hardship, starvation and disease. The effect of the war on the civilian population was severe and many died of malnutrition or infectious diseases. Most of the victims were women and children. It has been estimated that at least 26,000 Boer women and children, out of a total population of 118,000, died in the camps by the time the War ended.*

Altogether some 70,000 Boers (including some 10,000 from Natal and the Cape) fought against a total of 300,000 British troops. While many of the British troops were from Britain and other parts of the British Empire, such as Australia and Canada, others were local. The War was fought over practically the whole country, in the Transvaal, the Orange Free State, Natal, Zululand and the Cape Colony.

One important reason for the Boers' defeat is that they failed to receive the foreign support they had expected, and so fought alone against a stronger and determined enemy. At the same time they were let down by their cousins in the Cape Colony; they had hoped that the Afrikaners of that territory would rise against the British. Apart from a few volunteers from the Cape Colony and Natal, only the Orange Free State was fully involved in the War against Britain.

Boer soldiers

* For details of the economic effects of the War, see chapter 10.

Milner and General Kitchener of Great Britain and the Boer General de Wet signing the peace treaty at the end of the Boer War

The Peace of Vereeniging, 1902

The War dragged on in favour of the British who, by now, were numerically superior and were, in any case, better equipped and experienced. On 31 May 1902, hostilities were concluded by the Peace of Vereeniging. But, because of the bitterness which had been unleashed by the War, the Peace of Vereeniging simply ended the War; it did nothing to remove fear and restore real peace in people's minds.

Psychological effects apart, what was the practical significance of the Peace of Vereeniging? To answer this question we need to know something about the provisions of the treaty. Having lost the War, the Boer republics lost their independence and became British colonies. In return, Britain undertook to grant them fully responsible government or local autonomy as soon as the situation returned to normal. During the War much property, including buildings and farms, had been destroyed and the country's economy was considerably weakened. Accordingly, Britain gave £3,000,000 for the work of economic and social reconstruction, in addition to an enormous development loan free of interest.

However, although the Boers had lost the War, they emerged from the conflict strong and united as a nationality against the British and, in a real sense, more victorious than they had been on the military field. It is true that there were many jealousies and differences among them. There were those who wanted to continue with the War to the bitter end while others wanted to withdraw from it before any further damage could be caused. But, to their great credit, they agreed to suppress their differences in the interests of genuine and lasting unity. They extracted very favourable terms from Britain, particularly over the future political rights of the Africans. For centuries there had been severe disagreements over this subject, as explained in chapters 5 and 7. Now, after the War, the British Government made a concession to the defeated Boer republics which was destined to influence and shape the political development of South Africa right up to the present day. In a deliberate attempt to appease the white population of South Africa the British Government shelved the issue of political rights for Africans. It was agreed that the question of whether or not to grant voting rights to non-Europeans should not be decided until after the attainment of responsible government. From then on Britain gradually withdrew from its position as the guardian of humanity, liberty and the rights of the non-whites in general. Thus the road to apartheid and racial segregation was clearly charted in South Africa. It is principally for this reason that it would be justifiable to argue that, although the Boers lost the War, in effect they won a great deal of what thay had fought for over the years.

It would be wrong to assume that the conclusion of the Anglo-Boer War automatically ushered in a period of political unity and harmony. For one thing, while the ex-republics were directly ruled by Britain, the Cape and Natal had enjoyed responsible government from 1872 and 1893 respectively. There was no equality in status. Secondly, though all these territories were now under one authority, namely Britain, it was by no means clear whether the union which was expected to emerge would take the form of a federation, a full political union or even a confederation. Moreover, would the union be initiated from within by the South Africans themselves or from without, imposed by Britain? All these were unresolved issues and they remained so until 1910.

Between 1902 and 1910, however, one can safely say that the process of the unification of South Africa was in progress. It was during this period that significant steps were taken

Political organizations and constitutional changes

Louis Botha, Commandant-General of the Transvaal forces in the Boer War, joint founder of Het Volk Party Party

Jan Christian Smuts, joint founder with Louis Botha of Het Volk Party

towards closer union and final unification. As peace and economic stability slowly returned to the country, important political activities became evident in both the Transvaal and the Orange River Colony.* In the Transvaal Botha and Smuts founded a powerful party called Het Volk Party, i.e. 'the people's party', in 1905. Among other things, the party fully accepted the provisions of the treaty of Vereeniging, stressed the need for a reconciliation between the whites, and demanded responsible government for the ex-republics. The Orangia Unie Party, which was founded in the Orange River Colony, had similar aims.

Even the Cape Colony experienced the political effects of this period. Hofmeyr successfully transformed the Afrikaner Bond party from an exclusively Boer organization into a broader association called the South African Party. The new party was joined by English-speaking liberals, thus making it possible for both communities to work together. Reconciliation and the building of one nation became more possible, although enormous obstacles still stood in the way.

In 1897 Alfred Milner was appointed British High Commissioner to South Africa, and remained there till 1905. An able and devoted son of the Empire, he believed that Britain could only solve the tangled problem of South Africa through the annexation of the Transvaal. He favoured the formation of a united South Africa under British leadership and with British predominance. The British population had to dominate their Boer counterparts in the towns, the countryside and the government. In this he was supported by Britain's Colonial Secretary, Joseph Chamberlain, who authorized him to do everything possible to prepare the way for a British-led South African federation. This explains why Milner was adamantly opposed to Boer demands for independence. The British population in the Boer territories was still outnumbered by the Boers, while Boer loyalty to Britain was still uncertain. Although Milner was not convinced that it was opportune and wise to grant self-government to the ex-republics, as a gesture of goodwill the Transvaal was given representative government. As expected, this concession was not received favourably in Boer South Africa, where it was considered as grossly inadequate.

The Transvaal and the Orange River Colony become self-governing

In December 1906 the new British Liberal Government went a step further and granted complete self-government

* The Orange Free State was called the Orange River Colony after its conquest in 1900. In 1910 the old name was adopted once more.

Statesmen at the Inter-Colonial Conference held in Pretoria, 1908. Present are Smuts (back, third from left), Hertzog (back, middle) and Botha (front, third from left)

to the Transvaal. The following year the same concession was extended to the Orange River Colony. Het Volk Party won the Transvaal elections and Botha became the first Prime Minister, with Smuts as his deputy. In the Orange River Colony the election was won by the Orangia Unie Party and Abraham Fischer became the first Prime Minister. Among his senior ministers were General Hertzog and General de Wet. By 1907 therefore, the way was clear for the formation of the union of South Africa by white equals.

The first major step towards unification or closer union was taken in May 1908, when a conference was held to consider issues relating to the inter-colonial railways and customs. The objectives of the conference had nothing to do with politics as such, but the most important single result of the deliberations of May 1908 was neither economic nor social. It was agreed that a policy of closer union should be pursued in order to remove economic barriers from the path to co-operation and prosperity. It was further recommended that representatives from the four colonies should meet to consider the wider implications and details of closer union.

The 1908 Conference

Christian de Wet, Commander of the Orange Free State forces in the Boer War, later a politician

Later that year colonial representatives did meet at the National Convention, held from 12 October 1908 to 5 November 1908 in Durban, and from 23 November 1908 to 3 February 1909 in Cape Town. Among those present were prominent men such as Jameson (of the Jameson Raid), and ex-republicans, notably Botha, Steyn and de Wet.

The Convention was held in a cordial atmosphere and its results were of paramount importance for the future history of South Africa. First, it was unanimously agreed that there should be complete equality of the Afrikaans and English languages. Secondly, the name of the Orange Free State was to replace the Orange River Colony which had been in use since 1900. And, most important of all, the Convention accepted the idea of one legislative authority for the whole country, although it was emphasized that this would be a political union under the British Government.

Now that the Union of South Africa was fast becoming a reality, it was necessary to devise a suitable Constitution to form the basis of a stable nation and government. This task was competently tackled by the Convention.

According to the provisions of the draft Constitution for the Union, there was to be a Governor-General appointed by the British Crown, who would govern with the assistance of ten Ministers. The Union would have a two-chamber Parliament consisting of the Senate (whose life was ten years and in which the four provinces were equally represented) and the House of Assembly (with a life of five years). The ten Ministers could be chosen from either house. The issue of the right to vote for Members of Parliament was settled in characteristic South African fashion. The franchise was limited to adult European males only; non-Europeans were excluded from the Union Parliament.* To this very day the position remains the same (see chapter 12).

Apart from the above, there are other important aspects of the Union Constitution which merit some consideration. In the first place, provision was made for the inclusion of the British dependencies of Rhodesia (North and South), Basutoland, Swaziland and Bechuanaland, although no date was set aside for their actual incorporation. To remove any fear that their land might be seized by whites (who were eager to annex fertile land in their neighbourhood), the local people in these areas were assured that they would retain their land on incorporation. Britain was responsible

* Non-Europeans retained their votes in the Cape and Natal provinces; they could vote for members of their provincial councils only. Elsewhere non-whites had no voting rights.

The Union of South Africa, 1910

for the insertion of this particular clause. Ironically, none of the territories listed joined the Union though to this very day there exist strong economic ties between them and the Republic of South Africa.

Another important provision of the Constitution related to the status of the four territories which formed the Union of South Africa. The four colonies were to become provinces, i.e. provinces of the Union of South Africa. Each province would have a provincial council, which would be responsible for health, municipal councils and lower education. In addition each province would be under the direct control of an administrator, who would be appointed and paid by the Union Government. He would be assisted by a committee of four elected officials. There would be one Supreme

The Houses of Parliament, Cape Town, in 1876

Court for the whole country with provincial and district courts. The seat of the judiciary would be at Bloemfontein, that of the legislature, i.e. Parliament, at Cape Town, and Pretoria would become the executive capital. In this way local jealousies over the choice of the capital were overcome.

After some discussion and amendment, the revised Draft Bill was at long last accepted by all the four Parliaments, Natal being the last to agree to it. A delegation headed by Sir Henry (later Lord) de Villiers, Chief Justice of the Cape, was consequently sent to London to secure the British Government's approval. Finally, after a few minor amendments, the Bill was passed by the British Parliament as the South Africa Act. On 31 May 1910, the Union of South Africa came into being and the four colonies became its constituent provinces. The new Government was headed by General Botha as Prime Minister. The predominantly English-speaking Unionist Party, led by Jameson, formed the official opposition to the South African Party Government of Botha.

The birth of the Union of South Africa meant different things to different peoples. To the whites a new nation had been born, and the pangs of birth were only to be expected. But to the Africans the new nation promised anything but hope, justice and a bright future. In a real sense the Act of Union completed the process of British surrender to the racist policies and activities of white South Africans which had commenced at the signing of the Treaty of Vereeniging and possibly earlier. True, Britain retained her African

The first ministry of the South African Union

dependencies of Bechuanaland, Basutoland and Swaziland, and the two Rhodesias were not included in the Union. But the British Government neither sought nor secured any guarantees for the Africans in South Africa. 'In other words, the Union Constitution, in native policy at all events, represented the triumph of the frontier [extremist Boers], and into the hands of the frontier was delivered the future of the native peoples. It was the conviction of the frontier that the foundations of society were race and the privileges of race.'*

* Quoted in C. W. de Kiewiet, *A History of South Africa*, Oxford University Press, London, 1966, pp. 150–51.

Chapter 10

Economic and social development to 1961

Like its political development, South Africa's economic development is fraught with ups and downs, with good luck and hardship. The overall picture, however, is one of steady progress and prosperity. Among those factors which greatly contributed to the country's economic development were the early production of wine and wool, the discovery of gold, diamonds and coal in the nineteenth century, and a ruthless exploitation of cheap African labour.

It is evident from chapters 2 and 3 that for many years the economy of South Africa was weak and unsteady. Agriculture and pastoralism, which were the backbone of the economy, took a long time to reach a high standard of productivity. This was inevitable. In a new land and an unfamiliar climate numerous experiments had to be made before the right kind of crop could be discovered and produced on a reasonable scale. The success of pastoralism depended on the success of such experiments.

Early problems

Even after the experiments had been completed, both the crops and animals (cattle and sheep) required additional time for adaptation before they could flourish. And all this in the face of spells of bad weather, including prolonged drought, soil erosion, lack of adequate water over much of the country, and disease. Add to these the inexperience of the farmers and administrative incompetence, and the reasons for the unhappy economic situation before the middle of the nineteenth century at once become clear. The multiplicity of political divisions and the insecurity of the country, as well as the numerous wars which were fought, acted against economic stability and progress. Clearly, the golden age of South Africa was still a thing of the future.

Economic development was further hampered by the shortage of labour. As was pointed out in chapter 2, from the seventeenth century slaves were imported to cope with the demand for labour. However, this proved inadequate and an alternative source of labour had to be sought. The problem was particularly acute in the sugar plantations of Natal.

The solution which was adopted to improve the labour situation was fraught with danger for the future. Indians were encouraged and invited to go and work in Natal's sugar plantations. They were known as 'indentured' labourers (or 'coolies') because they went there on contract. Though some of them returned to India when their contracts expired, many stayed in the country. Others came in from India, recruited by the Indian Government. In due course many of them grew rich and acquired much property, including some land.

After the formation of the Union of South Africa the Government became alarmed at the increase in Indian

Indian traders in Durban today

Mahatma Gandhi on his arrival in Natal in 1893

population and wealth. The Indians' presence in the country thus became a problem, though originally they had gone to South Africa on invitation. In 1913 the South African Government passed the Immigration Bill aimed at preventing any further Indian immigration into the country. They were forbidden to enter the Orange Free State and to purchase land in Transvaal. Indian protest to this harsh and discriminatory treatment was led by Mahatma Gandhi, who had come from India to Natal as a lawyer. He organized Indians into passive resistance groups by refusing to co-operate with the Government. He also received the sympathy of the Indian Government of the day. Negotiations between Mahatma Gandhi and Jan Smuts, the Minister of Justice, achieved little, for the discriminatory laws and restrictions on Indians were not removed. Gandhi later went back to India where he led the nationalist struggle for independence which was won in 1947.

South Africa still relies on migrant labour from outside. Thousands of labourers come from Botswana, Malawi, Lesotho and Swaziland to earn a living either in the mines or on white farms. However, government policy forbids the use of African labour in the Cape Province where the Coloured population is given preference. Only those Africans who were born there or who have worked for one employer for a minimum of ten years are allowed to remain in the Cape Province.

Agriculture

During the early years of its existence the country's most important single export was wine. It was not until just before the outbreak of the Great Trek that wine lost its privileged position to wool, to become the second most important export commodity. The production of wool was so successful that from about 1840 it was the basis of South Africa's economic development. In 1862, for instance, the total amount of wool exported was 25 million pounds. Wool continued to dominate the economy until 1869 when diamonds were discovered at Kimberley. Even then wool, now replaced by diamonds as the leading single export commodity, continued to play a leading role in the country's economic development.

As already noted, agriculture, on which the country's economy was based, was not without its problems. In particular, the land owned by Africans was far too inadequate for their population. Yet Africans were confined to reserves despite the steady growth in population. The inadequacy and inferiority of the land set aside for African occupation and farming adversely affected the yield and quality of

Soil erosion on a tributary of the Vaal near Kimberley. Rivulets carry soil into the main stream

African agriculture. Soil erosion, a great handicap to agricultural development in the whole country, was especially harmful in African areas. It has been estimated that South Africa loses its topsoil (the productive part of the soil) at the annual rate of 1%. Added to this was the destruction of bush, overstocking, unscientific methods of farming, overcrowding and the fact that, in general, only old men, women and children were left behind to cultivate the land while the young able-bodied men flocked to urban areas.

The agricultural situation was the result of a combination of factors. From 1913 Africans were allowed to occupy and own only 20% of the land in the entire country, despite their numerical superiority. This meant that 80% of the land was owned by only one-fifth of the country's population. (Since then land owned by Europeans has risen to about 87% while Africans own only about 13%.) Pressure on land in African areas was intensified by the increase in population and overstocking. Partly because of this, partly due to lack of room for shifting cultivation and partly because the overwhelming majority of Africans were unable to practise crop rotation and to use fertilizers, their agricultural yield diminished progressively. Thus the annual food production was falling at a time when population was rising. For example, in 1875 the district of Victoria East in the Ciskei, with a population of less than 6,000, sold agricultural

produce worth £19,000. But in 1925, with a population of 12,000, the same district's produce fetched only £10,000. This decline in agricultural output was also experienced in the Transkei, which produced four-fifths of its maize requirements in 1932 and only half in 1943, Namaqualand and Griqualand West. In general, between 1921 and 1930 Africans produced 640 million pounds of millet but between 1931 and 1939 this declined to 490 million pounds.

As starvation and landlessness became more acute, many people had to migrate to European farms and towns. It has been estimated that by 1964 20% of married men in the Ciskei and 25% in the Transkei were landless. In the same year the population density was 79 people per square mile in the Ciskei and 82 people per square mile in Natal and Transkei. This accounts for the fact that, as far back as 1928–9, 71·7% and 67% of adult males in the Middledrift district of the Ciskei and the Sekhukhuneland district of the Transvaal, respectively, were away earning a living in towns and on European farms. Women of working age also left their homes to find work: in 1950 about 30% of such women in Keiskammahoek had gone to the towns. In this case, however, a third of them were wives who had gone to join their husbands. It is also worth noting that Africans were attracted to the mining areas by the high wages paid there.

Invariably the people who were left behind in the rural areas were impoverished. They lived on hills and in valleys, most of which had lost their topsoil and had become huge, grim and unproductive gullies. To alleviate the situation, soil conservation schemes were undertaken by the country's Native Affairs Department. The aim was to improve the land by preventing and stopping the process of denudation. To that end the Government encouraged Africans to reduce the number of animals (cattle, sheep and goats) they kept and to adopt better methods of farming. Africans were also encouraged to paddock the grazing areas, to build dams and sink boreholes for their livestock, and to terrace their land. At the same time the Government attempted to concentrate Africans in large settlements instead of in numerous but isolated homes which tended to be wasteful of land. Finally, from 1837 unsuccessful attempts were made, first in the Cape Colony and later in Natal, the Ciskei and Transkei, to introduce individual land tenure among Africans. Though the aim was to stop the wasteful practice of fragmentation of land this still persisted and productivity continued to fall.

In general African response to these measures was indifferent and in some cases hostile. The feeling was that they were part and parcel of the official policy of segregation. It was argued that since the Government recognized the exis-

tence of the land problem among Africans, the only effective and practical way of eliminating that problem was to give Africans more land. Hence the hostility to destocking and related agricultural reforms. Moreover, cattle were valued as a form of wealth, for example as bride-wealth, as well as for their milk. They were also used for ploughing. Any talk of reducing the numbers of cattle did not make sense to their owners. In any case the average number of stock units per family, among Africans, had progressively fallen from 9·1 per family in 1939 to 7·1 per family of the same size in 1954. And as cattle decreased in numbers, so also the milk supply diminished and ploughing became more difficult due to the scarcity and poor condition of oxen. On the other hand a few Africans made some progress by using the plough (since the nineteenth century) and the tractor (by 1948). The Zulu on the coast of Natal grew sugar cane, and some Africans bred sheep for their wool and skins. These they sold and with the money they bought new forms of wealth and luxuries, such as clothes, blankets, ploughs, furniture and sugar. Some of them spent their new wealth on their children's education.

Nevertheless, the general picture is far from satisfactory. Many African peasants found it impossible to grow enough food to live on and had, therefore, to depend on imported foodstuffs—maize, sorghum, wheat, sugar and coffee. It is true that few Africans now die of starvation but their diet is not as nutritious as it used to be. At the same time their chances of acquiring more wealth from the land are restricted by the official land policy and alienation. Poverty has become part of the daily life of Africans in rural areas. With the best will in the world their teaming millions cannot be adequately supported by the small amount of infertile and impoverished land set aside for their exclusive use. Their flight into the towns and to European farms, both for work and a change of atmosphere from the monotony and hardship of reserve life, is necessary and logical and cannot be successfully halted as long as the present conditions last.

Minerals

The agricultural problems already noted are common to many parts of the continent of Africa, but, unlike other parts of the continent, South Africa is blessed with a wealth of the world's most prized minerals, gold and diamonds. Copper mining started in 1852 at Springbokfontein in the Cape Colony and gave a minor stimulus to the economy. The discovery and working of diamonds, coal and gold gave the country's economy the momentum and strength without which the industrial revolution and economic prosperity of

The diamond mines at Kimberley—the ropes mark each individual prospector's claim

the first half of the twentieth century would have been almost impossible. Thanks to the discovery of these minerals the country which for centuries had survived on a weak and uncertain pastoral and agricultural economy was transformed into a strong, stable and wealthy industrial state.

1. Diamonds The discovery of diamonds at Kimberley in 1869 was followed by a period of significant changes. Many of these changes were positive and progressive; others were negative and harmful. The mining industry was destined to produce a combination of wealth and social problems. The discovery of diamonds made South Africa rich; by 1871 the value of diamond exports stood at £1,600,000 per year. All of a sudden South Africa found herself in the early stages of her industrial revolution and ceased to rely solely on agriculture. Large urban communities came into existence and the country's first industrial centres sprang up. By 1871, for example, Kimberley had vastly grown and its total population stood at 50,000. This was only surpassed by the population of the old administrative town of Cape Town—a remarkable development within a short space of two years. The diamond industry greatly stimulated the economy, increased the wealth of the country and attracted more capital for invest-

Prospectors sifting and washing the soil to extract diamonds

ment, accelerated the pace of modernization (e.g. in the transport industry where steel railways were built to Cape Town, Port Elizabeth, East London and Durban), opened new opportunities for employment and new markets for farmers, and attracted people to new industrial centres which became the urban centres of the new society. People from South Africa and all over the world flocked to the mining towns of Kimberley (the biggest of them all), Dutoitspan, Bultfontein and De Beers. Kimberley became an important mining and commercial centre. Diamond wealth also had the desirable effect of stimulating economic growth elsewhere in the country. For example, it resulted in a significant rise in the exports of Natal and Cape Town, as well as providing employment for people from both towns and countryside.

But while thousands of prospectors rushed to Kimberley, only a few of them became successful. The great majority of them ended up in abject poverty and misery. The industry suffered from a shortage of capital and technical knowledge. Other important problems were the growing number of shanty towns in the mining areas and the old issue of racial discrimination. For, in spite of the hardship they had to cope with, more and more Africans rushed to the mines. At least 10,000 of them were employed in the mines every year. By

Johannes Nicolas de Beer, owner of the farm on which de Beers mine was discovered

143

Africans on their way to work in the gold mines at Johannesburg

1912 there were 285,000 Africans (from South Africa, Nyasa-
land, Rhodesia, Basutoland and Bechuanaland) in the
country's mines compared with only 36,000 whites (from
South Africa, Britain, Australia, Germany and the United
States of America). They were the backbone of diamond min-
ing and the exploitation of 'cheap native labour' ranks fore-
most among the factors responsible for the economic
development of South Africa. The presence of large numbers
of unskilled African workers in the mines was viewed with
fear and a growing sense of insecurity by the whites. It was
felt that African workers were a threat to the poor whites
with whom they had to compete for jobs in the mines. Yet
Africans were confined to heavy tasks; they received low
wages and had no hope of rising to a higher status. The same
servile and discriminatory practice to which Africans were
subjected on European farms was extended to the mines.
Harsher laws were enforced to keep the 'native' in his place
and to make him work.

A diamond merchant's at Dutoitspan, 1872

Up until about 1881 the situation in the mining industry remained extremely confused. Before that date there were numerous diggers all competing with each other. Each digger or company of diggers had their own area of operation; this might be either large or as small as seven square yards. Altogether there were over 3,200 such claims in the Kimberley, De Beers, Bultfontein and Dutoitspan mines. Success for some and bankruptcy for others were the inevitable result of the muddle. By 1881, however, the situation had considerably improved. Thanks to the good leadership and business sense of Cecil Rhodes, most of the mines were gradually brought under one central control. They were collectively known as the De Beers Consolidated Mines Limited. By 1890 this company had acquired control over the entire diamond mining industry in the country. The reward for better organization and mechanization was more efficiency and greater productivity.

While the Orange Free State, Natal and the Cape became prosperous as a result of the diamond industry, Transvaal's prosperity was based on gold mining. Before 1864 gold had been worked on a small and unprofitable scale. The economy of the Transvaal remained weak until 1884 when large gold

2. Gold

deposits were discovered on the Witwatersrand. These are known to be the richest gold deposits in the world. Though the average gold content of the ore is low, the number of tons of ore is immeasurable—hence its high yield.

The results of the discovery of gold were similar to those already outlined in connection with diamond mining. A 'gold rush', intense speculation, prosperity, success and bankruptcy, the mushrooming of new industrial centres and urban communities, of which Johannesburg was the largest and wealthiest, and the growth of shanty towns were the immediate results. People flocked to Johannesburg on the Witwatersrand in tens of thousands from Britain, continental Europe, Australia, America and other parts of South Africa. By the close of the century its population was about 166,000. In the early period small diggers competed against each other and against companies. Only the bravest, most cunning and luckiest ones survived; thousands fell by the wayside. Yet only 40 miles from the busy, harsh and competitive world in the Witwatersrand lay peaceful Pretoria, the capital of Transvaal. The industrial experience gained at Kimberley was used by Cecil Rhodes and J. B. Robinson, among others, who consolidated the gold industry by bringing together the various mines under one company—The Consolidated Gold Fields of South Africa. This was accomplished within only six years of the beginnings of the industry. The results of improved organization coupled with the latest technological developments were impressive. The Witwatersrand became prosperous and the Transvaal was transformed into a modern industrial state with the Witwatersrand as its centre. Though progress was at first slow, the need for more railways, efficient transportation and banks, which resulted from gold mining and the attendant industrialization, soon stimulated the country's economy to a new significant level. Between 1887 and 1889, for instance, the revenue of the Transvaal alone rose from £638,000 to £1,500,000. In 1896, the gold industry accounted for 97% of the Transvaal's exports, and employed over 100,000 men.

Railways were built to cope with the high industrial demand. In 1887 the Transvaal was connected by rail to Delagoa Bay and five years later train services commenced between Delagoa Bay and Pretoria. More lines converged on Transvaal as its new economic strength increased. Among others, the Natal line reached Transvaal's border in 1891; the Port Elizabeth to Bloemfontein line reached the border the following year, in 1892, when the Cape line also reached the Rand; and Natal was connected by rail with the Rand in 1895. Whereas between 1860 and 1869 South Africa had only 68 miles of railway, by 1919 it had 7,696 miles.

The railway bridge over the Orange River

The new industrial population was largely composed of the so-called Uitlanders or 'foreigners', mostly British, who had come to prospect for gold and diamonds. Because of their impatience with the traditions of the Boers and the jealousy with which the Boers guarded their independence and culture, the two communities clashed, as already noted in chapter 9. By 1895 the Uitlanders outnumbered the Boers in the Witwatersrand mining area in the ratio of 7 to 3—hence Kruger's reluctance to enfranchise the Uitlanders. The Boers were afraid of political and cultural domination by the predominantly English-speaking Uitlanders.

3. Coal

The tremendous progress made by the economy of the Transvaal, in particular, and South Africa in general following the discovery of gold would have taken much longer to accomplish but for one important factor. This was the presence of large quantities of good quality coal in the Witwatersrand. The proximity of the coal to the gold mines greatly facilitated gold-mining. During the 1840s and 1850s more coal was found in Natal and the Cape Colony, respectively. Coal also made a valuable contribution to the process of industrialization in many other spheres of the country's economy. It was an important source of fuel for industry and so facilitated progress towards industrialization. At the same time, it was in itself a valuable source of wealth and provided employment for thousands of people.

Effects of the Anglo-Boer War

The rapid economic progress which had been made possible by the rich mining industry was thoroughly shaken and disrupted towards the end of the nineteenth and the beginning of the twentieth century by the Anglo-Boer War. During the War mining and economic activities were halted and industries and farms were destroyed in the Orange Free State and the Transvaal. Many white men joined the War and labour became scarce. The situation was made worse by the decision of some African workers to return to their home areas. By 1902 there were only 10,000 white and 45,000 black miners compared to double these figures in 1899.

Another reason for economic decline in the Boer republics was Lord Kitchener's policy of destroying Boer homesteads, farms and crops, and the capture of livestock. The extent of economic depression suffered by South Africa during the War is evidenced by the fact that exports fell from £26 million in 1898 to £9 million in 1900. During the same period, imports rose from £22 million to £23 million, and to £31 million in 1901. It should be noted, however, that Natal and the Cape Colony were not adversely affected by the War. Indeed, their economy was boosted by the presence of thousands of British soldiers who spent large sums of money.

Further developments during the twentieth century

Despite the end of the War in 1902, the economic situation did not improve immediately. This was to be expected in view of the extensive damage to mines, farms and industries. By 1906, however, the position was improving and labour in the mines had increased to 18,000 whites and 94,000 blacks. There was also a strong Chinese labour force of 51,000. The Chinese, who came as indentured labourers to offset the shortage of labour, had largely been repatriated by 1912.

The economy was partly boosted by the formation of the Union in 1910, which had the effect of creating a large market of about six million people occupying 471,00 square miles. Whereas in the past territorial boundaries had greatly restricted the local market, farmers and industrialists could now sell their products to a large local population as well as exporting them. At the same time the country diversified its economy and gave it a broader base. For example, by 1912, out of a total net national income of £133 million, mining accounted for only £36 million (27·1%), while agriculture and manufacturing were responsible for £23 million (17·4%) and £9 million (6·7%) respectively. Railway construction during the first two decades of the century provided a further stimulus to the economy, both as an investment and a source of employment. Between 1900 and 1919 a total of 5,582 miles of railway was built.

For some time, up to the First World War, the economy of South Africa remained in more or less the same progressive position, but the First World War was followed everywhere by severe hardship and a general depression. The Great Depression of 1929–32 affected the whole world and South Africa was no exception. Even in 1932 the country was still suffering from the after-effects. Prices for agricultural products fell drastically, and the gold industry slackened as old mines showed signs of exhaustion. In general there was economic stagnation and hardship. Between 1933 and 1950 the economy rallied and became stronger. This period witnessed tremendous activity in industry, the building of new factories and a corresponding growth in agriculture. At the same time there was a welcome boom in the mining industry. Part of this economic recovery was due to the general improvement in the international economic situation, but it was also largely the result of a combination of local factors.

Since the economic depression was a national as well as an international crisis, the State had to intervene to protect local industries, including farming, and to strengthen the economy. Some of the measures introduced by the Government were aimed at dealing with the immediate post-First World War situation, and many others were passed during the 1930s. As far back as 1912 a Land Bank Act had been passed to give financial assistance to farmers and to develop co-operative societies. In 1922 the Co-operatives Act was passed to strengthen co-operative societies and make them more useful to farmers. Two years later a Wine and Spirits Act was passed to stabilize prices and thereby assist the farmers concerned.

From 1925 the Government introduced protective measures for the benefit of its industrialists and farmers and the economy in general. In that year a Fruit Export Board was established and empowered to improve and control fruit exports. The following year, 1926, the export of dairy products was brought under the control of the new Perishable Products Export Board. To overcome the decline in international prices for sugar, in 1926 the duty on imported sugar was raised from £4 10s (sterling) to £8 per ton in order to protect and stimulate the local industry. As a result, by 1929 the annual sugar export stood at 86,000 tons. The land under sugar cane increased from 264,000 acres in 1927 to 336,000 acres in 1932. Further decline in world sugar prices made it necessary for the Government to increase the tariff (i.e. tax) on imported sugar in 1932, first to £12 10s and, later the same year, to £16 per ton. But South Africa just could not win. By 1933 it had a surplus of sugar worth more

Government measures against the Depression

than £1 million while on the world market sugar was virtually worthless—it was sold at less than a penny per pound! Hence in 1936 a Sugar Act was passed to restrict sugar production.

Severe measures to protect the agricultural industry were also applied to dairy products, wheat, maize, wool and meat. In 1930 the Government created the Dairy Industry Control Board. Its responsibilities were to control the industry, fix the prices for dairy products, and to stipulate the quantity of the products to be exported by each farmer. The result was a fall in dairy imports and a rise in exports. After 1932 South Africa exported much more dairy products than she imported, partly because local output was greatly expanded in response to the new high prices of butter and cheese. The same policy of paying more for local products resulted in the expansion of maize acreage and an increase in exports. By the end of the 1930s maize exports were 16 times the 1927 figures. In 1930 wheat was also brought under the same control with similar results: more output, greater acreage, more exports and less imports. In 1929–32 land under wheat increased as follows: 0·1% in Natal, 8·7% in the Transvaal, 24·6% in the Orange Free State, and about 66·6% in the Cape Province. However, as in the case of sugar, the policy led to huge and expensive surpluses which had an adverse effect on the economy.

In 1937 a Marketing Act was passed to stabilize prices and narrow the gap between agricultural incomes and those in towns. Subsidies were also extended to exports of wool, mohair, wattle-bark and fruit. Earlier, in 1933, the Government had set up the Meat Board to control the number of slaughtered animals which could be sold and to fix maximum prices. Official efforts to protect and promote the agricultural industry were extended to soil conservation when, in 1946, the Soil Conservation Act was passed. It was aimed at controlling soil erosion, thereby increasing agricultural production.

War demands

During the period leading to the Second World War many factories were built for the production of army equipment, clothing and foodstuffs. Though such factories had to switch over to the production of civilian goods after the War, they remained important as a source of employment as well as for the new goods they produced. Between 1939 and 1942 alone South Africa spent £100,000,000 on war supplies, most of them manufactured locally. As the economy improved, more capital for development began to flow in from abroad.

Discovery of new goldfields and other minerals

By far the most important single stimulant to the economic recovery of South Africa was the discovery of rich new gold-

fields. These extended from the Witwatersrand in the Transvaal into the Orange Free State. At the same time new coalmines were opened up. The effect on the economy was immediate. New towns sprang up in the mining district, creating new demands and new market opportunities, and houses had to be built to accommodate the new urban communities. Furthermore, as the process of industrialization gathered momentum, the demand for steel, machinery and building and construction materials shot up to new peaks. For example, during this period the steel industry expanded to such an extent that its output trebled, due to increased industrial demand.

The period also saw an increase in the exploitation of less important minerals, such as uranium. In addition there were plans to build a big industry to extract oil from coal. All this was part of the same story—economic recovery and expansion based on industrialization and new techniques.

Economic map of South Africa, showing the railway network and the chief mining areas

The growth of a town: Johannesburg in the 1880s

Johannesburg in 1895

As already mentioned, the discovery of minerals during the last half of the nineteenth century was largely responsible for the rapid industrialization of the country. And mining and industrialization were in their turn responsible for the growth of new centres of population such as Kimberley and Johannesburg. Before 1870 South Africa was primarily an agricultural country with the bulk of its population in the countryside. Although there were towns, these were either administrative centres such as Pretoria, Pietermaritzburg and Bloemfontein or ports and commercial centres such as Durban, Port Elizabeth and Cape Town.

With the increasing industrialization at the end of the nineteenth century more and more people migrated to the towns and swelled the urban population. Town life had many attractions: employment opportunities, good wages, excitement and a chance to make money in the mining industry. At first, however, Afrikaners were slow to exploit the new opportunities and preferred instead the quiet, rural way of life. They regarded towns as foreigners' homes for they were full of white men from the United States of America, Britain, Russia, Germany and Australia. By the beginning of the twentieth century, however, more Afrikaners had moved into the towns where they numbered about 10,000. This figure

Growth of towns and urbanization

Johannesburg today

The small port of Port Elizabeth in 1866. Today it is a thriving city and a major South African centre

dramatically rose to 600,000 by 1959, a remarkable development in only 60 years. By 1960 Afrikaners accounted for 51% of the total white urban population as compared to 44% in 1936.

Thus urbanization gathered momentum from the last decade of the nineteenth century to about 1960, and this process involved both whites and blacks. During 1890–91, for example, only 35·8% of South Africa's white population lived in towns while in 1904 and 1960 it was 53% and 83·6% respectively. Among the Africans 13% of the total population were living in towns in 1904, compared to 27·2% and 31·8% in 1951 and 1960 respectively. Unlike the Africans, the Coloured and Indian population was urbanized much earlier. According to available information, by 1911 about 46% of both communities was urban. In 1960 some 68·3% of the Coloured population and 83·2% of the Asian population lived in towns.

As already mentioned, the growth of large towns coupled with substantial urbanization had far-reaching consequences. A case in point was the extent to which urbanization affected social values and the family group. On the whole, owing to the fact that they migrated to towns as family units rather than as

One of the new generation of Africans who were born and live in the towns

individuals, the whites, Coloureds and Indians were able to preserve the unity of their respective families in their new homes. The African population, however, was drastically affected by the move to the towns. Their way of life, which was rooted in the countryside, was inevitably shattered by urbanization. Male Africans moved to towns alone, leading to a temporary separation of husband and wife, and greatly weakening the unity of the family. The dislocation of the family was accelerated by the scattering of kinsmen in towns in search of employment, and the gradual waning of the authority of the father which had bound the family together in the countryside. Moreover, due to the shortage of accommodation urban Africans could not live in family units as was the practice in rural areas. It became necessary for young people to live separately from their parents and relatives, especially after marriage. Ultimately there emerged communities based on job interests as distinct from kinship groups based on family ties.

Owing to a combination of factors, such as the shortage of accommodation and the high cost of living in towns, urban Africans tended to marry only one wife instead of several as in the countryside. Increasingly marriage became a matter

between two individuals as old practices and tradition (such as the rules of exogamy) were cast aside and kinship ceased to matter. At the same time African women in towns acquired a high status and a considerable degree of independence because of their employment and income.

It goes without saying that such an extensive disruption of society was bound to have harmful effects on urban Africans. For example, the prolonged separation of husband and wife resulted in illicit marriages in towns and the break-up of many formal marriages. Prostitution was another result of the new way of life. Furthermore, as will be seen in chapter 12, Africans were subjected to stringent restrictions in respect of employment, income, residential places, property ownership and political rights. The bulk of urban Africans lived in crowded, poor and filthy areas, which had a bad effect on their morals. Many of them turned to crime, such as robbery and trade in illegal liquor, as a means of earning a livelihood.

In other respects the impact of industrialization and urbanization was equally revolutionary. This may be exemplified by the radical change in the social values of urban Africans. Previously cattle had been the most important form of wealth, and the number of cattle a man possessed determined his status. In the traditional society a wealthy man had many wives and children and his home abounded in food and drink. Land was the most important form of security, as well as the main source of livelihood. All this was fundamentally changed by industrialization and urbanization. Instead of cattle, money now became the most important form of wealth, and also the medium of exchange. There thus emerged a new class of men who were rich, but without any lasting security. A person's status was now determined by the quality of his education, his occupation and income, and the kind of house he lived in. Prosperous men were, and still are, distinguished by their style of dress, eating habits and the type of cars they drive. Teachers, businessmen, church ministers and doctors are among the most respected and influential members of the community.

Distribution of wealth What were the implications of the new wealth and how was it distributed among the various races? To a certain extent this question has already been answered. We have noted that Africans have always held an inferior position in South Africa's economy. They have always been confined to heavy unskilled tasks, though the position is different among themselves and in their own areas. They are denied any opportunity to climb the social ladder. Furthermore, they are discriminated against in industries, offices and the business sector, and consequently their wages are low in comparison

with those of their white counterparts.

Under such circumstances the Africans' share of the country's wealth is bound to be pathetically small. And this in spite of the fact that Africans constitute about two-thirds of the country's labour force! In other words, though African labour is the backbone of the country's economy, the Africans' share of the wealth produced by that labour is, in sharp contrast, insignificant. Africans are the lowest paid people in the country, their average income being less than one-fifth of the earnings of the whites. For example, in 1946–47 the average annual salary of Europeans was £405·7, that of Asians and Coloureds was £167·3, and that of Africans was a mere £100·2. After the Nationalist Party came to power in 1948 drastic measures were enforced to strengthen the privileged position of the white population, thus making the condition of Africans even worse. By 1960–61, though there was a considerable rise in the average income of European workers, that of Africans was still very low. At that time the average annual income of Europeans was about £1,000, while that of Africans stood at just under £185, and that of Asians and Coloureds at about £295. Within 14 years the average income of Europeans had more than doubled while the position of non-whites remained unsatisfactory despite minor improvements.

It is thus evident that, despite the tremendous economic growth during the twentieth century in particular, the racial disparity in incomes has had an adverse effect on the average income per head of population. In 1960, for example, the national income was over £2,135 million. The average annual income per head of population was, on the other hand, just about £133. No wonder South Africa holds a middle position between the richest and poorest nations of the world. The wealth of the country is concentrated in the hands of only a small proportion of the population, which is determined to cling to power. This is South Africa's greatest problem, and a solution is remote unless the political pattern of the country undergoes a radical liberal change.

Political development to 1961

In chapter 9 we saw how the white population of South Africa, with the support of the British Government, finally succeeded in uniting the country under one South African Government. The birth of the new nation was accompanied by a number of important problems, which was only to be expected; it is much the same story with every new nation the world over. On the other hand, the very nature of South African problems makes it particularly necessary for us to try and answer the question: How will the new nation work and what are its special problems?

In a very real sense the problems facing South Africa after unification were the same problems which had been in existence from the early days of European occupation and settlement: cultural conflicts, nationalism, race relations and the issue of the rights of Africans and of other non-whites. The last two topics will be discussed separately in chapter 12.

Cultural conflicts

The question of culture was of immense importance both before and after unification. Indeed, it was partly out of the desire to retain their culture and to avoid Anglicization that the Afrikaners of South Africa had several times clashed with British authorities. But the question of culture was not simply an isolated issue. To successfully preserve their culture, the Afrikaners had to gain effective political control, and the issue of Afrikaner culture was closely linked with that of Boer nationalism. In contrast, British culture and institutions were identified with alien rule and alien culture, both of which were hated by the great majority of the Boers.

Unfortunately for the Boers, by 1910, the year of unification, the British were dominant in many spheres of life. In practice there was no real equality, although it was enshrined in the Constitution of the new nation. By virtue of their political control of the country for many years, the British held top jobs in the civil service, local government and the railways, yet they could neither speak nor understand Afrikaans, the language favoured and spoken by the Boers of South Africa. The British even despised Afrikaans as irrelevant and inferior. It did not help the Boers that, unlike the English language and culture, Afrikaans was new

and therefore not widely spoken or understood. The same was true of Afrikaner culture, which was still in the process of formation. Thus, as already pointed out, the cultural and political issues were intertwined. The cultural issue, the privileged position of English as against the inferiority and limitations of Afrikaans and Afrikaner literature, became an important source of friction. Afrikaner nationalism gained the upper hand with the accent on hatred for all things British, Empire and traditions alike.

These sentiments were particularly championed by James Barry Munnik Hertzog, a radical Boer nationalist and a member of the Government who had fought as a general in the Anglo-Boer War. Hertzog's school of thought sought to elevate Afrikaner culture, literature and the Afrikaans language to a position of superiority. In his opinion, South Africa should be ruled by the Afrikaners, i.e. the Afrikaans-speaking whites, the Boers. He was against all forms of co-operation with the British.

James Hertzog, leader of the United Party

Though Botha and Smuts did not support these extreme Boer sentiments, in general Boers all over South Africa were in full agreement with Hertzog and his supporters. To promote Afrikaans and Afrikaner culture the Boers adopted three important measures. First, since education is vital and the medium of tuition important, the use of Afrikaans in schools was strongly encouraged. Second, and closely connected with this, Boers built their own Christian schools for their children, in order to avoid the process of Anglicization to which their children would be subjected if they went to government schools. Third, attempts were made to promote Afrikaner culture and literature by, for example, encouraging the publication and use of such literature. This of course, was coupled with a general discouragement of the use of English literature and the prevalence of English culture.

Politics was another important area where the new nation early experienced bitter conflict and disharmony. As already noted, the Government was dominated by the Boers, and among the Boers themselves there were two broad categories of politicians—the moderates led by Prime Minister Louis Botha and his colleague Jan Christian Smuts on the one hand and, on the other, the radical nationalists led for some time by Hertzog.

Political conflicts and organizations

In December 1912 Hertzog was dismissed from the Government because of his conflict with Botha and Smuts, but his dismissal marked the beginning of the end for Botha's South African Party Government. With its popular slogan

The Nationalist Party under Hertzog

Dr Daniel Malan, first Nationalist Prime Minister, 1948

*The United Party,
the Dominion Party and the
'Purified' Nationalists*

of 'South Africa First', the Nationalist Party, the new party formed in 1913 and led by Hertzog, won immense support from the Boers. They criticized the Government's involvement in the First World War because, in their view, the British did not deserve any assistance and the War did not promote South Africa's interests. They favoured republican status and complete independence for South Africa, and were even prepared to fight for the independence of the former Boer republics alone should the British refuse to grant independence to the whole country. The radical Nationalist Party became so popular with the electorate that in the 1920 elections it only narrowly lost to the South African Party, which formed a coalition with the English Unionist Party.

Though the Boers remained in political control, South African politics remained confused and the political situation was consequently fluid. After the elections of 1924, which were won by Hertzog's Nationalist Party, a Coalition Government was formed with the small South African British Labour Party. Now that Hertzog was content with the existing dominion status* for his country, his former radical position was taken over by Dr Daniel Malan, who stood for republicanism and complete independence.

The year 1933 saw the formation of a new and strong party, the United Party, which was a merger of Smut's South African Party and Hertzog's Nationalist Party. The new party was led by Hertzog. Almost simultaneously two other new parties emerged: Malan formed a radical party called the 'Purified' Nationalists, devoted to republicanism, and some radical Englishmen formed the Dominion Party because they felt that their ally, Smuts, had moved too close to extreme Boer policy.

By 1933, therefore, there were three major political parties in South Africa. Of these the United Party was the strongest. In 1951 (three years after the elections of 1948, which were won by the Nationalists and Afrikaner parties) a new enlarged Nationalist Party was formed, uniting most of the Afrikaner parties and therefore a purely Afrikaans-speaking party. This is still the party in power in South Africa, with the United Party in opposition.

* As a result of the Imperial Conference of 1926 and 1930, Hertzog modified his political views on republican status for the country. These conferences brought dominion status in the British Empire into existence. Dominion status conferred full independence on South Africa and similar countries in the British Empire. It thus weakened the argument for republican status; hence Hertzog's change of mind.

A brief examination of the policies of the main political parties shows that, in spite of some differences, they have a great deal in common on the crucial subject of race relations: the attitude of the parties to the policy and practice of apartheid (racial segregation or separate development) is basically the same. The main legislative measures and implications of the policy of apartheid are outlined in chapter 12. Here our main concern is the attitude of the various parties to the subject of extreme racialism.

First let us consider the ruling Nationalist Party which came into power in 1948 with Dr Malan as Prime Minister. Stating his party's stand on the issue of segregation, Dr Malan said:

> If one could obtain total or complete territorial apartheid, everybody would admit that it would be an ideal state of affairs. It would be an ideal state, but that is not the policy of our party . . . When I was asked in the House on previous occasions whether that was what we are aiming at . . . I clearly stated . . . that total territorial separation was impracticable under present circumstances in South Africa, where our whole economic structure is to a large extent based on native labour.*

Under Dr Malan and his successors, the Nationalist Party Government enforced the policy of apartheid with unprecedented vigour and precision. Their aim was to keep South Africa white by entrenching the privileged position of the white population and by permanently keeping Africans (or Bantu as they are known in South Africa) in an inferior position. This could only be attained by separating whites from blacks and by reserving certain jobs, particularly top jobs and skilled ones, for the whites.

The opposition United Party which was defeated in the elections of 1948 also supported the policy of white supremacy, but its attitude on the subject was so vague that many of its supporters deserted it in protest. Even after the elections of 1953, which it lost, the United Party could do no better than advance another vague policy on the subject of the position of Africans in South Africa. In 1954 a new policy was adopted, advocating racial integration and co-operation in the economic sphere, but at the same time the policy stated that white supremacy had to be maintained. It also supported segregation in social activities, and called for the establishment of separate residential areas for the various races in the country.

* Quoted in J. A. Davis and J. K. Baker (eds.), *Southern Africa in Transition*, Frederick A. Praeger, New York, 1966, pp. 21–2.

Helen Suzman, the only member of the Progressive Party in Parliament today

It is thus evident that the United Party's attitude to segregation was not only equivocal but confused. The party advocated what amounted to permanent white leadership with a certain amount of justice for non-whites. On the important issue of the right to work, the party's policy was clearly in favour of the white population. In 1957 the party chief, Sir de Villiers Graaff, 'talked of the need for protecting white workers against unequal competition from non-whites.* This was no different from the Nationalists' policy. Yet despite this concession to extremists, the United Party again lost the elections in 1958.

On the question of Bantustans (separate and semi-autonomous territories for Africans) which were introduced by Dr Verwoerd's Nationalist Government, the Opposition's stand was equally vague. It was opposed to the idea and thought Africans should continue to be represented in Parliament, although their representatives had to be European, as before. The Opposition leader, de Villiers Graaf, suggested that Africans could only lose their representatives in Parliament when the new black states, or Bantustans, became independent. Thus his party accepted the principle of Bantustans and apartheid. The two main parties therefore only differed on methods, not the objective.

The Progressive Party and the Liberal Party

Two other parties, the Progressive Party and the Liberal Party, merit special consideration. Unlike the other parties, they were moderate and anti-racialist. They advocated fundamental human rights and criticized the practice of racial segregation and discrimination. They wanted the franchise to be extended to all suitably qualified citizens, irrespective of their race. Unfortunately, neither the Liberal Party (which was founded in 1953) nor the Progressive Party (founded in 1959) enjoyed the support of the white electorate.

Attitudes to the two World Wars

Botha's South African Party Government gave full support to the British during the First World War. In 1915 South African forces won South West Africa from the Germans and four years later the Treaty of Versailles empowered South Africa to administer South West Africa as a mandate territory, i.e. on behalf of the League of Nations. Botha wanted South African troops to participate in the war till its successful completion, but the prolongation of the war cost Botha and his Government a great deal. He became unpopular as a supporter of the British and the Nationalist

* *Ibid*, p. 30.

Rhodesian troops in Damaraland, South West Africa, in 1915

Party, which never ceased to criticize the Government for its role in the war, was able to strengthen its position. At the same time and partly due to reaction against Britain, republicanism became active once more, championed by the Nationalists. The Government's involvement in the war was strongly criticized by many people who would have preferred neutrality or support for Germany. In 1914 General Smuts had to suppress a rebellion among his forces of those who, led by General de Wet, were sympathetic to Germany. Altogether 136,000 Europeans and 7,000 Africans took part in the First World War in various capacities. Some fought in England, East Africa and France as well as in South West Africa.

South Africa's contribution to the Second World War was more important and South Africans fought wherever the British fought. About 80,000 Africans and 45,000 Cape Coloureds took part in the war, yet this war was even more unpopular among South Africans than the first one. Smuts, who from 1939 was leader of the Coalition Government of the United Party and the small Labour and Dominion Parties, was largely responsible for the decision to join the war. Hertzog, leader of the United Party, in common with the majority feeling in South Africa, favoured a policy of neutrality. Some Afrikaners even sympathized with Germany. Hence the mounting unpopularity of the Government, which finally collapsed at the end of the war.

Towards a republic

In the years after the Second World War, and in particular after 1948, republicanism gained the upper hand in South Africa. At every stage this was accompanied by increasing Afrikaner nationalism, and in a sense the two were synonymous. The trend was clearly towards republican status and the Afrikaners were in effective political control. Their mouthpiece, the Nationalist Party, grew from strength to strength, increasing its majority in Parliament in 1953 and again in 1958.

Definite moves towards the establishment of a republic were taken in 1960. On 5 October a referendum was conducted on the important constitutional issue of whether or not a President should replace the Queen as Head of State. Only Europeans were allowed to vote. With only a narrow majority, the Government got the necessary mandate to change the Constitution and in April 1961 the South Africa Act of 1909 was accordingly amended. The President replaced the Queen as Head of State and was appointed to serve for a period of seven years. He was to be elected by

The first President of the South African Republic, Charles Swart, driving to the inaugural ceremony in Pretoria, 1961

secret ballot at a joint meeting of the Senate and the House of Assembly.

A month later South Africa became a republic outside the Commonwealth. The decision to leave the Commonwealth was influenced by the increasing pressure from the non-white members of the Commonwealth who have never stopped criticizing South Africa's racialist policies. They threatened to leave the Commonwealth unless South Africa changed these policies, which Dr Verwoerd described at the time as 'good neighbourliness'. This prompted Prime Minister Nehru of India to retort that if apartheid was good neighbourliness he would not like to be Dr Verwoerd's neighbour, and he and other critics of South Africa demanded her expulsion from the Commonwealth. The result was that South Africa voluntarily quit the Commonwealth, but this did not, however, solve the basic problem. To this day the war of words still rages, and in the final chapter I shall explore this, South Africa's greatest problem.

Chapter 12 Apartheid and African nationalism

We have seen that from the earliest encounter between Europeans and Africans, South African history has been substantially influenced by racial considerations and interests. These have in turn been determined by self-interest and fear, on the part of Europeans, of being dominated by the numerically superior Africans. To put it crudely, the South African problem is no more nor less than a struggle for power. On the one hand the Europeans are determined to cling to political, economic and social power and all the privileges that go with such domination. To that end they have resorted to all sorts of devices. Africans and other non-whites are, on the other hand, determined to have equal rights with Europeans, which necessitates the destruction of European domination. This is the crux of the matter. How will the problem be solved?

The South African problem has been variously called 'apartheid', 'racial segregation', 'separate development' and 'racial discrimination'. Commenting on the operation of discriminatory laws in South Africa, Marquard said:

> It is impossible to spend even a few days in South Africa without realizing the distinctions that are made between European and non-European. On railway stations and on trains and buses, at airports, post offices, and all public buildings, in banks, at race-courses and sports grounds, on the beaches, and in graveyards, there are separate 'facilities' for European and non-European, and the notices 'Whites Only' and 'Non-Whites' are ubiquitous. Restaurants, hotels, tea-shops, cinemas and theatres make the same distinction but it is unnecessary to put up notices to that effect. The social, economic and political life of South Africa is based on these distinctions.*

The doctrine of separate development or apartheid is founded on fear. It is not simply that Europeans want to preserve their civilization, but rather that they are afraid that the extension of political rights and of social and economic privileges, as well as the concession of the principle of

* L. Marquard, *Peoples and Policies of South Africa*, Oxford University Press, London, 1962.

A segregated footbridge in South Africa: 'Whites only' on the right, 'Non-whites' on the left

equality and justice to non-whites, will undermine their precarious political, economic and social supremacy.

Before outlining the main legislative measures passed by successive South African Governments to entrench European domination and conversely to suppress Africans and other non-whites, let us see what, in effect, the doctrine of apartheid or separate development stands for. Here it is fitting to quote at length the ruling Nationalist Party's pamphlet of 1948 on the subject of segregation, its meaning and motivations:

On the one hand, there is the policy of equality which advocates equal rights within the same political structure of all civilized and educated persons, irrespective of race or colour, and the gradual granting of the franchise to non-Europeans as they become qualified to make use of democratic rights. On the other hand, there is the policy of separation, which has grown up from the experience of the established European population of the country, and which is based on the Christian principles of justice and reasonableness. . . . We can only act in one of two directions. Either we must follow the course of equality, which must eventually mean national suicide for the white

race, or we must take the course of separation ('apartheid'), through which the character and the future of every race will be protected and safeguarded, with full opportunities for development and self-maintenance in their own ideas, without the interests of one clashing with the interests of the other.*

But, as many white South Africans themselves confess, complete territorial separation, i.e. total apartheid, is impracticable. For one thing South Africa depends on black labour in industry, agriculture, mines, offices and in the homes of the whites. It would therefore be impossible to attain a state of complete racial and territorial separation. Secondly, the land reserved for African settlement is only about 13% of the total land in the Republic and is inadequate for their needs, as they number close on 14,700,000 compared to 3,700,000 whites, 2,000,000 Coloureds and 620,436 Asians. Europeans own about 87% of the land, including the bulk of the best agricultural land in the country. The teeming African population cannot but drift into urban areas, the mines and European farms, regardless of the legal consequences. And finally, when white South Africans talk of separate development they mean separate development under European domination and direction. Any talk of the possibility of South Africa eventually becoming a commonwealth of autonomous white and non-white states is misleading, unrealistic and meaningless. I shall say more about this later, but first I shall leave the theory of apartheid to consider its actual application, particularly the main legislative measures relating to land, labour and political and social rights.

Territorial segregation
1. The Land Act, 1913

As far back as 1913 a Land Act was passed with the object of dividing the country into two distinct racial areas, Native and Non-Native. By the same Act Africans were forbidden to reside outside their designated districts ('reserves'). They were, however, allowed to live away from their areas when working for Europeans.

2. The Native Urban Areas Act, 1923

The Native Urban Areas Act of 1923 had the effect of controlling the number of Africans allowed to live in urban areas. One of its important aims was to effect the permanent separation of European and African areas. To alleviate the hardship created by the inadequacy of land set aside for African occupation, the Native Trust and Land Act of 1936 empowered the Government to give an additional 15,345,000

* Quoted in Lord Hailey, *An African Survey*, Oxford University Press, London, 1957.

The living quarters of African miners on a rich Transvaal gold mine

acres to African areas. The act also set up the South African Native Trust, which was charged with the responsibility of purchasing extra land for Africans. However, as about 87% of the land still remained in the hands of the whites, who constitute only about 20% of the country's population, pressure on the land in African areas continued to be acute, indeed more acute than ever as the population increased.

In 1950 the policy of separating whites from non-whites was carried a stage further by the Group Areas Act. The Act specified the areas where only members of one racial group could live or own immovable property such as land. It also classified the racial groups as whites, Coloureds (people of mixed racial descent) and natives. The same year saw the passage of the Population Registration Act. It made it compulsory for all persons above a certain age to possess an identity card on which, among other things, their race was written. Because of their light complexion, many Coloured people qualified as white and enjoyed a privileged position and preferential treatment.

3. The Group Areas Act and the Population Registration Act of 1950

The same policy of segregation was extended to the field of labour. Here the main aim was to relegate Africans, at a national level, to a permanent position of hewers of wood and drawers of water—the performers of unskilled and low-paid heavy work. Skilled employment was to be reserved for Europeans. This is the so-called 'civilized labour policy'.

Labour

Clements Kadalie, African trade unionist

In 1911 the Mines and Works Act was passed. It forbade the employment of Africans in the mines as skilled workers. Though discrimination had existed in the mines before, it had not been enforced by legislation. Henceforth a legal colour bar was applied in many areas of labour. The Colour Bar Act of 1925 amended the Act of 1911. It restricted certain aspects of mining employment to Europeans, Cape Coloureds and half-breeds from Mauritius. Industrial laws became more complex as whites and non-whites were forbidden to belong to the same workers' organizations. The Government feared that the trade union movement would become a means by which Africans could voice their political grievances, and so threaten the Government. At any rate it would be contrary to the declared government policy to allow and encourage whites and non-whites to organize themselves together and to discuss their common grievances as equals. The trade union movement could embarrass the Government and become the training ground for African politicians who were bound to be hostile to and critical of the official policy of discrimination in matters of work, pay, housing and related amenities. An excellent example of this was set by Clements Kadalie from Nyasaland (present Malawi) who founded a militant African workers' movement in 1923. Known as the Industrial and Commercial Workers' Union of Africa, it won great support among Africans by demanding better wages and the abolition of discriminatory laws. By 1931, however, it had begun to weaken due to poor organization, internal rivalries and lack of funds and because, as a mass movement, it was divided between political and trade union factions and a third group somewhere between the two.

As if it had decided to declare an all-out war against Africans on the labour market, in 1937 the Government passed the Industrial Conciliation Act, under which Africans could not belong to any registered trade union. Thus Africans were effectively denied the important and powerful right of collective bargaining. They remained weak and divided, although they were the basis of the country's economy. In 1953 African workers were given a small but ineffective concession under the Native Labour (Settlement of Disputes) Act, which created separate machinery for settling disputes by African workers. It also allowed Africans to form their own trade unions, but these unions were ineffective because they were closely controlled and regulated by the Government. In 1951 the building industry was also brought under the restrictions of apartheid. The Native Building Workers Act of that year prohibited the employment of Africans as skilled workers in urban areas.

Next, political rights—or rather lack of them. The first major legislation affecting the political rights of Africans, the Representation of Natives Act, was passed in 1936. Among other things, it removed the Africans of the Cape Province from the common voters' roll and set up a separate Cape Native Voters' Roll. Africans were now required to elect their three white representatives in Parliament on the new and separate voters' roll. In addition Africans throughout South Africa were allowed to elect four people to represent them in the Senate but, like the three representatives in the House of Assembly, they had to be Europeans. They would be elected by electoral colleges, rather than by the general electorate. The Act also established a Native Representative Council, consisting of 16 African members (12 elected and four nominated), the Secretary for Native Affairs (the Chairman), and the six Chief Native Commissioners, who had no voting rights. The Council had no real power, and was purely advisory. It could make recommendations on matters affecting Africans and give advice, but its views were generally disregarded by the Government and its criticism of discriminatory laws was not heeded. Accordingly, in 1945 it adjourned indefinitely in the vain hope that these laws would be abolished. The Council was finally dissolved and replaced under the Bantu Authorities Act of 1951. In 1951 Coloureds were also removed from the common voters' roll and, like the Africans in 1936, placed on a separate roll. This was effected by the Separate Representation of Voters Act* of 1951, which further empowered Coloured voters to elect four European representatives to the House of Assembly.

In another attempt to gag the disgruntled non-white majority further legislation, the Suppression of Communism Act, had been passed in 1950. It defined Communism as acts likely to promote racial hostility. A better pretext for rounding up all those who were opposed to the injustices and harshness of European racial discrimination could hardly have been found. The main target of the legislation was the African National Congress, a major national African political organization which had originally been founded in 1912. One clause of the Act authorized the Minister of Justice to blacklist any political party or members of a banned organization. Those affected automatically ceased to be members of Parliament, provincial councils or any other such organizations. Another clause empowered the Governor-General to ban any publication (including newspapers) suspected of

* This Act was subsequently nullified by the Supreme Court on the grounds of wrong procedure in its passage through Parliament.

being sympathetic to Communism (as defined by law). There was no appeal against any government action taken in fulfilment of the provisions of the Act. Sentences of up to ten years were to be imposed on anybody found guilty of furthering the interests of banned organizations. When, therefore, in 1952 the African National Congress launched a civil disobedience campaign against discriminatory and harsh laws, the Communism Act of 1950 was invoked. The leaders of the campaign were charged with being Communists and 8,000 of their followers were arrested. I shall return to this story later.

The Public Safety Act and the Criminal Law Amendment Act of 1953 strengthened still further the hand of the Government and frightened all but the bravest of the opponents of segregation. The Public Safety Act empowered the Governor-General to declare a state of emergency for a period of up to one year, during which time civil liberties were automatically suspended. The Criminal Law Amendment Act increased the fines for participation in or encouragement of civil disobedience and similar movements.

Social segregation and restrictions

As in the political and economic fields, so also in the social sector. Legislation was passed enforcing segregation in social activities and contacts. In 1949, for example, the Prohibition of Mixed Marriages Act was passed prohibiting inter-racial marriages. The following year under the Immorality (Amendment) Act, the restriction was extended to physical love between white and non-white men and women, referring to it as 'irregular carnal intercourse'.

Restrictions on the free movement of Africans was the next step in the move to segregate the races and to keep Africans under effective control. Indeed these restrictions had existed since the early nineteenth century. Britain had introduced them in the Cape Colony to control the movements of the Hottentots and they had been extended to cover all Africans. Though they were subsequently abolished in the Cape Colony, the Boers enforced them in their new homes after the Great Trek. Even after the attainment of the Union in 1910, these restrictions were not repealed. In 1952 the Natives (Abolition of Passes and Co-ordination of Documents) Act modified these unpopular and cumbersome restrictions, or 'pass laws' as they are better known. But at the same time the Act imposed other stringent restrictions on Africans. First, they had to obtain the permission of their local labour office before they could leave their areas to take up (not merely to seek) employment in urban areas. Second, as soon as they were employed, their service contract had to be registered. Third, an African had to get a permit to enter

an urban area if his visit was to last up to 72 hours. Fourth, an African must have permission to be outside his village or location after curfew hours, otherwise he would be prosecuted. Finally, he had, at all times, to carry with him the book containing all these permits and registrations.

As a result of this Act, the position of Africans became increasingly insecure and their civil liberties minimal. As Marquard says, 'Any police official may at any time demand to see any one of these papers [i.e. permits and registrations], and failure to produce it is an offence involving a fine or imprisonment. It has been said that the number of technical offences of which an African may be guilty is such that any police official can at any time arrest any African and be sure of obtaining conviction.'*

Successive South African racist Governments left no stone unturned in their declared war on the rights of man—justice, equality and human dignity. It was not enough to segregate the African and to relegate him to an everlasting position of labourer and servant. To prepare him to play that role without complaint, he had to be subjected to the right kind of indoctrination and education. Africans had to receive the kind of education which would prepare them for their inferior station in society; they had to be prepared for life in their separate areas. The kind of education given by the missionaries, on the other hand, encouraged them to exercise their talents, to expect reward for merit, and to be able to compete with Europeans for professional and non-professional jobs. This was the very antithesis of official policy and public practice. From the earliest time of contact between blacks and whites, the subject of African education had aroused mixed feelings. Many whites argued that academic and professional training was unsuitable for Africans, who should receive only agricultural education to equip them for life in their tribal areas. In this way industrial and literary education would be preserved for the whites in conformity with their dominant status in the country. It was further argued that Africans should remain 'natural' and uncontaminated by education. As recently as 1936 the Inter-departmental Committee on Native Education reported that opposition to African education was still strong. According to many whites, the education received by Africans made them obstinate, insubordinate, lazy and unfit to perform manual labour. Furthermore, such education undermined African culture by widening the Africans' horizons, instead of encouraging them to respect and foster their local culture.

Education and indoctrination
The Africans

* Marquard, *op. cit.*

In 1949 a Commission was established to determine the right principles and aims of education for Africans. The new education system had to accomplish two broad aims. First, it had to serve the special needs of Africans as an independent race with their own past and present as well as their own characteristics. Second, the new education system had to conform to the official policy of separate development, and to prepare Africans to perform their subordinate and inferior role in the country more effectively. The Commission made a number of recommendations, most of which were enforced by the Bantu Education Act of 1953. First, all African education was to be conducted through the mother tongue for the first eight years. Second, mother tongue instruction was to be gradually extended to secondary schools and training colleges. The Commission further recommended that Afrikaans and English should be taught from the very beginning but 'in such a way that the Bantu child will be able to find his way in European communities; to follow oral or written instructions; and to carry on a simple conversation with Europeans about his work and other subjects of common interest'.* Manual skills were also to be taught in African schools.

As Dr Verwoerd, then Minister for Native Affairs, said in Parliament in 1953, henceforth the aim of education was to 'train and teach people in accordance with their opportunities in life'. This was, according to the official view, the surest way of reducing any racial friction which might be caused by frustrated Africans who had received the 'wrong' kind of education. Henceforth African education was geared to meet the needs of Africans in the 'reserves', where it was supposed to do 'its real service'. Dr Verwoerd further declared that the Bantu had to be prepared to serve their own society, for outside that society they had no place in the European community 'above the level of certain forms of labour'. Their education had to be strictly functional. He continued, 'Up till now he [the Bantu] has been subjected to a school system which drew him away from his own community and partially misled him by showing him the green pastures of the European but still did not allow him to graze there.'

The Bantu Education Act removed African education from missionary control and made it a government responsibility. The Government would henceforth determine the content, nature, quality and type of education for Africans. From then on the Government discouraged higher education for Africans in urban areas by building most high schools in the 'homelands'. At the same time trade schools were built

* *Oxford History of South Africa*, Vol. II, p. 225.

African children being taught their lessons in Afrikaans

in the 'reserves' to prepare Africans to play their role in society more effectively without encouraging them to compete for skilled jobs with whites. This was in addition to a total of six technical schools for Africans in towns, which had by 1964 trained some 385 pupils. However, in spite of the numerous restrictions, a class of professional men and women have emerged among Africans. Among others, they comprise teachers, lawyers, doctors, nurses and technicians.

To further the objective of the Government, a new Department of Bantu Education was set up in 1966. Its chief responsibility was to preach and encourage the ideology of Bantustans as noble, profitable and workable. This was achieved by encouraging parochialism and regionalism among Africans. The educational system promoted ethnic studies rather than the study of South Africa as a whole. Ethnic groups were taught only about their traditions and the value of those traditions in isolation from the rest of their countrymen. To achieve maximum results the use of Bantu languages was encouraged in place of English or Afrikaans. In this way tribal pride and feeling was promoted, to the detriment of wider African consciousness and patriotism.

Multi-racial students at a South African university

The policy of separate development was also extended to higher education. This was a logical development of the racist doctrine, since there were different schools and curricula for different racial communities. In compliance with this doctrine, the Extension of University Education Act of 1959 introduced apartheid in university education. There would be three university colleges for Africans (in rural areas), one for Asians and another one for the Coloured community. The Universities of Natal, Witwatersrand and Cape Town were to admit only whites, except where permission was granted by the Government to non-whites. Such permission, however, was difficult to obtain.

The whites While South Africa's education was planned to prepare non-whites for the subordinate role they were to play in society, it was also designed to prepare the whites for their dominant position in the country's economic, political and social life. Thus all the measures which were passed restricting African education also had the effect of strengthening the competitive and privileged position of the whites. Indeed, this was the basic aim of all legislation relating to apartheid.

In 1905 the Cape School Board Act separated public schools in the Cape Province along racial lines so that Africans, Coloureds, whites and Asians could go to their own schools. Public schools had originally been built to enable white children to be taught in isolation from non-white children, with whom they had previously mixed in missionary schools.

In general, however, the standard of education in the country was low, leading to increasing competition for jobs among whites and non-whites. This was the very reverse of government policy, which aimed at separate development and the maintenance of white domination. Furthermore, due to their low standard of education, there was a danger that South Africa's whites might become in their turn hewers of wood and drawers of water for the new arrivals from Europe who were better educated. This was especially so from the late nineteenth century when industrialization created a demand for men with technical education. To overcome this particular limitation the educational system for the whites was changed and the accent placed on agricultural training and technical education in industrial and commercial fields. This was important since skilled technical jobs were reserved for whites only. Accordingly, by the Apprenticeship Act of 1922 urban whites were encouraged to enter into industry by receiving the necessary technical training. Since prospective apprentices were required to have a minimum education of eight years, Africans and many Coloureds and Asians were excluded. As already noted the aim was to keep the numerically superior Africans ignorant and therefore unable to compete for skilled jobs with the whites for whom such jobs were reserved. To a large extent this was accomplished, for between 1926 and 1946 the student enrolment in vocational schools for whites rose by over 150% while Africans continued to receive inferior education.

The Bantustans

At the beginning of this chapter some reference was made to the theoretical aspects of the doctrine of apartheid. Among other things, it was stated that the policy is aimed at so-called separate development, and we have already noted how between 1913 and the early 1950s legislation after legislation was passed to separate whites from non-whites and to reserve a small part of the country as Native Areas. The Bantustans are these Native Areas, sometimes known as the Bantu homelands or states.

In 1959 the Promotion of Bantu Self-Government Bill was passed in Parliament. It came into force on 30 June 1960, and abolished the existing (white) representation of Africans in Parliament. It also proposed to create eight Bantu 'national

Dr Hendrik Verwoerd, Nationalist Prime Minister, assassinated in 1966

units', i.e. Bantustans. The principal aim of the Bill was to develop the African areas into 'self-governing' territories for the Africans or Bantu. It was vaguely hoped that, depending on their ability to develop and become self-sufficient, they would, at some unknown time, form a South African Commonwealth with white areas of South Africa. At the same time the Bill expressed the hope that, if and when a South African Commonwealth became a reality, it would be guided and led by white South Africa. The young Bantu 'states' would thus continue to be ruled and controlled by the whites. The principle of separation and independence was, to say the least, vain, confused and contradictory. The proposed commonwealth could only be meaningful and successful if all the member states enjoyed equal rights and if they were effectively and directly represented in the central government. Yet the reverse was and still remains the case.

The reason for creating these unworkable states was twofold. First, Dr Verwoerd,* his Government and supporters were bent on entrenching and maintaining white supremacy and domination and this was one way of achieving their objective. Second, the racist régime and the whites of South Africa were afraid of a possible united action by non-whites, particularly Africans. To maintain their supremacy they had to weaken the Africans by dividing them into separate ethnic and linguistic groups, so-called 'states'. In this way Africans would tend to act not as one large united group, but as separate and numerous small units with diverse interests and jealousies. Their resistance could therefore be easily overcome. Moreover, the idea of separate states for Africans was bound to appeal to a few Africans who had quarrels amongst themselves, and the whites would therefore have some valuable allies among the Africans.

It should be added that the creation of Bantustans was partly supposed to allay the fears of the critical world outside South Africa. The Government argued that this was positive apartheid; it gave Africans the important principle of self-determination, and was it not for self-determination that colonial people in Africa and Asia were struggling? This, of course, was mere camouflage for the Government's declared policy of racial segregation, racial discrimination and white domination. In an attempt to justify its policy of 'positive apartheid' and the creation of Bantustans the Government said:

* Dr Verwoerd was assassinated in Parliament on 6 September 1966. He was succeeded by John Vorster, another staunch advocate of apartheid.

Separate Bantu housing at Nyanga West, near Cape Town

The right to self-determination, like liberty, is indivisible. If all African peoples are entitled to self-determination, it is true also of the white South African nation. In the South African situation a way has to be found in which hitherto dependent Bantu peoples can achieve their autonomy without jeopardizing the independent nationhood of the whites. The ultimate aim is the co-operation of independent Bantu states and a white nation—a Commonwealth of South Africa.*

But would the Africans have any say in the central government of the South African Commonwealth? Were the proposed Bantu 'states' not too small to be economically self-sufficient? Was their creation not a backward step in so far as it promoted ethnic rather than national sentiments, and prevented a broad outlook? And finally, what would become of the one and a half million or so Coloured people and about half a million Asians who would belong to neither the white nation nor the proposed Bantu 'states'? Perhaps they will also be given their own homelands, the caricatures of nations.

* Quoted in R. Oliver and A. Atmore, *Africa since 1800*, Cambridge University Press, 1967.

The Bantustans in South Africa

In spite of the uncertainty surrounding the whole issue of Bantustans, the Government went ahead with its plans. The Transkei became the first Bantustan; the others are Ciskei, Kwazulu, Venda, Lebowa, Gazankulu, Basotho Qwaqwa and Bophutatswana. In 1959 the first meeting of the Transkei's local authority, i.e. territorial government, was held. The authority comprised chiefs, government nominees and representatives of the Xhosa-speaking people themselves. The authority was given power over local matters, including administration, but all its activities and enactments are subject to the approval of the Union Government. Thus, the local authority has only a semblance of power; real power belongs to the central Government.

African reaction to the Bantustans

The main objections to the Bantustan system were summarized recently by Chief Gatsha Buthelezi, Chairman of the

Zulu Executive Council and a moderate African leader, when he said:

I think that the main objection is that it's a system that is prescribed for black people by a white minority. That's the first thing. Secondly, so far there's no evidence that these states that we envisage under the system can ever be economic entities, in other words that they have any potential for economic viability. And also, for us, although we regard whites in South Africa as indigenous to South Africa—just like blacks in America—nevertheless I think that emotionally it is objectionable to us as the aborigines of South Africa that a white minority should prescribe where we may have a stake in our own land and where we may not. So that what makes it repugnant, of course, is the very idea of imposing a system of government—the whole thing is an imposition—by people who initially were foreigners although I say they have become indigenous.*

Buthelezi further argues that the so-called 'budding states' are none other than the territories to which Africans have been relegated by Europeans by force of arms from the earliest times of inter-racial conflict and as such they are not new, they have always been there. Suffering from poverty and ignorance and neglected by the white-controlled Government, these are the areas where Africans have always lived. The Government is merely giving them a dignified but hollow status by refering to them as 'homelands' or 'native states'.

The general African response to the Bantustan experiment was unfavourable. They had not even been consulted and they were opposed to the appointment of chiefs by the Government. In May 1960 there were serious disturbances in Pondoland. The Government reacted characteristically: the police were let loose on the people and did their job ruthlessly. Hundreds of people were arrested and tortured and finally a state of emergency was declared in the troubled area. It took the Government until 1961 to restore law and order, but at incalculable expense in terms of human suffering.

African unease was again demonstrated in April 1961, at the annual meeting of the Territorial Authority of the Transkei. At that meeting the government-appointed chiefs and headmen (120 altogether) expressed a number of grievances. They declared that they were unpopular with the people and that the new administration was unpopular, and they demanded firearms for their protection. They then went much further and passed a unanimous resolution

* *Africa*, no. 18, February 1973, p. 12.

Chief Kaiser Matanzima,
Chief Minister of the Transkei

urging the Government to grant self-government to the Transkei. This was an excellent test of the Government's sincerity on the issue of the Bantustans but the Government, realizing its predicament, simply told the Territorial Authority of the Transkei that self-government would be granted at some unknown future date. For the time being, they were told, there was a shortage of civil servants in the new 'states'.

In the meantime, discussions with the Government continued, resulting in a new Constitution for the Transkei. Its chief provisions were as follows:

1. There would be a Legislative Assembly of 64 nominated chiefs and 45 elected members.
2. The Legislative Assembly would elect a Prime Minister.
3. The Prime Minister would appoint an executive council, i.e. a council of ministers.
4. The Legislative Assembly would be in charge of internal affairs, e.g. agriculture and social welfare.
5. The Union Government would continue to control defence, foreign affairs, public transport, immigration, posts and telegraphs, currency, public loans, customs and excise, and certain aspects of justice.
6. Laws passed by the Legislative Assembly had to be approved and signed by the President of the Republic before they could be implemented.

The new Constitution was adopted by the Territorial Authority in May 1963. The Authority had no real power, but the first Bantustans had been born. Chief Kaiser Matanzima's party, which was supported by the Union Government, formed a government and it was narrowly returned to power in the election of 1964.

African response to apartheid

How have the Africans reacted to the harsh and inhuman laws by which they are governed? How have they responded to their loss of human dignity, justice and independence? And, finally, what is the future of this rich and beautiful country? These are some of the questions to which we must now turn. In doing so we shall confine ourselves to the period since the formation of the Union, for earlier activities have already been covered.

Pondoland

We have already noted how the people of Pondoland in the Transkei reacted unfavourably to the creation of the Transkei Authority, the first Bantustan. There was widespread discontent which prompted the Government to send in troops and police to impose law and order. An outbreak of violence followed; houses were burnt, there was looting, murder and armed resistance which culminated in mass arrests and the proclamation of a state of emergency.

The Pondo setting out from their village to hear the report of the Commission of Enquiry into the trouble in Pondoland, 1960

From the very beginning, German rule aroused much resentment among the Africans of South West Africa, owing to the Germans' insatiable greed for cattle and land. By 1902 Africans owned only 45,910 cattle compared to the Europeans' 44,490. Although Africans had lost about 95% of their herds in the cattle epidemic of 1897, a considerable number of the remainder subsequently passed into European hands by unfair means.

African reaction to German rule was haphazard, unco-ordinated and ineffective. Outstanding among the nine-teenth-century clashes with the Germans was the 1893–4 war with Hendrik Witbooi's Hottentots, which ended in stalemate. In 1896 and 1897 Chiefs Hendrik Witbooi of the Hottentots and Samuel Maherero of the Herero (who were unsteady German allies) supported the Germans against further local risings. In January 1904 Samuel Maherero led his people into the most memorable war of the decade against the Germans in South West Africa. This was the famous Herero Rising which was the culmination of two decades of conflict, mistreatment, aggression and numerous malpractices on the part of the Germans. Among the more immediate causes of the war were the Government's decision in 1903 to set up a reserve for the Herero (which the Herero

detested as a further attempt to alienate their land), the Government's directive of 1903 requiring Africans to pay their debts to European cattle traders within a year, and the construction of a railway through the Herero country. In practice European traders pressed for payment in a shorter time than allowed by the law, and Africans suspected that the railway would lead to further loss of their land. Fighting dragged on until August when resistance collapsed. Out of 15,000 white soldiers who were in South West Africa at the height of the war, 1,000 were killed and many others wounded. As against this the Herero were virtually wiped out and lost nearly all their cattle. About three-quarters of the Herero died, either during or as a result of the war, and only about 1,600 survived. Samuel Maherero himself led a few survivors into Botswana while many others perished in the desert. Most of the survivors tried to return to Hereroland only to be exterminated by the Germans.

South West Africa, despite numerous protests and resolutions by the United Nations, is still ruled by the Republic of South Africa as if it was an integral part of her territory. The area is rich in zinc, silver, uranium, lead and diamonds. Hence its attraction to South Africa. Just as the Germans had ruthlessly crushed African revolts, the South African Government suppressed the uprising of 1919, led by King Mandune. In 1922 a Hottentot group called Bondelswarts refused to pay the 'dog tax' which the South African Government had introduced. The authorities retaliated by crushing all resistance with machine-guns and bombers. In the following decades South West Africa was subdivided into white and non-white areas. The policy of Bantustans was extended there and from 1949 the whites were represented in the Union Parliament in Cape Town.

Since 1966, however, the resistance movement has been better organized though success is not within sight. On 25 August 1966 the South West African People's Organization (SWAPO), led by Sam Nujona, launched a fierce armed struggle against white rule. SWAPO's aim was to liberate the country and to create a new independent nation where justice, liberty and human dignity and happiness would prevail. The struggle still continues.

The attitude of South Africa to South West Africa has provoked much criticism on the grounds that the Republic has violated the terms of the world body's mandate which empowered it to rule there. It has been argued, and with plenty of justification, that the Republic is ruling South West Africa in a manner which is contrary to the original intention of the world body. It was intended that the governing authority, i.e. South Africa, would protect and

Sam Nujona, President of the South West African People's Organization

promote the interests of the territory's inhabitants. This is now not so. In 1966 the International Court of Justice at the Hague in Holland gave an unfavourable decision on South Africa's right to administer South West Africa, and in June 1971 the Court ruled that South Africa had no mandate to administer the territory. Nevertheless, and despite the United Nation's subsequent condemnation of South Africa, the position remains unchanged.

The African National Congress is the largest and best known nationalist movement in South Africa. Although it has met with little success so far, Congress has trained Africans in an entirely new way to fight the struggle for independence. There is no need to go into all the details of its history; a brief outline of its activities will suffice. In January 1912 prominent Africans gathered at Bloemfontein in the Orange Free State and formed the South African Native Congress. In 1935 it was reorganized and renamed the African National Congress. Among its members were lawyers, journalists, teachers and chiefs. The aims of the Congress were as follows:
1. to bring about and encourage mutual understanding in the country
2. to bring all the people of the country together
3. to defend the liberty, rights and privileges of the people.
 As first organized, Congress adopted a moderate and constitutional approach to the country's and Africans' problems. It saw itself as the people's representative, and it passed resolutions and presented fruitless petitions to the Government. It did not organize Africans into a mass political group; it was not demagogic; it was peaceful and responsible. All it demanded was a share in the government of the country. This cautious and constitutional approach soon became unpopular in some sectors. In particular, during and after the Second World War the younger generation became disillusioned with the old leadership and demanded a militant approach. In 1943 they formed the Youth League as an adjunct of Congress. The League wanted action, not words or mere petitions; it wanted 'national freedom' and not simply justice. It produced a Programme of Action, adopted by Congress in 1949, which defined the aim of the struggle as 'national freedom' and independence. It rejected white domination, segregation and apartheid, and called for greater African participation in commerce and in the economy in general. It also recommended that more funds be made available for African education.
 From 1949, therefore, when the African National Congress adopted the Programme of Action, it became a militant

The African National Congress

Oliver Tambo, Acting President of the African National Congress

Chief Albert John Luthuli, late President of the African National Congress

...er Sisulu, ex-Secretary-General ...rican National Congress

political party. Its policy was bound to be rejected by the Government since it now became a threat to the existing economic, political and social structure based on white domination. In doing so, Congress became a target of attack by the Government, and was henceforth continually harassed. Because of their comparative weakness and in view of the Government's antipathy to their policy and organization, members of Congress decided to adopt non-violent means to achieve their objective. At the same time the party mobilized the masses and made them politically conscious. It was thought that by resorting to civil disobedience, which involved passive non-co-operation with the state and industrial strikes, Africans would win major concessions from the Government since the country was dependent on African labour. This was the only way of avoiding legal action. But the Government had other ideas. Congress was a hostile organization and a threat to European leadership and domination. Life must be made difficult for it and its leaders. As already seen, numerous legislative measures were passed restricting freedom of association and of movement. Congress leaders were rounded up and political gatherings made virtually impossible. The most important of such laws were the Riotous Assemblies Act of 1956 and the Suppression of Communism Act of 1950.

These measures had a far-reaching effect on the African National Congress. One after another, Congress leaders were barred from participating in its activities and their movements were restricted. In 1952 its President, Albert John Luthuli, was banned; the ban was renewed in 1954 and 1959. The Congress's Secretary-General, Walter Sisulu, was similarly banned in 1954 and 1959. In fact in 1954 the ban was almost universal, for in that year several African National Congress provincial leaders were barred from taking part in its activities. Among them were J. L. Z. Njongwe, the Acting Provincial President of the Cape; the President of the African National Congress Youth League; and the Provincial Secretaries of the Cape, Transvaal and Natal. The efficiency and morale of the African National Congress were seriously undermined. The Government made sure that the leadership of the party was crippled and the systematic seizure of experienced leaders left the Congress disorganized and weak.

Nevertheless, the struggle was intensified in some quarters, sometimes underground. After 1945 the African National Congress joined forces with the Indian Congress. Eight years later the predominantly European Congress of Democrats and the Coloured People's Organization joined the alliance. Then, when the Communist Party was banned

in 1950, many of its former members joined the African National Congress. Though the alliance did not work well, it gave encouragement to the harassed African National Congress. In 1955 Congress adopted the Freedom Charter which was prepared by the National Acting Council of the Congress of the People, one of the co-ordinating committees of the allied Congresses.

If the African National Congress was already unpopular with the Government, which was busy arresting and restricting its leaders, its position worsened after the adoption of the Charter. Among other things, this radical document demanded the restoration of 'human rights', the nationalization of mines and industries and a redistribution of all land. Many African National Congress members were opposed to the Charter. They regarded it as an imposition by other Congresses which had a multi-racial membership and thought these groups were trying to divert and modify

Demonstrators in Durban in 1960

Robert Sobukwe, ex-leader of the Pan-African Congress

African nationalism. Instead they wanted purely African leadership and independence. Many of these Africanists did not join the 'stay-at-home' strike of 1958 which was called by the African National Congress, and as a result their leaders, Potlako Leballo and J. M. Madzunya, were expelled from the African National Congress. In April 1959, this faction formed the rival Pan-African Congress, led by Robert Mongaliso Sobukwe. It was joined by the largest and most active of the African National Congress branches, the Orlando branch. The Pan-African Congress adopted a much more militant approach, launching a fierce Anti-Pass Campaign. The African National Congress followed suit in an attempt to retain its membership and popularity.

In March 1960 the Pan-African Congress organized a large but peaceful demonstration against pass laws. The

Africans burning their pass books as a gesture of defiance, 1960

response in towns was particularly impressive, especially in Langa and Sharpeville. In many urban centres Africans protested against the hated law by defiantly marching to police stations without a pass, so that they might be arrested for breaking the pass laws. However, only a few of the leaders were arrested by the police, and the angry crowd demanded their release. But in Sharpeville the police opened fire on the unarmed and defenceless mob; 69 people were killed and 180 arrests made in what became known as the famous Sharpeville Massacre. The African National Congress retaliated by declaring 28 March a day of national mourning. Again the response was good and the industrial life of the country came to a halt as thousands of African workers stayed at home. The Government stepped in and declared a state of emergency, mobilized the troops, banned public

Victims of the Sharpeville Massacre

Nelson Mandela, African freedom fighter, now in detention

meetings and arrested and confined people without trial. Altogether about 20,000 arrests were made. There were mass demonstrations all over the country by furious Africans. One such demonstration took place in Cape Town; it was between 30,000 and 50,000 strong and was led by Philip Kgosana. On 8 April the Government banned both the African National Congress and the Pan-African Congress and they were forced underground. Practically all African leaders were arrested or restricted. Among the best known are the late Chief Albert Luthuli, President of the African National Congress and a keen Christian; Robert Sobukwe, who led an unsuccessful demonstration to Johannesburg; and Nelson Rolihlala Mandela, an ardent freedom fighter who worked underground till his arrest and life imprisonment on Robben Island in 1965. His wife was also arrested in July 1969 and detained; she was released in 1970 but later placed under house arrest.

Today Albert John Luthuli is dead, and Mandela and other nationalists still languish in detention camps without any hope of being released. But the Liberation Committee of the Organization of African Unity is committed to the cause of freedom in southern Africa, and the struggle still continues underground. To succeed, the nationalists of South Africa require money, arms, ammunition, trained manpower and the goodwill of the outside world. They must also unite and work hard, for the whites of South Africa will not yield easily. The struggle is physical and military. More recently South Africa has extended a hand of friendship to the neighbouring African states of Lesotho, Botswana and Swaziland. She has diplomatic relations with Malawi, and President Banda of Malawi paid a state visit to South Africa in August 1971. But all this does not necessarily demonstrate a genuine change of heart; mere friendship between African states and white South Africa is unlikely to result in the granting of political, economic and social rights to the Africans of South Africa.

The support of Western Europe and the United States of America is an important prerequisite for the success of the nationalist cause but this support is not guaranteed. Western Europe and the United States have enormous investments in South Africa and their trade with South Africa is highly profitable. They dare not offend the South African Government. For example, in October 1970 President Kaunda of Zambia led a delegation of the Organization of African Unity to Western capitals to persuade their Governments not to sell arms to South Africa. In the United States they did not meet President Nixon at all, while the meeting with Prime Minister Heath of Great Britain was not fruitful. Thus it

President Kaunda of Zambia and Mr Heath, Prime Minister of Great Britain, after their talks in London in 1970

appears that the liberation of South Africa can only be won through the efforts of the Africans of South Africa themselves. They must be united and better organized, but they still need the material support of African nations and of all friendly and sympathetic states. Moral support alone is not enough. It remains to be seen how and when the battle will be won, though one hopes it will be accomplished peacefully. But that depends on the whites of South Africa. As Chief Buthelezi of the Zulu homeland has said:

> I think that South Africa can only be saved by radical thinking. I don't know how this will come about—whether through ordinary thinking or through violence or whatever. The salvation of the country will come about if all the people of the country share the wealth of their country; if they share in dertermining their future. All race groups . . . must have equal share (sic) in determining the future and having a say in the country. All people, including my people, must have a share in the wealth of the country, not just one race group keeping all the wealth and the power to itself.*

Paradoxically this well-known supporter of the Bantustan experiment has become disenchanted with the system and

* *Africa*, no. 18, February 1973, p. 15.

concludes that the 'people who will liberate blacks are blacks themselves within the situation in South Africa'. However he is unable to say how this goal will be attained.

In conclusion, here are the last words of Mandela to the judges who tried him for his contribution to the nationalist cause:

> During my lifetime I have dedicated myself to the struggle of the African people. I have fought against white domination, and I have fought against black domination. I have cherished the ideal of a democratic and free society in which all persons live together in harmony and with equal opportunities. It is an ideal which I hope to live for and to achieve. But if need be, it is an ideal for which I am prepared to die.*

These are brave words. Will the objective for which so many died and for which thousands still languish in prison, detention and exile be achieved? How and when will this come about? At present the position is far from clear.

* J. C. Anene and G. Brown (eds.), *Africa in the Nineteenth and Twentieth Centuries*, Ibadan University Press, 1966.

Selected Bibliography

For students

Afigbo, A. E., Ayandele, E. A., Gavin, R. J., and Omer-Cooper, J. D., *The Growth of African Civilization: The Making of Modern Africa*, Vol. 1, Chapters 7, 8 and 9, Longman, London, 1968

Kiewiet, C. W. De, *A History of South Africa*, Oxford University Press, London, 1966

Lumb, S. V., *A Short History of Central and Southern Africa*, Cambridge University Press, 1969

Ward, W. E. F., *A History of Africa*, Book 1, Chapter 4, George Allen & Unwin, London, 1960

For the teacher

Bryant, A. T., *Olden Times in Zululand and Natal*, C. Struik, Cape Town, 1965

Carter, C. M. (ed.), *Five African States*, Cornell University Press, New York, 1963

Davis, J. A., and Baker, J. K., (ed.), *Southern Africa in Transition*, Frederick A. Praeger, New York, 1966

Hailey, Lord, *An African Survey*, Oxford University Press, London, 1957

Hofmeyr, J. H., and Cope, J. P., *South Africa*, Ernest Benn, London, 1965

Luthuli, A., *Let My People Go*, Collins, London, 1962

Omer-Cooper, J. D., *The Zulu Aftermath*, Longman, London, 1966

Macmillan, W. M., *Bantu, Boer and Briton*, Oxford University Press, London, 1963

Marquard, L., *Peoples and Policies of South Africa*, Oxford University Press, London, 1962

Marquard, L., *The Story of South Africa*, Faber, London, 1966

Stow, G., *The Native Races of South Africa*, C. Struik, Cape Town, 1964

Theal, G. M., *South Africa*, George Allen & Unwin, London, 1894

Thompson, L. M. (ed), *African Societies in Southern Africa*, Heinemann, London, 1969

Walker, E. A., *A History of Southern Africa*, Longman, London, 1957

Walker, E. A., *The Great Trek*, A. & C. Black, London, 1948

Webster, J. B., 'Leadership in Nineteenth-Century Africa', *Tarikh*, Vol. 1, No. 1, November 1965

Wilson, M., and Thompson, L., (ed.), *Oxford History of South Africa*, Oxford University Press, London, Vol. I (1969) and Vol. II (1971)

Index

Prepared by Vera Varley